MAGNUM
MAGNUM

MAGNUM

MAGNUM

Edited by Brigitte Lardinois

With 413 photographs in colour and duotone

Thames & Hudson

First published in the United Kingdom in 2007 by Thames & Hudson Ltd,
181A High Holborn, London WC1V 7QX

www.thamesandhudson.com

This compact flexibound edition first published in 2009
© 2007, 2008 and 2009 Thames & Hudson Ltd, London

Photographs by W. Eugene Smith © The Heirs of W. Eugene Smith
All other photographs © the photographers/Magnum Photos

Art direction and design by Martin Andersen /Andersen M Studio
www.andersenm.com

Text edited by Philip Watson

Texts by Antoine d'Agata, Bruno Barbey, Raymond Depardon, Jean Gaumy,
Bruce Gilden, Harry Gruyaert, Guy Le Querrec, Lise Sarfati and Patrick
Zachmann translated from the French by Philip Watson

Text by Erich Lessing translated from the German by Philip Watson

Texts by Alex Majoli and Ferdinando Scianna translated from the Italian by
Andrew Brown

Text by Gueorgui Pinkhassov translated from the Russian by Andrew Meier

British Library Cataloguing-in-Publication Data
A catalogue record for this book is available from
the British Library

ISBN 978-0-500-28830-6

Printed and bound in China by C&C Offset Printing Co., Ltd.

CONTENTS

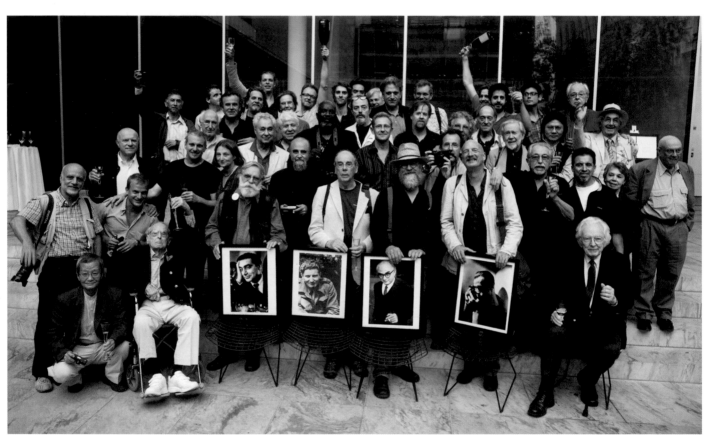

At the Annual General Meeting of Magnum Photos, New York, 2007. Photo: Micha Erwitt.

1 Hiroji Kubota **2** Burt Glinn **3** Robert Capa **4** George Rodger **5** David Seymour
6 Henri Cartier-Bresson **7** Wayne Miller **8** Ferdinando Scianna **9** Constantine Manos
10 Christopher Anderson **11** Jim Goldberg **12** Susan Meiselas **13** Micha Bar-Am **14** Abbas
15 David Hurn **16** Stuart Franklin **17** Larry Towell **18** Peter Marlow **19** David Alan Harvey **20**
Dennis Stock **21** Gueorgui Pinkhassov **22** Ruth Hartmann **23** Bruce Davidson
24 Chris Steele-Perkins **25** Thomas Hoepker **26** Donovan Wylie **27** Bruno Barbey
28 Elliott Erwitt **29** Nikos Economopoulos **30** Alex Majoli **31** Martine Franck
32 Guy Le Querrec **33** Mark Power **34** Eli Reed **35** Jonas Bendiksen **36** Bruce Gilden
37 Thomas Dworzak **38** Marco Bischof **39** Richard Kalvar **40** Martin Parr **41** Alex Webb
42 Harry Gruyaert **43** Paul Fusco **44** Ian Berry **45** Chien-Chi Chang **46** Trent Parke
47 Alec Soth **48** Simon Wheatley **49** Philip Jones Griffiths **50** René Burri

PREFACE

'I am a gambler', wrote Robert Capa in a famous quotation from his 1947 memoir-novel *Slightly Out of Focus*. In context the quote, from one of Magnum's founders, explains his decision to travel with Company E on the first wave of the D-Day landings: a decision that led to several of his iconic World War II photographs. Sixty years on we took another gamble: to invite photographers to select each other's pictures. This idea from Martin Parr came up in the course of discussion at a Magnum meeting.

When I asked Jean Gaumy what it felt like being edited by others he said: 'Russian roulette.' He and fellow-photographers in Paris thought it highly dangerous to be exposing a lifetime's work to the curatorial gaze of their peers. Naturally, it depends which kind of Russian roulette you play: the old-fashioned game, as the Russian army did it in Romania in 1917, by removing just one bullet from the cylinder. Or the way the writer Graham Greene played it as a boy (six times – out of boredom), with the chamber carrying just one charge.

Either way it was a risk. Or was it? Brigitte Lardinois, the book's editor, and a long-term Magnum-ite - without whom the book would not have been possible - was amazed and moved by the intense friendships she found: 'For me to see at such close range how much respect and real friendship there is between [photographers] is what makes this book outstanding. At the end of the day that is the only reason Magnum has survived.' Probably true.

Such close-knit camaraderie is revealed in the short texts that each photographer wrote about his/her selection from another photographer's work. This is exemplified in David Hurn's writings on Josef Koudelka: 'Little did I know that this man would truly enrich my life and become, in feel, the brother I had never had.'

Magnum has often been described in familial terms. Eve Arnold, a member since 1951, wrote on Magnum's fiftieth anniversary of her experience of being a member: 'It's like being part of a family. You love all of them, but you don't like all of them. It is an organic thing.' So, like many family affairs, deciding who would be paired together in this book produced the biggest challenge for the editors. It took all of Brigitte's considerable flair for diplomacy to ensure that everyone was more or less content with the pairings.

The result, evident in the work selected, is a wonderful, fresh and diverse collection of photographs. The dichotomy – between art and photojournalism – that has often been used to describe division inside Magnum, simply vanishes in the multiplicity of approaches to documentary photography. And it crystallizes in the special quality of the photography that defies categorization, surprising the editors already very familiar with Magnum's opus.

One commented: 'the thing that shines through in the work, as much as in the text, is the character and soul that you don't find in other photographic work... I can't think of another book like it.' There hasn't been another book like it. Certainly, it's the first Magnum group book that includes all the photographers invited to participate.

As to the question of whether photographers edit the work of others better than their own, you'll have to judge that for yourself. In any event, the beauty of this book is that it has become more than the sum of its parts. *Magnum Magnum* is more than a book about photographs and text – it offers a unique glimpse into the heart and soul of the world's greatest picture agency.

Since its first publication in 2007, the 'big book' *Magnum Magnum* has enjoyed widespread critical acclaim, bringing Magnum's talents, strengths and triumphs to the forefront of public awareness. This new compact version will bring Magnum's own brand of authorship and passionate story-telling to an even larger audience.

In France, if a gambler wins more than the chips on the table, he is said to 'faire sauter la banque'. A black shroud is placed over the table until more chips can be brought. I think we have sautéed the bank, tombéed amorously beside the camp-fire and proved once more the old adage that risk-takers – among whom are gamblers – who take creative, emotional, and intellectual chances will inherit the future.

Stuart Franklin
President, Magnum Photos

WHAT IS A
MAGNUM PHOTOGRAPH?

If you mention the word Magnum to any halfway photo-literate person, what image immediately springs to mind? Robert Capa's Spanish militiaman at the moment of death? Almost anything by Henri Cartier-Bresson? But let's say that wonderfully cheeky Parisian urchin cradling two bottles of wine.

Others would fit the bill. For over sixty years, Magnum photographers have been responsible for taking some of the world's most memorable photographs, images that have become an instantly recognizable part of our cultural landscape. However, those most likely to pop into our minds will probably share certain features. They will almost certainly be black-and-white photographs taken with a 35mm camera – one could guess with a Leica, even – and they will have been taken on the wing, without formality or fuss, perfect examples of 'decisive moment' photography (a phrase commonly associated with Cartier-Bresson). Furthermore, they will be firmly in the 'concerned photographer' mode, classics of photojournalism, or 'reportage' as the French call it.

In short, we tend to have a preconceived notion of the ideal Magnum photo. And, like many preconceptions, it is partly true and partly false. The chances are that the image we will think of comes from Magnum's early years. After all, the classics have had more time to sink into our collective cultural consciousness.

Magnum was founded just after World War II by photographers for photographers – by men who cut their teeth during the politically turbulent 1930s and the war. Following the conflict, there was a burgeoning market for reportage photography and the mass circulation picture magazines. But Magnum was not only about exploiting markets, it was about photographers banding together to work on the kinds of assignment they believed in and, importantly, retaining the copyright after the stories were published. This was not the general practice then, and the fact that nearly all the photographs in this book come from the Magnum Archive is testament to their success.

So, while its members operate in a certain commercial environment – as do all photographers, even so-called 'art' photographers – the Magnum ethic demands that they maintain a certain standard, that they work as independently as possible within the constraints of whatever commercial sphere they choose. And the Magnum ethic – which they still debate fiercely among themselves – demands that they should try to lead the market rather than simply follow it, making the pictures according to their own promptings, and then selling them, or placing them in the appropriate context.

In the beginning that context was primarily the picture magazine, the kind of weekly journal, such as *Look* or *Life*, *Picture Post* or *Paris-Match*, *Stern* or *Du*, that would devote several (or many) pages to the photoessay – a sequence of pictures laid out to form a narrative on a particular theme. Photojournalism had begun in such magazines in the 1920s, matured in the 1930s, and then, after the war, enjoyed a 'golden age' of three decades or so before television inevitably took over as the main disseminator of visual information about the world. That this period from 1945 to roughly 1980 could be described as a highwater mark for reportage was due in no small measure to Magnum photographers. The traditional

Magnum style – and the seminal images we associate with Magnum – derives from that epoch, which did not end overnight, but evolved into something else. And Magnum itself, which was never a static organization, evolved as markets changed.

Magnum has been described, and describes itself, as a family, and this analogy, while crude, is also apt. As in all families, its members sometimes argue fiercely – at their renowned and frequently fractious annual general meetings, criticism of one Magnum photographer by another may be candid in the extreme – but if the family body is threatened, they immediately band together. The organization now contains over sixty photographers, all with egos, all passionate about what they do, all passionate about Magnum's tradition, its spirit and its future. In this book, we are provided with a view of Magnum by Magnum, an insider's view that gives us a fascinating insight into the membership, both as individual photographers and as an entity that makes photographs.

It will be seen immediately that the 'traditional' Magnum photograph – in the 'classic' reportage mode – is still very much in evidence. Established editorial markets may have shrunk and changed, but there is still a demand for in-depth picture stories about our times and about world events. War, political strife and disaster – staple subjects for Magnum – are unhappily as prevalent as ever. The Vietnam of Philip Jones Griffiths has been replaced by the Bosnia of Gilles Peress or the Iraq of Paolo Pellegrin. Leicas and black-and-white film (or digital cameras set to 'monochrome' mode) remain standard Magnum issue.

New times have demanded new techniques and new attitudes In the 1960s, out of economic necessity, some Magnum photographers turned their journalistic talents to advertising assignments and corporate annual reports, earning the disapprobation of others. But there was an even more sharply contested issue, emanating from the fact that the cultural status of the photograph was also in flux. The art museum (and with it the art market) discovered photography. New applicants for Magnum membership in the 1980s brought different approaches, working in colour, making much more personal images, and considering themselves artists as much as reportage photographers. As the editorial market shrank, the 'cultural' market – commissioned exhibitions from museums and galleries – took off, a situation Magnum was able to exploit very well.

The more recent, younger members have greatly expanded the Magnum vocabulary – beyond recognition, according to some of the traditionalists. It is not, however, simply a matter of 'art'. The current media explosion, especially the advent of digital media and the Internet, has eroded the old certainties attending the idea of the camera as witness. Photojournalists – and more pertinently their viewers – are much more aware of the ambiguities, moral or otherwise, in reporting on the world.

So, if there is a trend to be discerned in today's Magnum, it is not so much a move towards art as a move towards a certain self-reflection. As photographers realize that objectivity is probably chimerical, it becomes more acceptable to wear one's subjectivity on one's sleeve. Magnum has witnessed the prevalence of a powerful contemporary 'diaristic' mode, seen here, for example, in the work of Jim Goldberg and Antoine d'Agata,

both exponents of a strictly personal journalism, shot in a highly impressionistic 'stream of consciousness' manner.

Extreme lucidity is also in evidence. Colour is used as a powerfully descriptive medium, whether in the forensic ring-flash of Martin Parr, or the large view-camera pictures of Mark Power and Alec Soth. This work, giving the 19th-century topographical style a contemporary twist, could hardly be more different from the 'classic' Magnum style.

While diehard traditionalists may argue with their younger colleagues, two things seem clear. Photographers do not join Magnum primarily to make art. They join because they want to make photographs about the world. Styles may change, markets may change, approaches may vary, but the basic desire remains – to look at life, to witness our times. The raging arguments (which they love, and which stimulate them all) are more a matter of style wars than any real substance.

Secondly, whatever their stylistic or aesthetic convictions, Magnum members make photographs to be published. Despite the inordinate number of classic single images to their credit, almost every picture has been made as part of a story, a narrative. The photographers exhibit in galleries, and magazine markets have diminished, but the essence of being members of Magnum is to get their picture essays in print – or perhaps online. So the book has become increasingly important to them, and their stories are being presented online in the new Magnum in Motion initiative. The web is giving photographers the opportunity to expand the whole notion of the picture essay in exciting ways, combining still images with movie footage, sound and text. Print remains crucial, but a revised version of this book in ten years' time may well include more than the printed page alone.

There are some old friends here, images we know and love, but there are surprises too. Susan Meiselas chooses little-known (and stunning) images from Spain by Robert Capa. Peter Marlow does likewise with London Blitz imagery by George Rodger. And while some select their six favourite pictures from their chosen colleague, others stay true to the reportage code and present six photographs from a single story – such as Steve McCurry's work from Cambodia, selected by Elliott Erwitt.

The clearest – and sharpest – judgment on an artist's work tends to come not from critics or curators, but from their artistic peers. No group of photographers judges itself more rigorously than the members of Magnum. So when they select work from the colleagues they most admire, their choices ought to demand our closest attention.

Gerry Badger

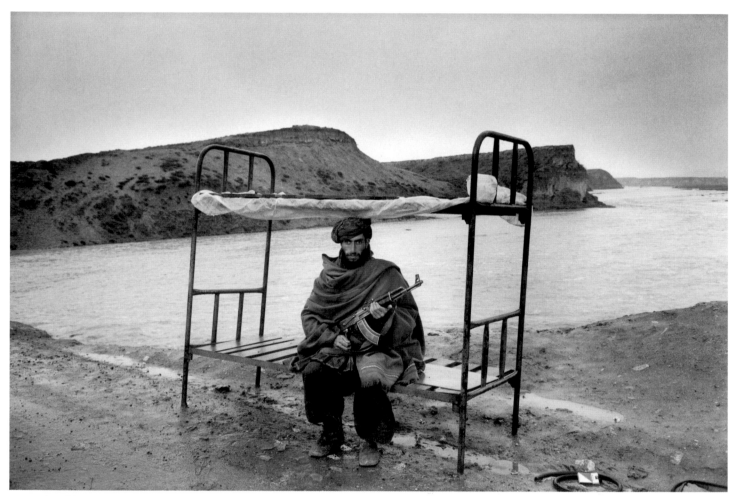

A member of the Hezbi Islami guarding the road to Kabul.
Afghanistan, April 1992

ABBAS

An Iranian born in 1944 and transplanted to Paris, Abbas has dedicated himself to documenting the political and social life of societies in conflict. In his major work since 1970 he has covered wars and revolutions in Biafra, Bangladesh, Northern Ireland, Vietnam, the Middle East, Chile, Cuba, and South Africa during apartheid.

From 1978 to 1980, Abbas photographed the revolution in Iran, to which he returned in 1997 after seventeen years of voluntary exile. His book *Iran Diary 1971–2002* is a critical interpretation of Iranian history, photographed and written as a private journal.

During his years of exile Abbas travelled constantly. Between 1983 and 1986 he journeyed through Mexico, attempting to photograph a country as a novelist might write about it. The resulting exhibition and book, *Return to Mexico: Journeys Beyond the Mask*, helped define his photographic aesthetic.

From 1987 to 1994, he focused on the resurgence of Islam throughout the world. *Allah O Akbar: A Journey Through Militant Islam*, the subsequent book and exhibition, spanning twenty-nine countries and four continents, attracted special attention after the 9/11 attacks by Islamic jihadists. A later book, *Faces of Christianity: A Photographic Journey* (2000), and touring show explored Christianity as a political, ritual and spiritual phenomenon.

Abbas's concern with religion led him in 2000 to begin a project on animism, in which he sought to discover why non-rational ritual has re-emerged in a world increasingly defined by science and technology. He abandoned this undertaking in 2002, on the first anniversary of 9/11, to start a new long-term project about the clash of religions, defined as culture rather than faith, which he believes are replacing political ideologies in the strategic struggles of the contemporary world.

A member of Sipa from 1971 to 1973, then of Gamma from 1974 to 1980, Abbas joined Magnum Photos in 1981 and became a member in 1985.

I am a non-believer. Unless I find convincing proof of the existence of God, I will live the rest of my life as an atheist. I believe that unless humankind adopts rational thinking on an unprecedented scale, we are in for big trouble over the coming century.

This is why Abbas is such a fascinating photographer for me. It is hard to find any other who has more diligently sought out religion in all its forms, sizes and colours, and documented where it intersects with culture and conflict. Year after year since the 1970s, he has traversed the planet, bringing back critical images from the ranks of the faithful. Interestingly, his images almost never judge a religion's flaws or merits, or put one above the other. Trawling through his vast amount of work, I'm given a bird's-eye view of the phenomenon of religion itself; his pictures form an archive of what, for me, is one of humanity's most sweeping and perplexing behaviours. I wanted to choose an edit that covered the gamut from spiritual experience, to political-religious upheaval, gently flavoured with a pinch of the absurd.

His epic image of the crowd in Tehran came as a natural start; Abbas is Iranian, and the image combines both the political and religious fervour of the revolution, as well as touching Abbas's roots there. The Christian baptism in South Africa and the image from the Hajj are both graphic, yet gentle. Although Abbas has spent much time in the midst of revolutions and war, these images of religious experience have a serenity about them. They touch upon what I assume religious experience to feel like: the tight intimacy of the community as each member reaches for their own divinity. The much busier image of the Haitian sacrifice got me where I wanted to go visually, down on the floor, amid the chaos of the rituals.

But the most alluring images for me are the two from Afghanistan: the Islamic fighter looking out of place, and the groomless bride. If Abbas's mission with images like these was to help us think about religion's place in our society and culture, then Bingo! – he certainly did it for me. Despite the bemused gaze of the two subjects, the images are still perfectly tender and respectful: a treacherous tightrope walk Abbas has performed for several decades.

Jonas Bendiksen

Opposite
A wedding party: a framed picture shows the woman's fiancé, who has migrated to Germany. Kabul, Afghanistan, April 1992

Following pages
Pilgrims gathering on Mount Rahma, where Muslims believe Adam met Eve. Mecca, Saudi Arabia, 1992

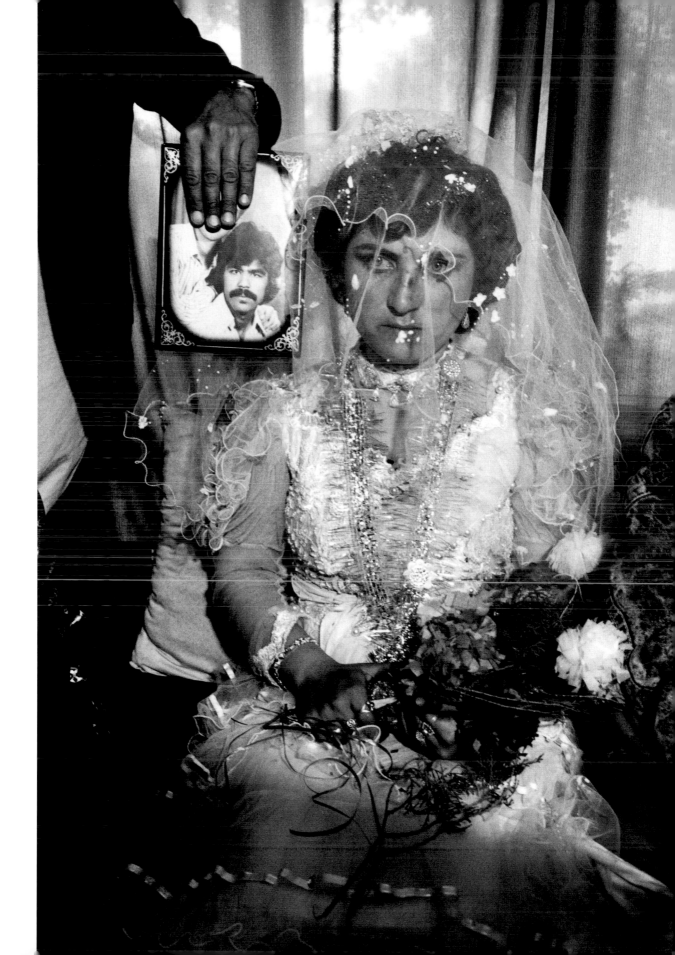

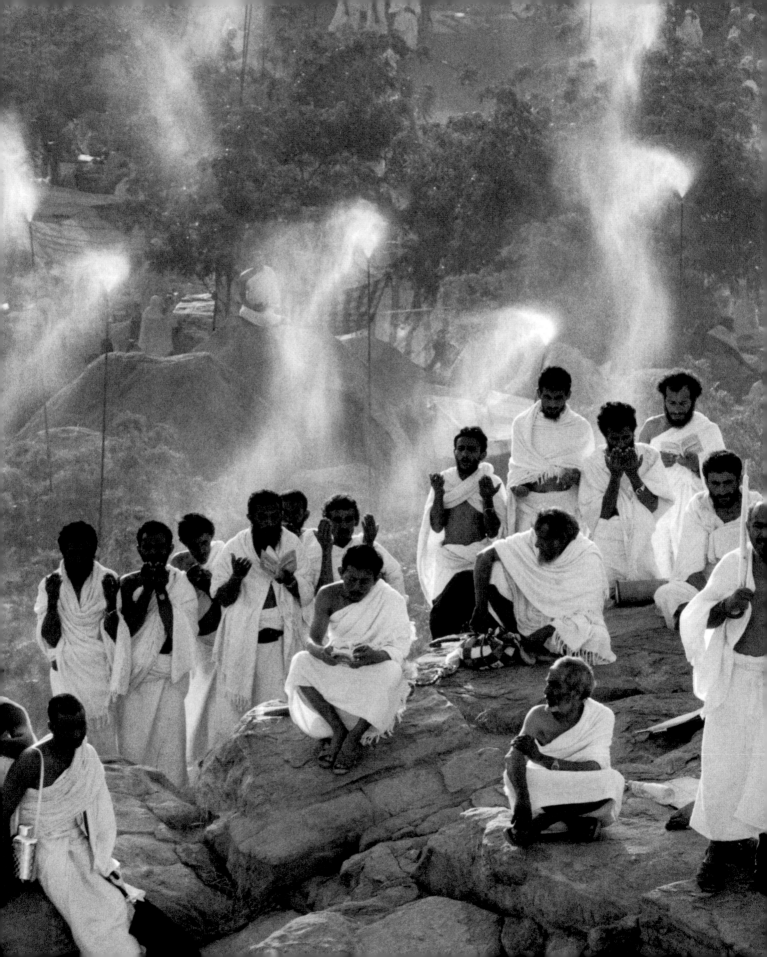

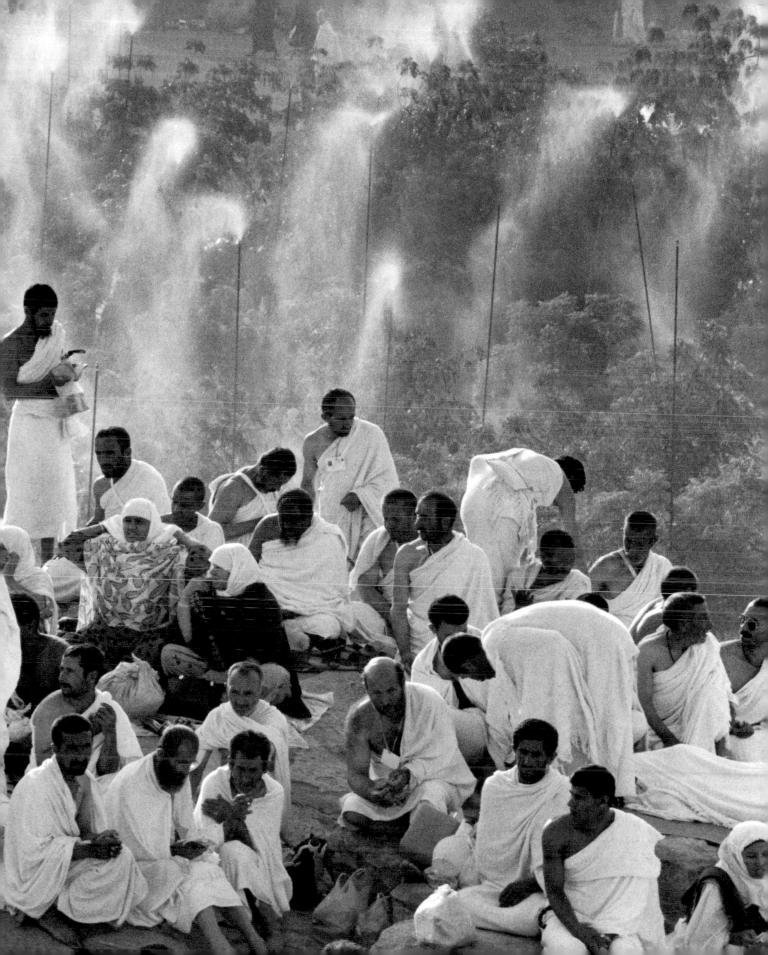

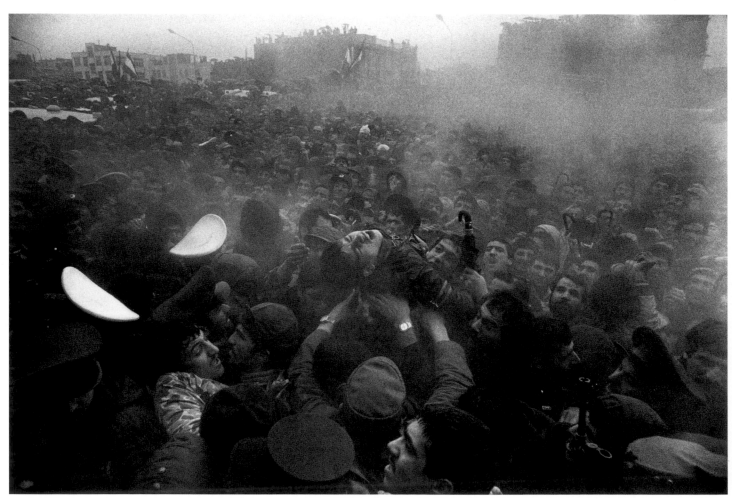

A man faints during celebrations on the first anniversary of the
Revolution. Tehran, Iran, 11 February 1980

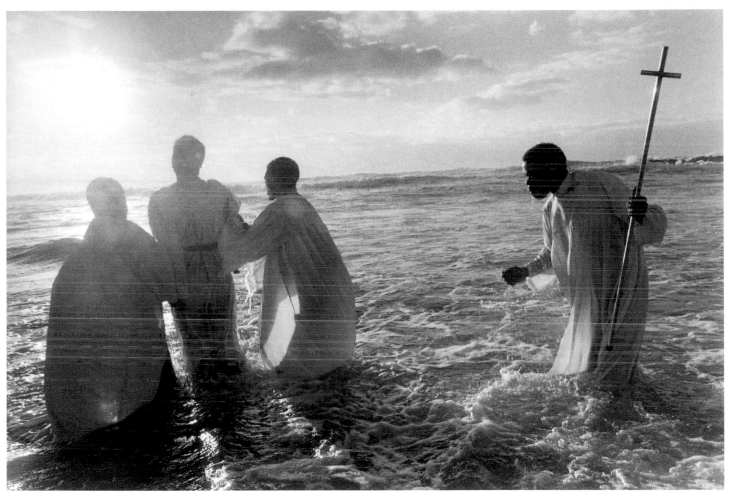

Priests of the Zion Church taking new converts to the sea to be
baptized at dawn. Cape Town, South Africa, 1999

Following pages
A bull being sacrificed to the voodoo spirit Ogoun. Plaine du Nord,
Haiti, 2000

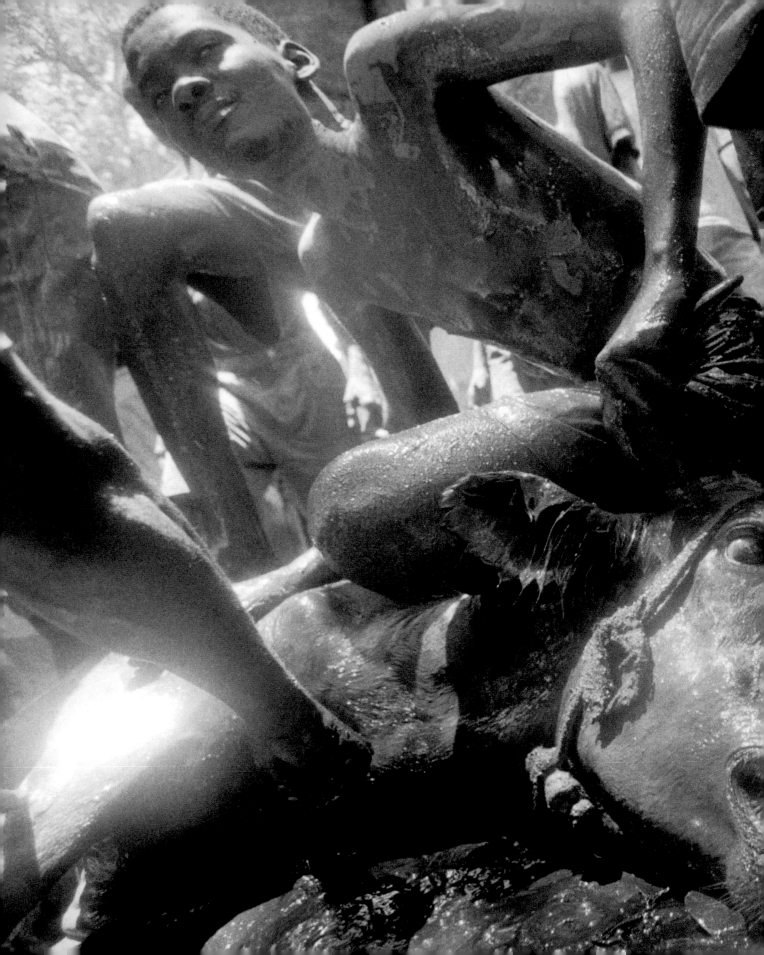

Gaza, Palestine, 1999

ANTOINE D'AGATA

Born in Marseilles in 1961, Antoine d'Agata left France in 1983 and remained overseas for the next ten years. Finding himself in New York in 1990, he pursued an interest in photography by taking courses at the International Center of Photography, where his teachers included Larry Clark and Nan Goldin.

During his time in New York, in 1991–92, D'Agata worked as an intern in the editorial department of Magnum, but despite his experiences and training in the US, after his return to France in 1993 he took a four-year break from photography. His first books of photographs, *De Mala Muerte* and *Mala Noche*, were published in 1998, and the following year Galerie Vu began distributing his work. In 2001 he published *Hometown*, and won the Niépce Prize for young photographers. He continued to publish regularly: *Vortex* and *Insomnia* appeared in 2003, accompanying his exhibition *1001 Nuits*, which opened in Paris in September; *Stigma* was published in 2004, and *Manifeste* in 2005.

In 2004 D'Agata joined Magnum Photos and in the same year, shot his first short film, *Le Ventre du Monde* (*The World's Belly*); this experiment led to his long feature film *Aku Anu*, shot in 2006 in Tokyo.

Since 2005 Antoine d'Agata has had no settled place of residence but has worked around the world.

I like the idea that Antoine d'Agata is part of the 'Magnum family', because there is nothing more stimulating than trying to make photographers fit in who don't conform to the usual image of our venerable agency. Nothing could be more boring than accepting a new photographer who is a clone of ourselves.

When I saw Antoine's work for the first time, I had a shock. I had become saturated with photography in general, which I found repetitive and limited. I had tried other formats – square, panoramic, colour, then cinema – all in an attempt to escape boredom or repetition. Suddenly, Antoine's work proved to me that with photography you could still surprise and move people.

I really loved these photos that brought me into the world of the night. I found them unique, moving, sensual, brutal, sometimes even shocking, wavering between desire, pleasure and suffering – one moment attracting us to desirable bodies or exciting situations, and the next to something we have no reason to desire.

D'Agata spares us nothing, and he spares himself nothing. He seems to photograph everything he experiences, in its entirety, to excess. He puts himself in danger and takes photos at moments when most of us would have given up. You cannot tell where the private ends and the professional begins. This is what drives most photographers, in a constant to and fro between the inner world and the outer world. His work shows a need to speak, to show, to reveal oneself, to cry out – a sense of urgency, as if our existence was threatened.

Henri Cartier-Bresson claimed that one has to step back from reality and become invisible. Robert Capa said you have to get so close to your subject that you feel fear. As for D'Agata, while he belongs perfectly properly to the tradition of reportage, he gets close enough to his subjects to make them blurred, and even includes himself in some pictures, as if to show that to leave oneself out would be a delusion.

Whether it is the work of a photographer, painter or film-maker, a work of art makes sense and touches me when it bears traces of the artist's self-portrait.

Patrick Zachmann

Opposite
Nuevo Laredo, Mexico, 1998

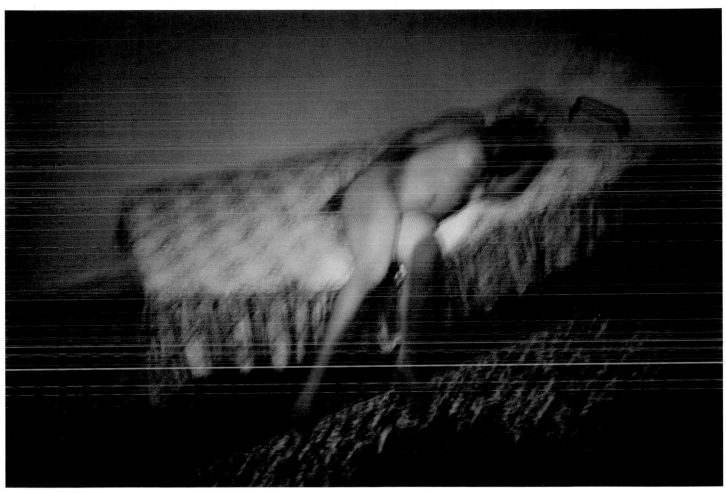

Istanbul, Turkey, 2003

Opposite
Hamburg, Germany, 2000

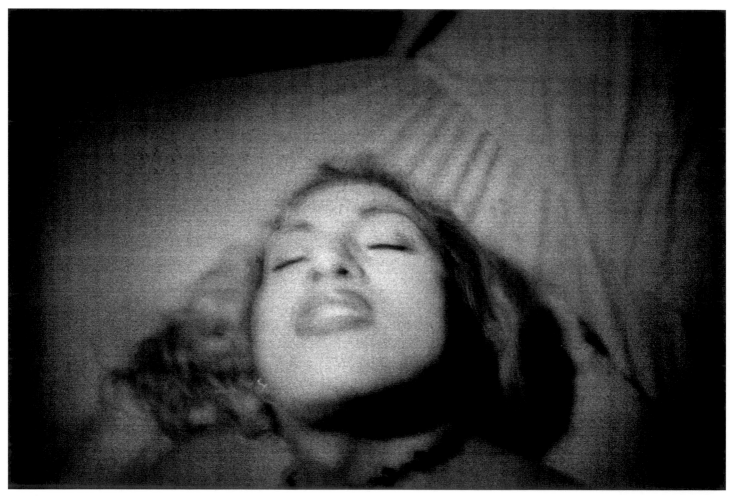

Hamburg, Germany, 2003

Guatemala, 1998

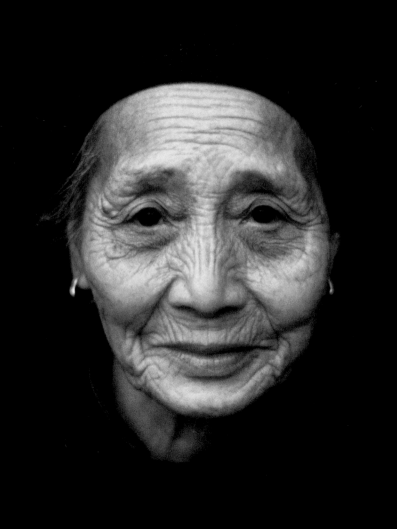

EVE ARNOLD

Eve Arnold was born in Philadelphia, Pennsylvania, in 1912 to Russian immigrant parents. She began photographing in 1946, while working at a photo-finishing plant in New York City, and then studied photography in 1948 with Alexei Brodovitch at the New School for Social Research in New York.

Arnold first became associated with Magnum Photos in 1951, and became a full member in 1957. She was based in the US during the 1950s but went to England in 1962 to put her son through school; except for a six-year interval when she worked in the US and China, she has lived in the UK ever since.

Her time in China led to her first major solo exhibition at the Brooklyn Museum in 1980, where she showed the resulting images. In the same year, she received the National Book Award for *In China* and the Lifetime Achievement Award from the American Society of Magazine Photographers.

In later years she received many other honours and awards. In 1995 she was made fellow of the Royal Photographic Society and elected Master Photographer – the world's most prestigious photographic honour – by New York's International Center of Photography. In 1996 she received the Kraszna-Krausz Book Award for *In Retrospect*, and the following year she was granted honorary degrees by the University of St Andrews, Staffordshire University, and the American International University in London; she was also appointed to the advisory committee of the National Museum of Photography, Film & Television in Bradford, UK. She has had twelve books published.

Opposite
Retired woman. China, 1979

If you were asked to conjure up a seasoned journalist–photographer who has travelled extensively, worked in the most difficult and remote parts of our globe, managed to penetrate and be accepted in exotic cultures at one time, and then average or even banal, familiar ones right afterward, all the while observing and recording with great heart and sympathy the manifestations of our human condition, you would surely come up with the legendary Eve Arnold … a very big person in a very compact package.

Eve Arnold is the quintessential journalist. Or better, she is what the quintessential photojournalist should be. That is, a curious, visual person, the inconspicuous fly on the wall observing situations without participating in them or attracting attention, opinionated but not judgmental.

I have known Eve as a suburban wife and doting mother in the Long Island exurbs fifty miles from New York City, where she lived years ago, and as a literary person and author of many fine works, now based in her sublime, book-lined London apartment. But I know her especially as the intrepid, highly energetic photographer and colleague, producing picture story after picture story, and picture book after picture book, and as a pillar of our Magnum Photos cooperative. In all of Eve's work, as with her person, the special ability has been getting close to her subjects – often becoming a trusted friend, regardless of their caste or fame, while always maintaining the dignity that permeates her character.

Eve Arnold's legacy is as varied as it is fascinating. It is hard to fathom how one person's work can be so diverse. It covers the humblest to the most exalted, the meanest to the kindest, and everything in between. The subjects are all there in Eve Arnold's photographs and they are treated with intelligence, consideration and sympathy. Most important is Eve's ability to visually communicate her concerns directly, without fanfare or pretence, in the best humanistic tradition.

Elliott Erwitt

Opposite
Francis Bacon in his studio. London, England, 1978

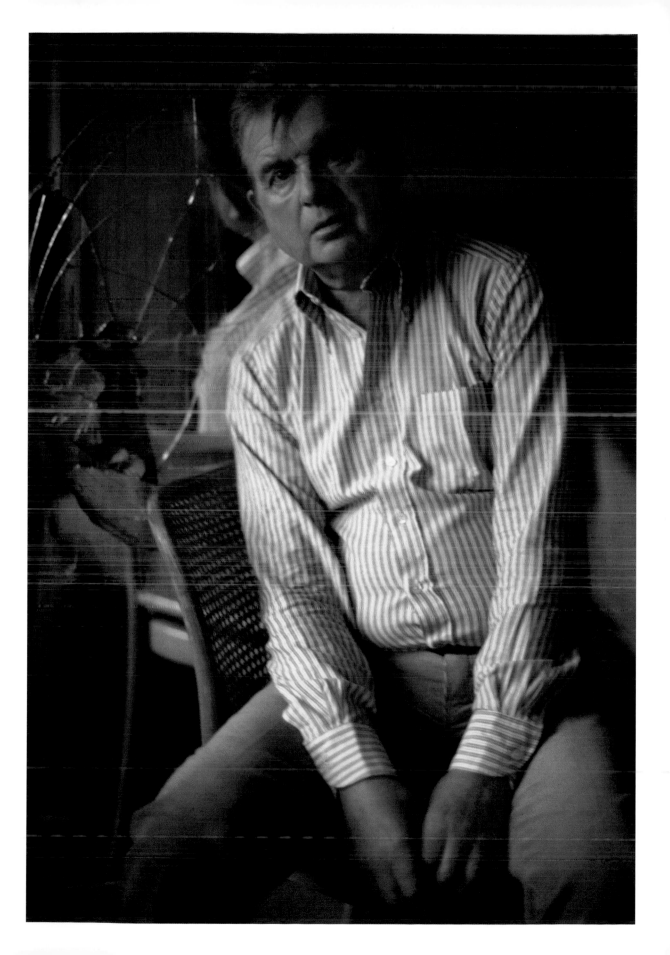

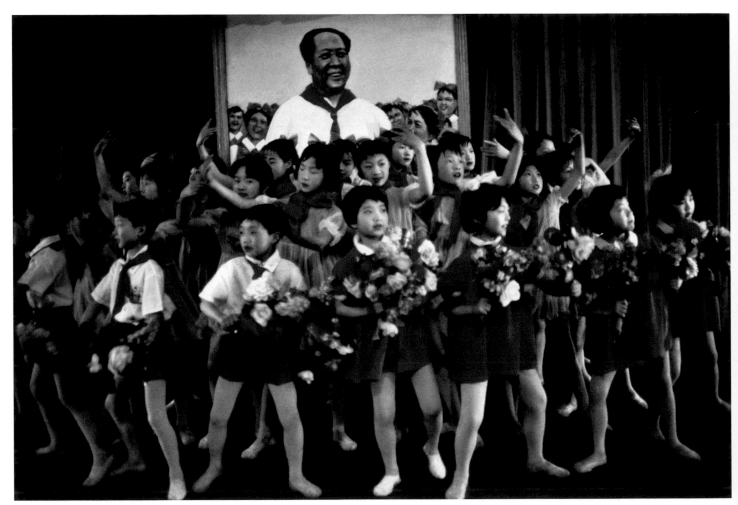

School play. Chungqing, China, 1979

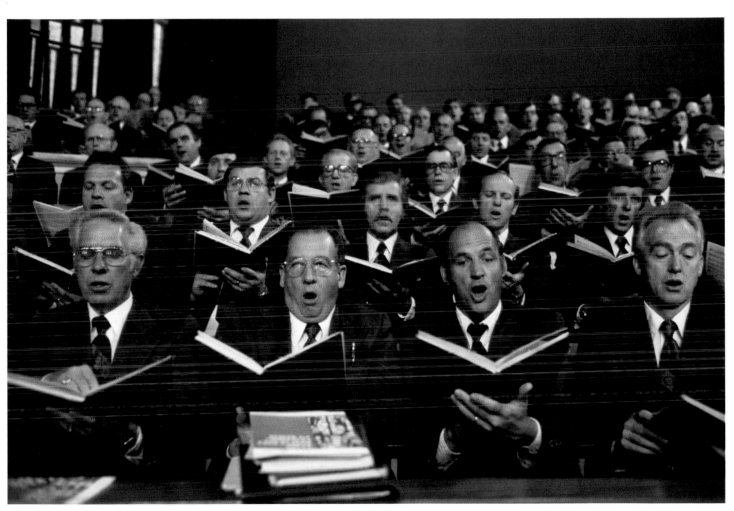

The Mormon Tabernacle Choir. Salt Lake City, USA, 1984

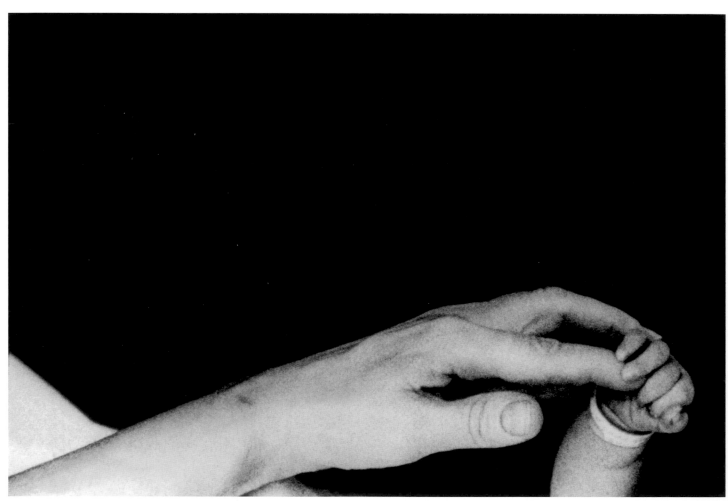

A mother and her newborn child. Long Island, USA, 1959

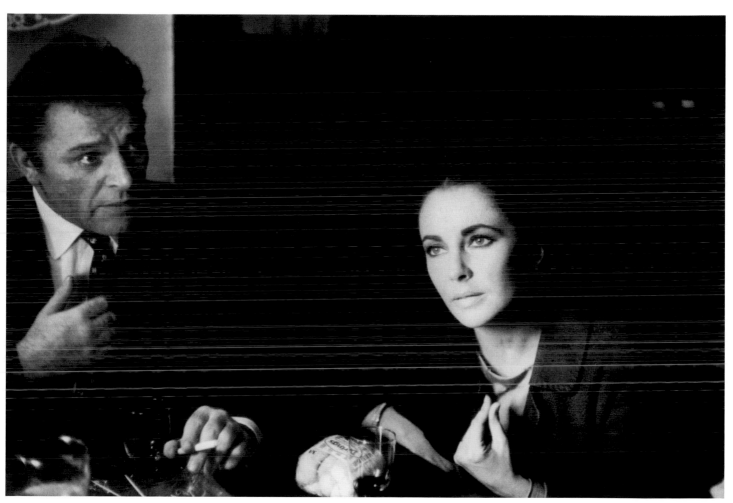

Richard Burton and Elizabeth Taylor at a pub during the filming
of *Becket*. Shepperton, England, 1963

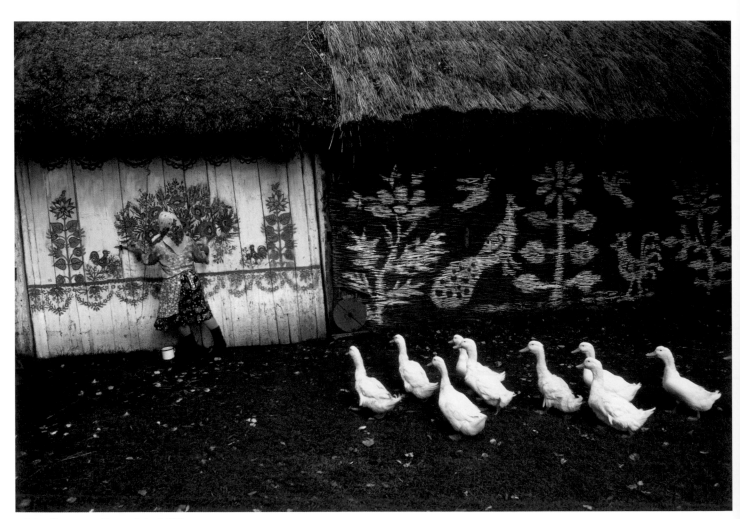

Painted houses near Ternow, Poland, 1976

BRUNO BARBEY

Bruno Barbey, a Frenchman born in Morocco in 1941, studied photography and graphic arts at the École des Arts et Métiers in Vevey, Switzerland. Between 1961 and 1964 he photographed the Italians, treating them as protagonists of a small 'theatrical world', with the aim of capturing the spirit of a nation.

During the 1960s, he was commissioned by Éditions Rencontre in Lausanne to report from European and African countries. He also contributed regularly to *Vogue*. Barbey began his relationship with Magnum Photos in 1964, becoming an associate member in 1966, and a full member in 1968, the year he documented the political unrest and student riots in Paris. A decade later, between 1979 and 1981, he photographed Poland at a turning point in its history, publishing his work in the widely acclaimed book *Poland*.

Over four decades Barbey has journeyed across five continents and into numerous military conflicts. Although he rejects the label of 'war photographer', he has covered civil wars in Nigeria, Vietnam, the Middle East, Bangladesh, Cambodia, Northern Ireland, Iraq and Kuwait. His work has appeared in most of the world's major magazines.

Barbey is known particularly for his free and harmonious use of colour. He has frequently worked in Morocco, the country of his childhood. In 1999 the Petit Palais, Paris, organized a large exhibition of photographs that Barbey had taken in Morocco during the previous three decades. He has received many awards for his work, including the French National Order of Merit; his photographs have been exhibited internationally and are in numerous museum collections.

Bruno Barbey became connected with Magnum at about the same time as I did, so it was natural that we became friends. My first impression was of a dapper figure out of a Jane Austen novel: suave, tall, elegant, with perfect manners.

The first picture is from Poland and was taken in a small village. The occupants of a house have painted it inside and out. The decoration is naïve art at its most delightful. The whole is turned into a photographic miracle by Barbey's capturing the instant when a flock of geese parades by, blending into the designs on the wall.

My second choice, from Bruno's Italian book, is structurally different. Three men stare from behind a snooker table. The picture reeks of menace. Photography has the power to capture abstract feelings – a sensation of strangeness inside the familiar. The ability to record what is visually not there is often the sign of a great photographer.

Bruno's pictures of Italy interested me, particularly one taken in Naples in 1963. A group of children play in the foreground, with a beggar, visually much smaller, in the background. The overall feeling is illusive and I enjoy that. The geometry is violent and the picture poses many questions. It still hangs on my wall at home.

The fourth image was the first colour picture I ever collected. Taken in Tokyo in 1971, it is of a protest confrontation. A picture of extreme theatricality, it reminds me, in structure, of paintings by Uccello or films by Kurosawa.

Bruno loves the sun and has spent many photographic years battling with the problems of light and contrast. I have picked two pictures from this genre. The first is a picture from Morocco of tanning skins drying in the sun, as they have done for hundreds of years. One can almost smell the guano used in the process.

Finally, a picture from Portugal of women carrying bread, with the shadow of the roof ridging echoing the patterns of the loaves. It produces a coincidence that is extraordinary.

Understanding the essence of things comes only from experience.

David Hurn

Opposite, top
Caltanissetta, Sicily, 1963

Opposite, bottom
Naples, Italy, 1963

Following pages
A demonstration against the construction of Narita Airport. Tokyo, Japan, 1971

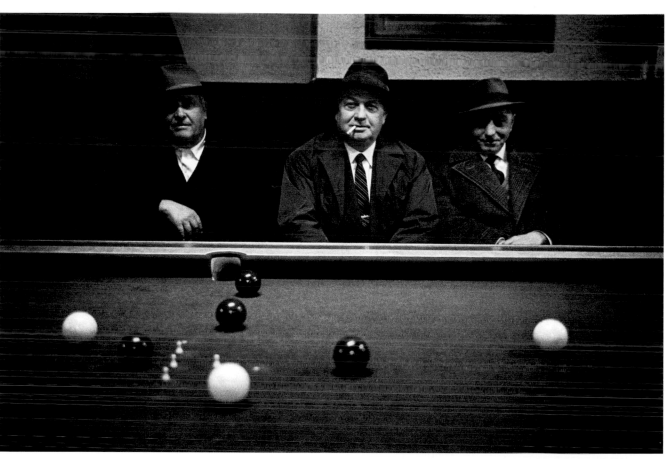
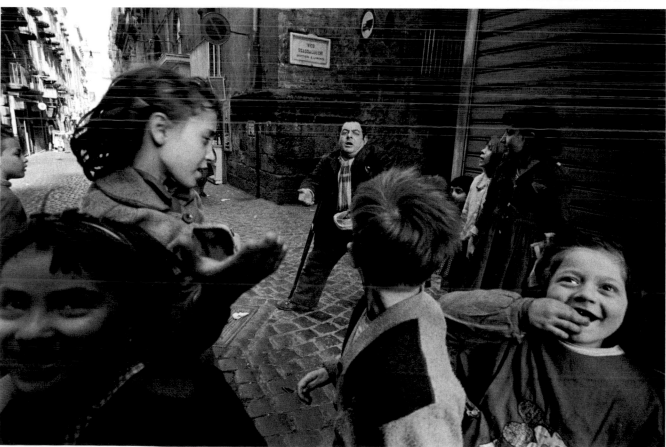

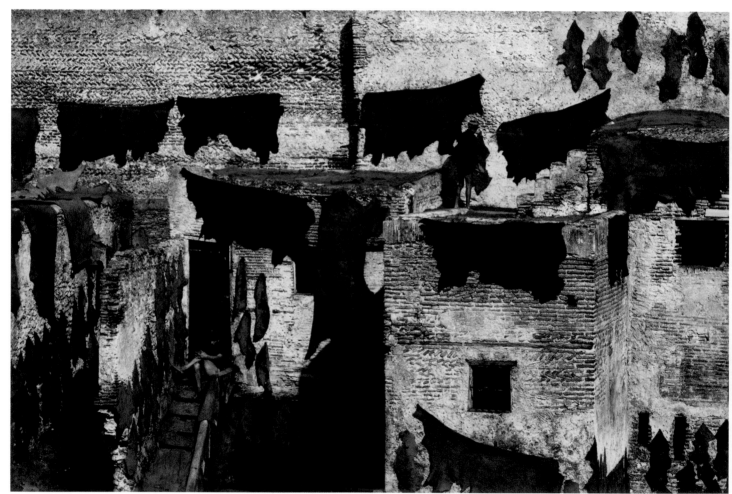

Tanners of Sidi Moussa, Fez. Morocco, 1984

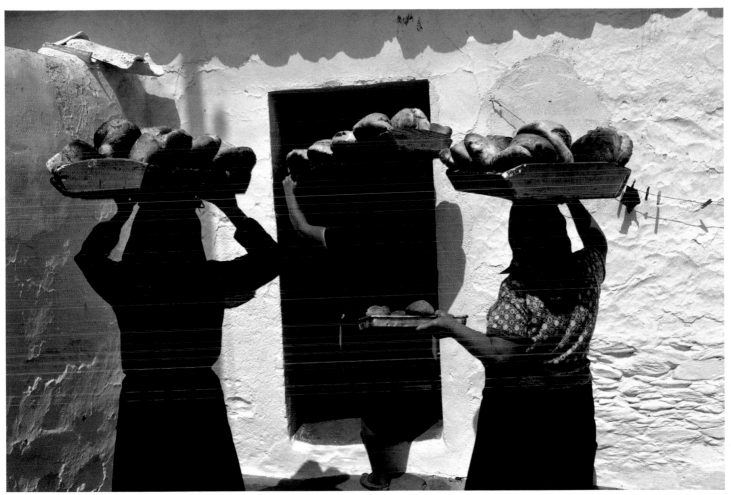

Near Castro Marim. Portugal, 1979

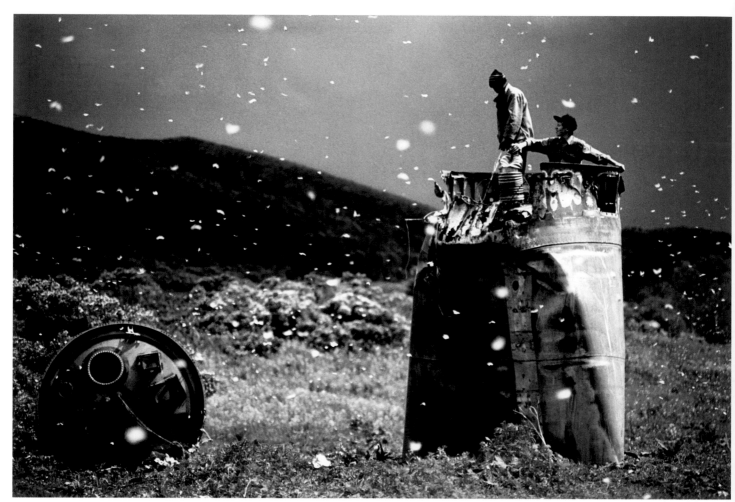

Villagers collecting scrap from a crashed spacecraft, surrounded
by thousands of white butterflies. Altai Territory, Russia, 2000

JONAS BENDIKSEN

Jonas Bendiksen is Norwegian and was born in 1977. He began his career at the age of 19 as an intern at Magnum's London office, before leaving for Russia to pursue his own work as a photojournalist. Throughout the several years he spent there, Bendiksen photographed stories from the fringes of the former Soviet Union, a project that was published as the book *Satellites* (2006).

Here and elsewhere, he often focuses on isolated communities and enclaves. In 2005, with a grant from the Alicia Patterson Foundation, he started working on *The Places We Live*, a project on the growth of urban slums across the world, which combines still photography, projections and voice recordings to create three-dimensional installations.

Bendiksen has received numerous awards, including the 2003 Infinity Award from the International Center of Photography, New York, and second place in the Daily Life Stories for World Press Photo, as well as first prize in the Pictures of the Year International Awards. His documentary of life in a Nairobi slum, *Kibera*, published in the *Paris Review*, won a National Magazine Award in 2007.

His editorial clients include *National Geographic*, *Geo*, *Newsweek*, the *Independent on Sunday Review*, the *Sunday Times Magazine*, the *Telegraph Magazine*, and the Rockefeller Foundation.

He lives in New York with his wife, Laara, and son, Milo.

Jonas appeared in Magnum's New York office in the spring of 2004, like a whirlwind of fresh air. He showed us photographs from countries and regions we had never even heard of: Transdniester, Birobidzhan, Qikiqtarjuaq, Kyrghyzstan, Abkhazia – names one has to Google to believe that they really exist. Jonas had taken pictures as wondrous and absurd as the extraordinary names of these strange lands.

Jonas is a lot of fun to be with – he has an enduring smile and the nervous energy of a greyhound just before the race starts. He writes funny e-mails from the hinterlands of Nepal, from an Inuit island on the fringes of Canada, from Indonesia, the Gaza Strip or Kenya. He has been with Magnum since he was 19, first as an intern in the London office. Then he went off to take pictures for himself. He got assignments from *Geo*, *National Geographic*, *Newsweek*, and won awards. When he was 27 he declared that he wanted to be a Magnum photographer; he was voted in as a nominee, and then in 2006 as an associate. At this moment he is Magnum's youngest photographer. 'This has to change,' says Jonas. 'We need to find someone younger than me.'

Now Jonas has embarked on his most ambitious project yet, an exhibition/installation called *The Places We Live*, a monument to the slums of this world. 'The urban population of the planet is about to overtake the rural, the number of people living in big city slums is passing one billion,' writes Jonas. So he is constantly out there in Kenya, India, Venezuela and Indonesia, photographing life in the world's largest and nastiest slums. He has simultaneously invented his own new medium of presentation. His exhibition will open in the Nobel Peace Centre in Oslo in 2008 as an invitation to experience life in a virtual slum. Eighteen digital projectors will recreate what Jonas saw in Nairobi, Mumbai, Caracas and Jakarta. We will witness the lives of families in their cramped quarters, complete with original sound, we will hear them talking about their lives, we will experience their ambience, the misery and foulness of these places, and the human dignity and struggle within them.

Thomas Hoepker

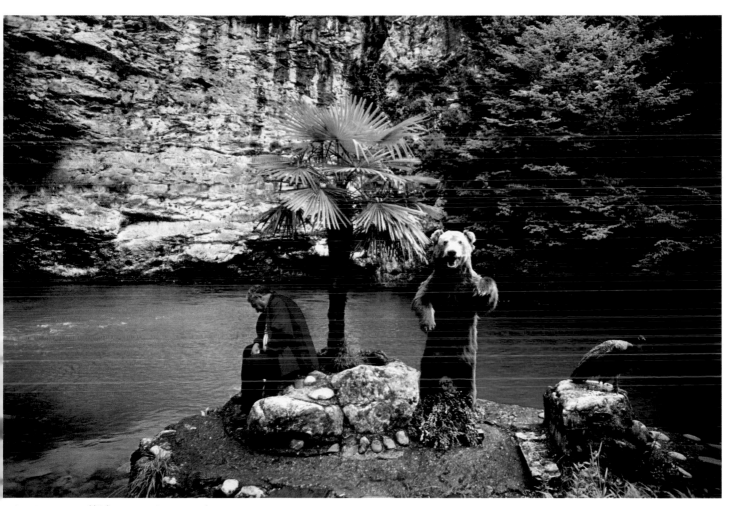

An entrepreneur and his bear at a tourist stop near the
Black Sea; he charges visitors to take photographs.
Abkhazia, 2005

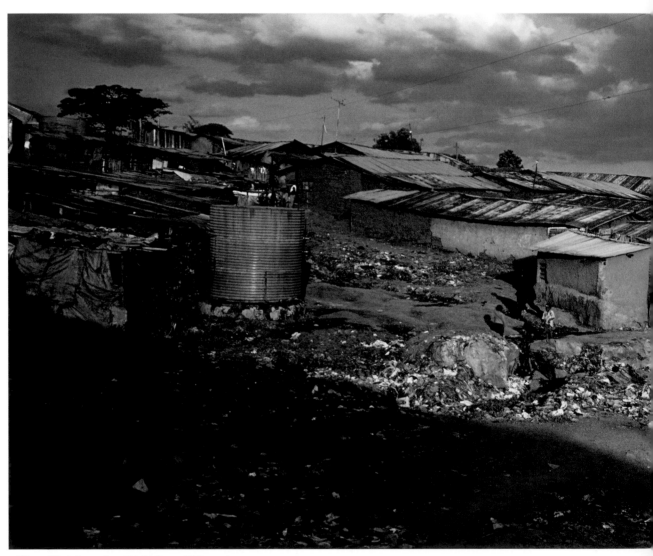

Kibera, Africa's largest slum. Nairobi, Kenya, 2005

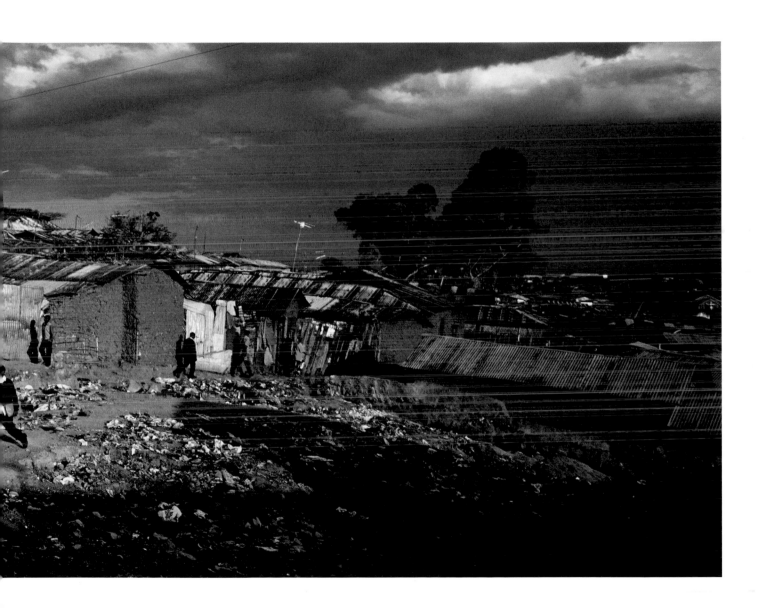

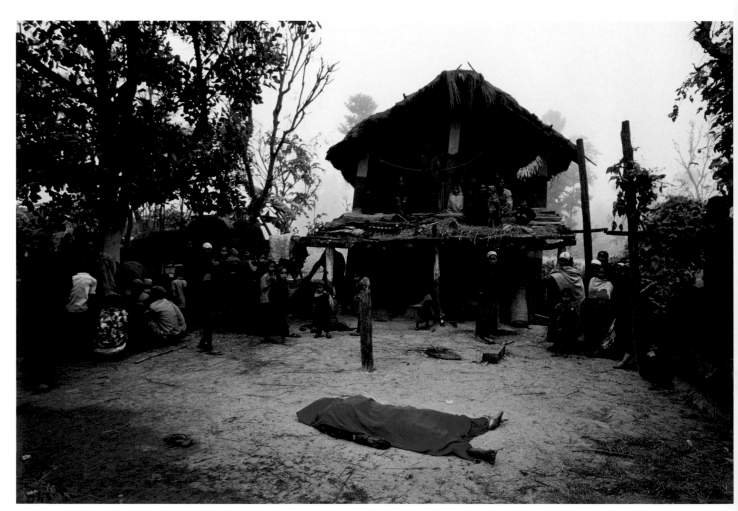

The body of a 23-year-old man killed by his neighbour in a
fight about water for irrigation. Babiyachour, Nepal, 2004

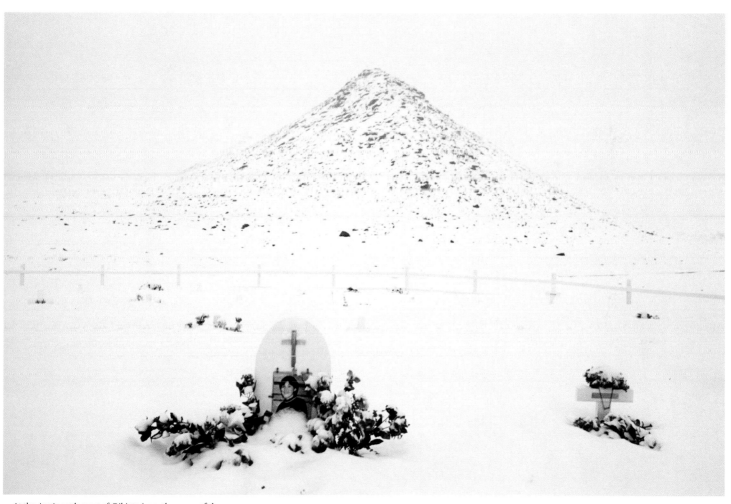

At the Arctic settlement of Qikiqtarjuaq, the grave of the
mayor's daughter, one of many teenage suicide victims.
Nunavut, Canada, 2004

Following pages
The Shilpiri household in Dharavi, one of Mumbai's oldest
slums. India, 2006

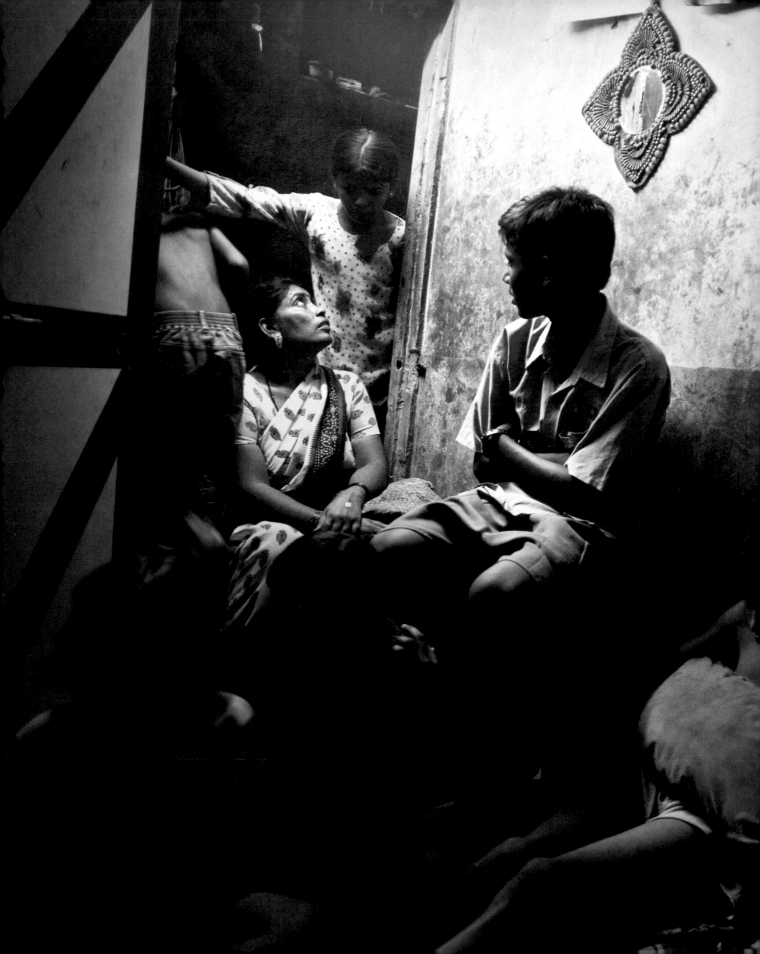

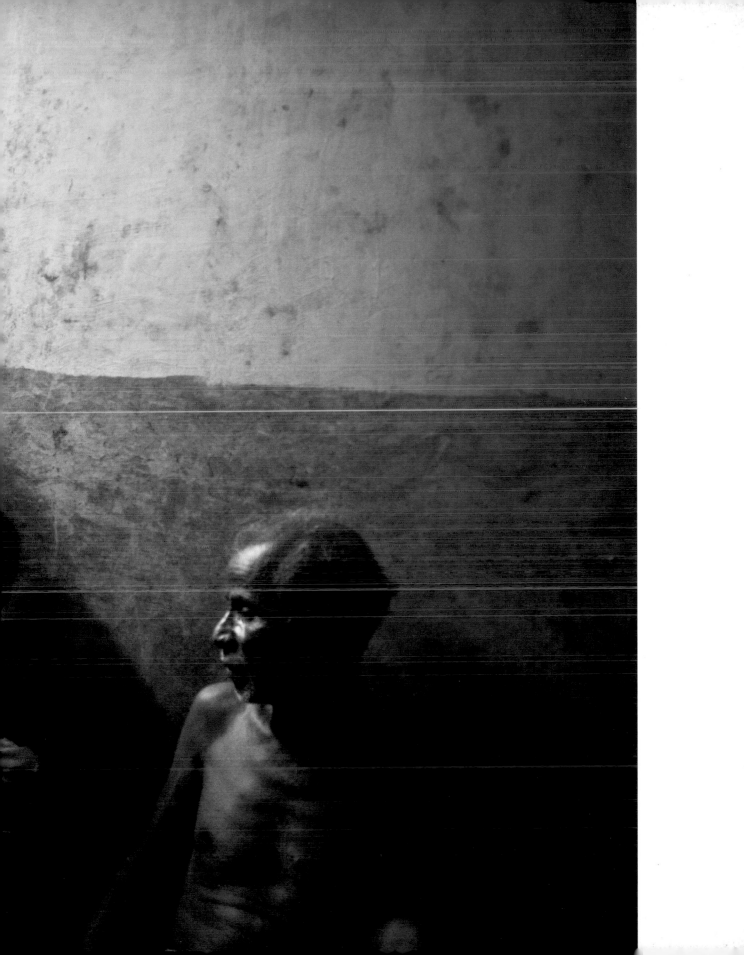

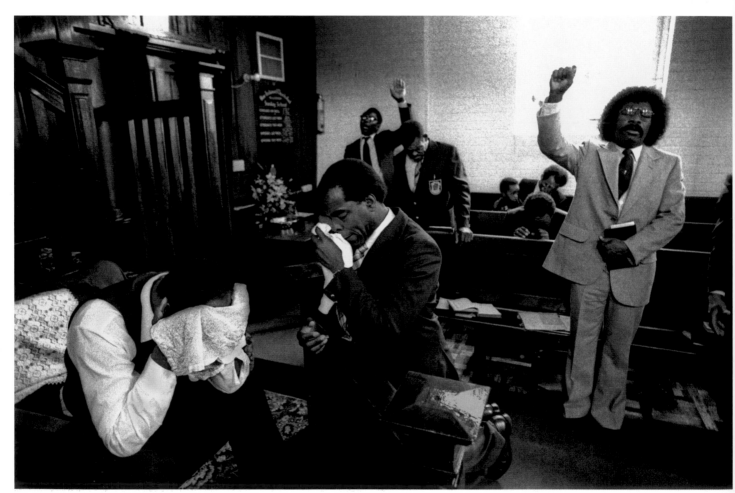

At an evangelical church. London, England, 1983

IAN BERRY

Ian Berry was born in Lancashire, England. He made his reputation in South Africa, where he worked for the *Daily Mail* and later for *Drum* magazine. He was the only photographer to document the massacre at Sharpeville in 1960, and his photographs were used in the trial to prove the victims' innocence.

Henri Cartier-Bresson invited Berry to join Magnum in 1962, when he was based in Paris. He moved to London in 1964 to become the first contract photographer for the *Observer Magazine*.

Since then assignments have taken him around the world. he has documented Russia's invasion of Czechoslovakia; conflicts in Israel, Ireland, Vietnam and Congo; famine in Ethiopia; and apartheid in South Africa. The major body of work produced in South Africa is represented in two of his books: *Black and Whites: L'Afrique du Sud* (with a foreword by the then French president François Mitterrand), and *Living Apart* (1996).

Important editorial assignments have included work for *National Geographic*, *Fortune*, *Stern*, *Geo*, national Sunday magazines, *Esquire*, *Paris-Match* and *Life*. Berry has also reported on the political and social transformations in China and the former USSR. Recent projects have involved tracing the route of the Silk Road through Turkey, Iran and southern Central Asia to northern China for *Condé Nast Traveler*, and photographing Berlin for a *Stern* supplement, the Three Gorges Dam project in China for the *Telegraph Magazine*, and Greenland for a book on climate control.

Ian Berry was the first Magnum photographer I ever met. He epitomised everything I thought a great photographer should be – egoless, self-effacing, always present but never seen, gliding like a ghost with a clicking Leica. In those days we clearly saw that the photographer was the second half of the equation: the first half was always the subject. How different things have become today, with reality taking second place to the 'vision' of the photographer!

Ian has showed us the world through his compassionate eyes. He has been everywhere, has seen it all and has never tried to impose a viewpoint on the rest of us. He has simply shown us the way it is, so that we in turn can delight and learn. He has never set up a picture or asked anyone to pose. His pictures *are* reality, and for me this is the indispensable factor that makes photography the most important medium in the history of mankind.

The old adage, 'f8 and be there', is one that has guided Ian. He makes Vasco de Gama look like a recluse. He has covered many of the world's most important events and yet is equally passionate in capturing the ebb and flow of ordinary life.

With Ian form and content meld in an extraordinarily seductive way that produces photographs that real people yearn to see.

No photographer could ask for anything more.

Philip Jones Griffiths

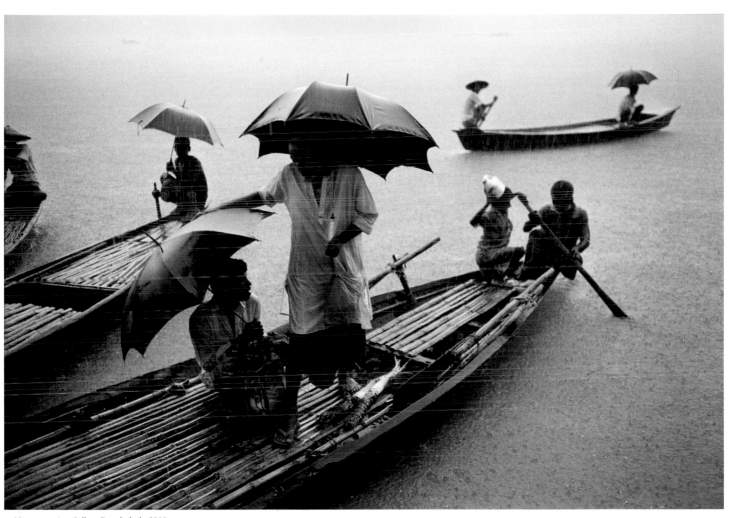

Monsoon rains. Sylhet, Bangladesh, 2000

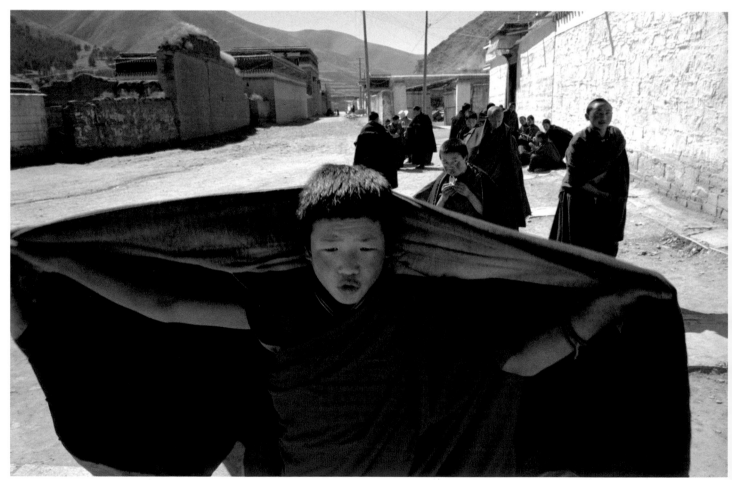

Tibetan novice monks on their way to prayer, Gansu
Province, China, 1996

Opposite
Siem Reap, Cambodia, 2007

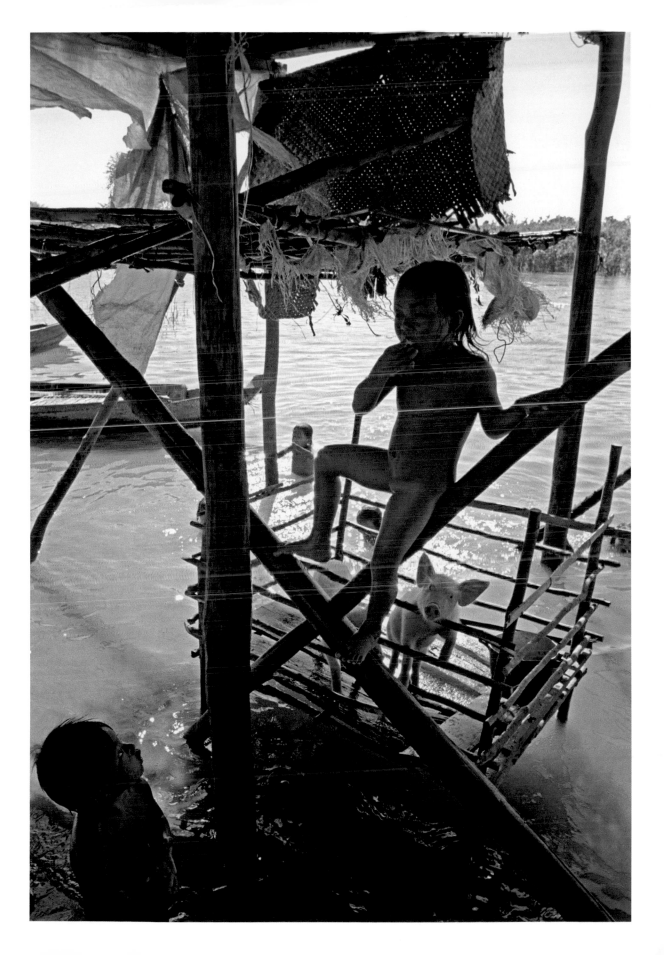

Liverpool, England, 1986

Docklands, London, England, 1992

Farmers at an inn. Puszta, Hungary, 1947

WERNER BISCHOF

Werner Bischof was born in Switzerland in 1916. He studied photography with Hans Finsler in his native Zurich at the School for Arts and Crafts, then opened a photography and advertising studio. In 1942 he became a freelancer for *Du* magazine, which published his first major photo essays in 1943. Bischof received international recognition after the publication of his 1945 reportage on the devastation caused by the Second World War.

In the years that followed, Bischof travelled in Italy and Greece for Swiss Relief, an organization dedicated to post-war reconstruction. In 1948 he photographed the Winter Olympics in St Moritz for *Life* magazine. After trips to Eastern Europe, Finland, Sweden and Denmark, he worked for *Picture Post*, *The Observer*, *Illustrated* and *Epoca*. He was the first photographer to join Magnum as one of the founding members in 1949.

Disliking the 'superficiality and sensationalism' of the magazine business, he devoted much of his working life to looking for order and tranquillity in traditional culture, something that did not endear him to picture editors looking for hot topical material. Nonetheless, he found himself sent to report on famine in India by *Life* magazine (1951), and he went on to work in Japan, Korea, Hong Kong and Indochina. The images from these reportages were used in major picture magazines throughout the world.

In the autumn of 1953 Bischof created a series of expansively composed colour photographs of the USA. The following year he travelled through Mexico and Panama, and then on to a remote part of Peru, where he was engaged in making a film. Tragically, Bischof died in a road accident in the Andes on 16 May 1954, only nine days before Magnum founder Robert Capa lost his life in Indochina.

I was in Peru when Marco Bischof asked me to edit his father's pictures. Naturally, I was honoured. I had just seen his *Boy Playing Flute* in the Lima market reproduced as a folk painting. His image had become an icon among the people it was about; it was taken a short time before he died when his car plummeted into a canyon.

Werner produced journalism with literature at its heart – he worked the sidelines, not the events, so his pictures were strong but never loud. He often left his camera in a rucksack to sketch his subjects in order know them better. His pictures became charcoal drawings of the world and he loathed the way they were used in the magazines of his time. 'Photography is superficial and journalism a disease,' he wrote, captioning the image of war photographers: 'Vultures of the Battlefield'. Yet he was a pioneer of photojournalism as we know it, including the journalism of conflict. He would have been disgusted by the idolatry of the rich and famous that garnishes the pages of magazines today.

Although he photographed much of the world in ten highly productive years, I have chosen pictures mostly from post-war Europe, taken on a trip that he began on a bicycle and ended four years later in a car. Near the finish, in Prague, he picked up a paintbrush to replicate 'the details of nature and light' on the wall of an orphanage. The children joined in. They made a mural together.

I chose these pictures because, like his diaries, letters and drawings, they reveal to me the man I think I would have liked. They also exemplify the compositional talent of an artist looking for beauty among the dispossessed, and order in a world of chaos.

Larry Towell

Opposite, top
Saint-Dié. Lorraine, France, 1945

Opposite, bottom
Men looking for work. Rouen, France, 1945

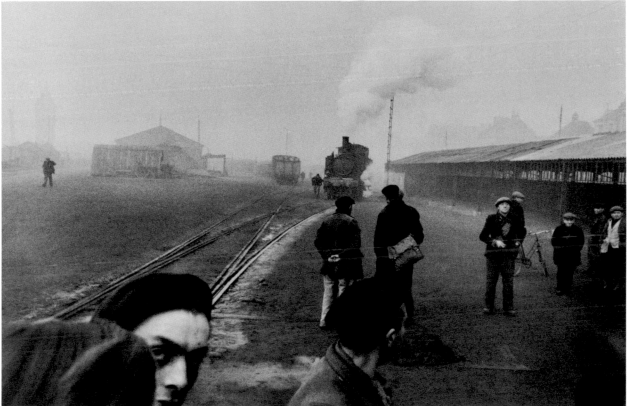

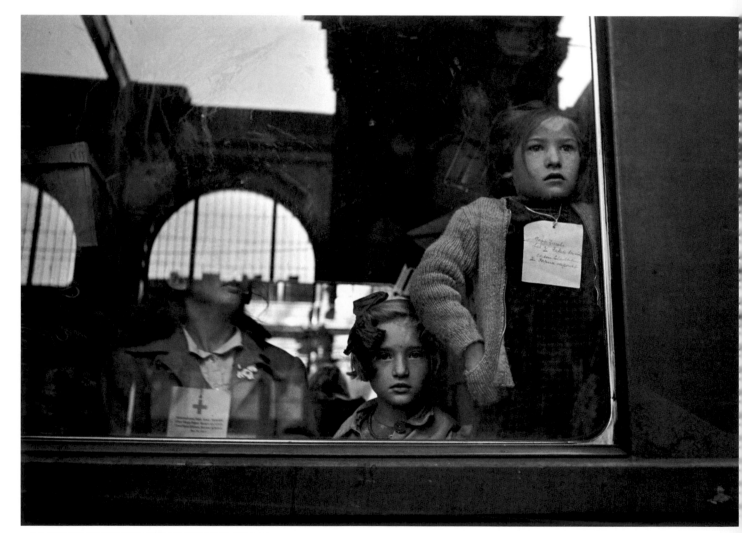

A Red Cross train transporting children to Switzerland. Budapest,
Hungary, 1947

Opposite
Naarva, Finland, 1948

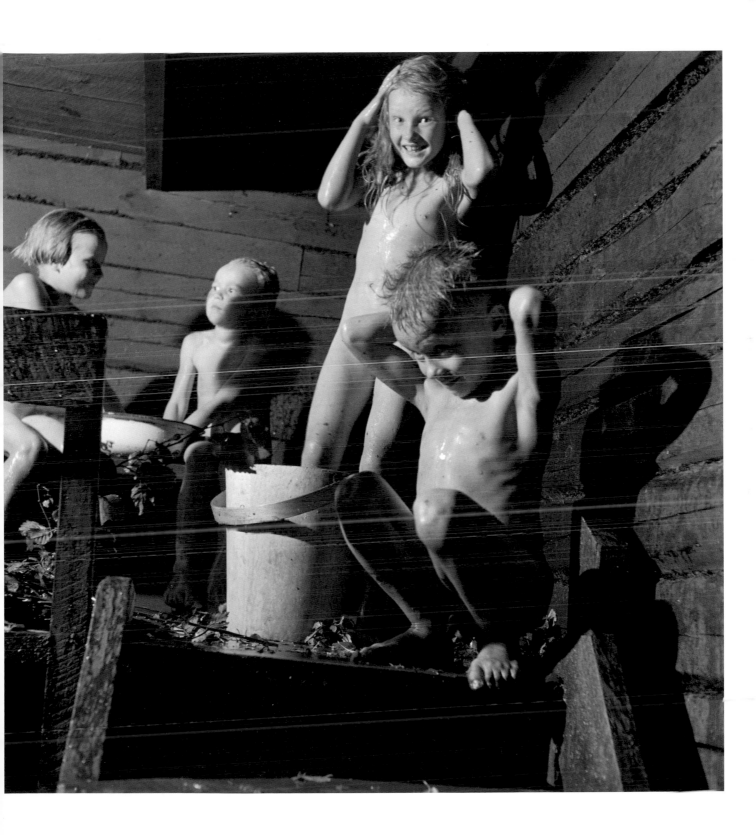

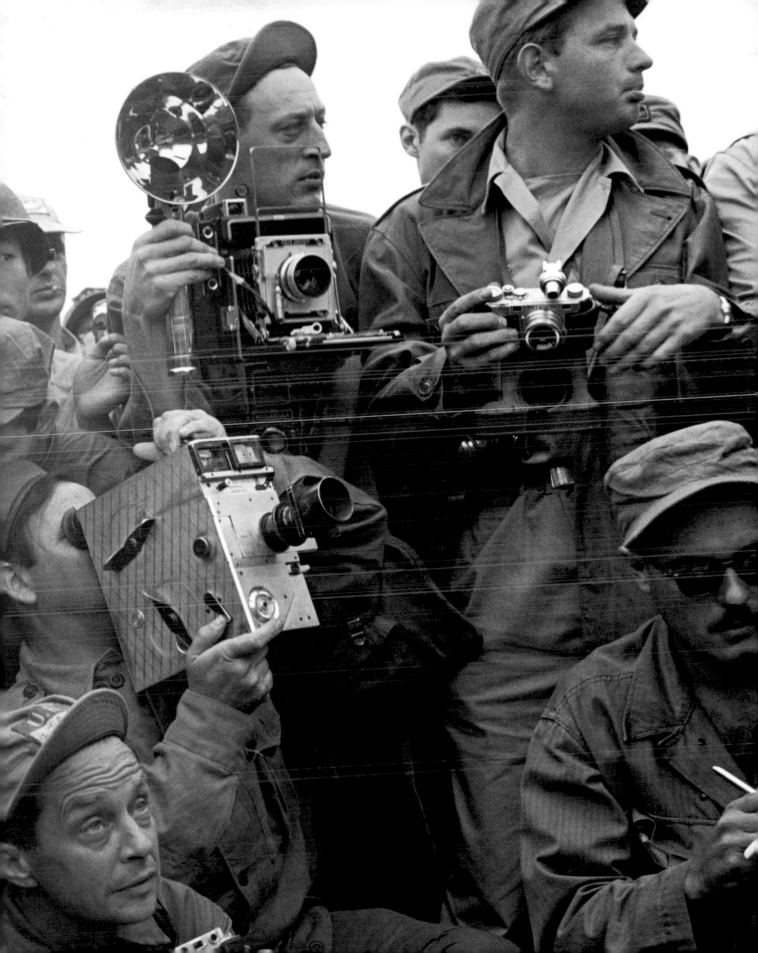

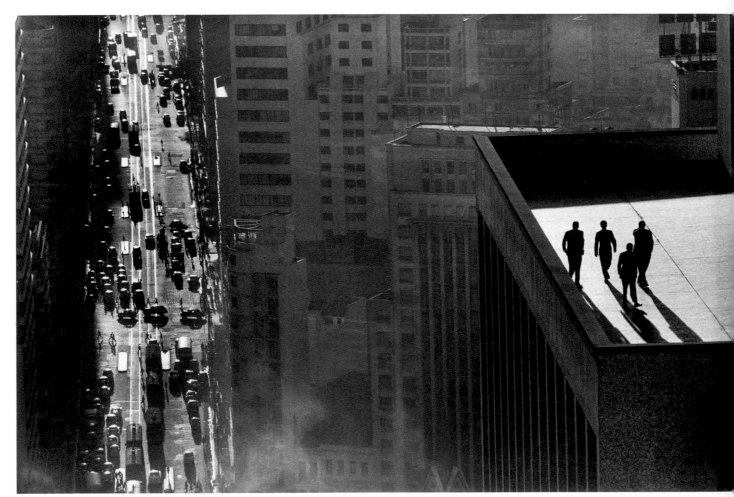

São Paulo, Brazil, 1960

RENÉ BURRI

René Burri, born in 1933, studied at the School of Applied Arts in his native city of Zurich, Switzerland. From 1953 to 1955 he worked as a documentary film-maker and began to use a Leica while doing his military service.

Burri became an associate of Magnum in 1955 and received international attention for one of his first reportages, on deaf-mute children, 'Touch of Music for the Deaf', published in *Life* magazine.

In 1956 he travelled throughout Europe and the Middle East, and then went to Latin America, where he made a series on the gauchos that was published by *Du* magazine in 1959. It was also for this Swiss periodical that he photographed artists such as Picasso, Giacometti and Le Corbusier. He became a full member of Magnum in 1959, and started work on his book *Die Deutschen*, published in Switzerland in 1962, and by Robert Delpire the following year with the title *Les Allemands*. In 1963, while working in Cuba, he photographed Ernesto 'Che' Guevara during an interview by an American journalist. His images of the famous revolutionary with his cigar appeared around the world.

Burri participated in the creation of Magnum Films in 1965, and afterwards spent six months in China, where he made the film *The Two Faces of China* produced by the BBC. He opened the Magnum Gallery in Paris in 1962, while continuing his activities as a photographer; at the same time he made collages and drawings.

In 1998 Burri won the Dr Erich Salomon Prize from the German Association of Photography. A big retrospective of his work was held in 2004–2005 at the Maison Européenne de la Photographie in Paris and toured many other European museums. René Burri lives and works in Zurich and Paris.

Image-wise, the late 1950s were not a good time for British magazines. Young photographers of the period tended to work mainly for newspapers. It was in 1962 that I discovered René Burri's book *Die Deutschen* (*The Germans*). It opened my eyes to entirely new photographic possibilities and I am eternally grateful.

On attempting to select six pictures I first looked at René's database, starting with 1955–60. From this short period there were over 1,300 pictures on show, and there were a further 47 years to select from!

Meeting René for the first time one can easily be overpowered by his presence and flamboyance. He wears extravagant hats; he is a hugger and grabber; his clothes are always the latest fashion; and he smokes large cigars. Yet nothing seems out of place, nothing seems artificial. Amazingly his pictures are almost diametrically the opposite. They are gentle and tender, never intrusive.

I could not leave out the first picture, taken in São Paulo. The street below is packed with bustling humanity, oblivious to a group of men above, in the rooftop sunlight.

My second choice was easy. When you love a book, you love all the pictures in it. The task is to pick one that reminds you of the whole. For me it is the cover of *Die Deutschen*: Frankfurt railway station. My original book has been handled so often only half of the dust jacket remains.

Children playing or fighting on a beach in Sicily in 1956. So much movement; such an interesting composition; so much mystery – this is an early indication of his gift for seeing the extraordinary behind the ordinary.

The landscape in China, always one of my favourites, has none of the obvious absorption with formalism and abstraction so often seen in other photographers. René has an affinity with his subject matter, which he then renders as elegantly as is possible.

Another pleasant surprise: a rear view of horses that is beautiful, both in emotion and design.

Finally, I found the picture of Giacometti a truly great portrait. It hints at so much about the act of concentration in art. It makes me feel that I would also love to have met the sculptor.

David Hurn

The old railway station, Frankfurt-am-Main.
West Germany, 1962

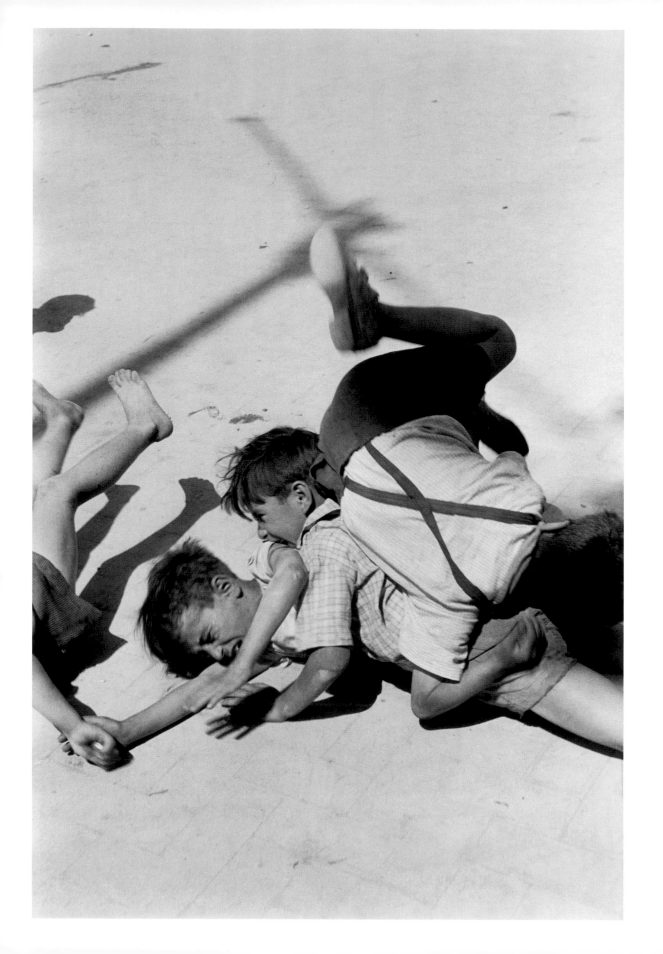

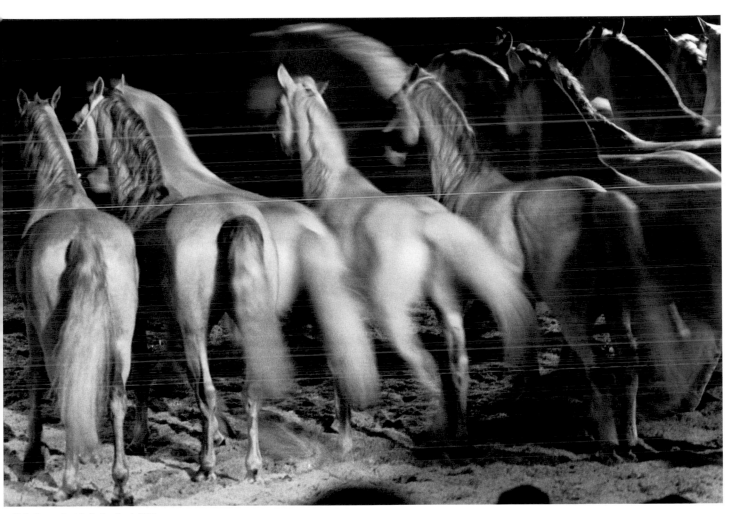

Knie Circus. Zurich, Switzerland, 1970

Opposite
Children playing. Sicily, Italy, 1956

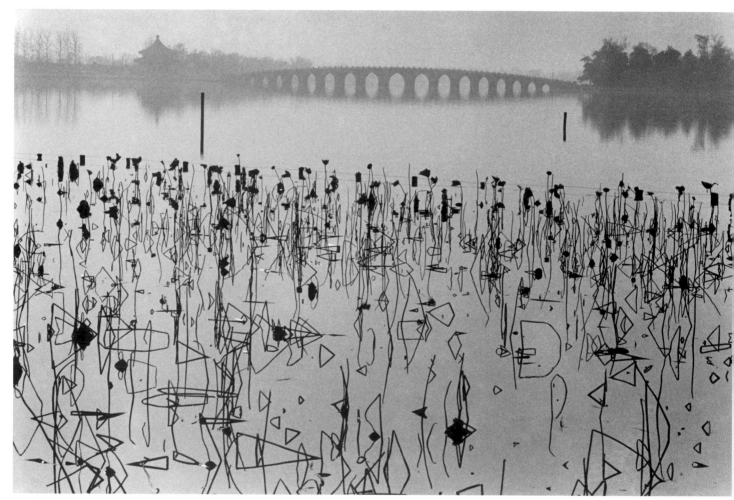

Dead lotus leaves on Kunming Lake in the grounds of the
Summer Palace near Beijing. China, 1964

Opposite
Alberto Giacometti in his studio. Paris, France, 1960

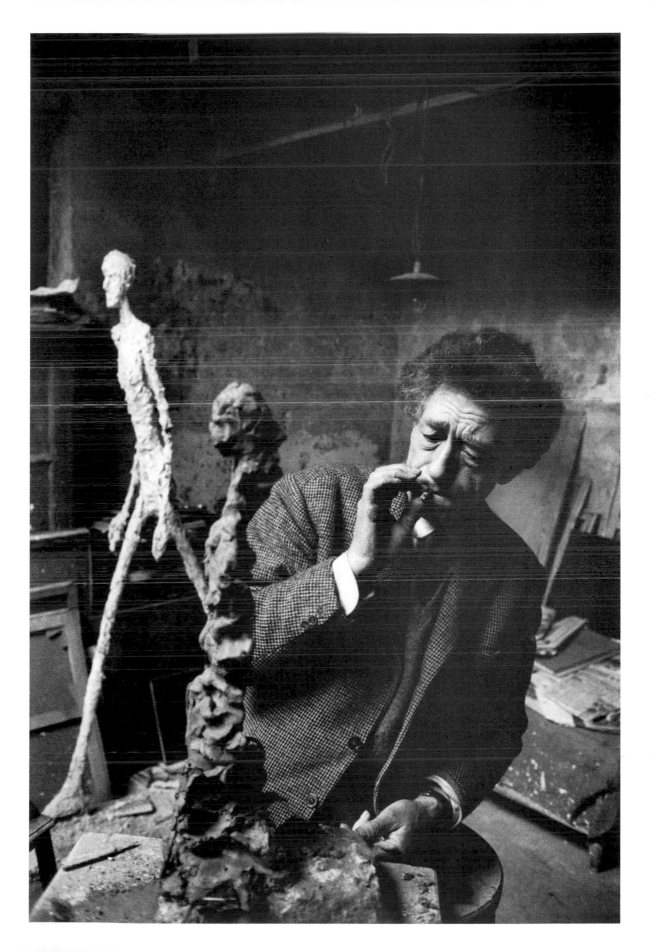

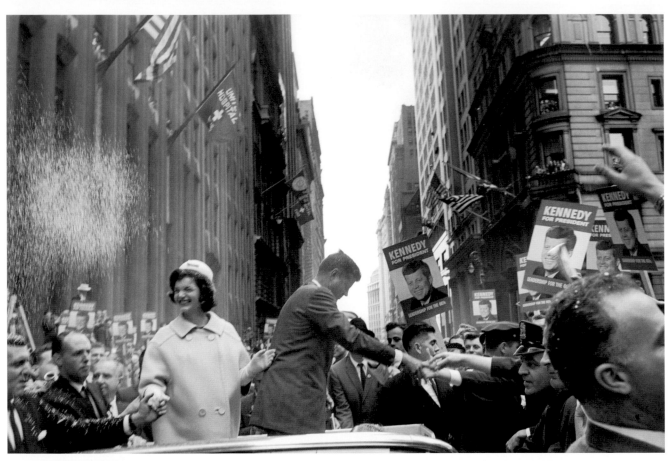
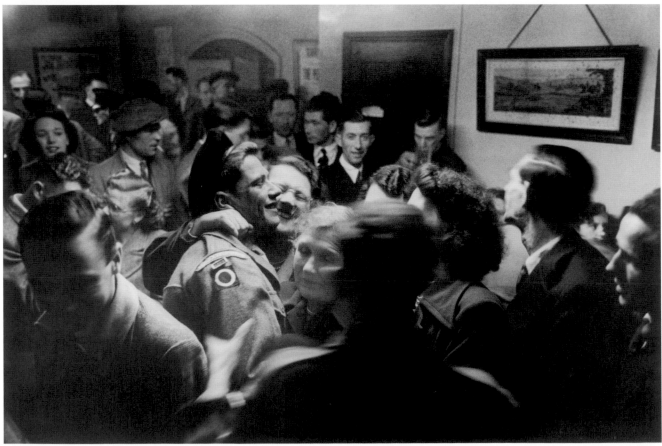

CORNELL CAPA

Cornell Capa was born Cornell Friedmann to a Jewish family in Budapest in 1918. In 1936, he moved to Paris, where his brother Andre (Robert Capa) was working as a photojournalist. He worked as his brother's printer until 1937, then moved to New York to join the new Pix photo agency. In 1938, he began working in the *Life* darkroom. Soon his first photo-story – on the New York World's Fair – was published in *Picture Post*.

In 1946, after serving in the US Air Force, Cornell became a *Life* staff photographer. Following his brother's death in 1954, he joined Magnum. After David 'Chim' Seymour's death in Suez in 1956, Capa took over as president of Magnum, a post he held until 1960.

In 1954, Capa made an empathetic, pioneering study of mentally retarded children. He also covered other social issues such as old age in America, and explored his own religious tradition.

While working for *Life*, Capa made the first of several Latin American trips. These continued through the 1970s and culminated in three books, among them *Farewell to Eden* (1964), a study of the destruction of indigenous Amazon cultures.

Capa covered the electoral campaigns of John and Robert Kennedy, Adlai Stevenson and Nelson Rockefeller amongst others. His 1969 book, *New Breed on Wall Street*, was a landmark study of a generation of ruthless young entrepreneurs keen on making money and spending it fast.

In 1974, Capa founded New York City's influential International Center of Photography, and for two decades he dedicated much of his considerable energy to serving as its director.

Cornell Capa died in New York on 23 May 2008.

Opposite, top
Senator John F. Kennedy campaigning for the presidency, with his wife Jackie. New York City, USA, 1960

Opposite, bottom
The Gloucestershire Regiment, celebrating their return to England from Korea. Britain, 1951

I first visited Cornell Capa and his wife Edie on Fifth Avenue in August 1962.

A year before, I met René Burri, Elliott Erwitt and Burt Glinn in Tokyo, and made up my mind to become a photographer. As I look back, the idea was rather reckless: I knew nothing of photography, nor had I any darkroom experience. Nonetheless, this ignorance did not hold back my good fortune.

The couple welcomed me warmly. Those were my first days in New York, and arriving from Japan you were only allowed to carry $500, so all I could afford was bananas. Edie gave me a fantastic Hungarian dish and offered me a Spanish red – my first taste of wine. They had no children. Perhaps they felt compassion towards this Japanese youth a long way from home. I felt as if they had adopted me as their son. Such a feeling of encouragement cannot be explained by words.

Cornell would invite me for a meal twice a month, but also got me some assistant jobs. Sometimes he would ask, 'Aren't you a little short on money?' Then he would hand me $50 or so, always making sure not to hurt my self-respect. What a noble deed it was.

In 1968, Cornell commissioned me to take charge of his Concerned Photographer exhibition in Japan. It was a huge success. When he asked me what I wanted in return, I asked for a round-the-world air ticket. I was able to visit Europe, the Middle East, and Southeast Asia for over eight months. Without these experiences, I would not be who I am today. It was like a dream to be able to put on exhibitions at the ICP. He held my China, America and North Korea exhibitions there.

Cornell was a man of eloquence and overflowing spirit. Yet, after suffering the loss of Edie a few years ago, he was diagnosed with Parkinson's disease, making it almost impossible to speak his own words, which must have been the greatest frustration of all.

What he achieved for us photographers, and for photography, is immeasurable. He was undoubtedly 'the godfather' of our world.

Hiroji Kubota

Opposite
A Hebrew lesson. New York City, USA, 1955

Following pages
Clark Gable and Marilyn Monroe on the set of
The Misfits. Nevada, USA, 1960

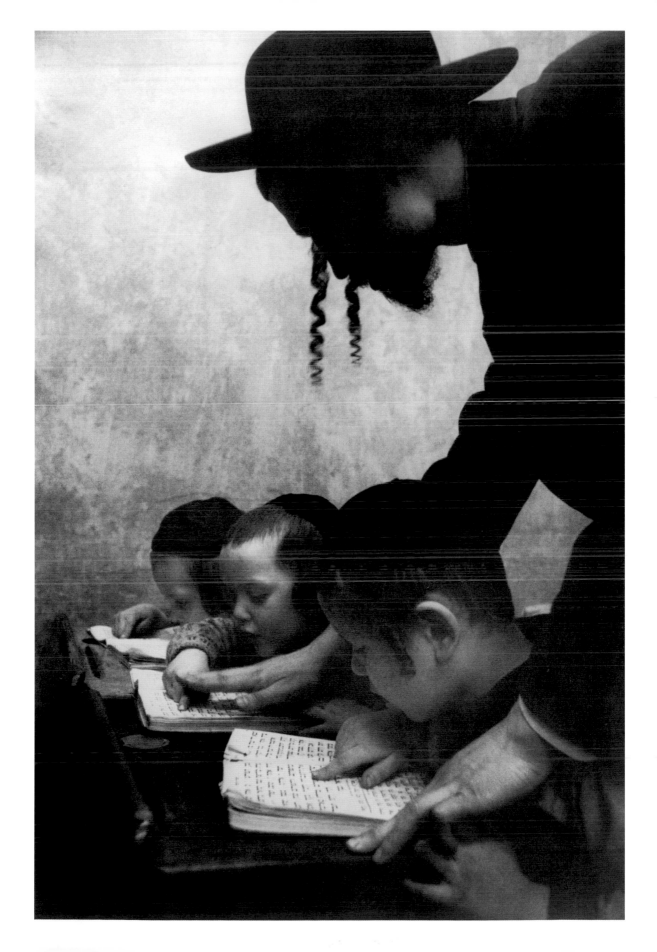

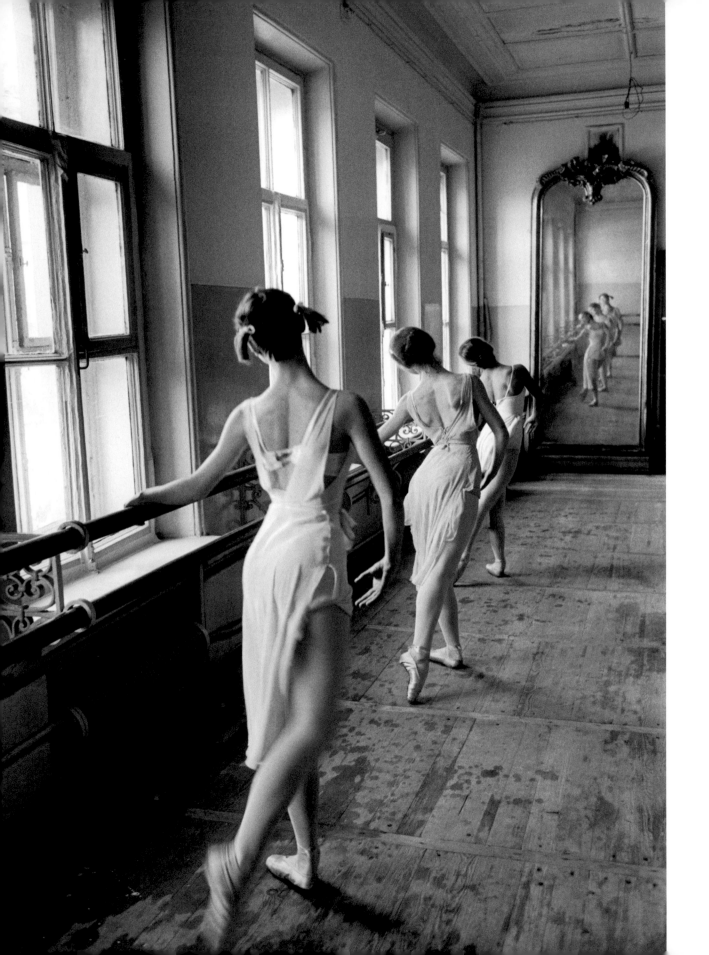

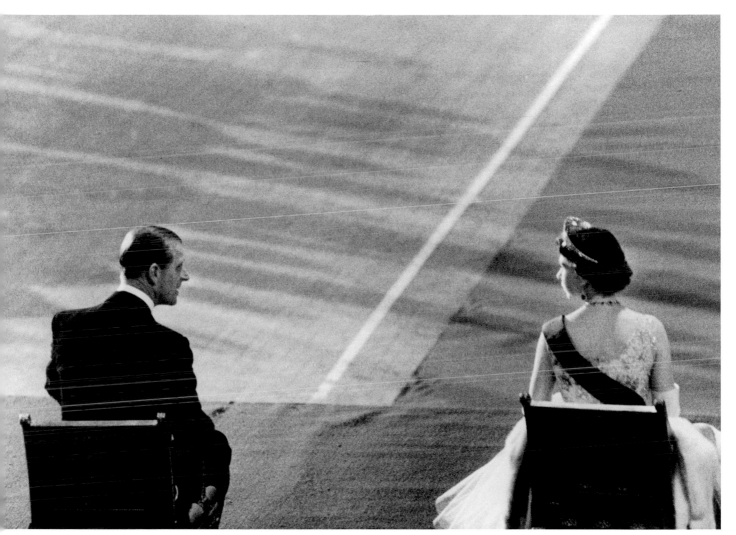

Queen Elizabeth and Prince Philip during their visit to the
USA, 1957

Opposite
The Bolshoi Ballet School. Moscow, USSR, 1958

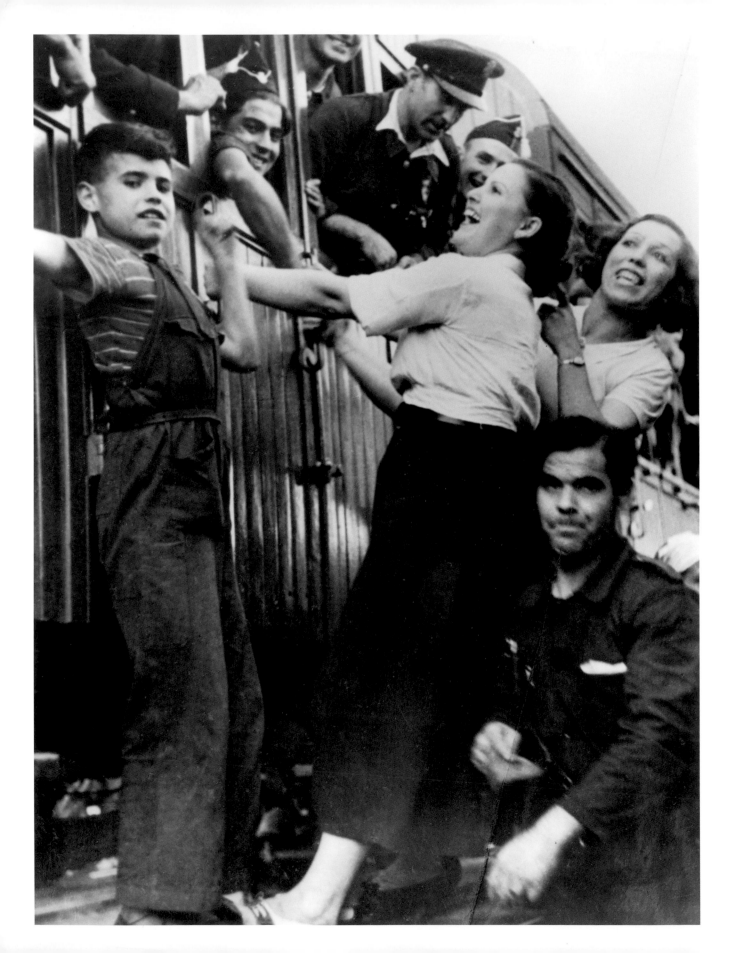

ROBERT CAPA

On 3 December 1938 *Picture Post* introduced 'The Greatest War Photographer in the World: Robert Capa' with a spread of 26 photographs taken during the Spanish Civil War.

But the 'greatest war photographer' hated war. Born Andre Friedmann to Jewish parents in Budapest in 1913, he studied political science at the Deutsche Hochschule für Politik in Berlin. Driven out of the country by the threat of a Nazi regime, he settled in Paris in 1933.

He was represented by Alliance Photo and met the journalist and photographer Gerda Taro. Together, they invented the 'famous' American photographer Robert Capa and began to sell his prints under that name. He met Pablo Picasso and Ernest Hemingway, and formed friendships with fellow photographers David 'Chim' Seymour and Henri Cartier-Bresson.

From 1936 onwards, Capa's coverage of the Spanish Civil War appeared regularly. His picture of a Loyalist soldier who had just been fatally wounded earned him his international reputation and became a powerful symbol of war.

After his companion, Gerda Taro, was killed in Spain, Capa travelled to China in 1938 and emigrated to New York a year later. As a correspondent in Europe, he photographed the Second World War, covering the landing of American troops on Omaha beach on D-Day, the liberation of Paris and the Battle of the Bulge.

In 1947 Capa founded Magnum Photos with Henri Cartier-Bresson, David Seymour, George Rodger and William Vandivert. On 25 May 1954 he was photographing for *Life* in Thai-Binh, Indochina, when he stepped on a landmine and was killed. The French army awarded him the Croix de Guerre with Palm posthumously. The Robert Capa Gold Medal Award was established in 1955 to reward exceptional professional merit.

Opposite
A troop train leaving Barcelona for the front. Spain, August 1936

I'm not sure when I first saw Robert Capa's pictures – perhaps it was in *Life* magazine, as a child imagining the world – but certainly since then many of his iconic images have resonated with me. Looking again now, I find myself especially drawn to some of his less well-known pictures from the Spanish Civil War.

Images of war invade our lives every day now, much more than they did then. Often we see the women who have stayed behind, sending their men off to war, simply hoping for their return. Or grieving as their remains are returned and mourning their loss.

These classic images by Capa signal a different message. These women are joyous; this is a particular kind of war, *their* war, which also became Capa's war. The connection was their idealism, expressed in that first image of women bidding farewell, as well as the next one; we rarely see women behind a barricade, as resolute as their men, all young volunteers, fighting side by side, to defend their homes and their lives. At times it must have seemed glorious, to stand with the men who looked out over the city during their one short moment of victory before the fall of Madrid, believing with them that they could own the future.

I can imagine Capa moving from the trenches to the hills, where there were few protected positions. I envisage him feeling the necessity to follow behind an anonymous figure, not knowing what was around the corner, with the enemy close on the other side. A slight blur – was he terrified, knowing he was on the most forward line of the front? I sense his fear and determination to be there – it's dramatic; implicit in its starkness is the truth of his vulnerability, and the hope it expresses to risk all. Such an image can only be made with total conviction.

Capa once wrote: 'It's not easy always to stand aside and be unable to do anything except record the sufferings around one.' He did just that: he recorded the total devastation of their homes, and their hopes. The family portrait hanging on the wall of a bombed and devastated dining room stands in for the absence of the people he came to love, but there is nothing clinical about his account of the aftermath.

War after war ... but Capa did not choose to be a war photographer. He was not so naïve as to believe that his photographs could end war. He photographed wars because in some way they were *his* wars; he supported the side he photographed because he believed in them, as an anti-fascist, a partisan. But he fought with his camera, not with a rifle, and he was willing to die to do so.

Susan Meiselas

Opposite
Militia-women defending a barricade.
Barcelona, Spain, August 1936

Following pages
Republican soldiers in the governor's palace at
Teruel. Aragon, Spain, 3 January 1938

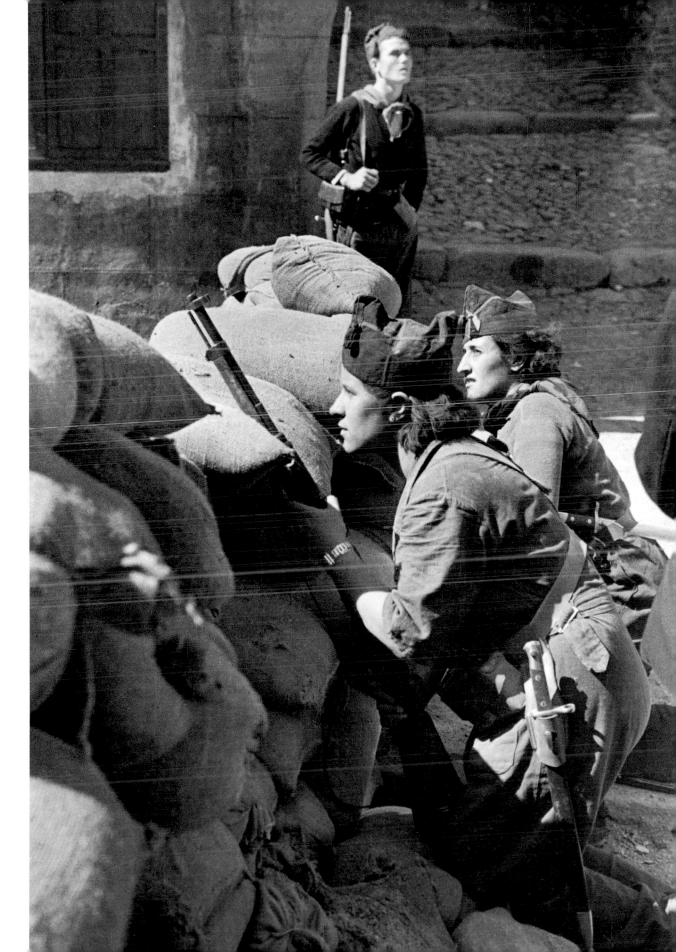

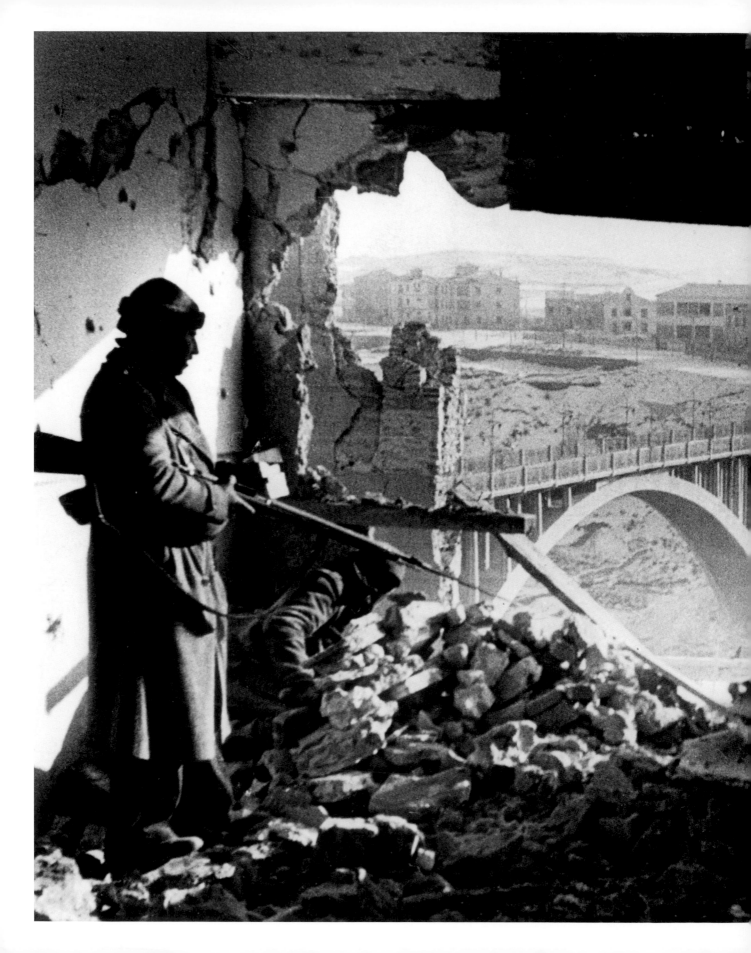

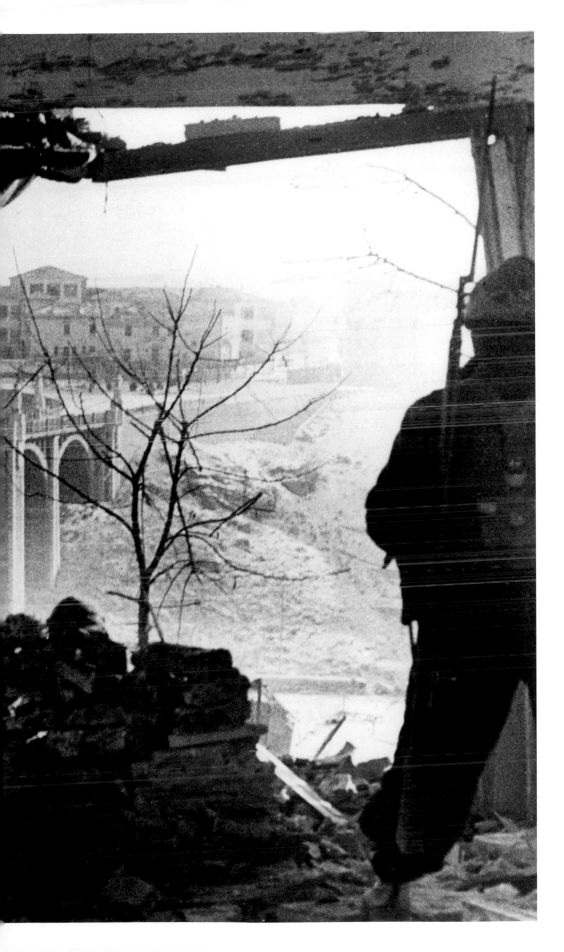

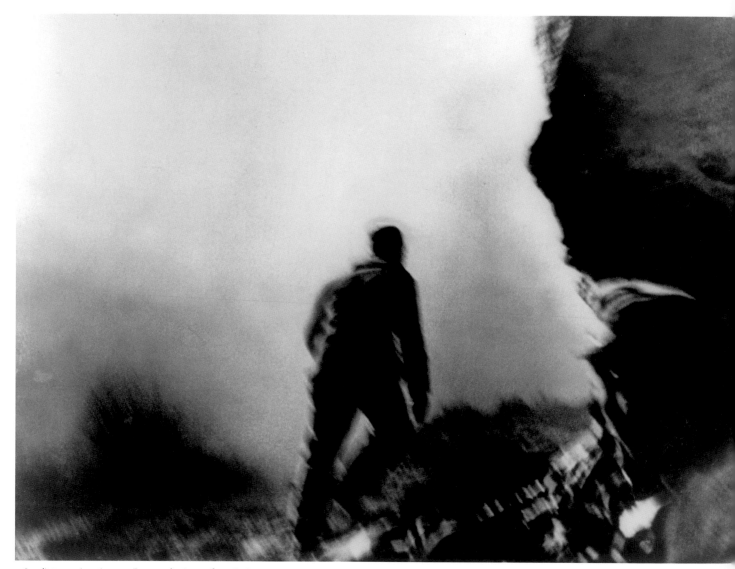

Loyalist troops in action near Fraga on the Aragon front. Spain,
7 November 1938

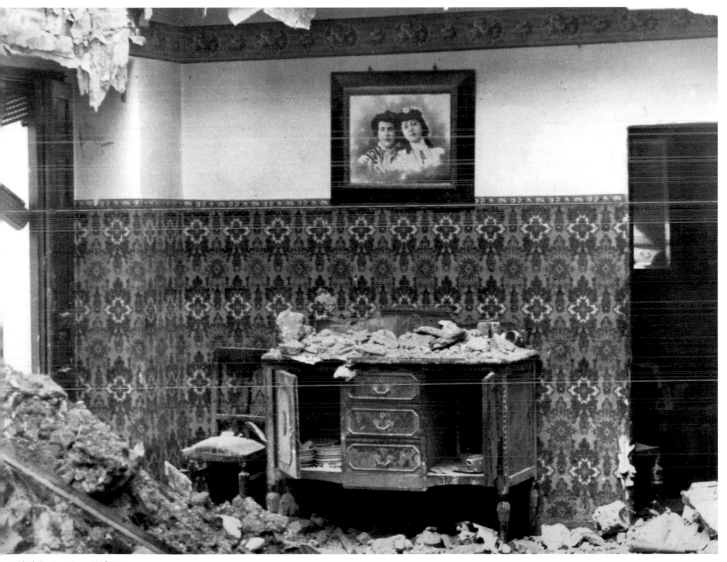

Madrid, Spain, winter 1936/37

Following pages
After an Italo-German air raid. Madrid, Spain, winter 1936/37

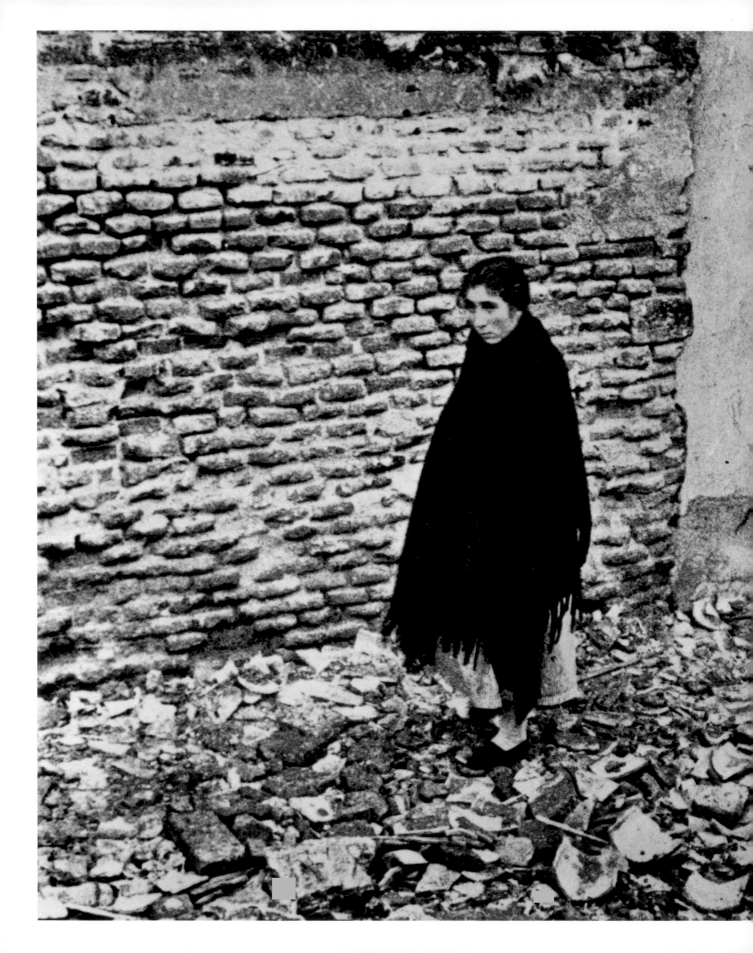

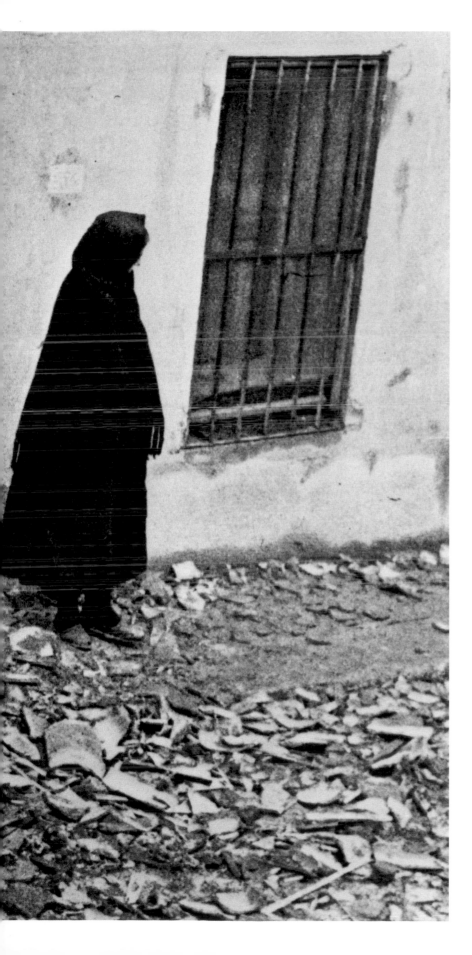

HENRI CARTIER-BRESSON

Born in Chanteloup, Seine-et-Marne, in 1908, Henri Cartier-Bresson developed a strong fascination with painting early on, and particularly with Surrealism. In 1932, after spending a year in the Ivory Coast, he discovered the Leica – his camera of choice thereafter – and began a life-long passion for photography. In 1933 he had his first exhibition at the Julien Levy Gallery in New York. He later made films with Jean Renoir.

Taken prisoner of war in 1940, he escaped on his third attempt in 1943 and subsequently joined an underground organization to assist prisoners and escapees. In 1945 he photographed the liberation of Paris with a group of professional journalists and then filmed the documentary *Le Retour* (*The Return*).

In 1947, with Robert Capa, George Rodger, David 'Chim' Seymour and William Vandivert, he founded Magnum Photos. After three years spent travelling in the East, in 1952 he returned to Europe, where he published his first book, *Images à la Sauvette* (published in English as *The Decisive Moment*).

He explained his approach to photography in these terms: 'for me the camera is a sketch book, an instrument of intuition and spontaneity, the master of the instant which, in visual terms, questions and decides simultaneously. … It is by economy of means that one arrives at simplicity of expression.'

From 1968 he began to curtail his photographic activities, preferring to concentrate on drawing and painting. In 2003, with his wife and daughter, he created the Fondation Henri Cartier-Bresson in Paris for the preservation of his work. Cartier-Bresson received an extraordinary number of prizes, awards and honorary doctorates. He died at his home in Provence on 3 August 2004, a few weeks short of his 96th birthday.

I once described Henri Cartier-Bresson as 'the poet with the camera'. From him I learned the need to try to tell an entire story in a single definitive image.

I knew HCB since 1954 and he never failed to surprise me. Hanging in my drawing room now is a photograph that he gave me (page 101, top) of women praying at dawn, waiting for the sun to come up – and as far as I'm concerned it's the best picture he ever made. It's unexpected, symmetrical and it just does something to you. He knew I was going into the hospital and he offered me a picture – he asked me to pick any picture I wanted, because I had arranged some shows for him for his ninetieth birthday.

The early days were yeasty times. The cramped and badly equipped Magnum office was filled with photographers and filled with enthusiasm. We talked photography, we talked ideas, and we showed each other our pictures. There would be bellows of laughter and Capa would be holding forth. Or there would be sudden silence and Cartier-Bresson would be looking at our pictures. He would hold a print upside down and talk about its photographic merit, or he would squint at it while making a right angle with both arms bent at the elbow. His judgment was always to the point, direct, thoughtful and fair.

I would be tremulous when I approached him, but I shall never forget his kindness and the time he took with me. I remember very little specific criticism he offered. He had that talent great teachers and editors have for making you excited. He created an awareness and a consciousness that went beyond the picture in hand to form a space in which you could be more demanding of yourself. He carried you beyond analysis into a world that could make you think the unthinkable, that made you free. He acted as a catalyst that enabled you to go beyond your own expectations.

I remember one spring evening in New York when Henri, Gjon Mili, Ernst Haas, Inge Morath and I stopped for coffee on our way from a gathering of some sort. Ernst, who loved to talk about photography in great elliptical terms, was expounding on form, colour, design and photography as art. We all listened; then Henri leaned across to me and said, 'Eve, when we are good, we are maybe little better than the watchmaker.'

Eve Arnold

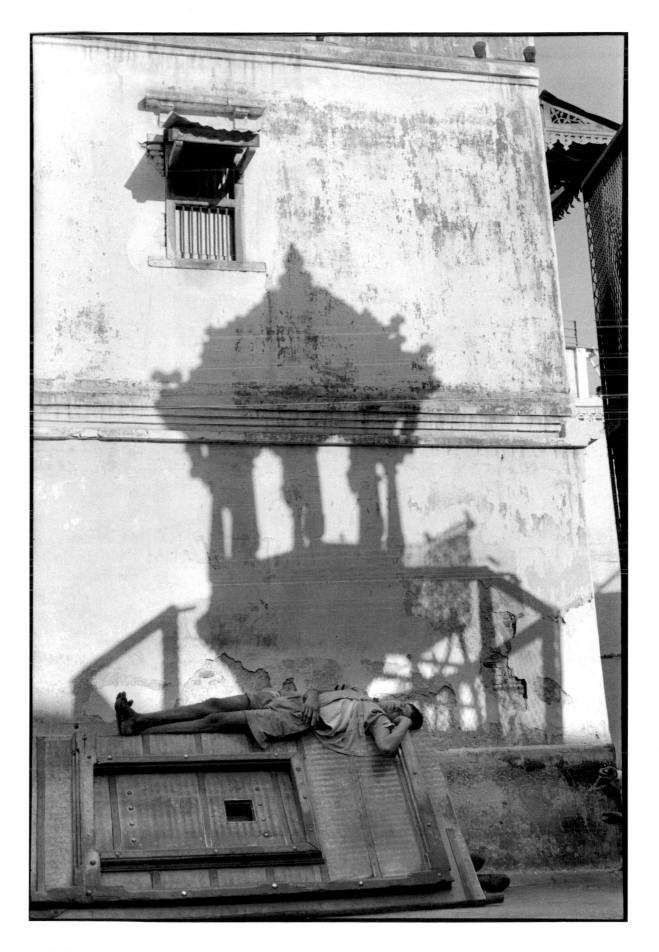

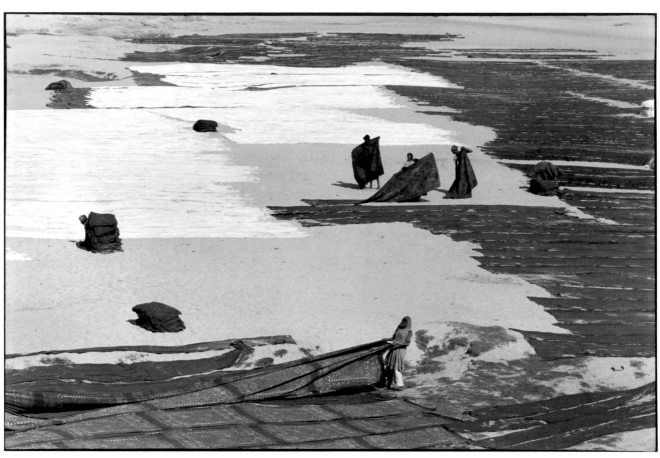

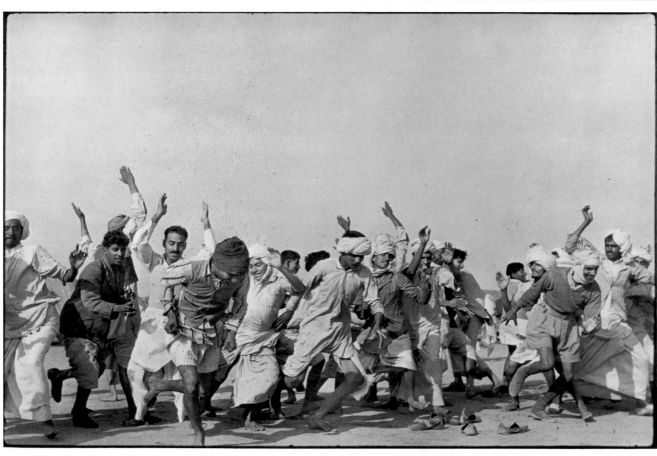

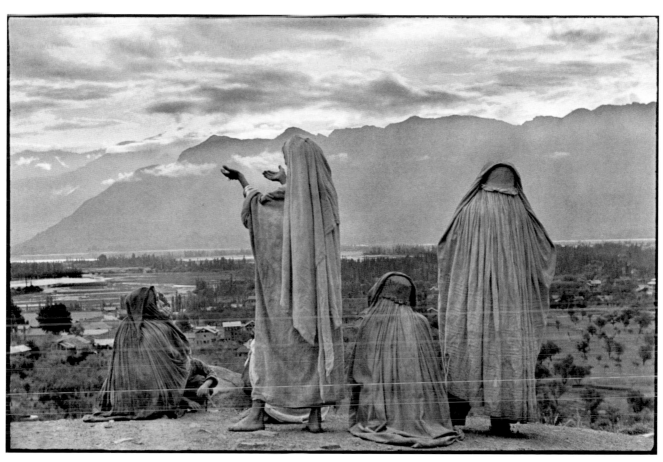

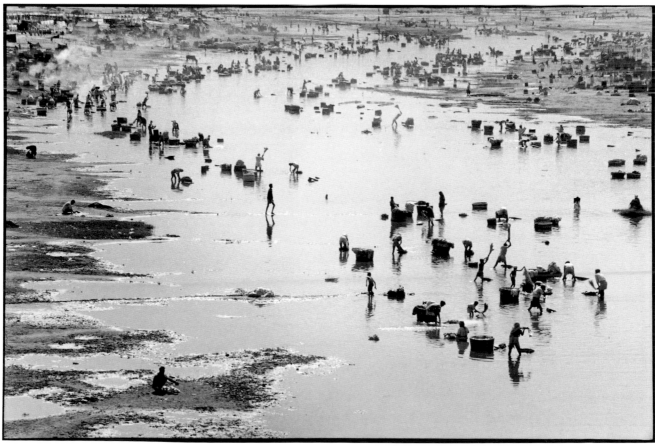

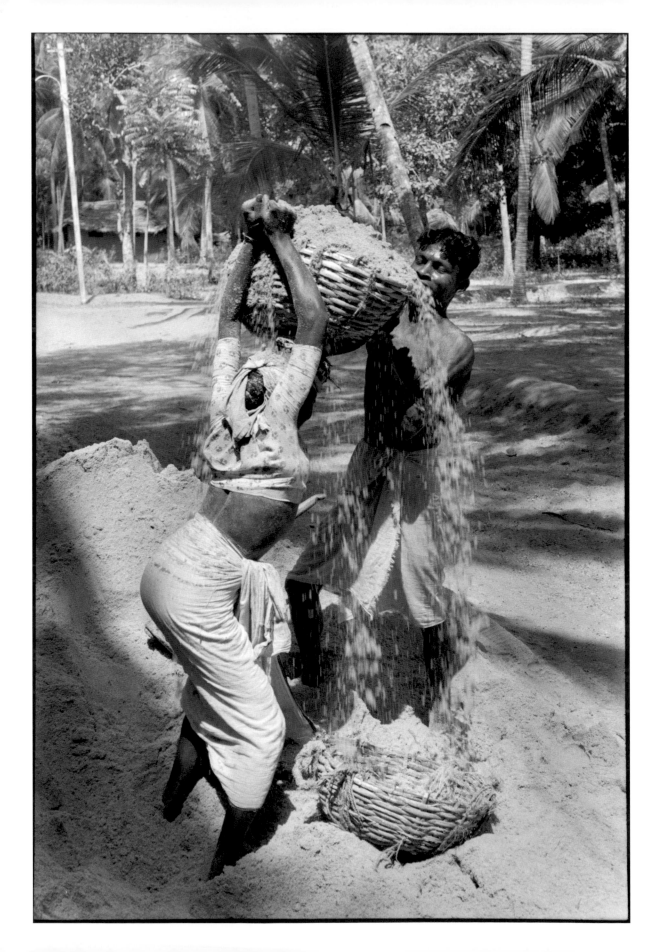

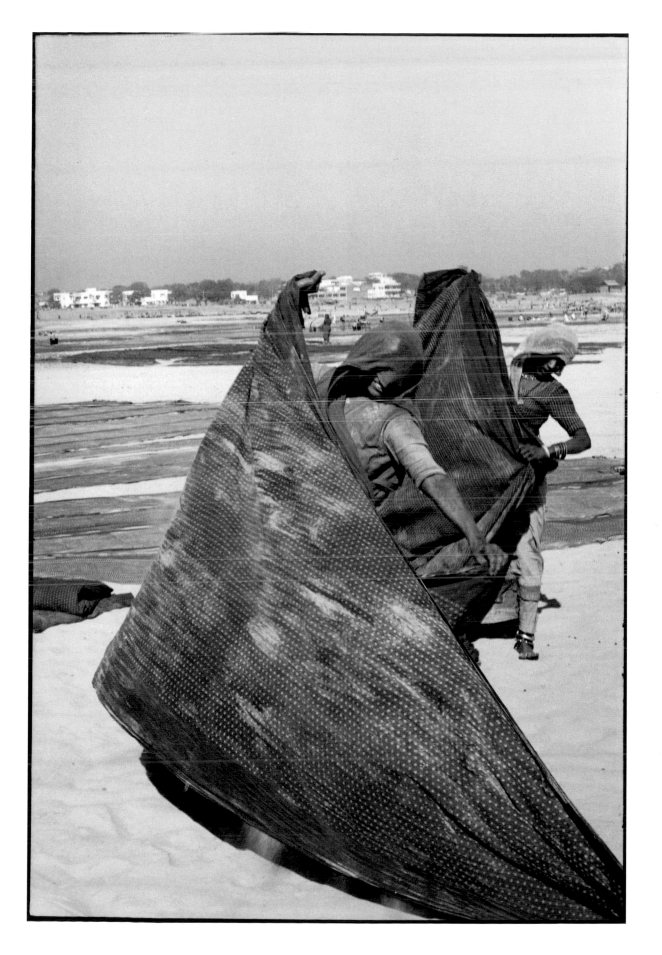

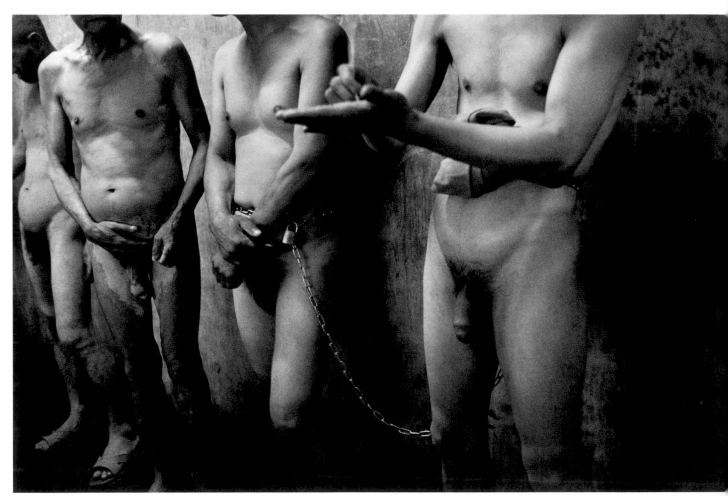

Mental patients in the restroom at Lungfa Tang Temple,
Taiwan, 1999

CHIEN-CHI CHANG

Alienation and connection are the subjects of much of Chien-Chi Chang's work. These themes surface particularly in *The Chain*, a collection of portraits made in a Taiwanese mental institution. An exhibition of these nearly life-sized photographs has toured internationally and been exhibited at venues including the Venice Biennale and the Biennal de São Paulo.

In two other books, Chang takes a jaundiced look at marital unions. *I do I do I do* is a collection of images depicting alienated grooms and lonely brides, while Chang's most recent publication, *Double Happiness*, is an examination of arranged marriages between Vietnamese country girls and older Taiwanese men. His investigation of the ties that bind one person to another – and to society – draws on his own immigrant experience. Born in Taiwan in 1961 he is now an American citizen.

Chang joined Magnum Photos in 1995. He lives and works in Taipei and New York City.

I got to know Chien-Chi Chang at a small dinner party given in his honour by a *New York Times* photographer. He stood there quiet, self-composed and observant, like a photo-Buddha, but not with a protruding belly. The gathering was held in a walk-up apartment in what is called 'Chinatown'. I never felt comfortable with its designation because it denotes the 'Other'. Chinatown is thought of as a place of secrets, suspicion and strangeness. Actually, it is all of the above, but it is also a place where Chinese medical doctors practice, of store front shops with goods from Asia, neighbourhood schools, and families surviving and thriving in a New York City community that is vibrant and visually interesting.

It is where Chien-Chi Chang explores aspect of the culture and the people living there. He uncovers the idea of 'Chinatown' in a way that is both lyrical and poetic. This is not an easy thing to do when people may be illegal immigrants, suspicious of outsiders, or where taking an image may be frowned upon for spiritual reasons. I think of his image of a man sitting on a 'flop house' fire escape in the dog days of summer. He is in what appear to be his underpants. He is taking in some fresh air and a sense of his own freedom high above the teeming streets. It would be interesting to know how Chien-Chi found his way into this tenement and gained the trust of its inhabitants.

Chien-Chi seems to connect to alienation. In his portrayal of patients in a Taiwanese mental institution, he chooses to photograph a group strung together with a chain. Here he chooses a formal straight-on view. At the Venice Biennale and other exhibitions, he chose to make these images life-size. Chien-Chi comes to grips with the concept of isolation. These photographs put the viewer into a powerful confrontation with the subject that is visually innovative.

Chien-Chi takes a close-up look at the abuse and banality of arranged marital unions. These marriages between naïve Vietnamese country girls and much older Taiwanese men show the incongruity and despair that is brought to the surface in Chien-Chi's exploration.

Chien-Chi Chang's inner eye goes beyond today's edicts of the media. One will not see sound-bite, fast-food photography in his work. He takes on subtle and difficult subjects that often go unnoticed and brings to light a vision that is passionate, penetrating and profound. Certainly, we can all learn from him.

Bruce Davidson

Opposite, top
An immigrant treating a work injury with Chinese healing methods. New York City, USA, 1998

Opposite, bottom
An immigrant on his day off. New York City, USA, 1998

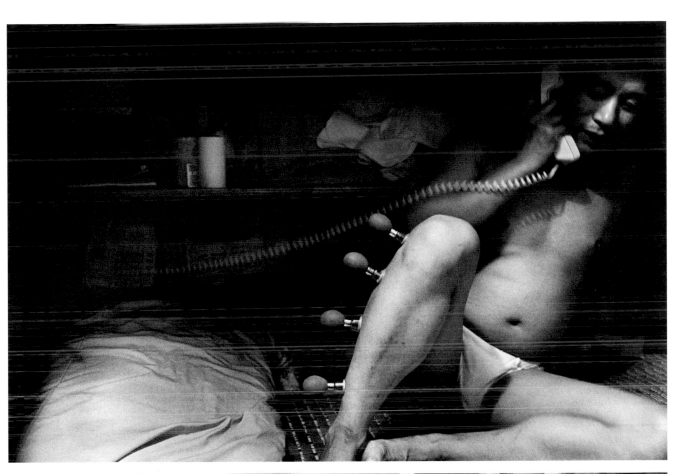

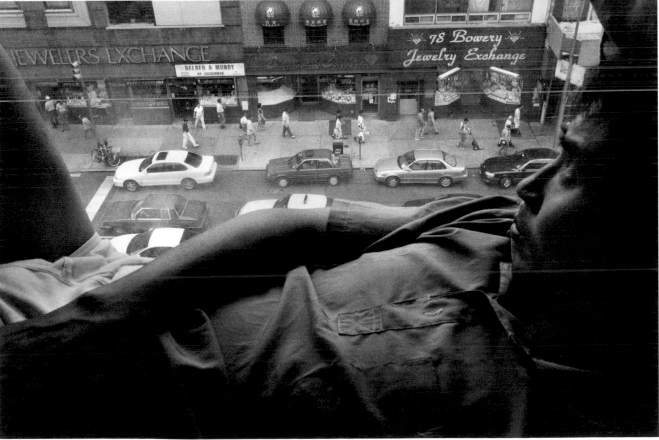

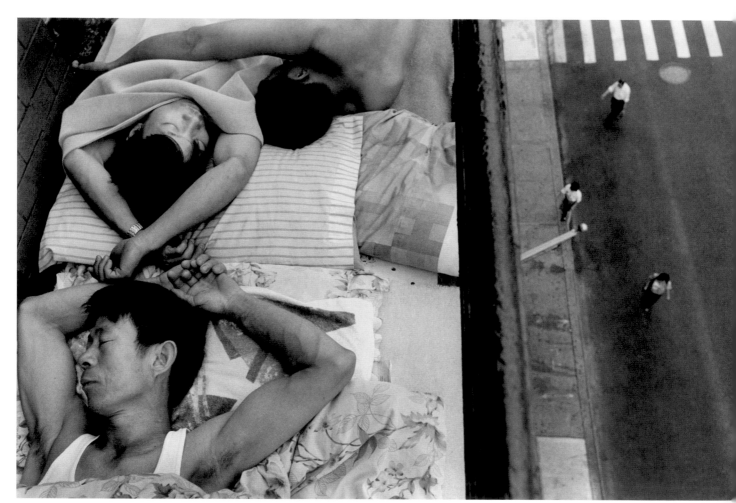

Immigrants sleeping on a fire escape in the summer heat.
New York City, USA, 1998

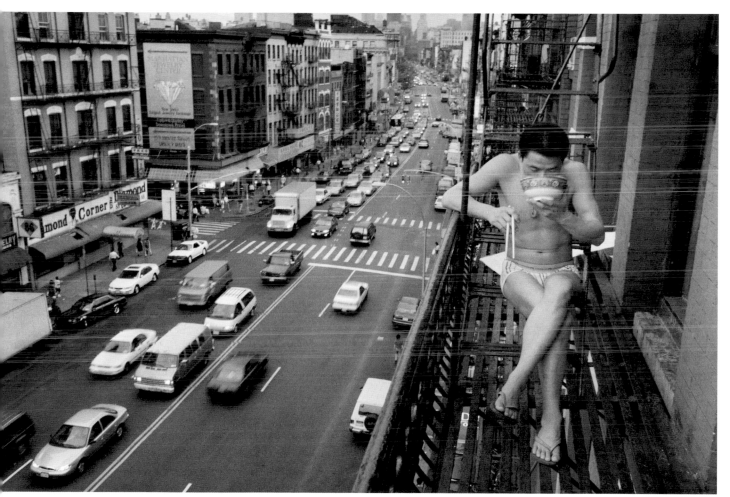

A newly arrived immigrant. New York City, USA, 1998

Following pages
Chinatown. New York City, USA, 1998

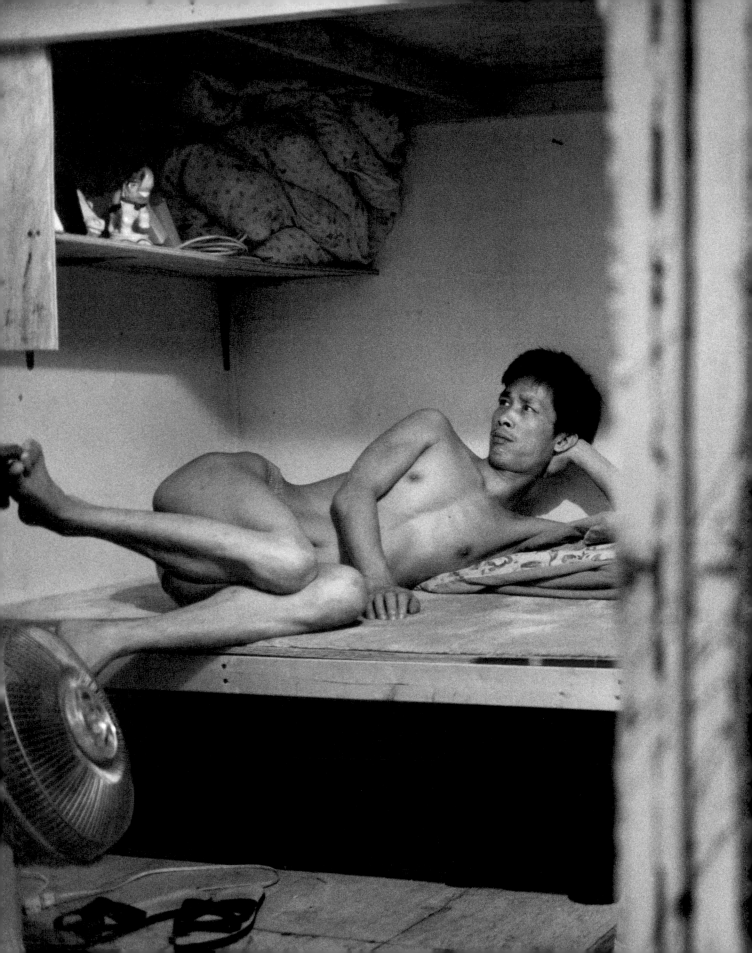

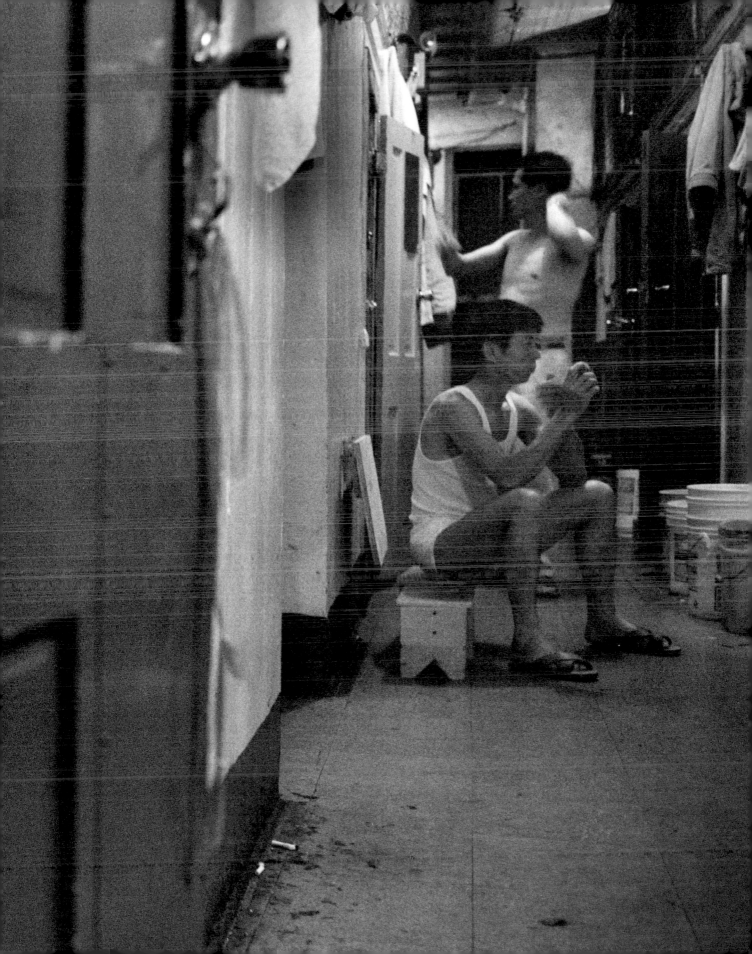

Coney Island, New York City, USA, 1959

BRUCE DAVIDSON

Born in Oak Park, Illinois, in 1933, Bruce Davidson won first prize in the Kodak National High School Competition at the age of sixteen. He went on to attend the Rochester Institute of Technology and Yale University.

During military service in Paris, Davidson met Henri Cartier-Bresson, one of the founders of Magnum Photos. In 1957 he worked as a freelance photographer for *Life*, and in 1959 he became a member of Magnum.

Davidson received a Guggenheim Fellowship in 1962 to document the Civil Rights Movement across the United States. In 1963 the Museum of Modern Art in New York presented his work in a one-man show that included powerful and historic images.

The first photography grant from the National Endowment for the Arts was awarded to Davidson in 1966, and he spent the next two years photographing one block in New York City: the resulting book, *East 100th Street*, presents his images of the inhabitants of a rundown tenement block in Spanish Harlem.

Davidson extended his view of the city with *Subway*, which explored the underground New York metro and its subterranean travellers, and *Central Park*, a four-year encounter with the city's magnificent green space, a convergence of humanity, nature and the city. Davidson's film *Living Off the Land* received the Critics Award from the American Film Festival.

Henry Geldzahler, the former Curator of Modern Art at the Metropolitan Museum, New York, said, 'The ability to enter so sympathetically into what seems superficially an alien environment remains Bruce Davidson's sustained triumph; in his investigation he becomes the friendly recorder of tenderness and tragedy.'

Davidson continues to live and work in New York City.

In this dilapidated, cockroach-infested boarding house above Bowery, there were about a hundred Chinese illegal immigrants living in cramped cubicles. I shared a unit with four bunkmates and naïvely thought I was ready to document the raw reality of the 'invisible people' in Chinatown. But after experiencing endless fumbling and frustration in this closed community, it was Bruce Davidson's *East 100th Street* to which I returned almost ritually for inspiration and comfort. That was how I managed to keep my sanity intact. Late in the evening, when most of my neighbours were sound asleep and snoring, I was wide awake reading the honest and touching account of his journey, looking at Davidson's real photographs of real people either in their inner sanctuary or off-limits environments.

So I have returned to Chinatown and continued to be amazed by Bruce's imagery – *Brooklyn Gang, Civil Rights Photographs 1961–1965, Central Park, Subway, Bruce Davidson Photographs, Portraits.* It was not only impractical but impossible to choose six images from his prolific and innovative career spanning half a century. My personal final six was chosen because I adore his profound ability to depict interrelationships particularly between couples who have paused and gazed at the photographer frankly and with confidence. The photographs are elegant and evocative. Many of Bruce's memorable, iconic photographs have become part of my memory and reality, even though they were taken before I was born. Bruce is a great contemporary photographer with an uncompromising eye as well as a compassionate, empathetic embrace of his subjects. Dear Bruce, what are you photographing today?

Chien-Chi Chang

Opposite
East 100th Street. New York City, USA, 1966

Central Park, New York City, USA, 1992

Opposite
East 100th Street. New York City, USA, 1966

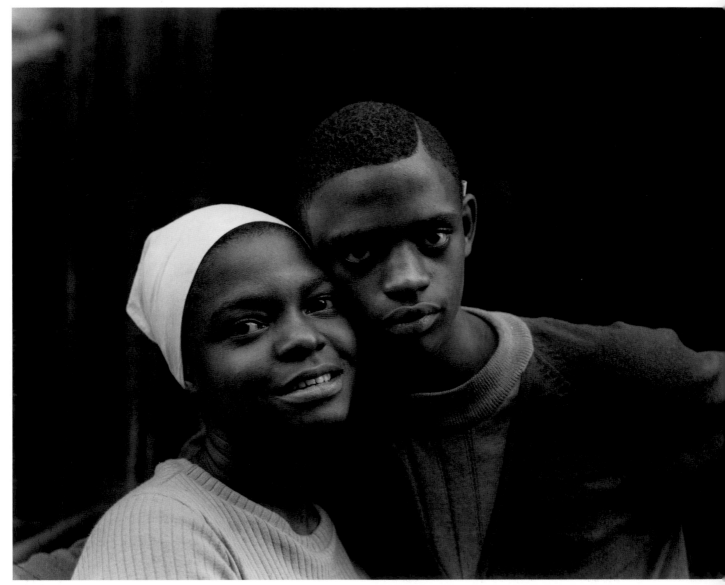

East 100th Street. New York City, USA, 1966

Opposite
East 100th Street. New York City, USA, 1966

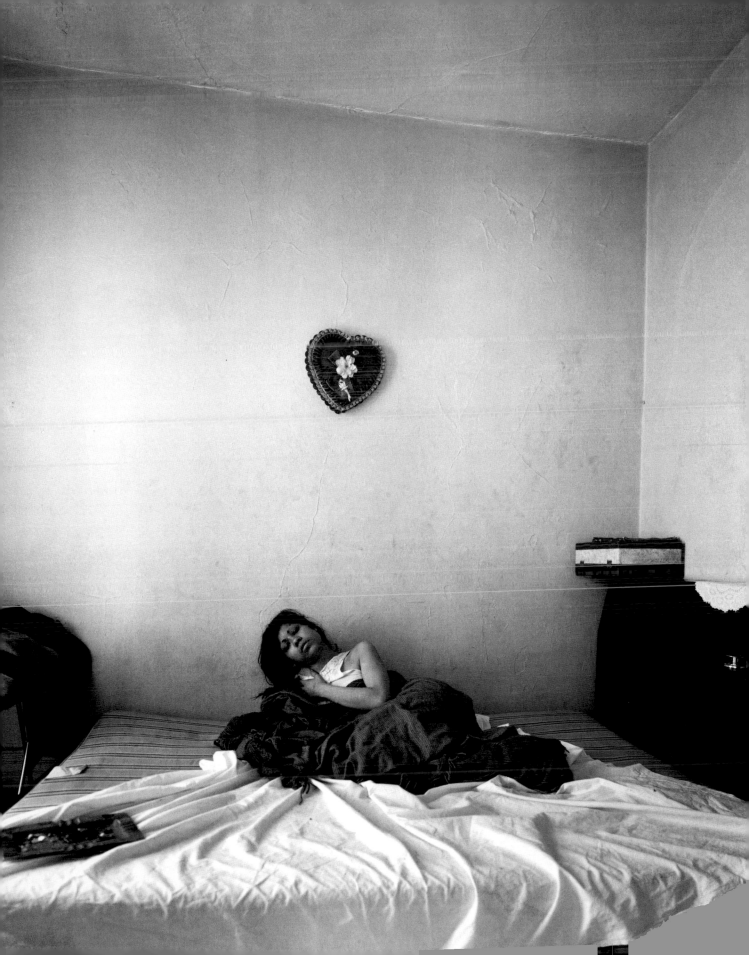

CARL DE KEYZER

Born in Belgium in 1958, Carl De Keyzer started his career as a freelance photographer in 1982, while supporting himself as a photography instructor at the Royal Academy of Fine Arts in Ghent. At the same time, his interest in the work of other photographers led him to co-found and co-direct the XYZ-Photography Gallery. A Magnum nominee in 1990, he became a full member in 1994.

De Keyzer, who has exhibited his work regularly in European galleries, is the recipient of a large number of awards including the Book Award from the Arles Festival, the W. Eugene Smith Award (1990) and the Kodak Award (1992).

De Keyzer likes to tackle large-scale projects and general themes. A basic premise in much of his work is that, in overpopulated communities everywhere, disaster has already struck and infrastructures are on the verge of collapse. His style is not dependent on isolated images; instead, he prefers an accumulation of images which interact with text (often taken from his own travel diaries). In a series of large tableaux, he has covered India, the collapse of the Soviet Union and – more recently – modern-day power and politics.

Whatever Carl photographs, it nearly always drags me back to Belgium. Not simply because we both were born on the same side of a particular speck of land, but also because of the ironic tone he uses, the delight in rubbing the viewer's nose in 'bad taste' … It is as if somewhere in Mongolia or in Krasnoyarsk there is a mirror reflecting a flowerpot, a painting or even a haircut that you could find in Jabbeke or in Ellezelles. When you're not Belgian you perceive the irony in Carl's pictures, but you can't really explain it. When you *are* Belgian you can't explain it either, but you *know* what you're looking at, and you recognize a self-deprecating sarcasm on top of that.

There are a few privileges to being Belgian. Even if the country is stinking rich, and even though we participate, Belgium still doesn't represent a lot on a geopolitical level these days. When it's hard to be taken seriously, it is safer for the individual to develop self-mockery instead of becoming arrogant. But mind you: self-mockery and irony are a serious business. Take a look beyond the surface and you'll find razor-sharp dissections of what's out there.

This could be the golden rule when meeting a Belgian: look beyond the surface … Some have ways of hiding things. Carl's pictures look cool. But it's got to be boiling inside.

Another privilege is that it feels as though we're not members of a real country any more, but of an interesting concept instead: a place where the only things that keep us together are a few die-hard politicians, a rotten climate and our culture. Culture is what we are left with after all the armies who have trampled our rich soil over the centuries are gone. Culture makes you belong to the world beyond your country. Culture needs people who keep it fluid, who question it, who use mirrors. Culture needs ambassadors.

For me, a Belgian living in Phnom Penh, it's still possible to spot the appeal of a particular bedspread in Mongolia· isn't that the sign that Carl's pictures are both specific and universal?

John Vink

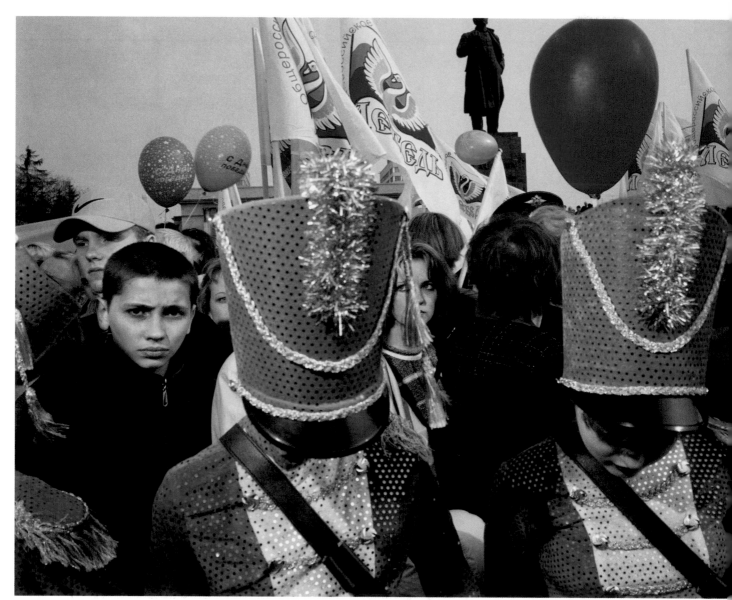

A national holiday parade, Krasnoyarsk. Siberia, Russia, 2001

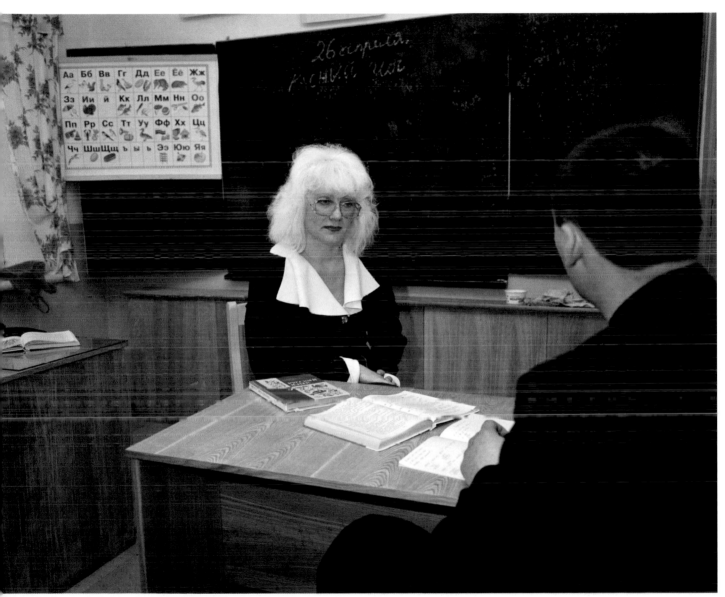

A school teacher, Camp 6, Krasnoyarsk. Siberia, Russia, 2001

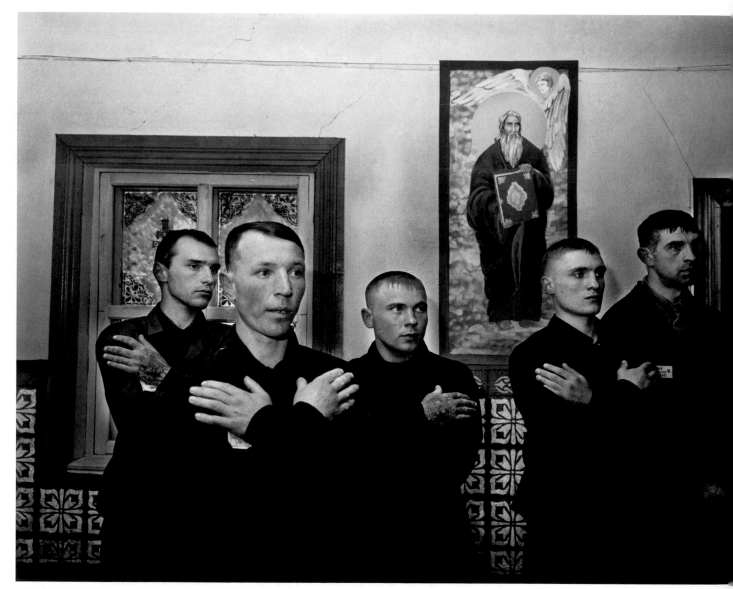

The first service in the new Orthodox church at Camp 15,
Krasnoyarsk. Siberia, Russia, 2001

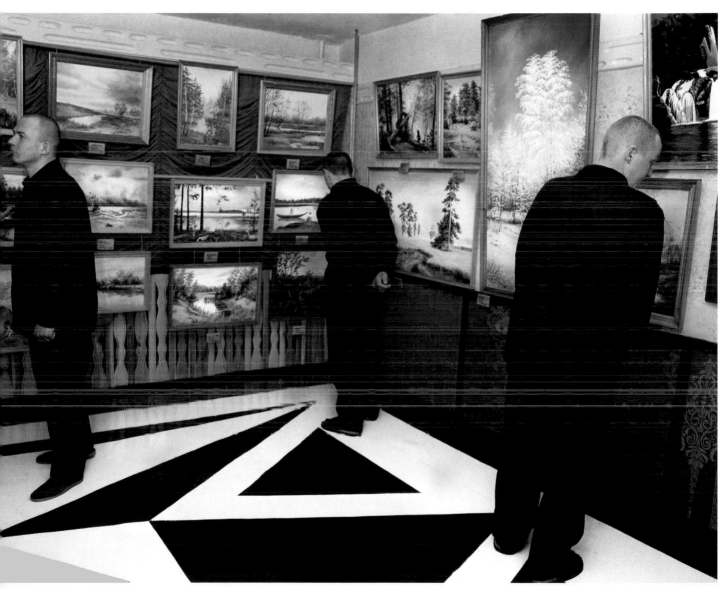

Prisoners looking at paintings made at Camp 27, Krasnoyarsk.
Siberia, Russia, 2001

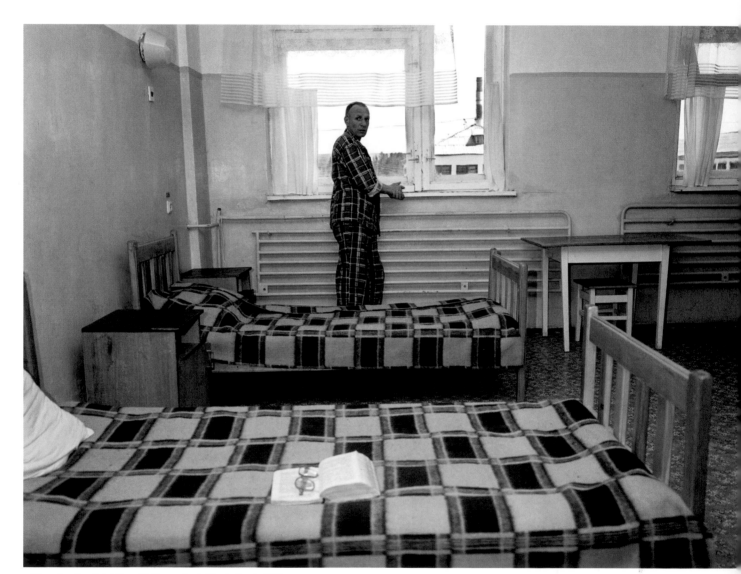

The prison hospital at Camp 37, Sosnovobosk. Siberia, Russia, 2001

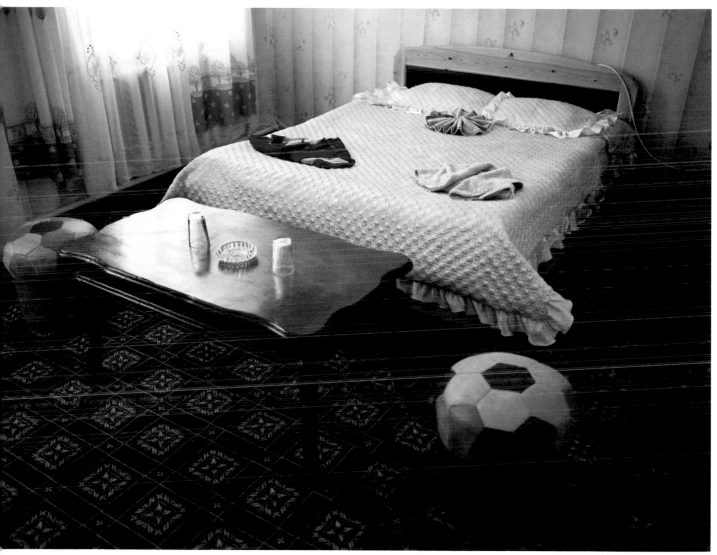

South Gobi, Mongolia, 2006

RAYMOND DEPARDON

Raymond Depardon, born in France in 1942, began taking photographs on his family farm in Garet at the age of 12. Apprenticed to a photographer-optician in Villefranche-sur-Saône, he left for Paris in 1958.

He joined the Dalmas agency in Paris in 1960 as a reporter, and in 1966 he co-founded the Gamma agency, reporting from all over the world. From 1974 to 1977, as a photographer and film-maker, he covered the kidnap of a French ethnologist, François Claustre, in northern Chad. Alongside his photographic career, he began to make documentary films: *1974, Une Partie de Campagne* and *San Clemente*.

In 1978 Depardon joined Magnum and continued his reportage work until the publication of *Notes* in 1979 and *Correspondance New Yorkaise* in 1981. In that same year, *Reporters* came out and stayed on the programme of a cinema in the Latin Quarter for seven months. In 1984 he took part in the DATAR project on the French countryside.

While still pursuing his film-making career, he received the Grand Prix National de la Photographie in 1991, but his films also won recognition: in 1995 his film *Délits Flagrants*, on the French justice system, received a César Award for best documentary, and in 1998 he undertook the first in a series of three films devoted to the French rural world. The Maison Européenne de la Photographie in Paris mounted an important exhibition of his work in 2000. The sequel to his work on French justice was shown as part of the official selection at the Cannes Film Festival in 2004.

As part of an initiative by the Fondation Cartier for contemporary art, Depardon made an installation of films on twelve large cities, shown in Paris, Tokyo and Berlin between 2004 and 2007. In 2006 he was invited to be artistic director of the Rencontres Internationales d'Arles. He is working on a photographic project on French territory which is due to be completed in 2010. He has made eighteen feature-length films and published forty-seven books.

Raymond Depardon has a disconcerting ability to move from one medium to another: photography, writing, books, films, documentaries and fiction.

This curiosity, this energy, this capacity to think differently according to mode, fascinates me – because I am probably the opposite, unfortunately; I'm unable to juggle several subjects, approaches and aesthetics at once.

It is this distance, this way of hesitating for a long time before attacking a project to find out whether it will be in colour or black and white (large format, medium format, or 35mm), that appeals to me: I don't work this way, and yet the city is shared territory.

While I am immersed in it, reacting impulsively to visual 'shocks' that I hope are going to turn into good pictures, Raymond Depardon constructs his work like a film, more on a quest for an idea for a series than for a 'unique' photo. I try to treat the power of colours in their ordinary state; he lines up pictures, above all avoiding the 'key shot', the one picture that takes too much prominence in the series.

Colour: for a long time I thought Raymond Depardon couldn't see it. I was impressed by his ability to photograph San Clemente in black and white, then to film it, creating two different works with two different messages.

Then in other films, I saw great self-control, a real documentary talent. It was when I really paid attention to the first catalogue of his Fondation Cartier exhibition that this really struck me, and it struck me again in the second, published by Steidl.

His use of colour is not 'affective' like mine; it is a very clear vision of what is real, without an emotive filter: he avoids the trap of dramatization, keeping at a distance, his way of looking at things 'portrait' – better for avoiding white space on the pages of a book – creating a sort of gap where the intimate appears on a street corner, all of a sudden.

Harry Gruyaert

Following pages, left
Berlin, Germany, 2004

Following pages, right
Shanghai, China, 2004

Page 132
Moscow, Russia, 2004

Page 133
Moscow, Russia, 2004

Page 134
Johannesburg, South Africa, 2006

Page 135
Buenos Aires, Argentina, 2006

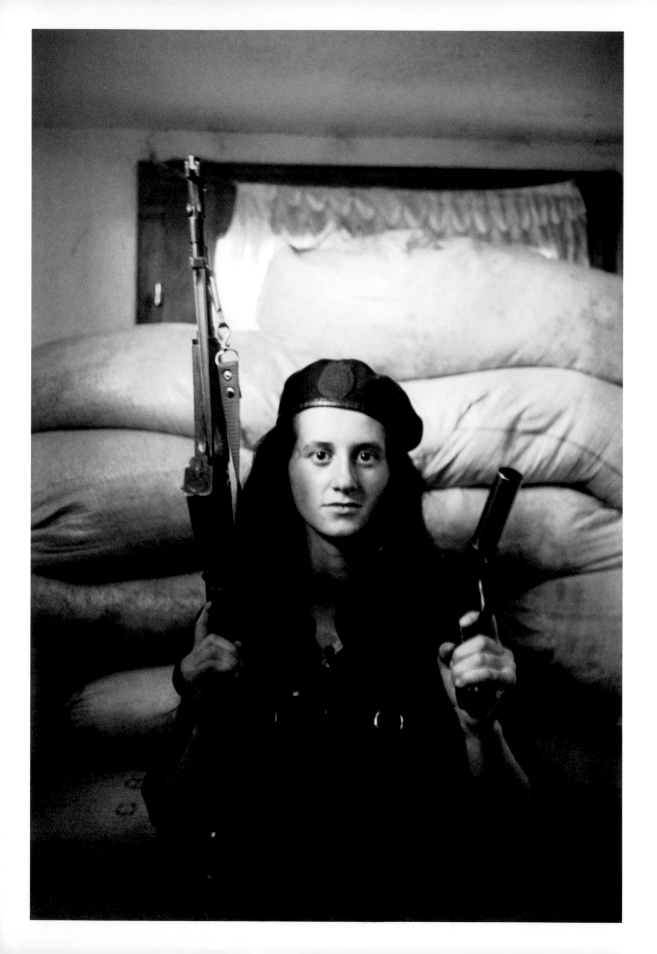

THOMAS DWORZAK

Thomas Dworzak was born in Kötzting, Germany, in 1972 and grew up in the small town of Cham in the Bavarian Forest. Towards the end of his high school studies, he began to travel and photograph in Europe and the Middle East, living in Avila, Prague and Moscow, and studying Spanish, Czech and Russian. After photographing the war in former Yugoslavia, he lived in Tbilisi, Georgia, from 1993 until 1998. He documented the conflicts in Chechnya, Karabakh and Abkhazia as well as working on a larger-scale project about the Caucasus region and its people.

Based in Paris from 1999, he covered the Kosovo crisis, mostly for *US News and World Report*, and he returned to Chechnya the same year. After the fall of Grozny in early 2000, he began a project on the impact of the war in Chechnya on the neighbouring North Caucasus. He also photographed events in Israel, the war in Macedonia, and the refugee crisis in Pakistan.

After 9/11, Dworzak spent several months in Afghanistan on an assignment for the *New Yorker*. He returned to Chechnya in 2002. Since then he has photographed in Iraq, Iran and Haiti, and covered the revolutions in the former Soviet republics of Georgia, Kyrgyzstan and Ukraine.

Based mainly in New York since 2004, Dworzak has been photographing the world of American politics and the impact of the war in Iraq. He is currently working on the projects *M*A*S*H IRAQ*, and *Valiassr*, an essay on Tehran's main avenue.

Dworzak became a Magnum nominee in 2000 and a member in 2004.

Opposite
A girl fighter of the ethnic Albanian National Liberation Army.
Slupcane, Republic of Macedonia, May 2001

I chose these pictures because they make me think of something other than what they are, something universal and so common that I have seen them in my own back yard. Carl Sandberg, a nineteenth-century American poet, said that poetry was like the opening and closing of a door, leaving those looking to guess what is seen.

These pictures are not poetry and Thomas is not a poet. He's a journalist. Yet there is something in them that speaks to both identities.

When Thomas was twenty he moved to Russia to learn to photograph. Since then he has documented most world tragedies from Bosnia to Chechnya, from Iraq to Palestine, and from Afghanistan to Haiti. Yet he has not hardened his heart, as do many of his colleagues, because, in the cobweb of political deceit, he manages to find the universal seed of truth. The door opens and the truth remains: for every act of hate, there is a revolt against hate; for every act of violence, a revolt against violence.

These photographs remind me that a photographer can redeem his own existence, and the existence of those around him, by observing small beauties and small hopes in these dark and appalling times.

Larry Towell

A memorial for a dead Russian soldier near Andi on the Chechen
border. Republic of Dagestan, July 2000

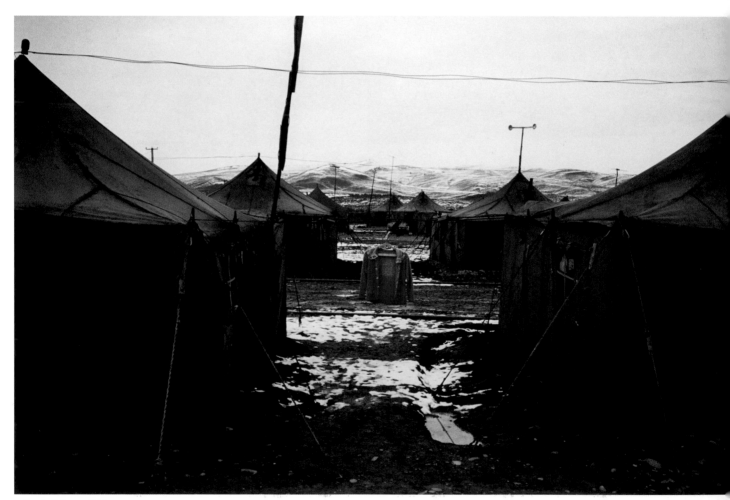

Russia, February 2001

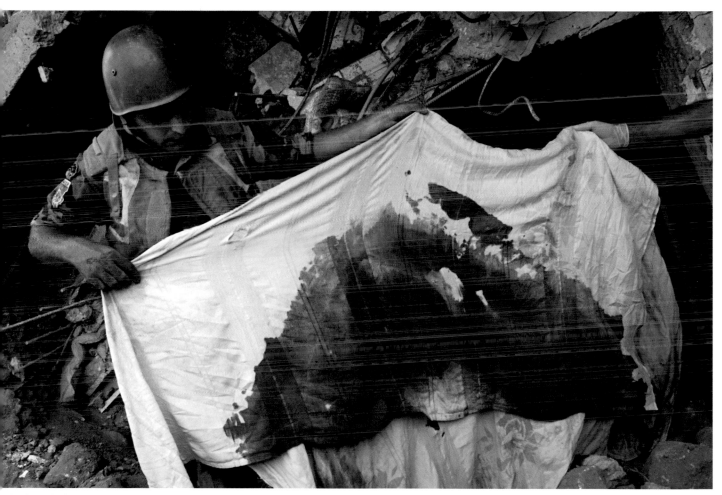

The aftermath of an Israeli air-strike that killed dozens of civilians,
mostly women and children. Qana, Lebanon, 30 July 2006

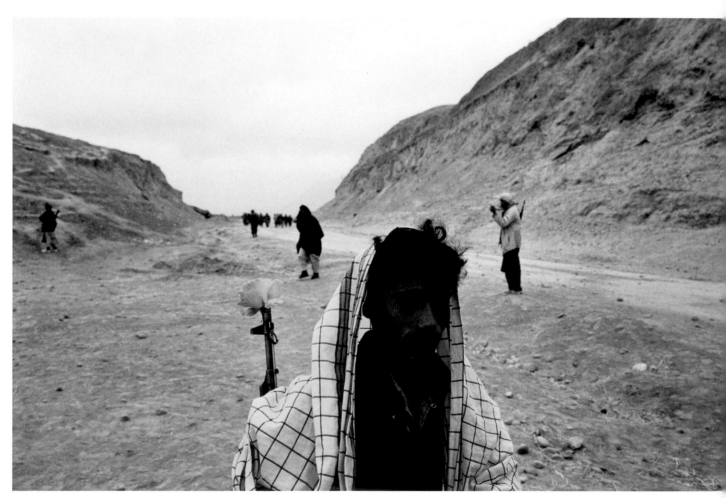

A soldier of the United Front/Northern Alliance on his way to the
frontline at Kunduz. Northern Afghanistan, 21 November 2001

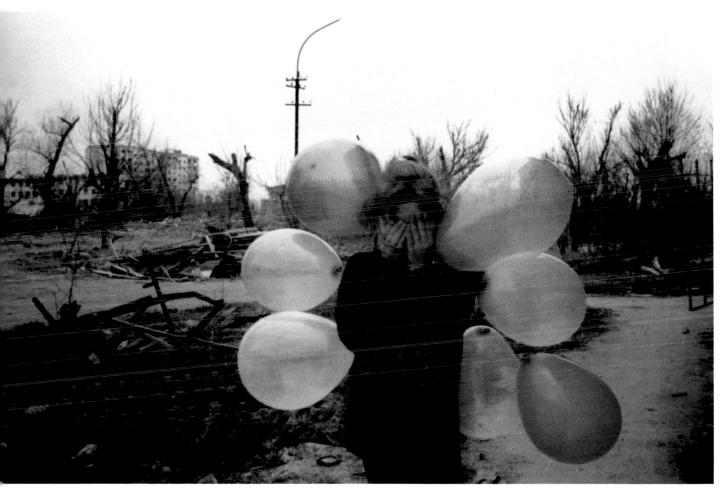

Grozny, Russia, February 2002

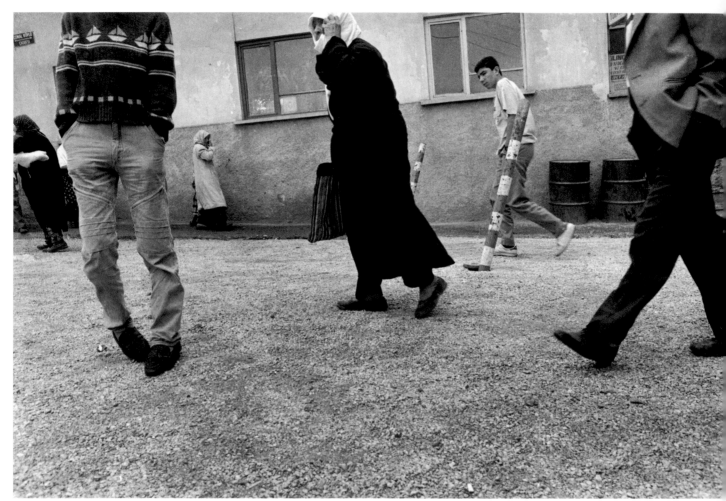

Sögüt village, Turkey, 1990

NIKOS ECONOMOPOULOS

Nikos Economopoulos was born in Greece in 1953. After studying law in Parma, Italy, he worked as a journalist in his native country. Meanwhile, he pursued photography, and in 1988 he began a long-term project in Greece and Turkey. He photographed whatever he came across on his daily walks: street scenes, public gatherings, solitary meanderers, or deserted landscapes.

In 1990 Economopoulos joined Magnum, and his photographs began to appear in newspapers and magazines worldwide. In the same year he started to take photographs in Albania, Bulgaria, Romania and the former Yugoslavia, investigating the territorial, ethnic and religious tensions of the region, as well as the endurance of traditional social and religious rites. This work earned him the Mother Jones Award in 1992.

Supported and encouraged by the charity Little Brothers of the Poor, Economopoulos undertook a project on poverty and exclusion in Europe, focusing on Gypsy communities in Greece. From 1995 to 1996 he photographed lignite miners and the Muslim minority in Greece. In 1997–98, he photographed people living along the Green Line dividing southern and northern Cyprus; illegal immigrants at the Greek–Albanian border; and young residents of Tokyo. During this period he also worked in Macedonia, Albania, Turkey, Corsica, and along the Greek–Turkish border.

In 1999 and 2000, he covered the mass emigration of ethnic Albanians fleeing Kosovo. Concurrently he completed a commission from the University of the Aegean on the preservation of the region's storytelling tradition. He was given the Abdi Ipektsi Award for peace and friendship between Greece and Turkey in 2001. A retrospective of his work was shown in 2002 at the Benaki Museum in Athens.

Nikos Economopoulos's work takes us on a fascinating journey into the lands and lives of the people of the Mediterranean. Not only do his pictures engage us with the people he photographs – the nomads, Gypsies, and transient peoples – but they also bring new meaning and insight into the way we see the world. It is as if he is creating a stage where his subjects come together as if in dance. These images represent the work of an exceptional photographer and storyteller.

Paolo Pellegrin

People queuing to apply for a visa at the Greek embassy.
Tirana, Albania, 1997

Following pages
top left
Nomads. Kars village, Turkey, 1990

bottom left
Gypsy camp. Euboea, Greece, 1997

top right
Korce, Albania, 1990

bottom right
A mother holding a portrait of her son, missing since the
war in Cyprus in 1974. Cyprus, 1997

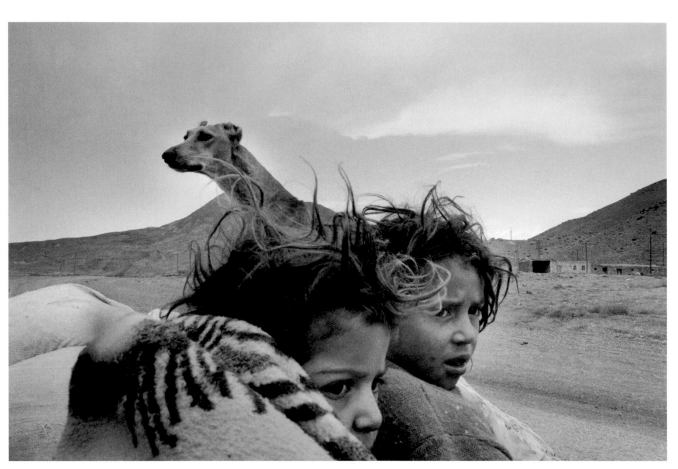

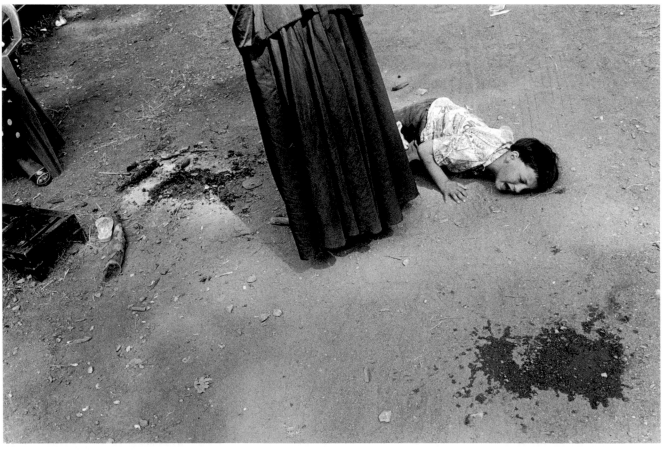

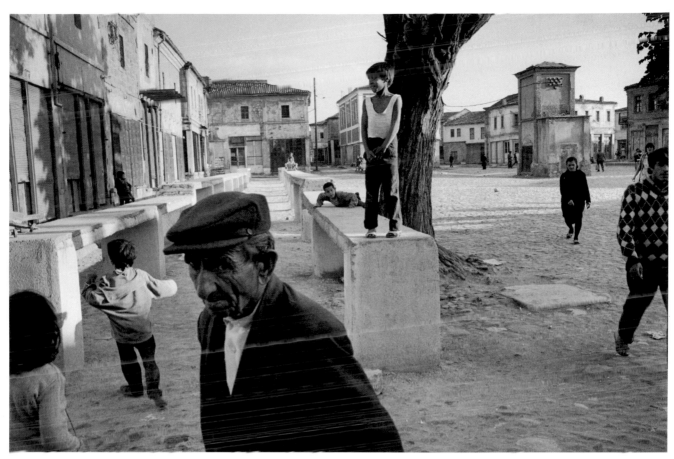

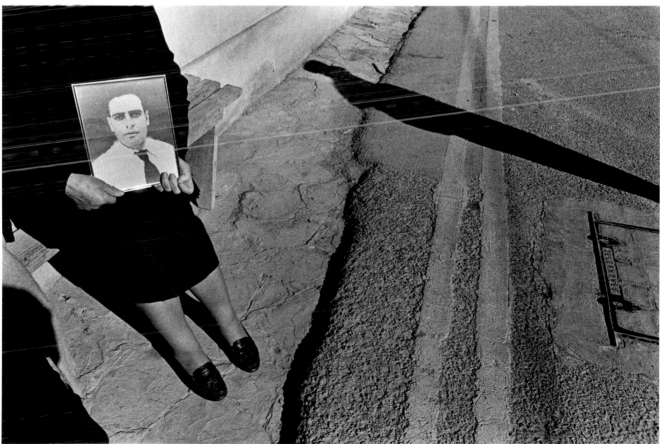

Moscow, Russia, 1957

ELLIOTT ERWITT

Born in Paris in 1928 to Russian parents, Erwitt spent his childhood in Milan, then emigrated to the US, via France, with his family in 1939. As a teenager living in Hollywood, he developed an interest in photography and worked in a commercial darkroom before experimenting with photography at Los Angeles City College. In 1948 he moved to New York and exchanged janitorial work for film classes at the New School for Social Research.

Erwitt travelled in France and Italy in 1949 with his trusty Rolleiflex camera. In 1951 he was drafted for military service and undertook various photographic duties while serving in a unit of the Army Signal Corps in Germany and France.

While in New York, Erwitt met Edward Steichen, Robert Capa and Roy Stryker, the former head of the Farm Security Administration. Stryker initially hired Erwitt to work for the Standard Oil Company, where he was building up a photographic library for the company, and subsequently commissioned him to undertake a project documenting the city of Pittsburgh.

In 1953 Erwitt joined Magnum Photos and worked as a freelance photographer for *Collier's*, *Look*, *Life*, *Holiday* and other luminaries in that golden period for illustrated magazines. To this day he is for hire and continues to work for a variety of journalistic and commercial outfits.

In the late 1960s Erwitt served as Magnum's president for three years. He then turned to film: in the 1970s he produced several noted documentaries and in the 1980s eighteen comedy films for Home Box Office. Erwitt became known for benevolent irony, and for a humanistic sensibility traditional to the spirit of Magnum.

I was thrilled and very proud that Elliott asked me to choose his photos for this book. It has been the pride of my life to have worked alongside him at Magnum. Yet not all colleagues become friends. Elliott became one. Then I noticed how happy he was to have caused me such a headache. To be forced to choose only six photographs from among all of Elliott's images has been real torture.

How can you put before a passionate gourmet thousands of the most delicious dishes and force him to taste just one? I spent weeks eliminating the thousands of his photographs that I adore. And every one pierced my heart.

When, exhausted, I had arrived at these six, I missed all the others.

Then I realized that I had not picked a dog photo. How can you not have one of those, I asked myself? But then again, why have one, after all? Don't we already know and love them all?

Ferdinando Scianna

Valdes Peninsula. Argentina, 2001

North Carolina, USA, 1950

Daytona Beach. Florida, USA, 1975

Opposite
Florida Keys, USA, 1968

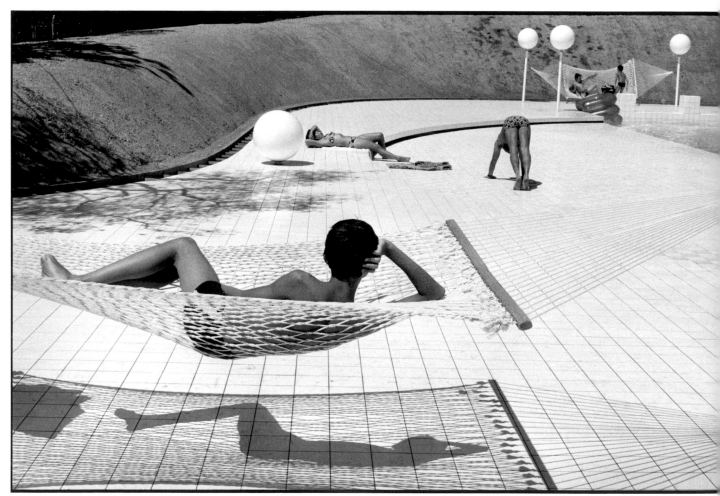

Le Brusc, France, 1976

MARTINE FRANCK

Born in Belgium in 1938, Martine Franck grew up in the United States and in England. She studied art history at the University of Madrid and at the École du Louvre in Paris.

After a trip to the Far East with Ariane Mnouchkine, Franck worked at *Time-Life* in Paris as an assistant to the photographers Eliot Elisofon and Gjon Mili. Her friendship with Mnouchkine also led her to follow the Théâtre du Soleil from its beginnings in 1964 until now.

After joining the Vu Photo Agency, she contributed to the founding of the Viva agency in 1972. Franck took many portraits of artists and writers, including a noteworthy series of women for *Vogue*. She undertook more far-reaching work for the French Ministry of Women's Rights in 1983. That same year she became a full member of Magnum Photos.

Since 1985 Franck has collaborated with the International Federation of Little Brothers of the Poor, a non-governmental organization which cares for the elderly and outcasts of society. It was in 1993 that Franck first visited the island of Tory, off the northwest coast of Ireland. There she studied the daily life of a traditional Gaelic-speaking community separated from the mainland.

She next travelled to Asia to meet Buddhist Tibetan children in India and Nepal. With the help of Marilyn Silverstone, a former member of Magnum Photos who became a Buddhist nun, she encountered the Tulkus, the young lamas who are thought to be the reincarnations of ancient great spiritual masters.

In 2003 and 2004 undertook a theatre project in which she shadowed the avant-garde stage director Robert Wilson at the Comédie Française, documenting his innovative rendition of La Fontaine's *Fables*.

The unforgettable Robert Doisneau defined Martine Franck's photography as the 'look of friendship', as opposed to the 'look of the cop' or the 'look of the doctor', which afflicts too many of today's photographers. I was friends with Martine's photography before I became friends with Martine the person. Then the two friendships became the same thing.

Martine's friendly attitude does not exclude a lucidity, which can sometimes be ironic, sometimes severe, often involved or curious, never contemptuous. Like a photojournalist, she naturally keeps the person in full view, seeking to understand and to help us to do so. Whether with celebrities or with unknown subjects, Martine always manages to open the window onto a human truth that reveals the person, the individual, each very different from the next, in a way that renders every one of them unforgettable. It is a rare gift, one that so few photographers possess.

Ferdinando Scianna

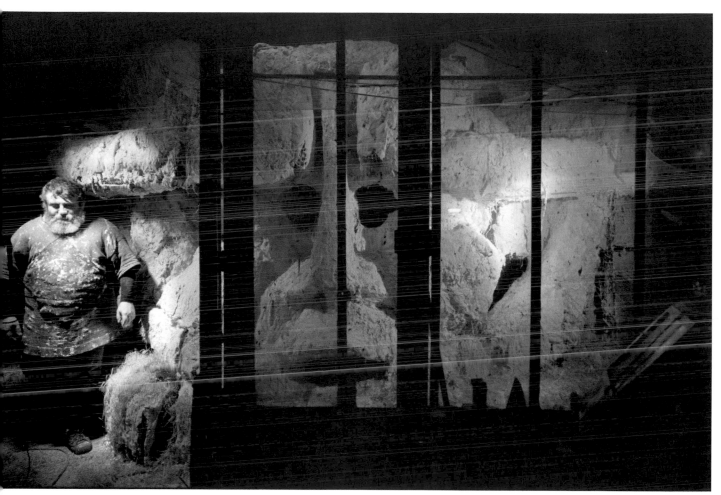

The sculptor Etienne Martin in his studio, working on *Maison 10.*
Paris, France, 1967

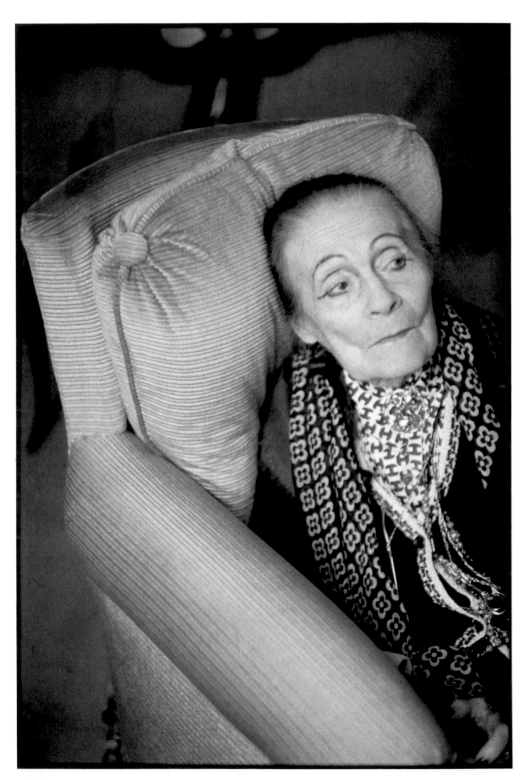

Lili Brick, the sister of Elsa Triolet and
companion of the Russian poet Vladimir
Mayakovski. Paris, France, 1976

Opposite
The French actor Charles Denner during the
filming of *Le Voleur*. France, 1966

Following pages
left
Melon plantations. Cereste, France, 1976

right
Paris, France, 1977

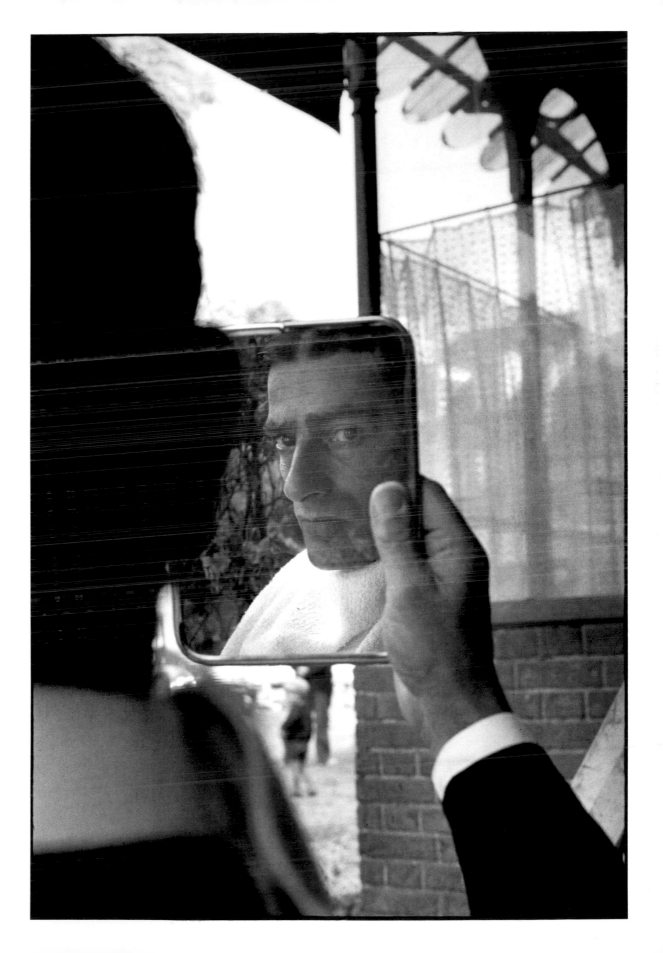

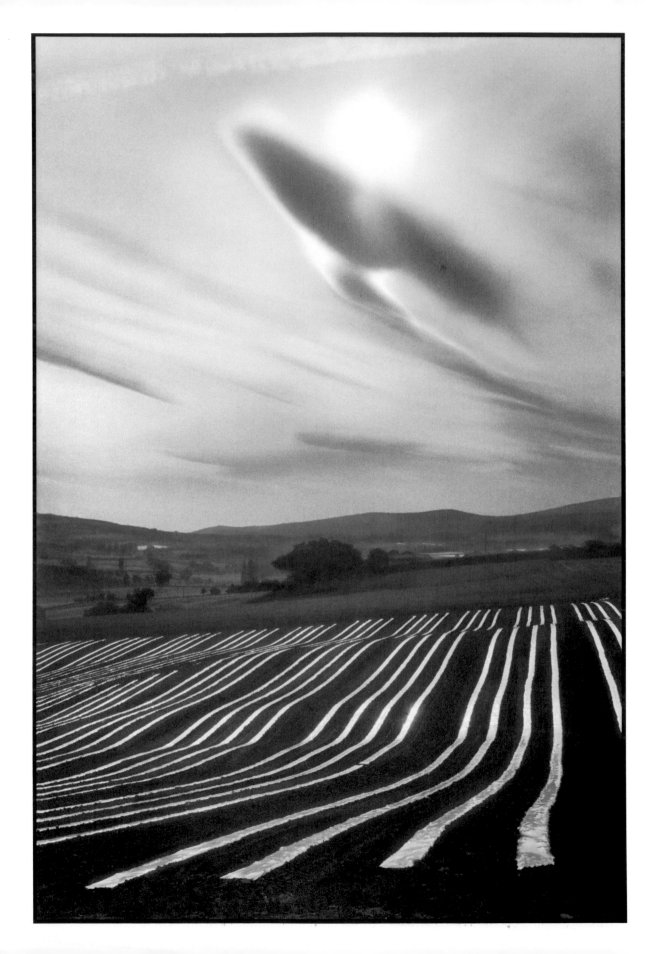

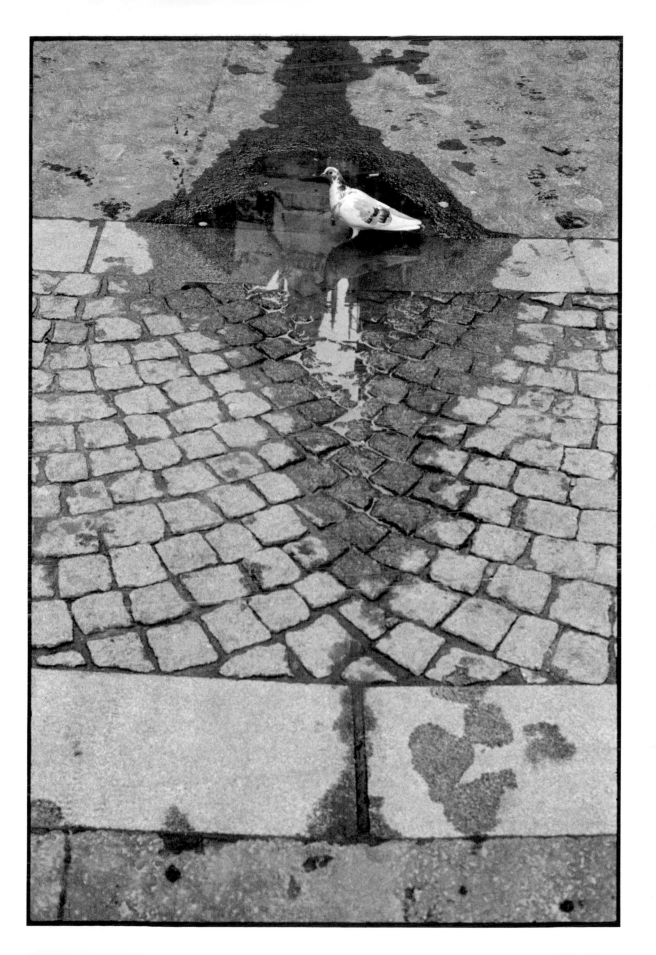

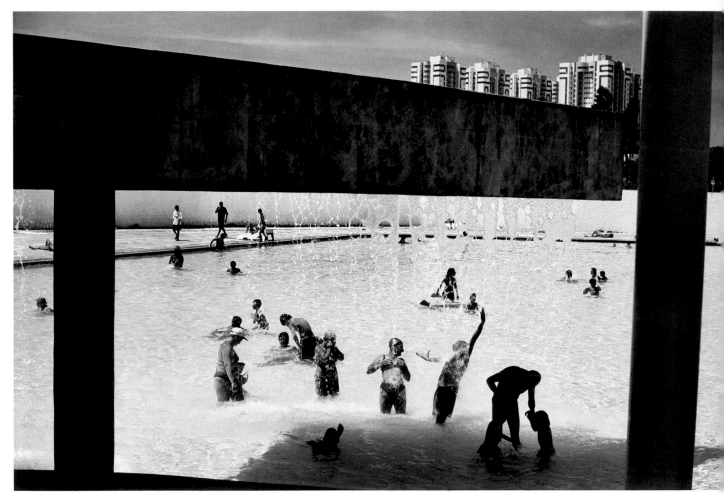

The largest pool in São Paulo draws working-class Paulistanos.
'You would never see a rich person here,' says a city resident.
São Paulo, Brazil, 2002

STUART FRANKLIN

Stuart Franklin was born in Britain in 1956. He studied photography and film at West Surrey College of Art and Design and geography at the University of Oxford (BA and PhD). During the 1980s, he worked as a correspondent for Sygma Agence Presse in Paris before joining Magnum Photos in 1985.

Franklin's coverage of the Sahel famine from 1984 to 1985 won him acclaim, but he is perhaps best known for his celebrated photograph of a man defying a tank in Tiananmen Square, China, in 1989, which won him a World Press Photo Award. Since 1990, Franklin has completed over twenty assignments for *National Geographic*. His documentary photography has taken him to Central and South America, China, Southeast Asia and Europe. Since 2004 he has focused on long-term projects concerned primarily with man and the environment.

In 1999 he produced *The Time of Trees*, a photographic essay examining the social relationship between nature and society through the prism of trees. This was followed four years later by *The Dynamic City*, about the evolution and everyday life of cities. In 2005 he completed Hôtel Afrique, an exhibition on Africa's elite hotels (the book of the same title is in progress); the same year, aided by a grant funded by the National Trust, he published *Sea Fever*, a documentary project about the British coastline. Franklin is currently working on a long term project on Europe's changing landscape, focusing in particular on the climate and on patterns of transformation.

Stuart Franklin has explored a number of areas, from journalism to landscape. He has worked with different formats from 35mm to 4" x 5" view camera; one of his favourite cameras falls somewhere in the middle – the venerable Rolleiflex with a formidable 75mm 3.5 Zeiss Planarlens. Throughout his work one thing remains consistent: a disciplined, formal sense of quality.

Among the pictures shown here, one group is missing: the landscapes. They are elegant images worthy of the best galleries, but Stuart made them out of his concern for the environment. He is typical of many Magnum photographers, who strive to make fine photographs not for the sake of the photograph alone but also to make a statement about the world in which we live. I have never heard a single Magnum photographer refer to himself or herself as an 'artist', nor refer to a photograph as a 'piece'. The photographers have a mission which goes beyond merely creating pretty images.

Of the photographs in this selection, there are three grand cityscapes in which the human element is dwarfed by the scale of the city (pages 166, 170, and 172). In the current art market these are the types of photograph, enlarged to huge sizes, that one sees in smart galleries at very high prices. Stuart made these before the fad began, and for the right reasons: to show what our civilization looks like.

Stuart did many assignments for *National Geographic* in which he showed his skill as a photographer of the human condition (page 171), a great Magnum tradition. Working with a small 35mm camera, he went into the innards of cities to photograph the ordinary people who inhabit the apartment blocks shown in his large-format pictures. The picture on page 169 is a powerful comment on race and the (literal) barriers which divide people.

The shadow picture with the cat in the chair (page 173) is the kind of picture I like to take and one I wish belonged to me. It is a very ordinary situation made extraordinary by the speed and skill of a photographer who is in complete control and who knows where to be and when precisely to push the button. It is simply a beautiful picture.

Constantine Manos

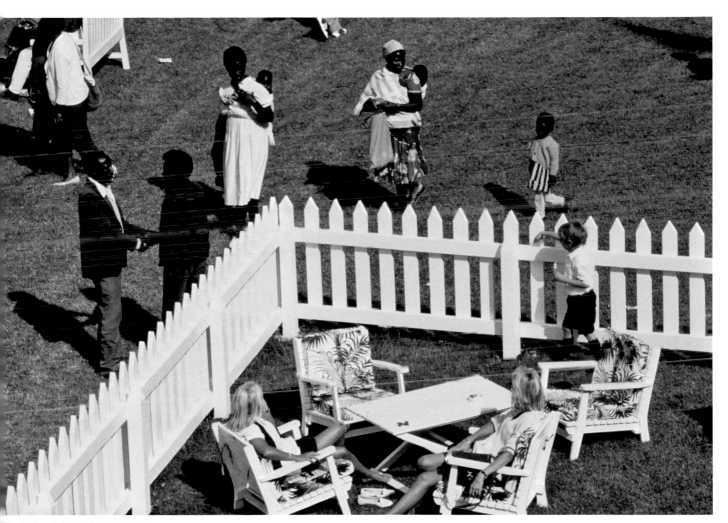

The Jockey Club. Nairobi, Kenya, 1988

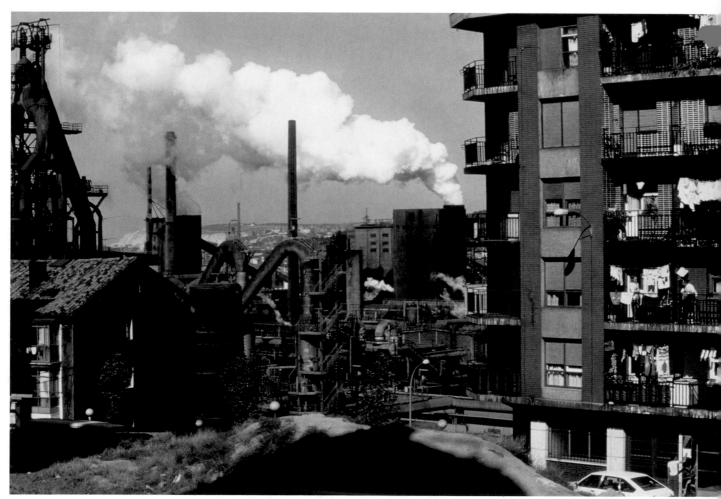

The power station, Altos Hornos. Bilbao, Spain, 1985

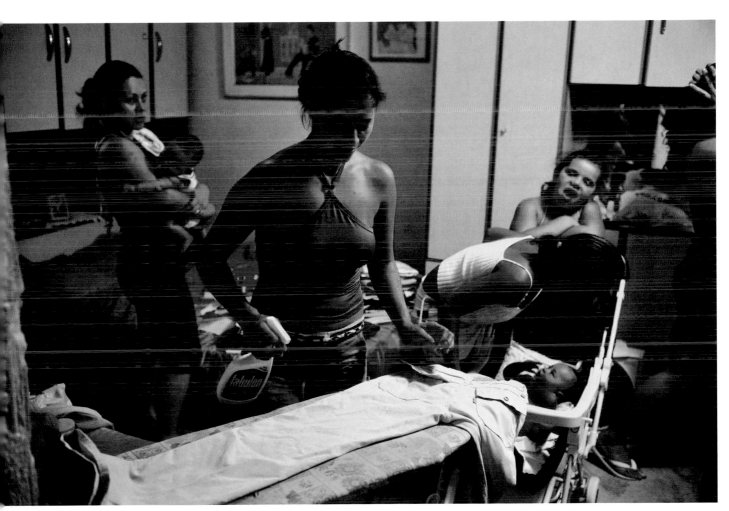

Nova Belem, the first self-built housing project. São Paulo, Brazil, 2002

Commuters on their way to work in the city centre. São Paulo, Brazil, 2002

The old city, Santo Domingo. Dominican Republic, 1992

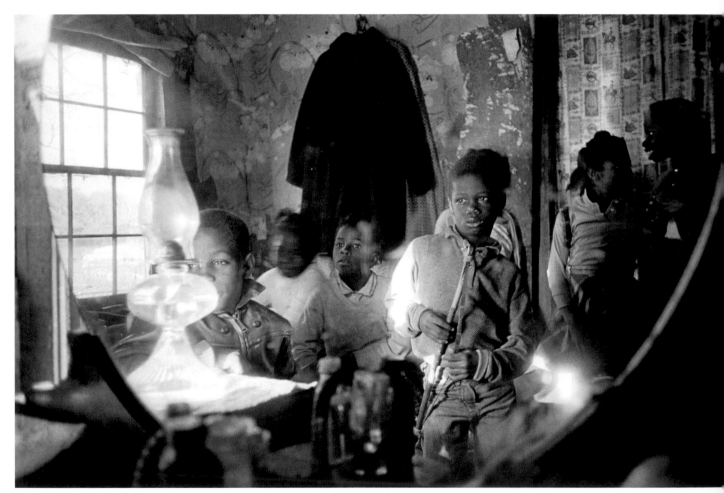

A poor family. South Carolina, USA, 1963

LEONARD FREED

Born in 1929 in Brooklyn, New York, to working-class Jewish parents of Eastern European descent, Leonard Freed first wanted to become a painter. However, he began taking photographs while in the Netherlands in 1953, and discovered that this was where his passion lay. In 1954, after trips through Europe and North Africa, he returned to the United States and studied in Alexei Brodovitch's 'design laboratory'. He moved to Amsterdam in 1958 and photographed the Jewish community there. He pursued this concern in numerous books and films, examining German society and his own Jewish roots; his book on the Jews in Germany was published in 1961, and *Made in Germany*, about post-war Germany, appeared in 1965. Working as a freelance photographer from 1961 onwards, Freed began to travel widely, photographing blacks in America (1964–65), events in Israel (1967–68), the Yom Kippur War in 1973, and the New York City police department (1972–79). He also shot four films for Japanese, Dutch and Belgian television.

Early in Freed's career, Edward Steichen, then Director of Photography at the Museum of Modern Art, bought three of his photographs for the museum. Steichen told Freed that he was one of the three best young photographers he had seen and urged him to remain an amateur, as the other two were now doing commercial photography and their work had become uninteresting. 'Preferably,' he advised, 'be a truck driver.'

Freed joined Magnum in 1972. His coverage of the American civil rights movement first made him famous, but he also produced major essays on Poland, Asian immigration in England, North Sea oil development, and Spain after Franco. Photography became Freed's means of exploring societal violence and racial discrimination.

Leonard Freed died in Garrison, New York, on 30 November 2006.

Leonard was a free spirit in soul, with a wonderfully focused intellect that never failed to show itself in his photographs. He saw everything and followed the beat of life in photographs that would announce themselves as 'beautiful prose committed to black and white film': a direct quote from my lips hopefully to God's ears.

Heaven received a wonderful artist and chronicler of mankind's joys, sorrows, humour, love, and all the bloody rest of it. The most interesting thing came up as I looked through Leonard's work. I was amazed at how many photographers tried to copy his work – most of them doing it badly! He was the perfect exponent of true Zen photography by showing up everywhere and letting the photographs take him.

He was a beautiful man and brilliant at what he did. The question comes to the forefront: 'And what was that?' The correct answer would be: 'He came, he saw, and then proceeded to give the rest of us a front seat to life in all of the various forms that it must take.'

Eli Reed

Opposite
A fire hydrant opened during the summer heat.
Harlem, New York City, USA, 1963

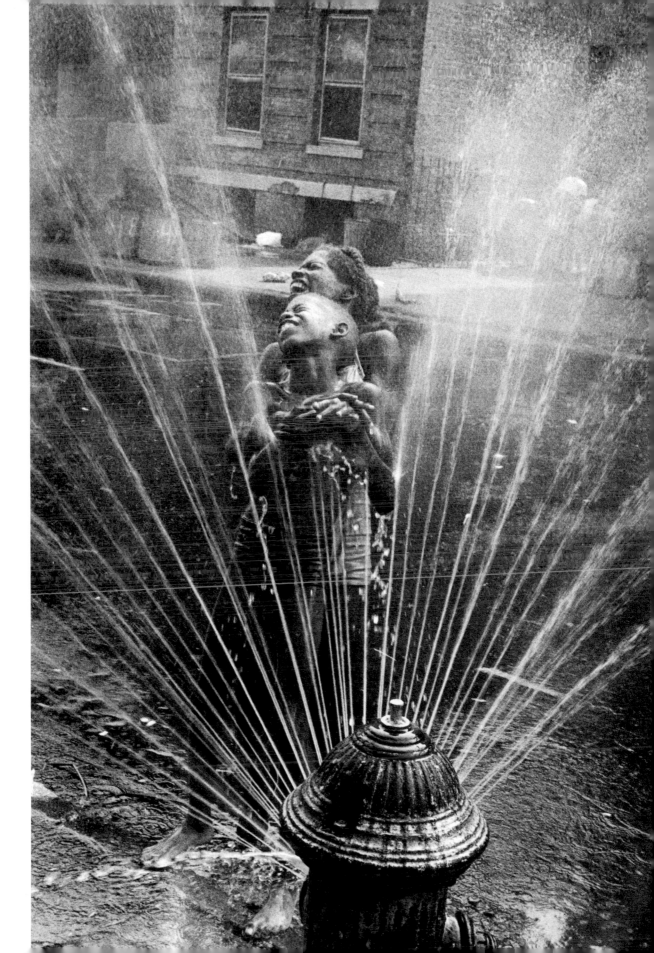

Family life. Düsseldorf, West Germany, 1965

gious Jews at home. Jerusalem, Israel, 1967

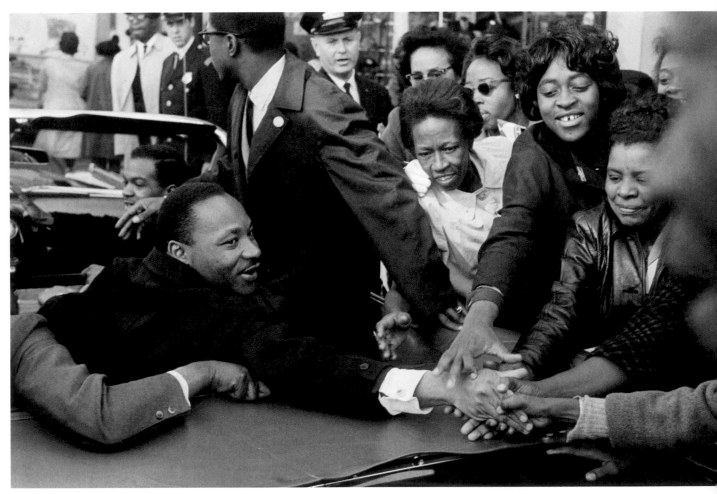

Martin Luther King on his return to the USA after receiving the
Nobel Peace Prize. Baltimore, USA, 1963

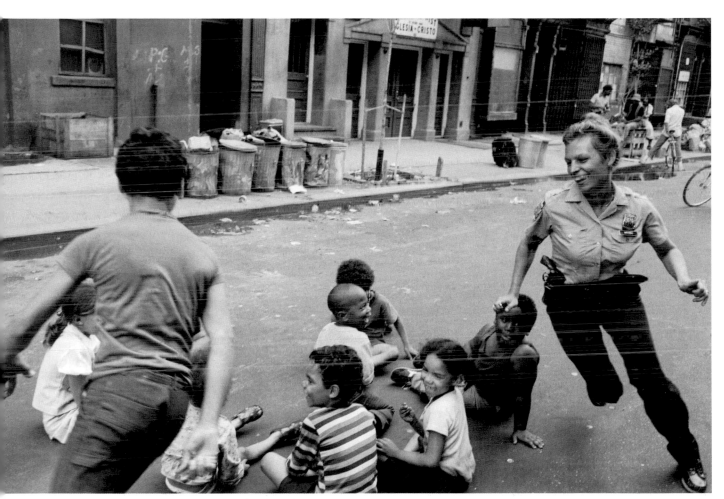

A policewoman playing with local children. Harlem, New York City, USA, 1978

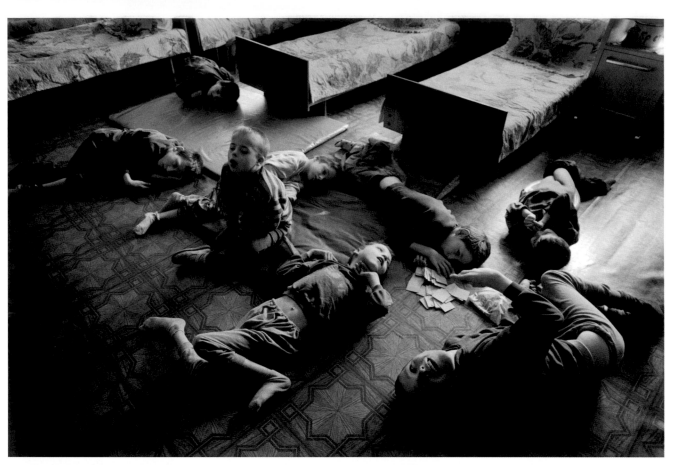

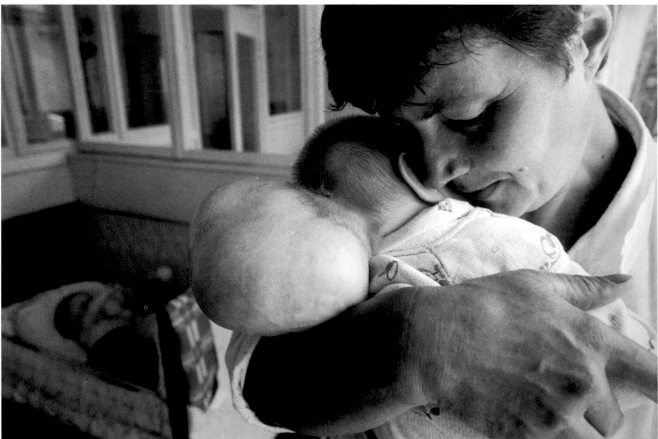

PAUL FUSCO

Paul Fusco was born in 1930 and is American. He worked as a photographer with the United States Army Signal Corps in Korea from 1951 to 1953, before studying photojournalism at Ohio University, where he received his Bachelor of Fine Arts degree in 1957. He moved to New York City and started his career as a staff photographer with *Look*, where he remained until 1971. In this role he produced important reportages on social issues in the US, including the plight of destitute miners in Kentucky; Latino ghetto life in New York City; cultural experimentation in California; African-American life in the Mississippi delta; religious proselytizing in the South; and migrant labourers. He also worked in England, Israel, Egypt, Japan, Southeast Asia, Brazil, Chile and Mexico, and made an extended study of the Iron Curtain countries, from northern Finland to Iran.

After *Look* closed down, Fusco approached Magnum Photos, becoming an associate in 1973 and a full member the following year. His photography has been published widely in major US magazines including *Time, Life, Newsweek,* the *New York Times Magazine, Mother Jones* and *Psychology Today*, as well as in other publications worldwide.

Fusco moved to Mill Valley, California, in the early 1980s to photograph the lives of the oppressed and of those with alternative lifestyles. Among his latest subjects are people living with AIDS in California, homelessness and the welfare system in New York, and the Zapatista uprising in the Mexican state of Chiapas. He has also worked on a long-term project documenting Belarussian children and adults sickened by radioactive fallout from the Chernobyl explosion. He is now based in New York City.

Opposite, top
Novinki Asylum. Minsk, Belarus, 1997

Opposite, bottom
Children's Home No. 1. Minsk, Belarus

When making a selection from Paul's photos one comes across a sensibility that is inherently American. For the purposes of this book Paul was also choosing some of my photographs. The first rushes of our respective choices that we showed to each other rapidly revealed the cultural differences that could exist between us, despite our similar approaches and personal sensitivities.

I wanted to pull six of his images away from their initial sense, cut them off from their origins, put them on an offbeat – to assemble them in a form used in some European films with open-ended bends, leading us off the beaten track, while showing the enigmatic and dreamlike relationships between them.

Paul isn't like this and he doesn't work in this spirit … I quickly came to the conclusion that taking him down that road would be cheating on him. He is the last person to whom I would dare do that, even if this sort of cheating, in the shuffling of the cards, could allow unexpected relationships to emerge.

Finally, without us having spoken to each other, Paul sent me something unexpected: photographs taken in Calcutta that he had never been able to show. (He is a specialist in this sort of thing: it took thirty years before we saw his photos taken from Bob Kennedy's funeral train.)

I know that Paul is a 'good person'. Throughout this exercise I have realized that behind his compassion there is something deeper and more complicated rumbling inside him, something that is fascinated and profoundly ill at ease.

So many of his photographic stories speak of dilapidated human bodies, of suffering, of wrecked lives and of death. When Paul sees and photographs the worst situations, as if to overcome the horror and stupor, he has an ethical and moral reflex that pushes him to have more than normal empathy with the people he is photographing. Paul wants desperately for there to be a strong relationship. He wants some hope. It is his way of negotiating with the absurd. He wants to render it acceptable.

Paul isn't a cynic, Paul isn't embittered, Paul is a human being.

Jean Gaumy

Opposite
A family watching as Robert Kennedy's funeral train passes by. USA, 1968

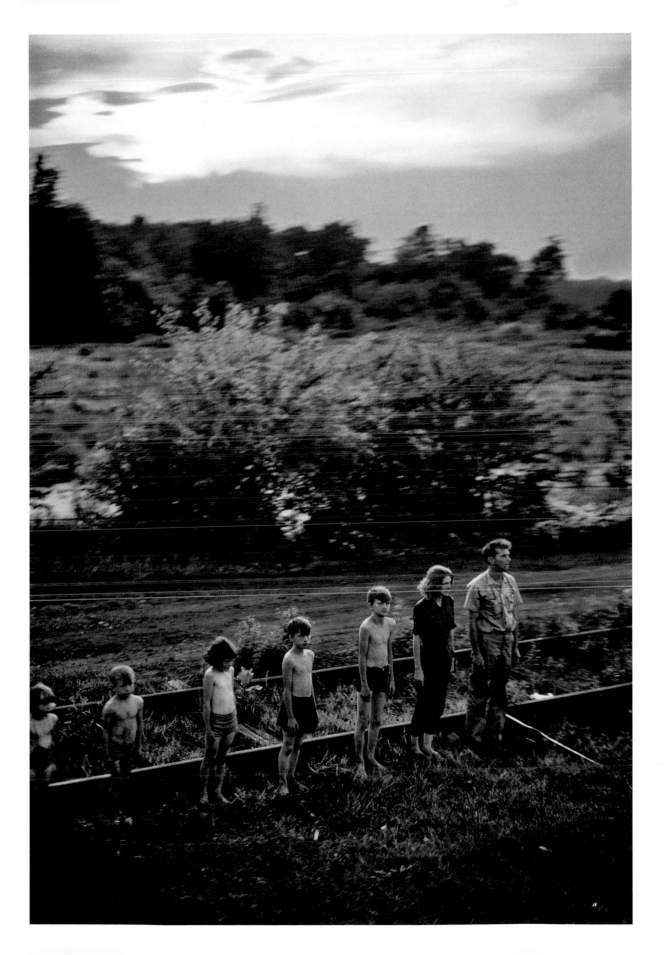

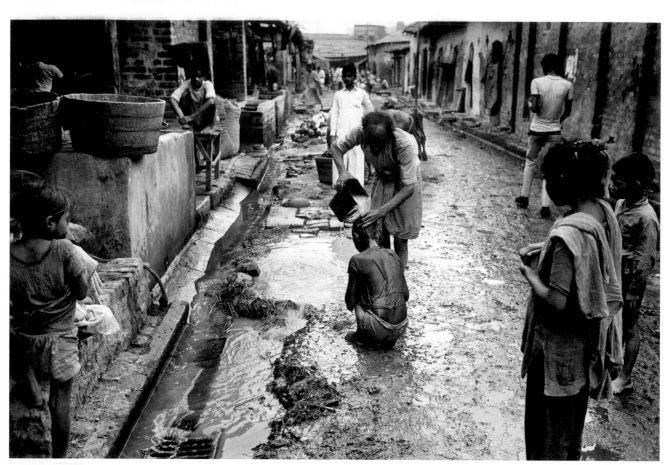

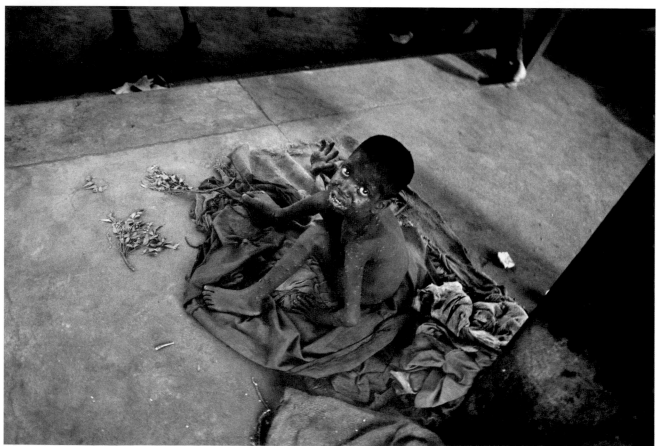

Opposite, top
Morning in Calcutta.

Opposite, bottom
Morning in Calcutta.

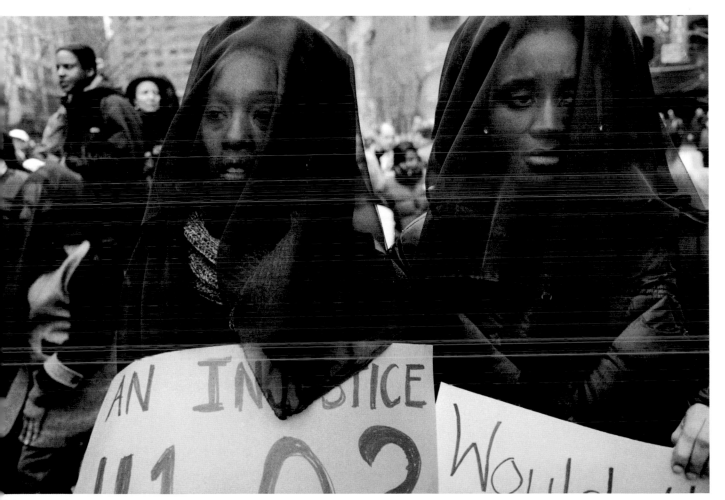

A demonstration by the group Women in Mourning and Outrage.
New York City, USA, 2000

Le Havre, France, 1984

JEAN GAUMY

Born in 1948 and raised in the southwest of France, Jean Gaumy began working as a writer and photographer for a local newspaper in Rouen while studying literature at university from 1969 to 1972. In 1973 he joined the Gamma photo agency and then, four years later, Magnum Photos.

In 1975 he was given permission to undertake an in-depth study of a French hospital, documenting the daily lives of doctors and patients. The result was a stark statement about the healthcare system. The following year he was the first photojournalist to be allowed inside a French prison; his work there resulted in a book in 1983: *Les Incarcérés* (*The Imprisoned*).

Gaumy completed numerous assignments in Europe, Africa, Central America and the Middle East. Between 1986 and 1994 he frequently visited Iran. His photograph of Iranian women during the Iran–Iraq War practising firing their weapons earned him international recognition.

Gaumy has often returned to his maritime roots. He sailed on fishing boats many times between 1984 and 1998. In 2001 he published *Le Livre des Tempêtes à Bord de l'Abeille Flandre* (*The Book of Storms on Board the 'Abeille Flandre'*). In the same year *Pleine Mer* (published in English as *Men at Sea*) appeared; this photographic overview of fourteen years spent studying the daily life of ships' crews, accompanied by excerpts from Gaumy's private diary, won the 2001 Nadar Award for the book of the year.

Since the 1980s Gaumy has written and directed several acclaimed, prize-winning documentary films. Most recently he spent four months under the sea in a nuclear submarine on a secret defence mission around the Arctic Ocean, making the first film of its kind; the project also resulted in a book, *Sous-Marin* (2006).

When I was asked to write about Jean, the first thing that came to mind was his great black and white photography. I asked him to suggest photos I might have missed, and he replied in his quiet voice: 'You might want to consider my colour – most people don't know me for that.'

I opened the file and the first photo I saw is the one you see here: 'Wow … look at that sea! Look at that wave … that man! *Call me Ishmael* … Jean, what is going on? What do you have in store for me – for us?'

We are suddenly in the grip of competing emotions, thoughts mixed with flashes of awe, trying to comprehend what is happening. Is this a suicide, a daredevil swimmer, a survivor of a shipwreck? Did he fall out of the sky, is this man confronting nature, is this man on a quest for immortality? Is it all of those?

One terrific photo and Jean's got me. He loves to dig deep into things we could never imagine for ourselves; for the men of the sea the struggle is unrelenting, the hold on life tenuous for everyone in the village. But ah, there is a victory, a fisherman is hoisting a tuna over his head – there is food.

I see a stark vista of the dark sea, a huge rock glistening ominously. I imagine the face of a giant stone-eating creature … or is it being choked with rock?

El Salvador, a mountain-top cemetery, cold rain. Three women wrapped in grief, bringing flowers in memory of their loved ones; three Muses attending to the final needs.

I would like to close with a few words Jean wrote to me: 'I hope so much this will please you. Everything is in: energy, beauty, but also the fragility of the life and man's responsibility (culpability too often) faced with the harmony of the world.'

Bon voyage, Jean.

Paul Fusco

Opposite, top
Saint-Pierre-et-Miquelon, Canada, 1979

Opposite, bottom
Grand Rivière. Martinique, 1979

Following pages
Grand Rivière. Martinique, 1979

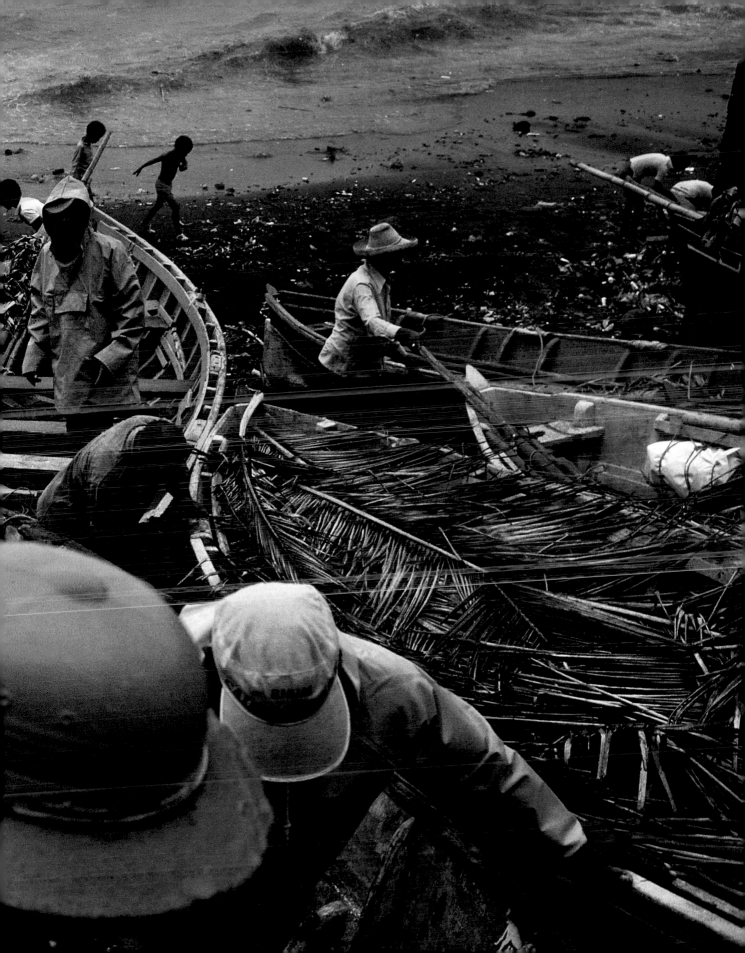

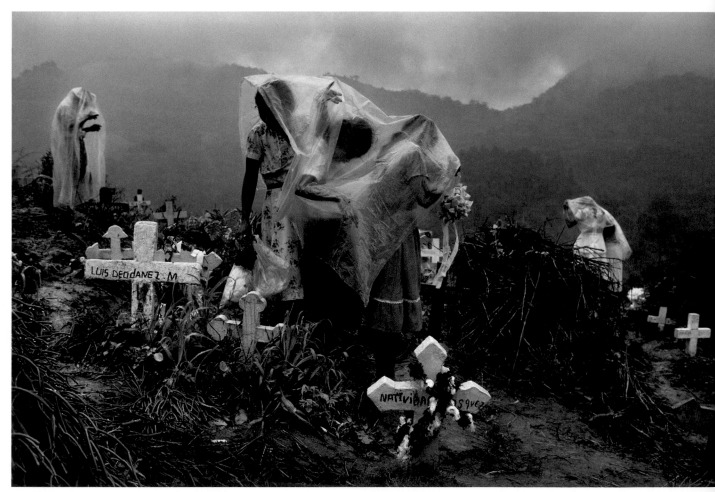

Celebrating the Day of the Dead. Panchimalco, El Salvador,
November 1985

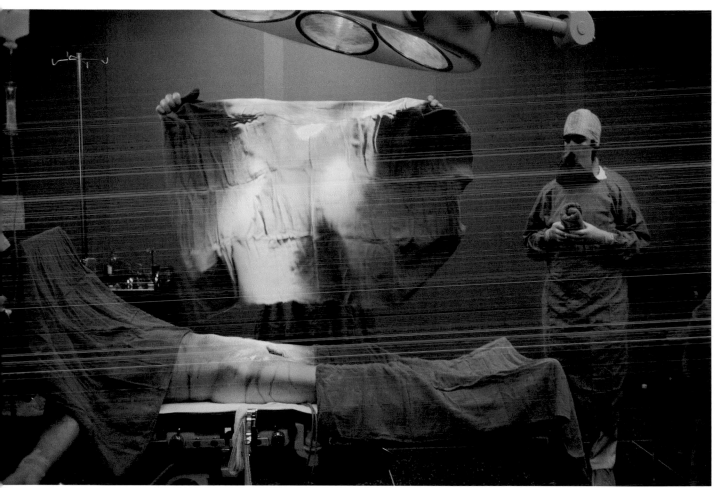

Hospital. Le Havre, France, 1975

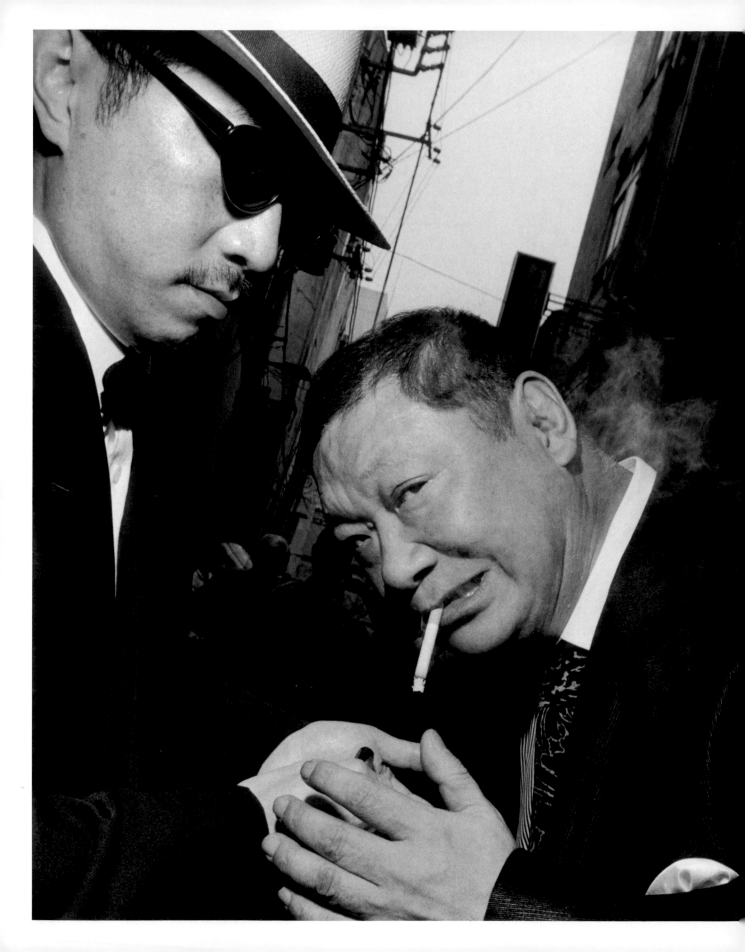

BRUCE GILDEN

Bruce Gilden was born in the US in 1946. His childhood in Brooklyn endowed him with a keen eye for observing urban behaviours and customs. He studied sociology, but his interest in photography grew when he saw Michelangelo Antonioni's film *Blow-Up*, after which he began taking night classes in photography at the New York School of Visual Arts.

Gilden's curiosity about strong characters and individual peculiarities has been present from the beginning of his career. His first major project, which he worked on until 1986, focused on Coney Island, and on the intimacy of the sensual, fat or skinny bodies sprawled across the legendary New York beach. During these early years Gilden also photographed in New Orleans during its famous Mardi Gras festival. Then, in 1984, he began to work in Haiti, following his fascination with voodoo places, rites and beliefs there; his book *Haiti* was published in 1996.

In June 1998 Gilden joined Magnum. He returned to his roots and tackled a new approach to urban spaces, specifically the streets of New York City, where he had been working since 1981. His work culminated in the publication of *Facing New York* (1992), and later *A Beautiful Catastrophe* (2005); getting ever closer to his subject, he established an expressive and theatrical style that presented the world as a vast comedy of manners.

His project *After the Off*, with text by the Irish writer Dermot Healey, explored rural Ireland and its craze for horseracing. Gilden's next book, *Go*, was a penetrating look at Japan's dark side. Images of the homeless and of Japan's mafia gangs easily bypassed the conventional visual clichés of Japanese culture.

Gilden, who has travelled and exhibited widely around the world, has received numerous awards, including the European Award for Photography, three National Endowment for the Arts fellowships, and a Japan Foundation fellowship. He lives in New York City.

Bruce Gilden is very much like his photographs. He is direct, loud and yet sophisticated and sharp. He is all-knowing and does not suffer fools gladly. In other words, he cuts through much of the bullshit that our lives are surrounded by. It is, of course, this directness that I enjoy about his images. They are highly charged and bursting with energy. They possess a very strong sense of design and the prints look quite stunning.

He is a master of street theatre. When we walk through the street, we see various people coming towards us; many are quite ordinary-looking. The members of Gilden's troupe seem to be in a pantomime; he makes them into characters from central casting. Where does he find these people? Well, the simple answer is that most of them are walking down Fifth Avenue in midtown New York, directly in the firing line of Gilden, his flash gun and wide-angled Leica.

Gilden is very New York indeed, and even when he travels to the likes of Tokyo he seems to find people there who could easily fit on an American sidewalk. That is why I have selected mainly the New York images. This is his home turf and his own auditorium, and his empathy with New York and its people comes through in the imagery.

Although all his best images are taken in the street – indeed, we can call them street photography – in fact I would say they are about something else entirely. Quite what this may be is part of the thrill and the mystery. But these characters are super-real, more real than in films, stranger than in fiction. They are part of Gildenland. He is the director of an ongoing movie in which people come and go, look the part and exit right, walking down the street.

Martin Parr

Opposite
New York City, USA, 1984

Following pages
New York City, USA, 1984

Page 202
New York City, USA, 1988

Page 203
Fifth Avenue. New York City, USA, 1989

Pages 204–5
Fifth Avenue. New York City, USA, 1984

BURT GLINN

Born in 1925 in Pittsburgh, Pennsylvania, Burt Glinn served in the United States Army between 1943 and 1946, before studying literature at Harvard University, where he edited and photographed for the *Harvard Crimson* college newspaper. From 1949 to 1950, Glinn worked for *Life* magazine before becoming a free-lancer.

Glinn became an associate member of Magnum in 1951, along with Eve Arnold and Dennis Stock – the first Americans to join the young photo agency – and a full member in 1954. He made his mark with spectacular colour series on the South Seas, Japan, Russia, Mexico and California. In 1959 he received the Mathew Brady Award for Magazine Photographer of the Year from the University of Missouri.

In collaboration with the writer Laurens van der Post, Glinn published *A Portrait of All the Russias* and *A Portrait of Japan*. His reportages appeared in *Esquire, Geo, Travel and Leisure, Fortune, Life* and *Paris-Match*. He covered the Sinai War, the US Marine invasion of Lebanon, and Fidel Castro's takeover of Cuba. In the 1990s he completed an extensive photo essay on the topic of medical science.

Versatile and technically brilliant, Glinn was one of Magnum's great corporate and advertising photographers, receiving numerous awards for his editorial and commercial photography, including the Best Book of Photographic Reporting from Abroad from the Overseas Press Club and the Best Print Ad of the Year from the Art Directors Club of New York. Glinn served as president of the American Society of Media Photographers. He was president of Magnum between 1972 and 1975, and was re-elected to the post in 1987.

Burt Glinn died in New York on 9 April 2008.

Burt Glinn was for me the embodiment of elegance – both personally and photographically. Always faultlessly dressed, he was in his element on elegant evenings in London or New York, but he was equally at home under an African tree with a beautiful girl. His photography reflects that personal elegance, both in his dealings with people and in his technical skills. His pictures of Japan and Africa show a quality that you seldom see repeated elsewhere, although it has been endlessly imitated.

In exactly the same way – in his life as in all his work – his photographs for annual company reports display characteristic sensitivity and elegance, creating a new style of clear outlines and outstanding composition. As president of Magnum and of the American Society of Media Photographers, his actions on behalf of his colleagues, and his constant striving for quality and decency, were pursued in equal measure with exemplary professional skill.

Only a tiny sample from the enormous variety and breadth of his work can be shown here and I hope that a big retrospective will give a true overview of one of the great photographers of our time.

Erich Lessing

Opposite
The Soviet leader Nikita Khrushchev in front of the Lincoln Memorial, Washington, D.C., USA, 1959

A boy crossing a dam near Guilin city. China, 1981

A runner in Central Park in the snow. New York City, USA, 1991

Following pages
Left
Monks from Mount Sichimen monastery in early morning
contemplation of Mount Fuji. Japan, 1961

Right
The IBM laboratory complex, San Jose, California. USA, 1979

JIM GOLDBERG

Jim Goldberg was born in 1953 and is American. A Member of Magnum Photos since 2006, he is also a Professor of Art at the California College of Arts and Crafts. He has been exhibiting for over twenty-five years and his innovative use of image and text make him a landmark photographer of our times.

He began to explore experimental storytelling and the potentials of combining image and text with *Rich and Poor* (1977–85), in which he juxtaposed the residents of welfare hotel rooms with the upper class and their elegantly furnished home interiors to investigate the nature of American myths about class, power and happiness. In *Raised by Wolves* (1985–95) he worked closely with runaway teenagers in San Francisco and Los Angeles to create a book and exhibition that combined original photographs, text, home movie stills, snapshots, drawings and diary entries, as well as single- and multi-channel video, sculpture, found objects, light boxes and other 3-D elements.

He is currently working on two new book projects – one a fictional autobiography, and the other on migration and trafficking in Europe. He is represented by Pace/MacGill Gallery in New York and the Stephen Wirtz Gallery in San Francisco. He lives and works in San Francisco.

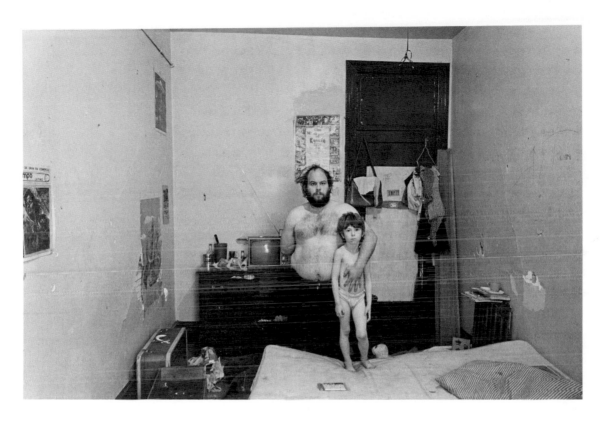

I LOVE DAVID. BUT HE IS TO
fragile for A Rough FATHER LIKE
ME

Larry J Benka

One long wall of Jim's studio is covered with pictures. There are snapshots and Polaroids, in black and white and colour; their borders overlap, their order is in flux. The work is there to look at, to interact with. It is pinned up so that he can play with the pictures to make sense of them and tell us a story.

Focusing on those who are largely invisible, by choice or by circumstance, Jim pushes beyond social stereotypes and against the walls of traditional documentary. In his early work, *Rich and Poor*, he entered the enclosed personal space of a stranger and initiated a collaboration. Each of those rooms revealed characters in their own play, with a script they wrote for Jim. In his pictures, they speak out and shape how we perceive their lives.

In *Raised by Wolves*, intimacy is created on a public street with teenage runaways whose lives are traced through disparate materials; maps, contacts, objects and scrawled notes, all stitched together with Jim's images, which capture the fragmentation of their lives. Jim is at his best when he mixes mediums, inventing unique narratives by collaging multiple frames and layers that both enhance and counter each other.

In contrast to those encounters, Jim does not flinch from making a photograph at the moment of his father's death, or from looking intensely and yet abstractly at a pile of his father's last whiskers. I most admire his boldness in registering a highly charged and profoundly private subject, not retreating from the moment. When faced with my own mother's death, despite holding a camera in my hand, I was unable to make an image at her last breath.

Jim's work moves from the intuitive and the lyrical, as with the figure in front of a curtain, to a more confrontational construction, with the portrait of an anonymous Moldavian girl, a victim of sex trafficking. Unlike many photographers, Jim gives his subjects a distinctive presence. Sometimes, they contextualize his images with their own markings and words. At other times, they stare out at him to engage us. But Jim is always the catalyst, inviting us into relationships we can otherwise only imagine, drawing us out of our own more comfortable lives.

Susan Meiselas

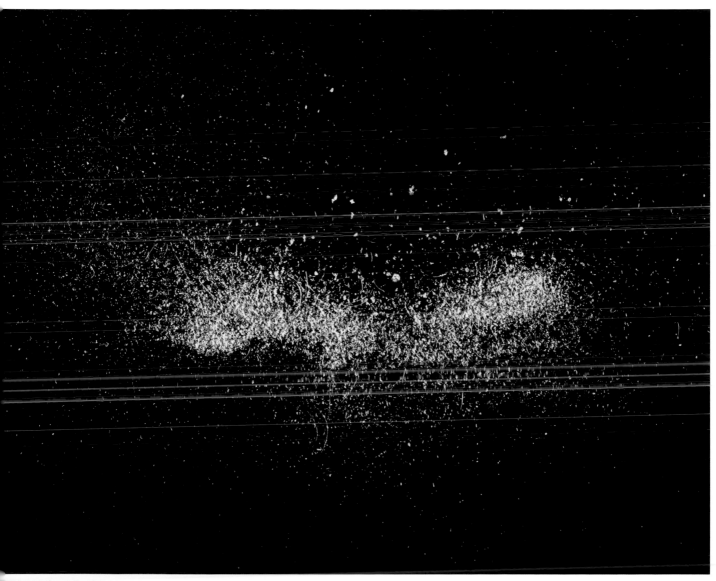

'Dad's Last Shave'. Florida/San Francisco, USA,
1993/1994

Following pages
left
'7:41 a.m.' Palm Harbor, Florida, USA, 1993

right
'The Last Look'. Tuscany, Italy, 2000

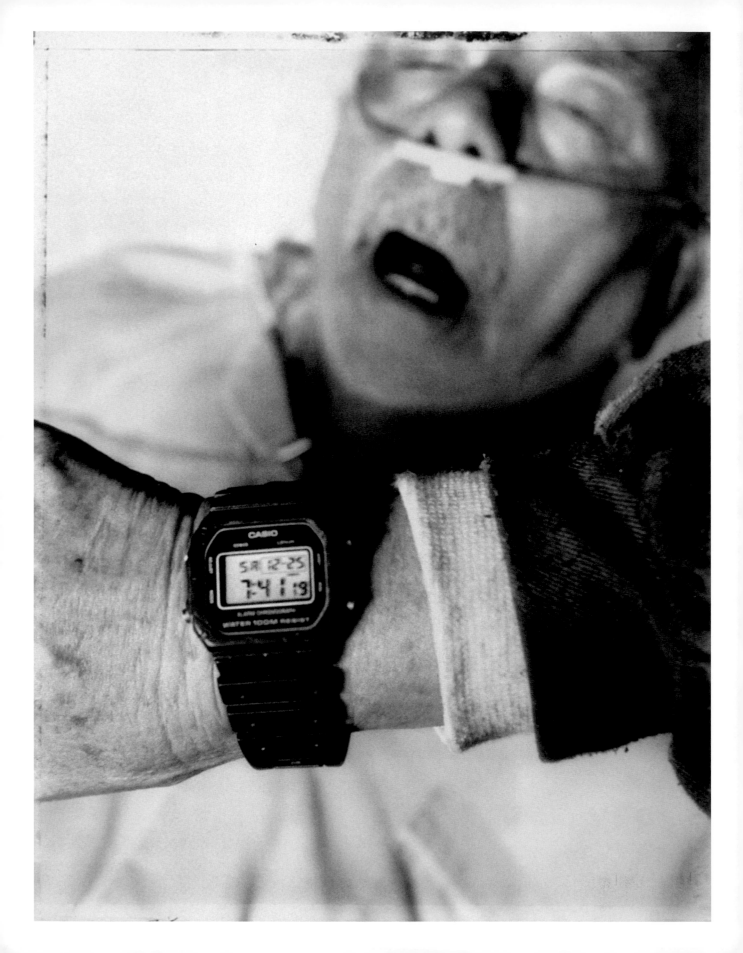

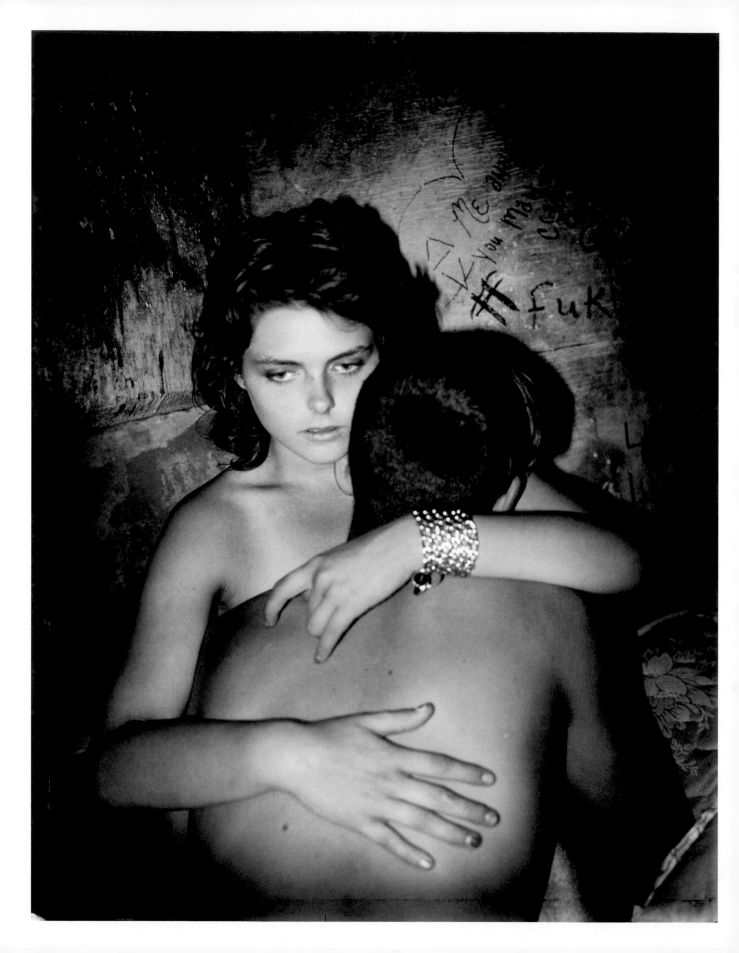

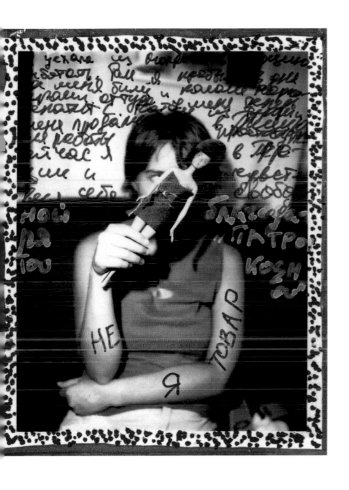

I left MOLDAVIA for
~~t$$A~~ TURKEY I 14 yrs
- ~~with~~
PROMISE ~~work~~ I
STAYED 3 DAYS and
BEATEN UP AND DRUGGED
AND THEY GIVE ME HEPC
THEY SOLD ME TO
GREECE MAN FOR SEX
FOR MONEY - NOW I AM
IN GREECE AND I FREE
THANKS TO GOOD
PEOPLE
I NO FOR SALE ANY MORE

A 14-year-old girl trafficked from Moldavia.
Athens, Greece, 2004

Opposite
'Destiny's Shiny Bracelet'. Hollywood, USA, 1989

Jim Goldberg 221

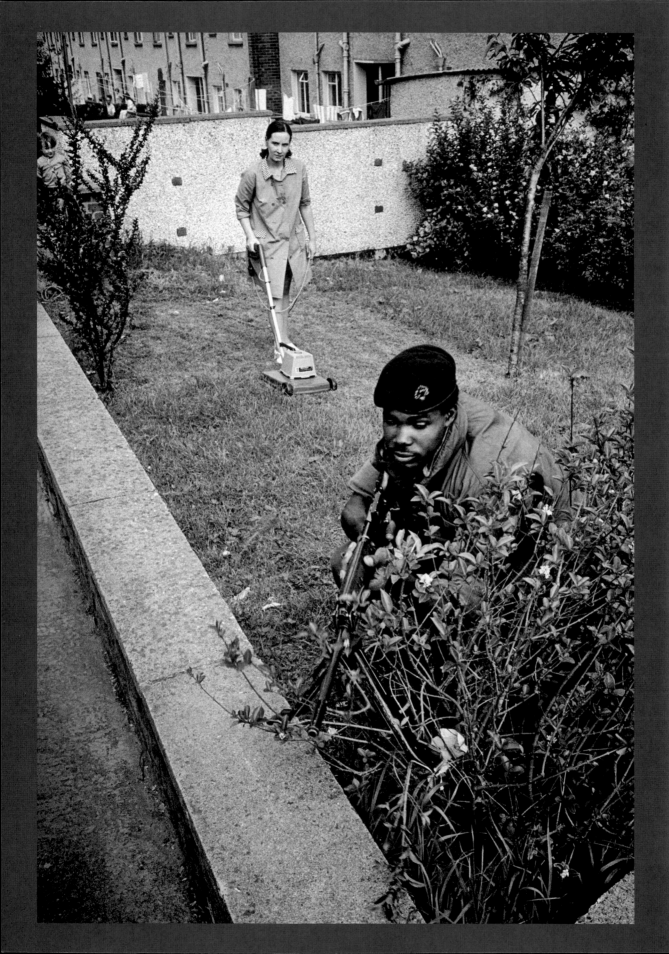

PHILIP JONES GRIFFITHS

Born in 1936 in Rhuddlan, Wales, Philip Jones Griffiths studied pharmacy in Liverpool and worked in London while photographing part-time for the *Manchester Guardian*. In 1961 he became a full-time freelancer for the London-based *Observer*. He covered the Algerian War in 1962, then moved to Central Africa. From there he moved to Asia, photographing in Vietnam from 1966 to 1971.

His book on the war, *Vietnam Inc.* (1971), crystallized public opinion and gave form to Western misgivings about American involvement in Vietnam. One of the most detailed surveys of any conflict, *Vietnam Inc.* is also an in-depth document of Vietnamese culture under attack.

An associate member of Magnum since 1966, Griffiths became a member in 1971. In 1973 he covered the Yom Kippur War and then worked in Cambodia between 1973 and 1975. In 1977 he covered Asia from his base in Thailand. In 1980 Griffiths moved to New York to assume the presidency of Magnum, a post he held for a record five years.

Griffiths's assignments, often self-engineered, took him to more than 120 countries. He worked for *Life* and *Geo* on stories such as Buddhism in Cambodia, droughts in India, poverty in Texas, the re-greening of Vietnam, and the legacy of the Gulf War in Kuwait.

A key theme of Griffiths's work is the unequal relationship between technology and humanity, summed up in his book *Dark Odyssey* (1996). Human foolishness always attracted his eye, but, faithful to the ethics of the Magnum founders, he believed passionately in human dignity and in the capacity for improvement.

Philip Jones Griffiths died in London on 18 March 2008.

I knew Philip for what seems like a hundred years. We first met in Cologne at what proved to be a dismal attempt to form some sort of Europe-wide collaboration of photojournalists.

We became friends, and some time later when I moved from Paris to London in a parlous financial state and with a pregnant wife, he offered to let us share his London flat. Such generosity was only offset by a refusal to let me use the bathroom when his films were hanging up to dry!

I got to know the man with an insatiable desire for chocolate digestive biscuits and a need to devour every newspaper for story ideas. Indeed, one had to negotiate a veritable maze of metre-high papers to traverse the flat.

I came to know a little of his youth when he spoke of a village friend in Wales with access to the local armoury. Philip was able to borrow a variety of weapons and decimate the local rabbit population with a machine gun! Perhaps this was the root of his subsequent hatred of violence and all things military?

He worked for *The Observer* and being an ex-pharmacist he had a great knowledge and background in all things photographic and technical. Indeed, I always depended on his passing on to me his expertise.

I was a young Magnum photographer and Philip decided that Magnum was the way for him to go too. Having become an associate, his decision to go to Vietnam was determined. Little did I realize that this would involve a five-year sojourn there and culminate in what is without doubt the finest – the definitive – photographic anti-war book of all time.

While dozens of photographers, including myself, made brief trips to Vietnam, almost no other stayed the course, risking the danger and hostility from all sides in the conflict, to produce not only a political but also a visual tour de force of unsurpassed power.

In choosing the pictures for this project I was faced with hundreds of great photographs shot around the world employing the combination of form and content for which he is famous. I thought that an ironic theme for a war-hating pacifist would be the very subject that brought Philip fame, the gun.

I have therefore chosen iconic images from *Vietnam Inc.*, one from Grenada to show that his passion never faded, and a Northern Ireland picture which for me illustrates not only the idiocy of political conflict but also Philip's incisive wit.

Ian Berry

Opposite
When American forces invaded Grenada they met with token resistance from a handful of defenders. The 6,000 elite troops were awarded 8,700 medals for valour and President Reagan declared that, thanks to them, America was again 'standing tall'. Grenada, 1983

Following pages
A civilian wounded by plastic fragments sprayed b a rocket fired from a US helicopter. Saigon, Vietnam, 1968

Pages 228–229
While destroying a village near Chu Lai on the Bantangan Peninsula, soldiers of Task Force Oregon chat up a local girl: for the Vietnamese smiling is the first line of defence against the enemy. Central South Vietnam, 1967

Pages 230–231
A soldier of the US 9th Division under fire during the battle for Saigon. Seconds later the house was demolished by a rocket. Vietnam, 1968

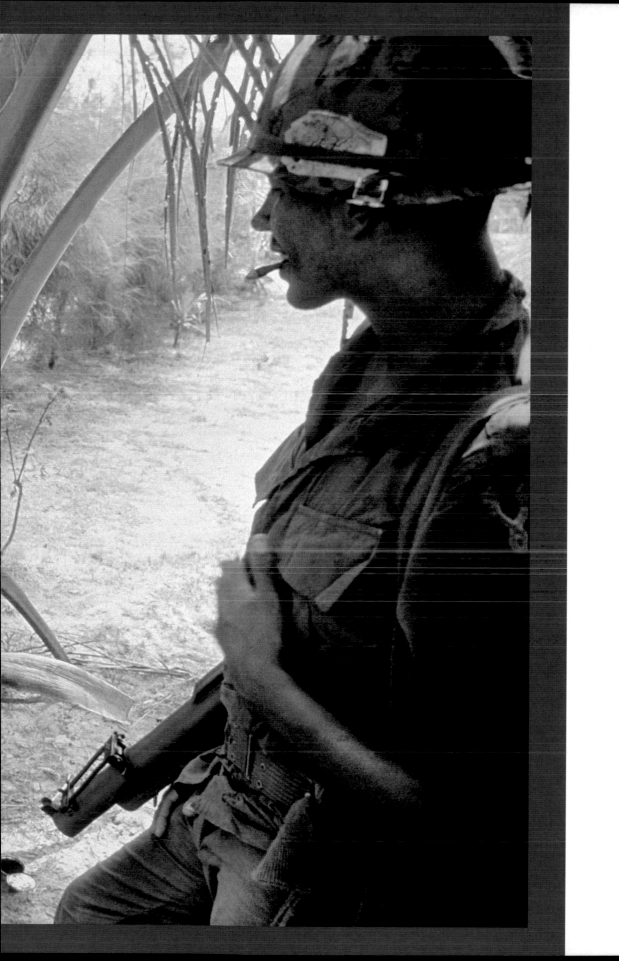

HARRY GRUYAERT

For more than thirty years, from Belgium to Morocco, and from India to Egypt, Harry Gruyaert has been recording the subtle chromatic vibrations of Eastern and Western light.

Gruyaert was born in 1941 and studied at the School for Photo and Cinema in Brussels from 1959 to 1962. He then began freelance fashion and advertising work in Paris, while working as a director of photography for Flemish television.

In 1969 Gruyaert made the first of many trips to Morocco. His total immersion in its colours and landscapes won him the Kodak Prize in 1976 and culminated in the publication of the book *Morocco* in 1990. He travelled to India for the first time in 1976 and to Egypt in 1987. Far from indulging in stereotypical exoticism, Gruyaert has a vision of faraway countries that locates the viewer within peculiar and somewhat impenetrable atmospheres.

In a different sphere he covered the Olympic Games in Munich in 1972. In the same year he photographed some of the first Apollo flights as they were shown on a crazy television set. This project, which exploits the colours of the screen, appeared under the title 'TV Shots' in *Zoom*. It was shown at the Delpire Gallery in 1974 and at Phillips de Pury & Co. in New York.

Gruyaert joined Magnum Photos in 1981. His book *Made in Belgium* was published in 2000, *Rivages*, a collection of portraits of shores around the world, in 2003, *Photopoche* in 2006, and *TV Shots* in 2007.

In his later work Gruyaert has abandoned the Cibachrome process in favour of digital print. Better suited to revealing the rich shades found in his films, digital print opens new possibilities for his work, bringing it one step closer to his original intention, namely to give colour the means to assert its true existence.

Harry is a friend of mine. The first time we met, at Magnum's Paris office, he showed me some photos he had just taken in the streets.

I already knew his work on Belgium, Morocco and the United States, but I was struck by his view of the French capital; there was something hard, but also realistic about it, a city that didn't want to let itself be seen in colour like this.

It was the opposite of those clichés on historic Paris or the reassuring humanism of the photographers of the 1950s. He told me that someone had even suggested he stop taking photographs of Paris … too many garish colours, too much solitude.

For me at the time, taking colour pictures in the street was still some way off, but I kept these images in my head for a long time. I had already made several documentaries about the police and political institutions. I knew that the aim of Harry Gruyaert's photographs was true – uncannily true.

Raymond Depardon

Street scene. Paris, France, 1980

Restaurant. Paris, France, 1981

Boulevard de Magenta. Paris, France, 1979

Café, waiter and customer. Paris, France, 1978

Street vendor. Paris, France, 1978

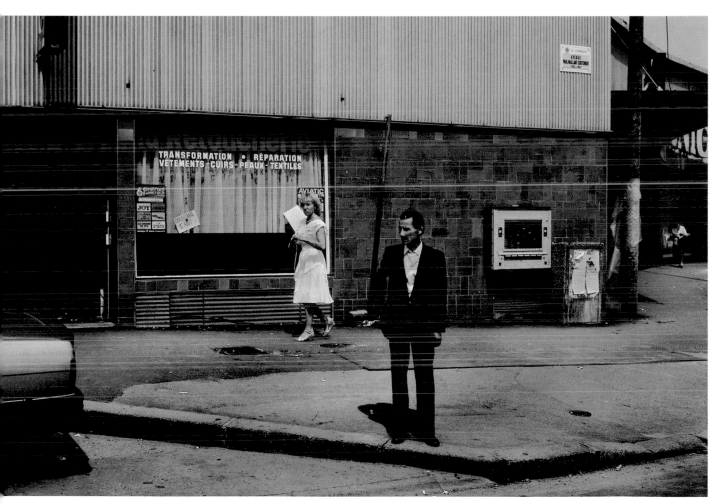

Street scene. Paris, France, 1982

PHILIPPE HALSMAN

Philippe Halsman was born in Riga in 1906, and began to take photographs in Paris in the 1930s. He opened a portrait studio in Montparnasse in 1934, where he photographed André Gide, Marc Chagall, André Malraux, Le Corbusier and other writers and artists, using an innovative twin-lens reflex camera that he had designed himself. He arrived in the United States in 1940, just after the fall of France, having obtained an emergency visa through the intervention of Albert Einstein.

In the course of his prolific career in America, Halsman produced reportage and covers for most major American magazines, including a record 101 covers for *Life* magazine. His assignments brought him face-to-face with many of the century's leading personalities.

In 1945 he was elected the first president of the American Society of Magazine Photographers, where he led the fight for photographers' creative and professional rights. His work soon won international recognition, and in 1951 he was invited by the founders of Magnum Photos to join the organization as a 'contributing member', so that they could syndicate his work outside the United States. This arrangement still stands.

Halsman began a thirty-seven-year collaboration with Salvador Dalí in 1941 which resulted in a stream of unusual 'photographs of ideas', including 'Dalí Atomicus' and the 'Dalí's Mustache' series. In the early 1950s, Halsman began to ask his subjects to jump for his camera at the conclusion of each sitting. These uniquely witty and energetic images have become an important part of his photographic legacy.

Philippe Halsman died in New York City on 25 June 1979.

Philippe Halsman was a highly successful portrait photographer. In the ordinary course of events it is not easy to get a picture onto the cover of a magazine more than a handful of times. Halsman's pictures appeared on 101 covers of *Life* magazine. The portraits of Alfred Hitchcock and Albert Einstein are examples of his consummate skill: they are engaging and enduring images that have become, through their usage (for example, on magazine covers and as postage stamps), iconic.

Few photographers working in the 1950s, aside from Halsman, had quite understood the surrealistic or strange potential of flash photography. The surrealistic moment is experienced through the illusion of freezing movement. The more complex the movement, the more the surrealistic the effect, which is no doubt why Salvador Dalí was so keen to collaborate with Halsman to create the 'portraits' on pages 244 and 247.

What Halsman does is play on two different kinds of photographic document: that which replicates the way we habitually see and experience events and that which is uniquely a photographic document akin to extreme macro-photography, X-ray imagery or satellite imagery of Earth. The 'Jump portraits' series further explores the dualism, on the one hand by bending truth with the illusion of stopping motion, but on the other hand seeking a greater truth from the jumper: 'In a jump, the subject, in a sudden burst of energy, overcomes gravity. He cannot simultaneously control his expressions, his facial and limb muscles. The mask falls. The real self becomes visible.'

Martin Parr, who participated in this selection, adds: 'I could not resist including the wonderful image of Edward Steichen jumping. Attired in his suit, and looking rather formal and stiff, it is a testament to Halsman's powers of persuasion that he was able to photograph him in the air. Halsman's legacy was his catalogue of portraits, but I also want to suggest that charm and inventiveness were an integral part of this, and the reason why so many of these portraits were so successful.'

Stuart Franklin

'Dalí Atomicus'. New York City, USA, 1948

Opposite
Mae West. Hollywood, California, 1969

Philippe Halsman 245

Southwestern France, 1979

ERICH HARTMANN

Born in Munich in 1922, Erich Hartmann was 16 years old when he went with his family in 1938 to Albany, New York, as a refugee from Nazi Germany. The only English speaker in the family, he worked in a textile mill, attending evening high school and later taking night courses at Siena College. He enlisted in the US Army, serving in England, France, Belgium and Germany. At the end of the war he moved to New York City, where he worked as an assistant to a portrait photographer and then as a freelancer.

Hartmann first became known to the wider public through his work for *Fortune* magazine in the 1950s. His poetic approach to science, industry and architecture shone through the photo essays 'Shapes of Sound', 'The Building of Saint Lawrence Seaway' and 'The Deep North'. He later did similar essays on the poetics of science and technology for French, German and American *Geo* and other magazines. Invited to join Magnum in 1952, he was for many years on the board of directors, becoming president in 1985.

Throughout his career, he pursued many long-term personal projects, and photographic interpretations with literary echoes: Shakespeare's England, Joyce's Dublin, Thomas Hardy's Wessex. He also explored abstract representations of ink-drops in water, patterns of laser light, and the beauty of tiny components of technology. In his later years he photographed the remains of the Nazi concentration camps, resulting in a book and exhibition, *In the Camps*. At the time of his death he was engaged in a photo project he called 'Music Everywhere.'

Erich Hartmann died in New York City on 4 February 1999.

Erich Hartmann was a gentle man. I met him first in 1978, during my stint as Director of Photography of the American edition of *Geo* magazine. He came to my office on New York's Park Avenue in a grey suit, tie-less, but very correctly dressed – unlike most photographers in jeans, T-shirt or parka, with their loud voices and boisterous manners.

Not Erich. He was low-key, polite, with a shy smile and an amused twinkle in his eyes. But when he showed his pictures, it became clear that he knew exactly what he was doing and why he was doing it. I was also charmed by the subtle humour in many of his best images, which he had snatched from daily life, far beyond turmoil and sensations. He had great clarity and convincing arguments but was always ready to listen. He showed me fascinating colour pictures of minuscule industrial objects, things he had found in electronics labs and factories. I asked Erich to go back and produce a full colour essay for *Geo*, which we published to great acclaim.

Soon we discovered that we had both been born in Munich – Erich fourteen years earlier than I. Even though Erich and his Jewish parents, brother and sister had fled Germany in 1938, when he was 16, he still spoke a very precise German, with just a touch of a Bavarian accent. Erich was well organized, reliable, thoughtful, cultured, well read and he loved music. All these traits, considered to be traditional German values, had become second nature to many German–Jewish families and were preserved even in life-long exile. Ironically, at the same time, most members of the self-anointed 'German master race' had trampled on these ideals and had developed a xenophobic, perverted and murderous state of mind. This contradiction must have haunted Erich all his life, so he finally decided to deal with his worst nightmares by photographing them. His book *In the Camps* was published in 1995, four years before his death. Erich and his wife Ruth had travelled to twenty-two former Nazi concentration camps, photographing the remnants of unspeakable horror, mostly in a grey winter light and with unflinching precision. A monumental and important book by an immortal photographer.

Thomas Hoepker

aris, France, 1982

A Gestapo court room in the death bunker at Auschwitz
concentration camp. Oswiecim, Poland, 1994

Opposite
Barbed wire fencing at the Majdanek concentration camp.
Lublin, Poland, 1994

Pemaquid Point, Maine, USA, 1960

Opposite
Pau, France, 1979

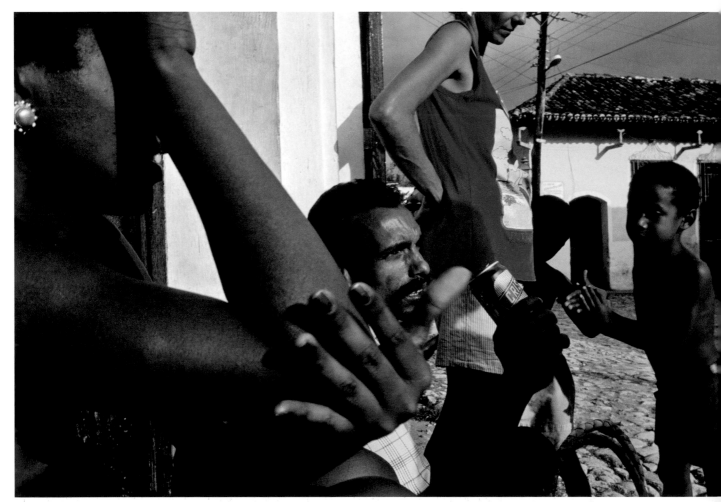

A group of friends gather in a doorway in the late afternoon.
Trinidad, Cuba, 1998

DAVID ALAN HARVEY

Born in San Francisco in 1944, David Alan Harvey was raised in Virginia. He discovered photography at the age of 11. Harvey purchased a used Leica with savings from his newspaper route and began photographing his family and neighbourhood in 1956.

When he was 20 he lived with and documented the lives of a black family living in Norfolk, Virginia, and the resulting book, *Tell It Like It Is*, was published in 1966. He was named Magazine Photographer of the Year by the National Press Photographers Association in 1978.

Harvey went on to shoot over forty essays for *National Geographic* magazine. He has covered stories around the world, including projects on French teenagers, the Berlin Wall, Maya culture, Vietnam, Native Americans, Mexico and Naples, and a recent feature on Nairobi. He has published two major books, *Cuba* and *Divided Soul*, based on his extensive work on the Spanish cultural migration into the Americas, and his book *Living Proof* (2007) deals with hip-hop culture. His work has been exhibited at the Corcoran Gallery of Art, the Nikon Gallery, the Museum of Modern Art in New York, and the Virginia Museum of Fine Arts. Workshops and seminars are an important part of his life, and Harvey currently writes a very popular online magazine–blog for emerging photographers.

Harvey joined Magnum as a nominee in 1993 and became a full member in 1997. He lives in New York City.

What fascinates me most about David is that while he takes his photographs very seriously, he doesn't take himself too seriously. He doesn't have a big ego at all, and I like him for that.

I first met him during the Magnum AGM of 1993. I was an associate then and could not be inside while the full members were voting on who to take as nominees. My work was not being discussed that year, so I was having a relaxed smoke outside. That is when I met David, who had submitted his portfolio in order to become a nominee.

We stood in the corridor, and I remember how much I liked the way he dealt with waiting to hear what they made of his portfolio. David was by then around 50 years old and an established photographer, and yet he reminded me of a teenager waiting to hear the results of his final exams. This openness made him vulnerable and extremely sympathetic to me. I remember thinking, 'I want this teenager to become my friend and colleague in Magnum.'

Later I saw his work. What I really like in photography is the possibility for it to exceed what it describes, when somehow a photograph becomes more than the subject itself, while at the same time expressing the obsessions of its creator. This makes a photograph very personal and full of emotion. Very often David succeeds in doing just that, despite being from the *National Geographic* school. This attitude is not always seen as positive as it does not prettify its subject or try to express an objective truth.

A special characteristic of David is his love for the South: the beautiful women, the *mojitos*, the balmy nights and the capacity to lie back and relax, without a trace of misery.

Sometimes I am jealous of you, cowboy!

Nikos Economopoulos

Opposite, top
A young boy standing on a street corner.
Trinidad, Cuba, 1998

Opposite, bottom
Street scene. Chile, 1990

Following pages
San Pedro de Atacama, Chile, 1987

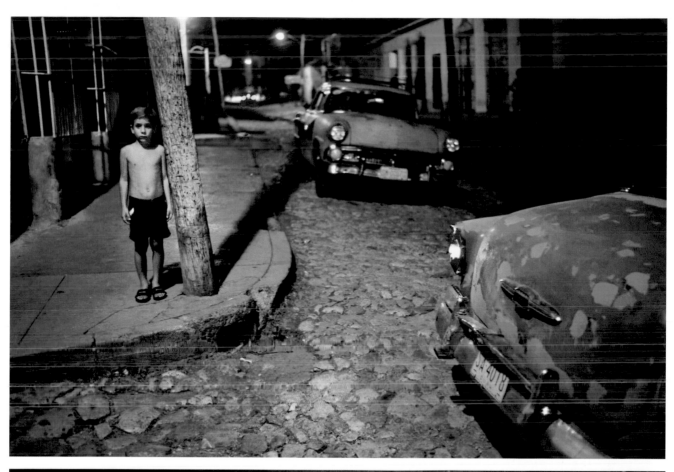

Easter. Yucatan, Mexico, 1975

market. Oaxaca City, Mexico, 1992

THOMAS HOEPKER

Thomas Hoepker was born in Germany in 1936. He studied art history and archaeology, then worked as a photographer for *Münchner Illustrierte* and *Kristall* between 1960 and 1963, reporting from all over the world. He joined *Stern* magazine as a photo-reporter in 1964.

Magnum began to distribute Hoepker's archive photographs in 1964. He worked as cameraman and producer of documentary films for German television in 1972, and from 1974 collaborated with his wife, the journalist Eva Windmoeller, first in East Germany and then in New York, where they moved to work as correspondents for *Stern* in 1976. From 1978 to 1981 Hoepker was director of photography for the American edition of *Geo*.

Hoepker worked as art director for *Stern* in Hamburg between 1987 and 1989, when he became a full member of Magnum. Specializing in reportage and stylish colour features, he received the prestigious Kulturpreis of the Deutsche Gesellschaft für Photographie in 1968. Among many other awards for his work, he received one in 1999 from the German Ministry of Foreign Aid for *Death in a Cornfield*, a TV film on Guatemala. Today Hoepker lives in New York. He shoots and produces TV documentaries together with his second wife Christine Kruchen. He was president of Magnum Photos from 2003 to 2006. A retrospective exhibition, showing 230 images from fifty years of work, toured Germany and other parts of Europe in 2007.

Opposite
A veiled woman at the Wild Wadi Water Park near Jumeira beach,
Dubai. United Arab Emirates, 2006

When I look at Thomas's photographs I strongly feel the presence of someone who has brought me into his world, a friend guiding me. I feel the compassion and empathy of this strong and gentle man who has travelled through much of the world to revel in the discovery, understanding and photographing of life with a vision that is broad and encompassing.

Thomas can capture and reveal the essence of the natural world, with reverence for its striking beauty, mystery and awesome power: water, rocks, sand, ice, mountains, seas, clouds, space, light … all seem to reveal their complex mysteries, to perform for his camera.

He shows the desires, yearnings, fears, triumphs, loves and fantasies of the human being. He is a master of the 'language' of photography and uses it with the insight of a Renaissance painter. His pictures compel us to evaluate life that he has come upon in his wanderings, and preserve it for all to see, feel and ponder.

The Best: a young Muslim woman, of great beauty and grace, splashing in a pool with children, at the intersection of conflicting worlds.

The Worst: 9/11 NYC, the fury that seared a city and the hearts of a nation.

Mother Love: Guatemala, mother and baby with a burden of wood, resolute in her determination to care for her family.

The Power of Faith: the Guatemalan Maya struggling to revive and restore their ancient religion and culture.

The Intrepid: Egypt, a tourist group on camels, poised to strike out across the trackless desert.

Horror: famine in India, so utterly severe that a whole village of afflicted scrambles towards one vehicle in desperate futility.

Thomas has seen much, cared much, loved much. He throws a great long swath of life before us.

We are overwhelmed, we are disconsolate, we are inspired, we roar with delight, renewed, awed by a vision that is fired by a deep reverence for life and humanity. We can hope. Thomas is an optimist.

Paul Fusco

Opposite, top
A Mayan woman on a mountain road to Nebaj.
Guatemala, 1997

Opposite, bottom
A Mayan priest and disciples lighting candles in a secret cave to celebrate the Mayan New Year.
Guatemala, 1997

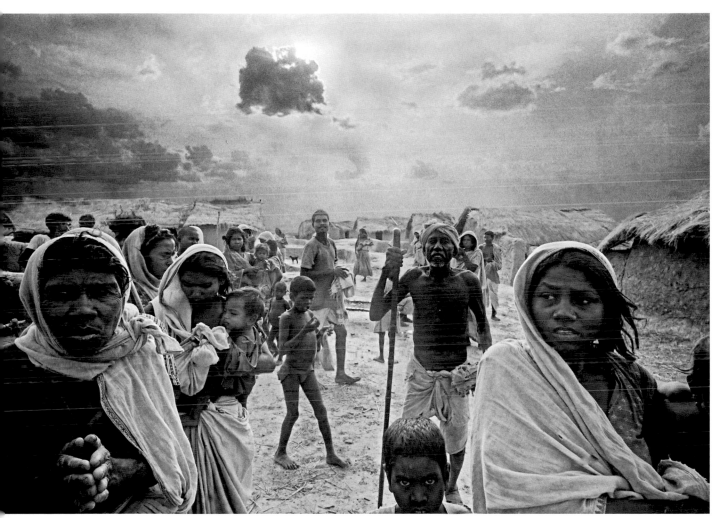

Villagers begging for food. Bihar, India, 1967

DAVID HURN

Born in 1934, of Welsh descent, David Hurn is a self-taught photographer who began his career in 1955 as an assistant at the Reflex Agency. While a freelance photographer, he gained his reputation with his reportage of the 1956 Hungarian revolution.

Hurn eventually turned away from coverage of current affairs, preferring to take a more personal approach to photography. He became an associate member of Magnum in 1965 and a full member in 1967. In 1973 he set up the famous School of Documentary Photography in Newport, Wales, and has been in demand throughout the world to teach workshops.

He recently collaborated on a very successful textbook with Professor Bill Jay, *On Being a Photographer*. However, it is his book *Wales: Land of My Father*, that truly reflects Hurn's style and creative impetus. In the last two decades of the twentieth century, Wales experienced a remarkable transformation. From a country with an economy, culture, and landscape dominated by agriculture and the heavy industries of coal, steel and slate, Wales has become a place where the mines, mills and quarries are closed – either for good or to be reinvented as mythical 'heritage' tourist attractions – and where the new industries are high-tech and computer-based. Hurn's book, a collection of carefully observed photographs, reveals both the traditional and the modern sides of the country.

David Hurn has a longstanding international reputation as one of Britain's leading reportage photographers. He continues to live and work in Wales.

Opposite
Sheep sheltering from the rain on a military artillery range.
Mynydd Eppynt, Wales, 1973

Looking at the work of David Hurn the first word that comes to mind is 'humanity'. Each of his pictures shows a specific human situation and a specific moment. There are no generalities here, and most of the images are gentle surprises. One not-so-gentle surprise is the picture on page 275, a frightening and violent image made in the US, outside his usual quieter milieu.

I remember visiting David in his lonely stone cottage on the River Wye in Wales, near the ruins of Tintern Abbey. Having grown weary of the world of photoreportage and travel, David went back to his roots in 1973 and has lived and worked in his rustic retreat ever since. He decided to do three books on his native Wales – he has completed two and is now working on the third. One can only admire and envy his solution to the age-old problem of how to concentrate all of one's creative efforts on exactly the work one wishes to produce.

Although David used medium-format cameras for two of the books, one of portraits and the other of landscapes, the majority of his work consists of candid human moments, influenced (as so many of us in Magnum have been) by the work of Cartier-Bresson. The two pictures on pages 276 and 277, made during his travelling days, are different takes on the same place. The picture of the sailor taking a picture is typical of Hurn humour. The other is an elegant photograph of the most ordinary happening, a smart lady taking a puff.

The final two pictures in David's portfolio, on pages 278 and 279, have a similar feel. The image of John Lennon is a picture that is good for its own sake and is not dependent on the celebrity of the subject. It is just a lovely picture of a man alone smoking his cigarette in a train compartment. The hand in the lower left corner beautifully repeats the hand of the subject. The other picture, of people just being together, is an image which is comforting and pleasing to contemplate, though nothing unusual or remarkable is happening. And this is one of David's great gifts, to make the ordinary into something personal and special.

Constantine Manos

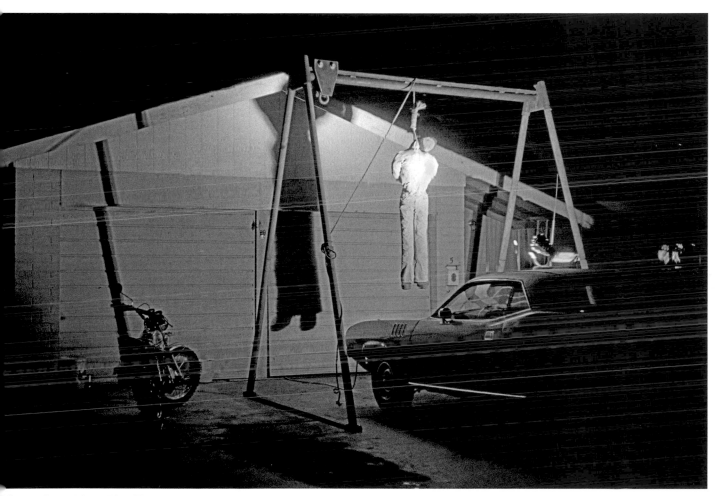

Halloween. Tempe, Arizona, USA, 1979

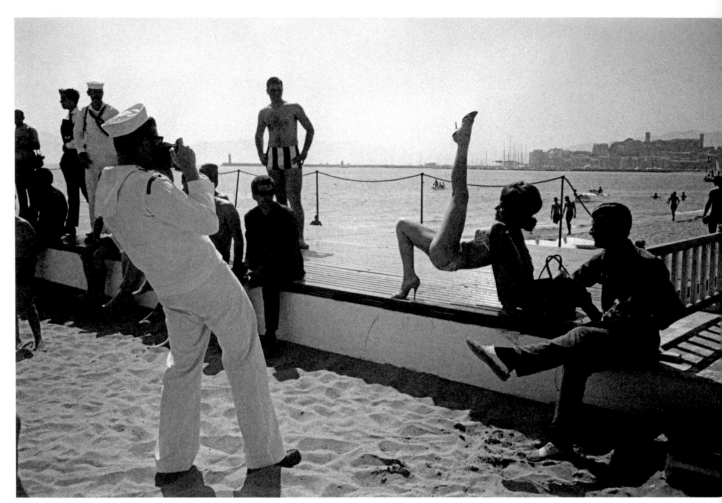

A minor star posing on the beach during the Cannes Film Festival.
France, 1964

Opposite
Cannes, France, 1964

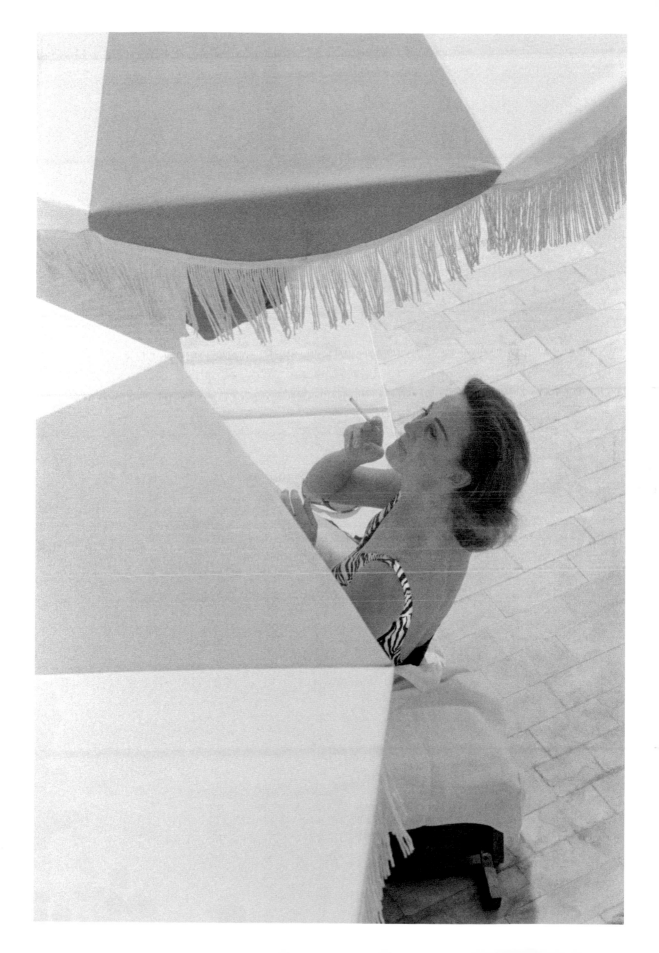

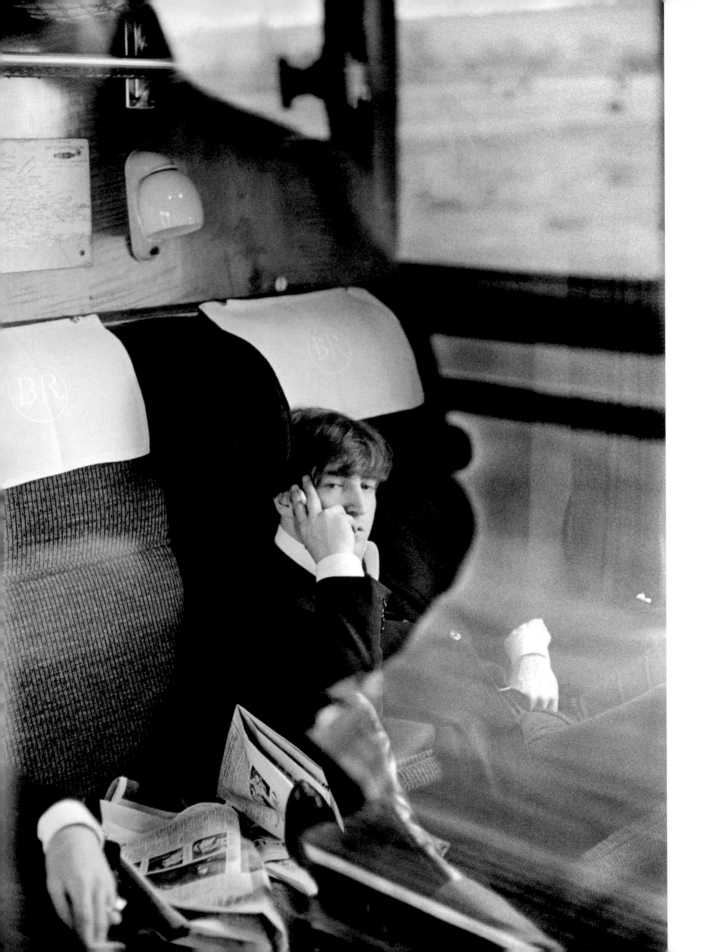

he Partisan Coffee Bar, Soho, a 1950s cultural meeting place.
ondon, England, 1957

posite
hn Lennon relaxing on the train between takes during the
ming of *A Hard Day's Night*. Britain, 1964

Miners' houses. Warsop Vale, Nottinghamshire, England, 1974

RICHARD KALVAR

Richard Kalvar, born in 1944, is American. After studying English and American literature at Cornell University from 1961 to 1965, he worked in New York as an assistant to fashion photographer Jérôme Ducrot. It was an extended trip with a camera in Europe in 1966 that made him decide to become a photographer. After another two years in New York, he settled in Paris and first joined Vu Photo Agency, before helping to found the Viva agency in 1972. In 1975, he became an associate member of Magnum Photos and two years later a full member, subsequently serving as vice-president and president.

In 1980 Kalvar had a one-man show at the Agathe Gaillard gallery in Paris, and has since participated in many group shows. He published *Portrait de Conflans-Sainte-Honorine* (1993). A major retrospective of his work was shown at the Maison Européenne de la Photographie in 2007, accompanied by a book, *Earthlings*. He has carried out extensive personal, editorial and commercial assignments throughout the world, notably in France, Italy, England, Japan and the United States, and continues to work on a long-term project on the city of Rome.

Kalvar's photographs are marked by a strong homogeneity of aesthetic and theme. His images frequently play on a discrepancy between the banality of a real situation and a feeling of strangeness that emerges from a particular choice of timing and framing. The result is a state of tension between two levels of interpretation, attenuated by a touch of humour.

I decided to make a selection of Richard's work because he has always made me curious about his way of looking at the world. His photos are appreciated and well known, but he always keeps himself hidden behind the irony and grotesqueness that he knows how to find in life. There's a sense of surprise in his photos, and you can hear his voice off-camera saying: 'Aha! I've seen you … now you can't hide.'

I was curious to know whether, in all his excellent work and these 'tender' photographs, I would be able to find a dark, lonely side, a moment of uncertainty or fragility. I knew that it wouldn't be easy; it was a question of unpicking a thematic thread that has been sewn through all these years. But working this way meant going beyond the plain mechanical editing of beautiful images, and became an investigation into that confusing maze through which the spirit of every photograph, sooner or later, has to pass.

Alex Majoli

Opposite, top
A man at a shooting stand, Coney Island. Brooklyn, New York, USA, 1968

Opposite, bottom
Prospect Park, Brooklyn. New York, USA, 1968

Following pages
Paris, France, 1975

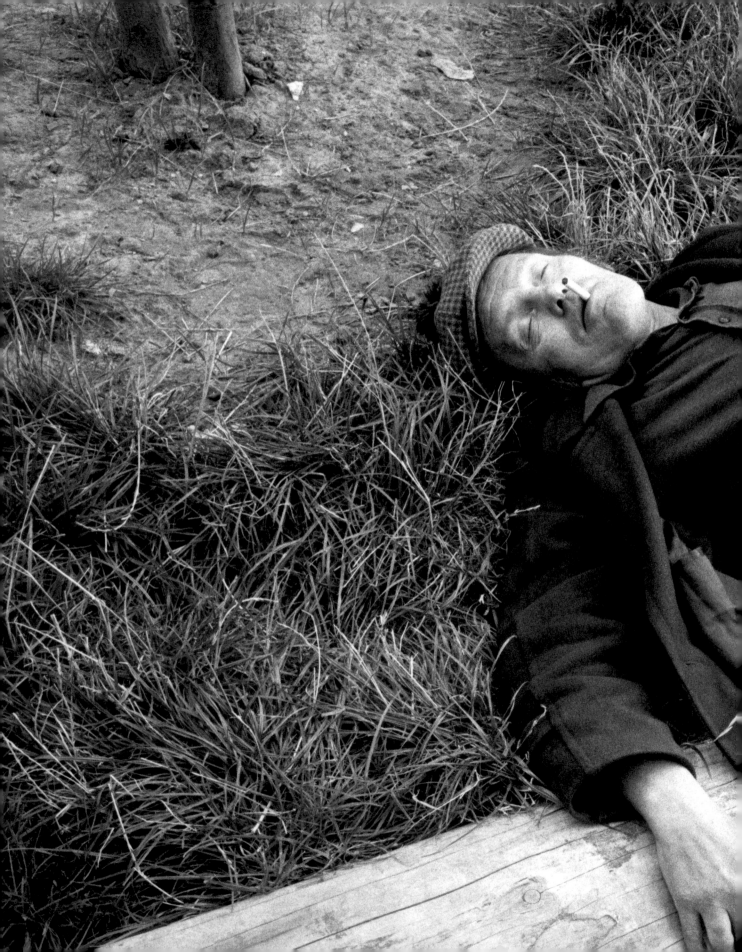

St Emilion, France, 1975

286 Richard Kalvar

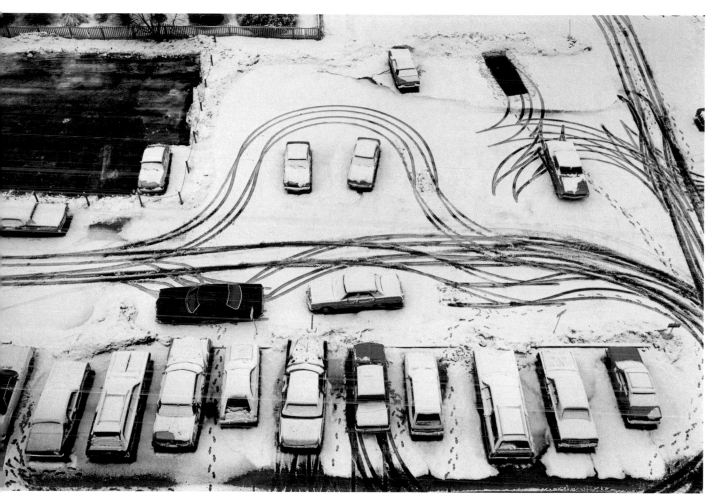

anchester, New Hampshire, USA, 1976

JOSEF KOUDELKA

Josef Koudelka was born in Moravia in 1938. He made his first photographs while a student in the 1950s. About the same time that he started his career as an aeronautical engineer in 1961 he also began photographing Gypsies in Czechoslovakia and theatre in Prague. He turned full-time to photography in 1967. The following year, Koudelka photographed the Soviet invasion of Prague, publishing his photographs under the initials P. P. (Prague Photographer) for fear of reprisal to him and his family. In 1969, he was anonymously awarded the Overseas Press Club's Robert Capa Gold Medal for those photographs.

Koudelka left Czechoslovakia for political asylum in 1970 and shortly thereafter joined Magnum Photos. In 1975, he brought out his first book *Gypsies*, and in 1988, *Exiles*. Since 1986, he has worked with a panoramic camera and issued a compilation of these photographs in his book *Chaos* in 1999. Koudelka has had more than a dozen books of his work published, including most recently in 2006 the retrospective volume *Koudelka*.

He has won significant awards such as the Prix Nadar (1978), a Grand Prix National de la Photographie (1989), a Grand Prix Cartier-Bresson (1991), and the Hasselblad Foundation International Award in Photography (1992). Significant exhibitions of his work have been held at the Museum of Modern Art and the International Center of Photography, New York; the Hayward Gallery, London; the Stedelijk Museum of Modern Art, Amsterdam; and the Palais de Tokyo, Paris.

first met Josef in 1970. Elliott Erwitt brought him to my flat in Bayswater, London. My initial impression was of a huge grin on which was superimposed a pair of wire-rimmed spectacles.

Elliott suggested that Josef should stay in my flat – affectionately known as 'the doss house' by the many itinerant photographers who had stayed there – for a few days, while he developed some film. My memory is that the 'few films' were actually 800 rolls and that he used the abode as his base camp for the next nine years.

Picking Josef's six pictures was comparatively easy. In the early years I had the privilege of spending many a long night looking through hundreds of his contact sheets, always being invited to make suggestions as to what 'worked'. He would pile proof prints in front of me, asking me to put my initials on the back of those I found the most interesting. Later I would often look over his shoulder, as he did at least a dozen different layouts for his book *Gypsies*. I must have known virtually every picture he had taken during this period of his photographic life.

It is logical to divide his work into six sections: early work, the theatre, Gypsies, Prague invasion, exiles and panoramas. From his photographic beginning he seemed to produce a mystical illumination of the world and this sense of the mystical guided my selection.

My first choice is from Prague, 1960: a ghost-like figure standing by two equally lean trees or posts.

The second is a 1964 photograph from Alfred Jarry's *Ubu Roi* in Prague. The exaggerated strange prison phantom figures powerfully capture this Theatre of the Absurd.

The third was taken in Romania in 1968. A statuesque horse in perfect harmony with man: the man seems to be talking, the horse apparently listening.

The fourth in Prague, August 1968. A moment is fixed by time; surprisingly this is not Josef's own wrist.

The fifth, in Sceaux Park, France, 1987. A dog which, if the picture had been taken in England, could have sparked the original thought for Conan Doyle's *Hound of the Baskervilles*.

The sixth, Nord-Pas-de-Calais, 1989: part of his panoramas which not only reproduce the visible but evoke the unseen.

On that first meeting little did I know that this man would truly enrich my life and become, in feel, the brother I had never had.

David Hurn

292 Josef Koudelka

HIROJI KUBOTA

Hiroji Kubota was born in 1939. During a visit by Magnum members to Japan in 1961, Kubota came to know René Burri, Burt Glinn and Elliott Erwitt. After graduating in political science from Tokyo's University of Waseda in 1962, Kubota moved to the US, settling in Chicago, where he continued photographing while supporting himself by working in a Japanese catering business.

He became a freelance photographer in 1965, and his first assignment for the UK newspaper *The Times* was to Jackson Pollock's grave in East Hampton. In 1968 Kubota returned to live in Japan, where his work was recognized with a Publishing Culture Award from Kodansha in 1970. The next year he became a Magnum associate.

Kubota witnessed the fall of Saigon in 1975, refocusing his attention on Asia. It took him several years to get permission to photograph in China. Finally, between 1979 and 1984, Kubota embarked on a 1,000-day tour, during which he made more than 200,000 photographs. The book and exhibit, *China*, appeared in 1985.

Kubota's awards in Japan include the Nendo Sho (Annual Award) of the Japanese Photographic Society (1982), and the Mainichi Art Prize (1983). He has photographed most of the Asian continent for his book *Out of the East*, published in 1997, which led to a two-year project, in turn resulting in the book *Can We Feed Ourselves?*

Kubota has had solo shows in Tokyo, Osaka, Beijing, New York, Washington, Rome, London, Vienna, Paris and many other cities. He has just completed *Japan*, a book on his homeland and the country where he continues to be based.

The photographic community should be pleased that Hiroji Kubota did not follow in his family's footsteps as heir and manager of Tokyo's finest eel restaurant (perhaps the best eel restaurant in all of Japan), which would have been a not inconsiderable position. As a young energetic rebel, eager to make his mark in the big wide world far from his home and in the glamorous universe of photography, Hiroji rejected the traditional family's sure and easy path and with steely determination, under the benevolent tutelage of Japan's master photographer Hiroshi Hamaya, he chose the uncertain life of the freelance documentary photographer.

Relatively clueless but a fast learner, in 1962 at the age of 23 he landed feet first and running in San Francisco with an assignment for a Japanese magazine. He eventually went on to Chicago and temporarily earned his keep in the catering business as a back-up to his more ambitious photographic aspirations.

Quickly learning the English language, he was soon ready to brave his way into an amazing career in photography. He started with modest assignments in the United States while he was an unofficial nominee of Magnum Photos (we were less formal in those days), and went on to a series of grandiose, long-term personal projects that have resulted in beautiful books carefully researched, meticulously planned and handsomely produced. His publications have spanned the United States (all fifty states in the union), China (every province), South and North Korea, Burma, Japan, world population, and the state of global food supplies, with special sensitivity to historic events in the Far East. All his subjects have been thoroughly investigated and grandly illustrated.

Essentially and by his own choice a loner, Hiroji progressed through the intricate Magnum web over the years and became a tenured member in 1986, although his working association with the group dates back to 1965. Soon after his 'coronation' and with his unbounded energy he was singularly responsible for the creation and establishment of our great Magnum asset, the fourth independent branch office, in Tokyo, representing our business interests and our photographers, as in our three other bureaus, in Paris, New York and London.

The essential Hiroji Kubota works hard and delivers a fascinating kaleidoscope of visual pleasure and information about our world.

Elliott Erwitt

Opposite, top
Tokyo, Japan, 2003

Opposite, bottom
A plane taking off from Kai Tak airport.
Hong Kong, 1996

Following pages
The make-up room at the Beijing Opera in
Shanghai. China, 1979

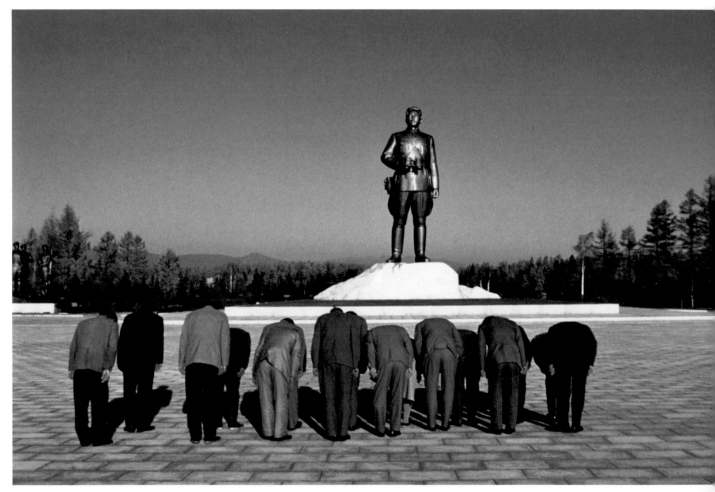

Local government and party officials paying their respects to a
statue of Kim Il Sung as a young military leader. Pyongyang,
North Korea, 1982

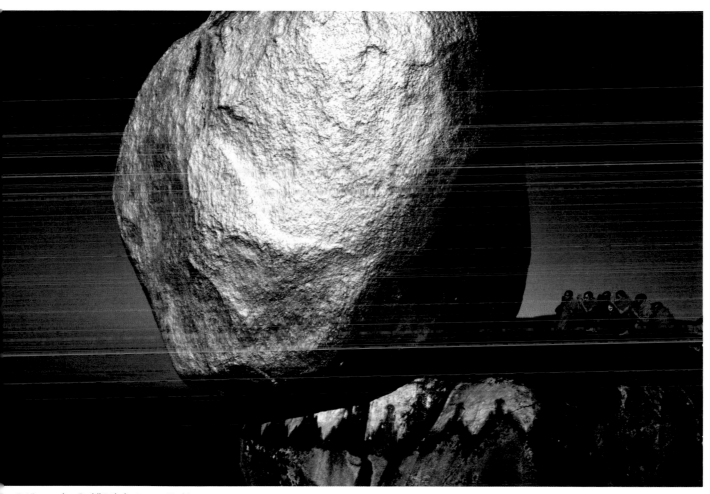

we Pyi Daw rock, a Buddhist holy site, near Kyakito.
n, Myanmar, 1978

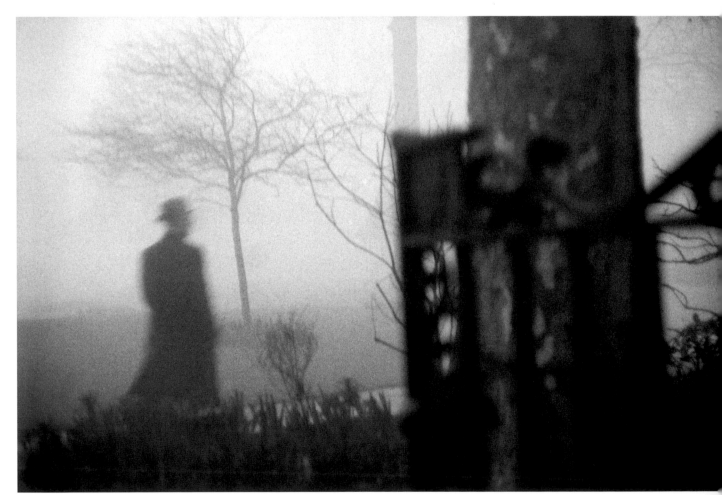

London, England, 1959

SERGIO LARRAIN

Sergio Larrain was born in 1931 in Santiago de Chile. He studied music before taking up photography in 1949, from which year until 1953 he studied forestry at the University of California at Berkeley. He then attended the University of Michigan at Ann Arbor before setting off to travel throughout Europe and the Middle East. Thus began Larrain's work as a freelance photographer. He became a staff photographer for the Brazilian magazine *O Cruzeiro* and in 1956 the Museum of Modern Art in New York bought two of his pictures.

In 1958 Larrain was given a grant from the British Council that allowed him to produce a series of photographs of London. The same year Henri Cartier Bresson saw his photographs of street children and suggested that he work for Magnum. Larrain spent two years in Paris, where he worked for international press titles. He became a Magnum associate in 1959 and a full member in 1961. He returned to Chile in 1961 when the poet Pablo Neruda invited him to photograph his house.

In 1968, he came into contact with Bolivian guru Óscar Ichazo and virtually gave up photography in order to pursue his study of Eastern culture and mysticism, adopting a lifestyle in keeping with his ideals. He has devoted himself to spreading knowledge of yoga, writing, painting in oils and occasionally taking the odd photograph. He continues to live and work in Chile.

I have never met Sergio Larrain and probably never will. Retired from the world, he lives like a hermit in the Chilean countryside, meditating, in the serenity of his vision of the world.

I followed some of his correspondence with Agnès Sire when she was working on the book *Valparaiso* in 1990. For a long time I have thought of Sergio Larrain as an unchanging cloud set high in the photographic heavens, stretching to the horizon, facing the infinite from some dreamlike place. With some hesitation and difficulty, I have chosen six of his photographs, having spent time looking at many others.

Standing well back from the evidence before him, Larrain looks with a clandestine, fleeting eye that shows reality via unusual, hidden doorways. He celebrates the uncertain, reveals secrets and rhythms that are often syncopated. He observes no formal rules, obeys no preconceived ideas. Liberated from convention, without looking for a particular performance, his eye, always alert, is free to wander, to improvise according to what attracts it.

The frame is unstable. It oscillates, pitches, moves off-centre, sways, threatens to capsize in the precarious ebb and flow of life. For Larrain, taking a photograph is not the result of a controlled strategy. It doesn't require stopping to steady and centre the shot at the moment of releasing the shutter. Without constraint, in permanent flux, he integrates his own movement with those of the hazards he encounters.

The scene sets itself, but is never set. The photo takes itself more than it seeks actually to be taken. In this drama *in extremis*, the resulting image is never reassuring. Once taken, just barely, on the edge of time, off balance, it gives rise to the strange feeling that it might topple out of the frame and cease to exist.

Guy Le Querrec

Opposite
London, England, 1959

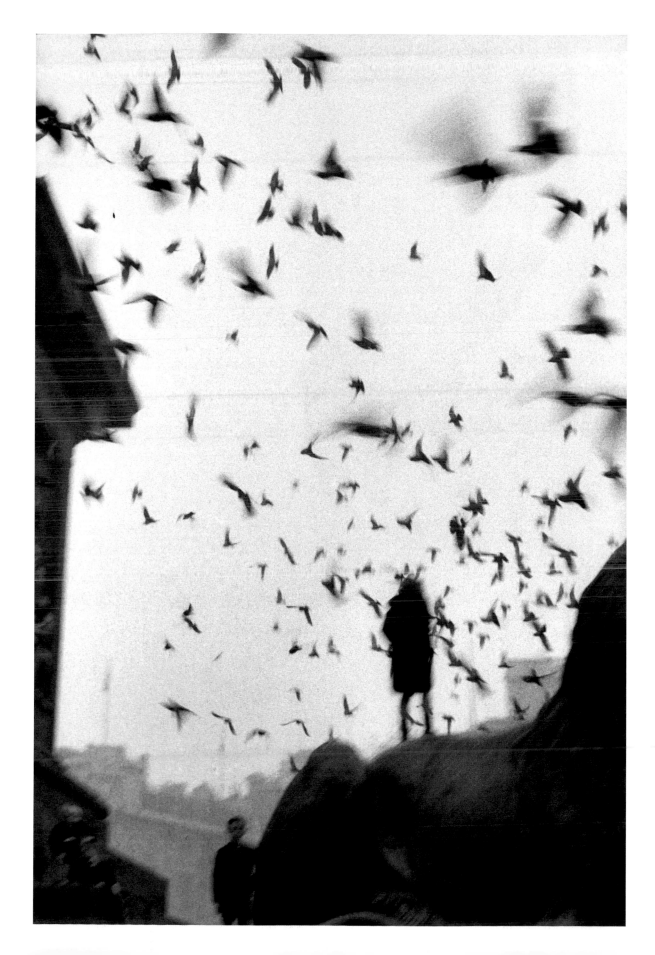

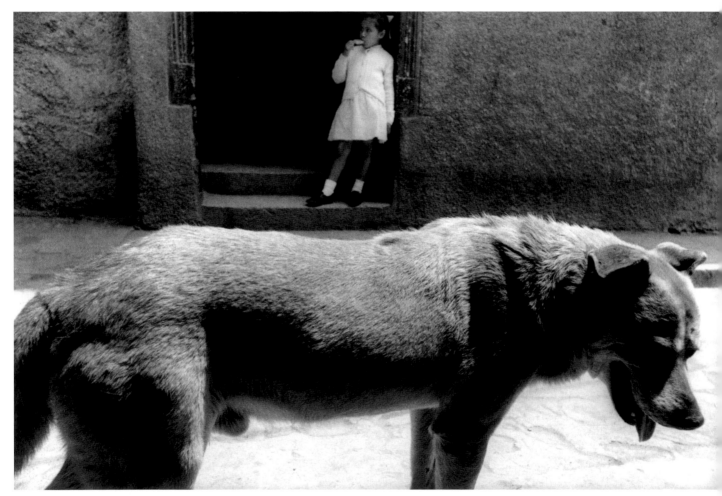

Valparaiso, Chile, 1963

Opposite
Café. Valparaiso, Chile, 1963

Following pages
Valparaiso, Chile, 1963

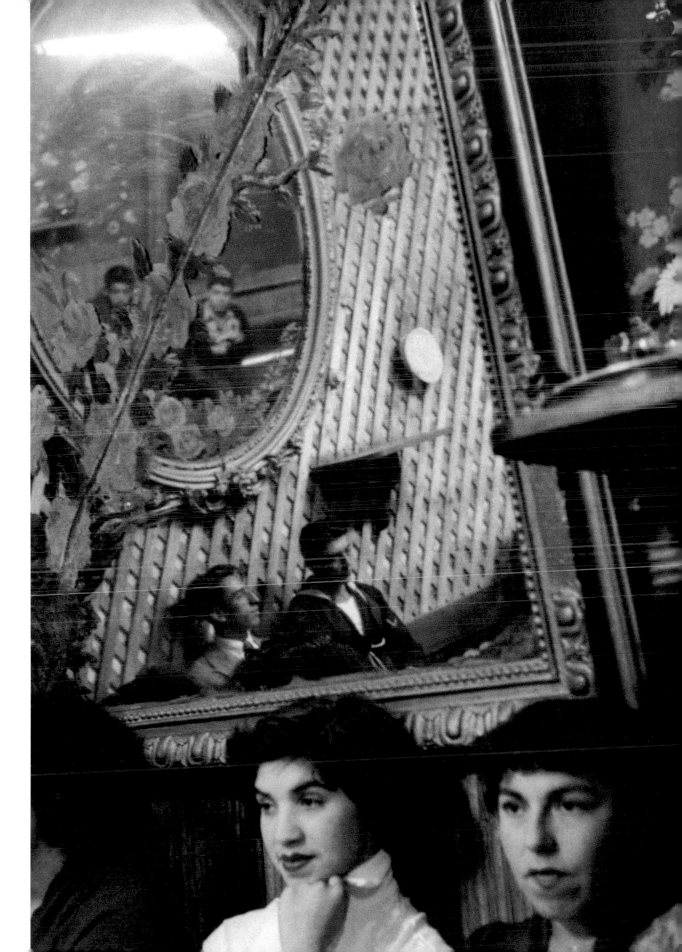

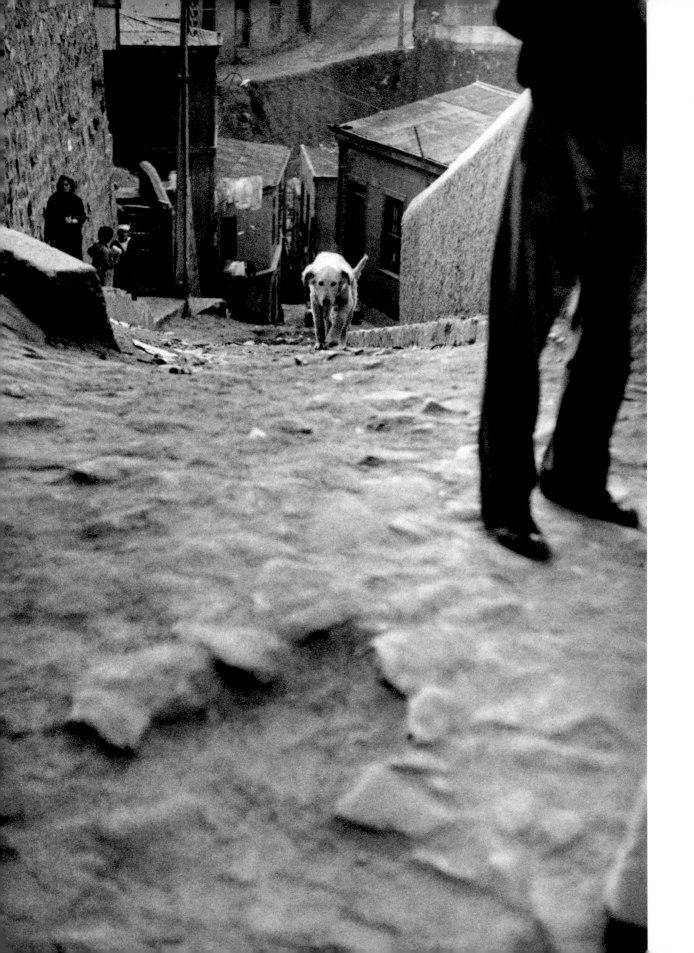

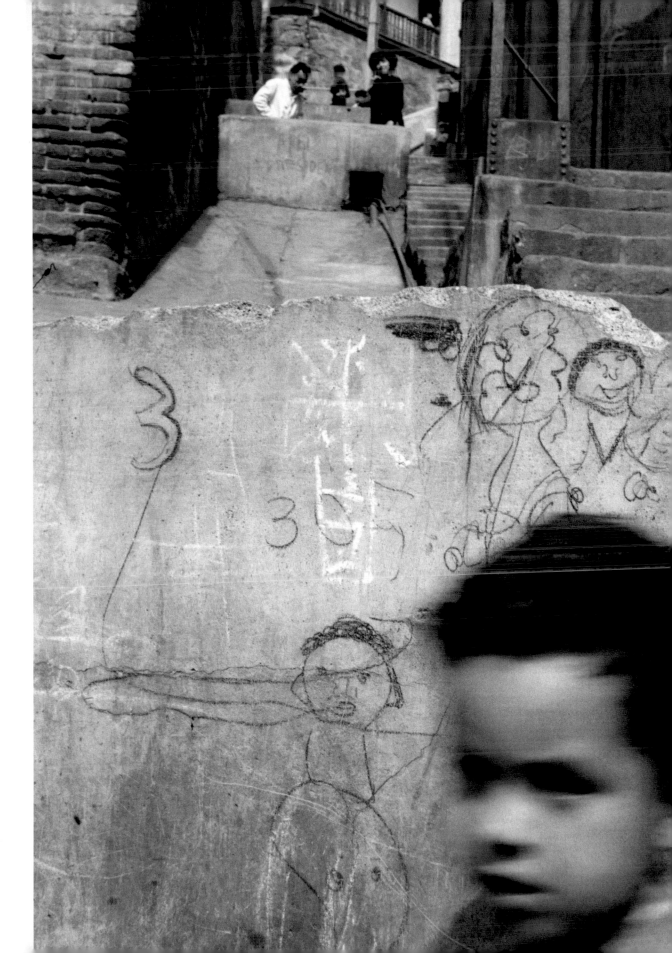

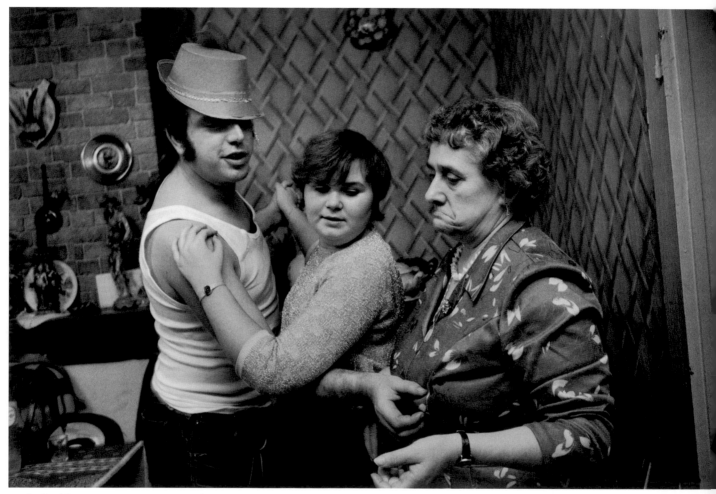

A family celebrating New Year's Eve. Denain, northern France,
Saturday 31 December 1983

GUY LE QUERREC

Born in 1941 into a modest family from Brittany, Guy Le Querrec shot his first pictures of jazz musicians in London in the late 1950s, making his professional debut in 1967. Two years later he was hired by the weekly *Jeune Afrique* as picture editor and photographer; he did his first reportages in Francophone Africa, including Chad, Cameroon and Niger. In 1971 he entrusted his archives to Vu, recently founded by Pierre de Fenoyl, and in 1972 he co-founded the co-operative Viva agency, but left it three years later. Le Querrec joined Magnum in 1976.

In the late 1970s he co-directed two films, and in 1980 directed the first photographic workshop organized by the City of Paris. During the Rencontres d'Arles in 1983 he created a new form of show by projecting photographs alongside a live quartet of jazz musicians, repeating the experiment in 1993 and 2006.

Le Querrec has undertaken numerous reportages on the Concert Mayol in Paris, subjects in China and Africa, and North American Indians. He punctuates his work with breaks devoted to jazz (festivals, clubs and tours), and has travelled through twenty-five African countries with the Romano–Sclavis–Texier trio.

Le Querrec's background in jazz has informed his photography. He sees everyday scenes as a musical score, played or activated by natural forces. Sun rays in a café could be a cry or a trumpet call; Spanish workers resting on the edge of a limestone quarry are musical notations in a solo piece.

Le Querrec has also devoted much time to teaching workshops and classes in France and other countries. He has exhibited regularly throughout the world.

I'm tall; Guy is small.

I see bald heads, he sees bosoms, buttocks and belly-buttons.

The air is rarefied, the weather often beclouded where I am; down below the view is clear.

At least it seems so, because close to the ground Guy sees a lot of peculiar things among ordinary people that are invisible to the rest of us.

Droll and touching at the same time. A funny, sad clown, this man.

<div align="right">**Richard Kalvar**</div>

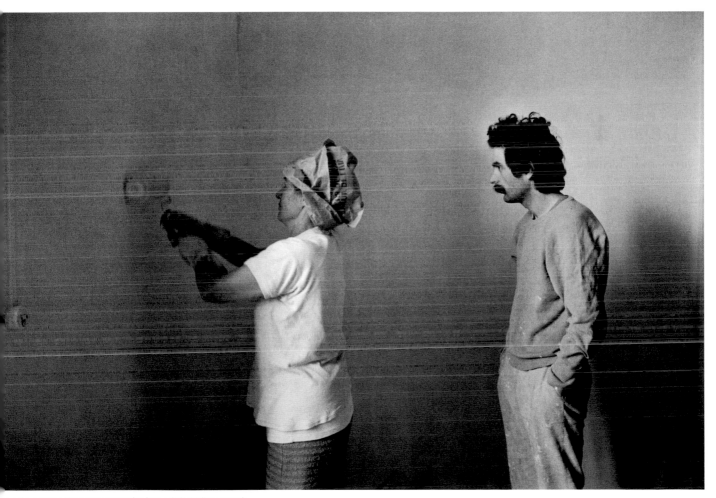

mother helping her son to repaint his home ('The Rolling Stone').
...ndée, France, Monday 18 September 1972

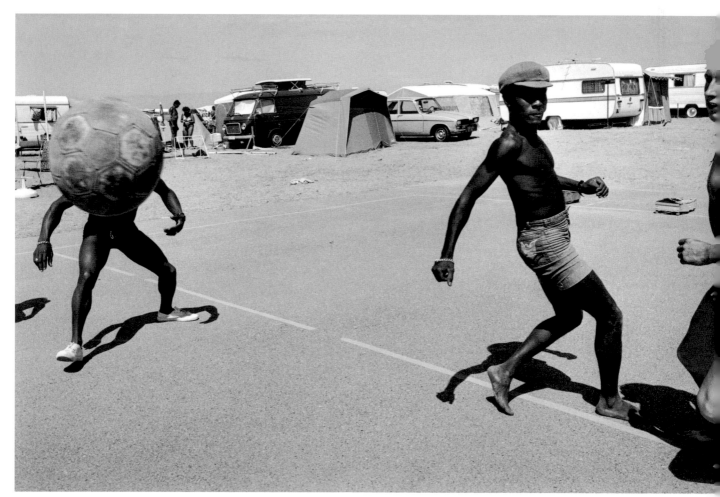

A camp site near the beach at Argelès-sur-Mer.
Pyrénées-Orientales, France, Sunday 1 August 1976

...estival International du Son. Paris, France, Friday 9 March 1979

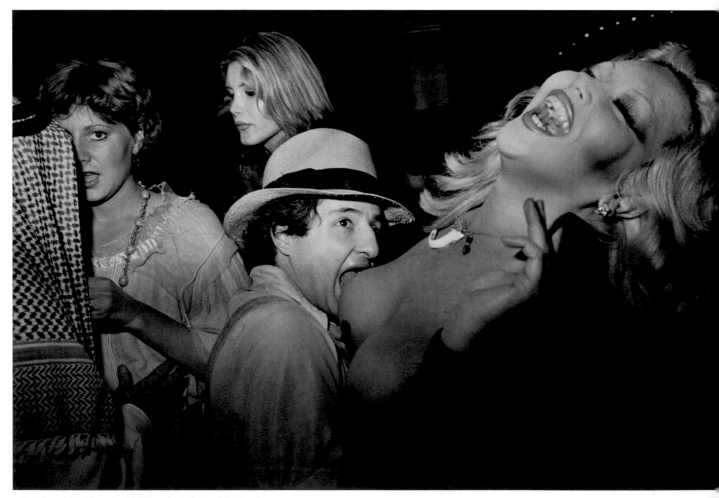

Le Palace night club on the third Thursday in Lent, celebrating the
seven deadly sins: Lust. Paris, France, 1980

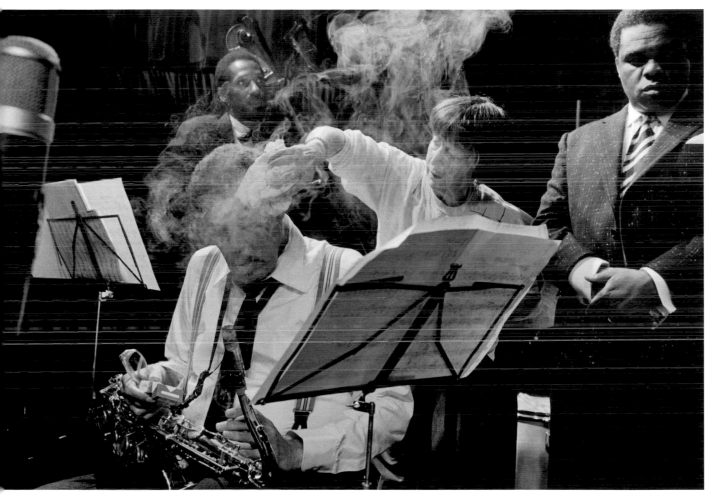

...om left to right: American jazzmen Ron Carter (bass), Dexter
...ordon (saxophone) and Freddie Hubbard (trumpet) during the
...ming of Bertrand Tavernier's *Autour de Minuit* (*Round Midnight*).
...ance, 1985

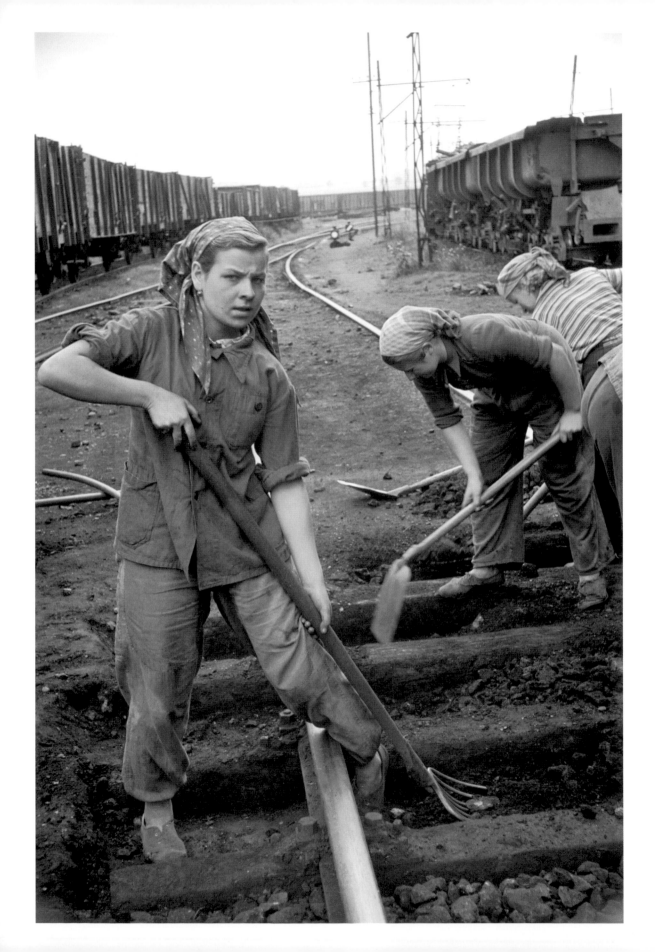

ERICH LESSING

Born in Vienna in 1923, Erich Lessing was the son of a dentist and a concert pianist. In 1939, before Lessing finished high school, Hitler's occupation of Austria forced him to emigrate to Israel (then British Mandate Palestine). His mother remained in Vienna and died in Auschwitz. Lessing studied at Haifa's Technical College, before working on a kibbutz; after his time as a soldier he also drove a taxi for a living.

During the Second World War, Lessing served in the British Army as an aviator and photographer. He returned to Vienna in 1947. He worked as a reporter and photographer for the Associated Press and was invited to join Magnum by David 'Chim' Seymour, one of the agency's founders. He became a full member of Magnum in 1955. Lessing covered political events in North Africa and Europe, and reported on the onset of the Communist period in Eastern Europe for *Life*, *Epoca*, *Picture Post* and *Paris-Match*. His pictures of the 1956 Hungarian Revolution serve as a record of the hope and euphoria of the first days of the revolt, so soon to be followed by the pain and punishment of its brutal suppression.

Lessing later became disillusioned with photojournalism as an agent for change. From the mid-1950s he turned to art, science and historical subjects. He specialized in large-format colour photography, publishing more than forty books and establishing himself worldwide as a photographer of culture.

Having taught photography in Arles, at the Venice Biennale, in Ahmedabad in India as a UNIDO expert, at the Salzburg summer Academy and at the Academy of Applied Art in Vienna, Lessing has been honoured with numerous awards. He is a member of UNESCO's International Commission of Museums, and CIDOC, its information branch. He lives in Vienna.

Erich Lessing, a great figure in photojournalism, has focused his lens on every kind of event, great or small, since the Second World War. His photographs of the Hungarian Revolution were seen around the world. Less well known but just as remarkable are the photos that I have chosen for this book from Poland in the 1950s.

Erich studies power, whether religious or secular, and notes its effects both on those who exercise it and those who are subject to it: 'I take humanity seriously, in all its aspirations and desires, as well as in everything that can follow, whether in religion or spirituality, art or politics. This was, and still is today, the starting point for all my photography subjects …'

In parallel with his life as a photojournalist, Erich has devoted himself all his life to history, via museums, churches, landscapes … 'This type of photography is not art,' he says, 'but it does throw light on art.'

Bruno Barbey

Opposite
A young boy selling flowers. Sopot, Poland, 1956

Following pages
The election of the first beauty queen in Communist Poland. Sopot, Poland, 1956

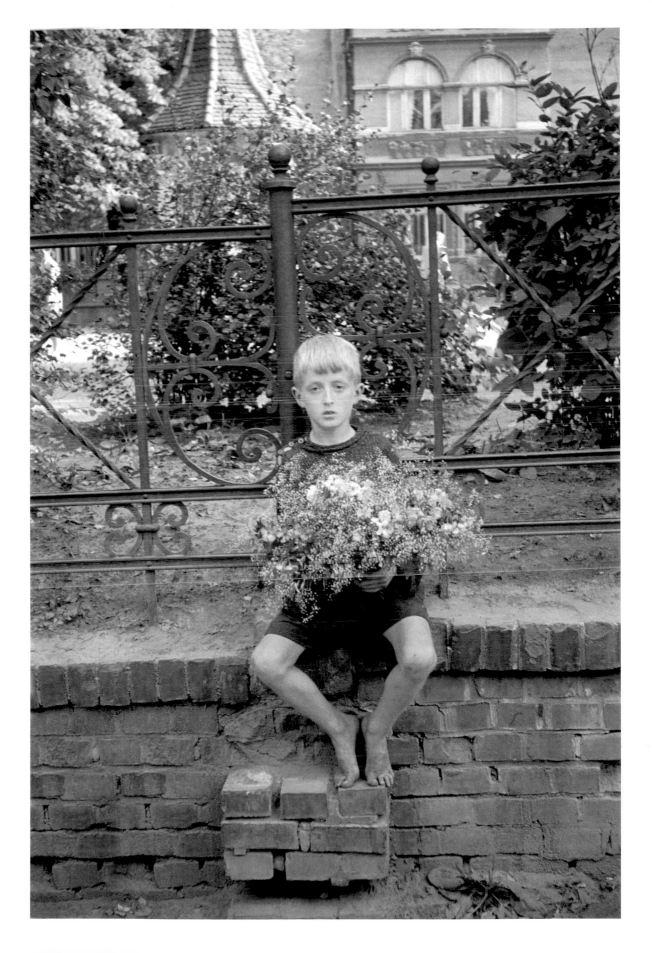

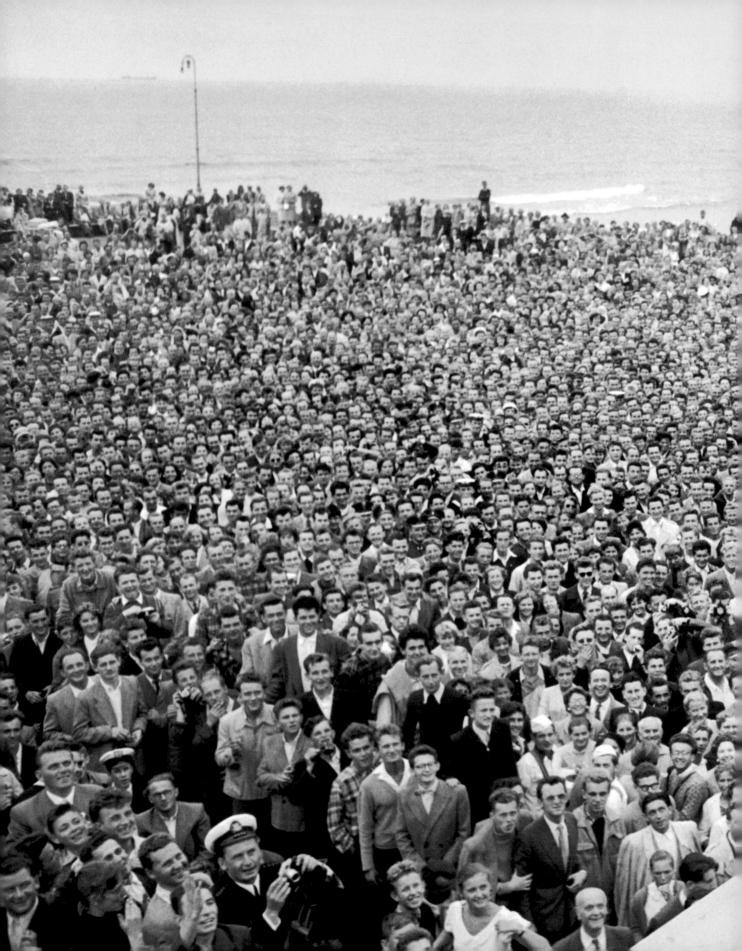

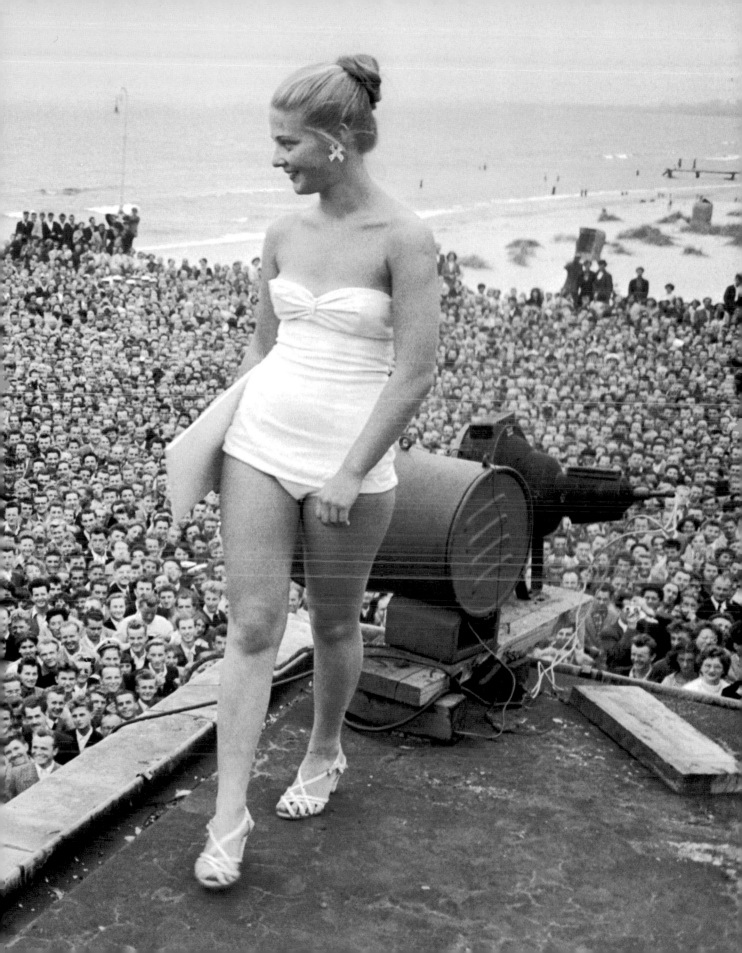

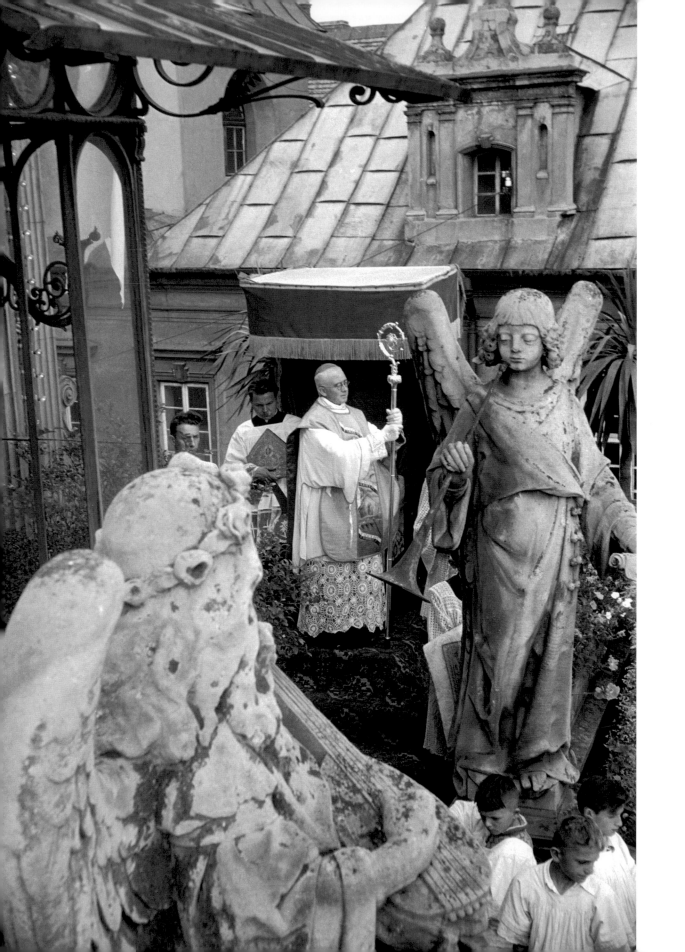

Opposite
The 'Black Madonna' of Czestochowa carried in procession through the town. Czestochowa, Poland, 1956

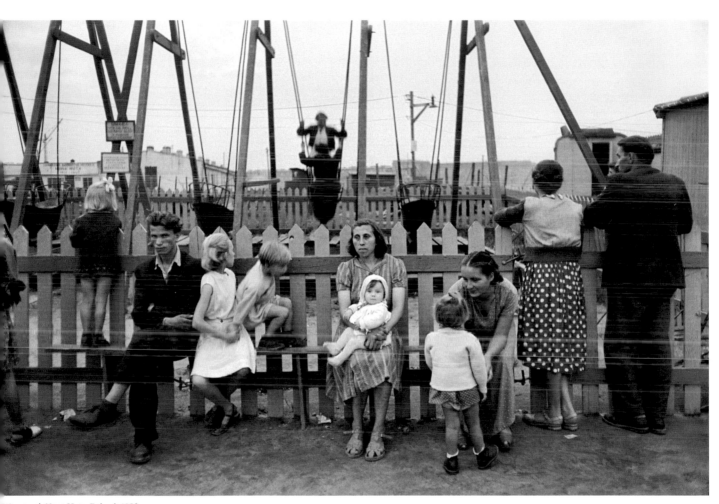

Fairground. Nova Huta, Poland, 1956

Following pages
Hebrew school. Cracow, Poland, 1956

ALEX MAJOLI

Alex Majoli was born in 1971 and is Italian. At the age of 15, he joined the F45 Studio in Ravenna, working alongside Daniele Casadio. While studying at the Art Institute in Ravenna, he joined Grazia Neri Agency and travelled to Yugoslavia to document the conflict. He returned many times over the next few years, covering all major events in Kosovo and Albania.

Majoli graduated from art school in 1991. Three years later, he made an intimate portrayal of the closing of an asylum for the insane on the island of Leros, Greece, a project that became the subject of his first book, *Leros*.

In 1995 Majoli went to South America for several months, photographing a variety of subjects for his ongoing personal project, 'Requiem in Samba'. He started the project 'Hotel Marinum' in 1998, on life in harbour cities around the world, the final goal of which was to perform a theatrical multimedia show. That same year he began making a series of short films and documentaries.

After becoming a full member of Magnum Photos in 2001, Majoli covered the fall of the Taliban regime in Afghanistan, and two years later the invasion of Iraq. He continues to document various conflicts worldwide for *Newsweek*, the *New York Times Magazine*, *Granta* and *National Geographic*.

Majoli, in collaboration with Thomas Dworzak, Paolo Pellegrin and Ilkka Uimonen, had an extremely successful exhibition and installation *Off Broadway* in New York in 2004, which travelled to France and Germany. He then became involved in a project for the French Ministry of Culture entitled 'BPS', or 'Bio-Position System', about the social transformation of the city of Marseilles. A recently completed project, 'Libera me', is a reflection on the human condition.

Alex Majoli lives and works in New York and Milan.

Alex's work sometimes reminds me of the photographer Ed Van Der Elsken –
wild and free. I don't really know where I am going when I look at Alex's
pictures, but I am always looking forward to it; his work holds a whole range of
emotions and observations to be experienced and savoured.

I chose some of Alex's early photographs for this book because I like the
naïve and experimental quality present in them; they have a real honesty that
I find very powerful, which has always remained throughout his work. He
shoots with diversity – whether it is news journalism, fashion, or portraiture –
and it always holds together coherently; his voice is clear. His work often feels
as though he is almost 'shooting from the hip', as if the image has a sense of
simply being a crazy snapshot; but simultaneously all his work, when you look
closely, is carefully considered and constructed.

I love the way he dives into the world without worrying; he blends
photography and experience beautifully and never seems to hold himself to
anything specific. In fact the very opposite: he seems to absorb everything. His
pictures are both sober and reactionary at the same time, and there is something
of the 'cult' about them and him.

Donovan Wylie

rita's plate, 2005

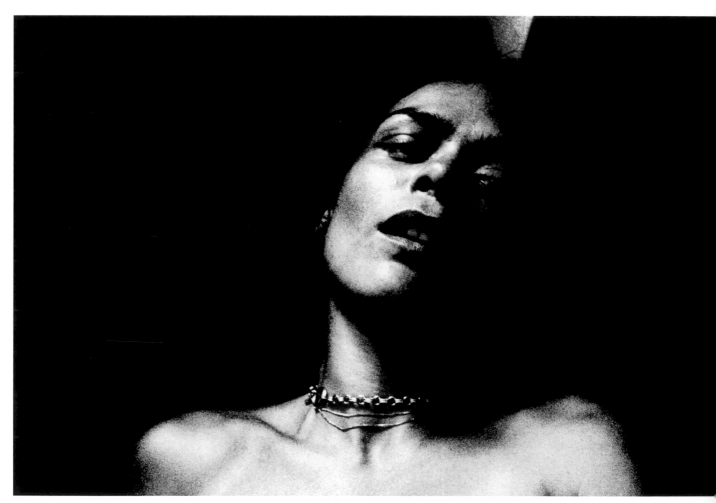

Daria, 2005

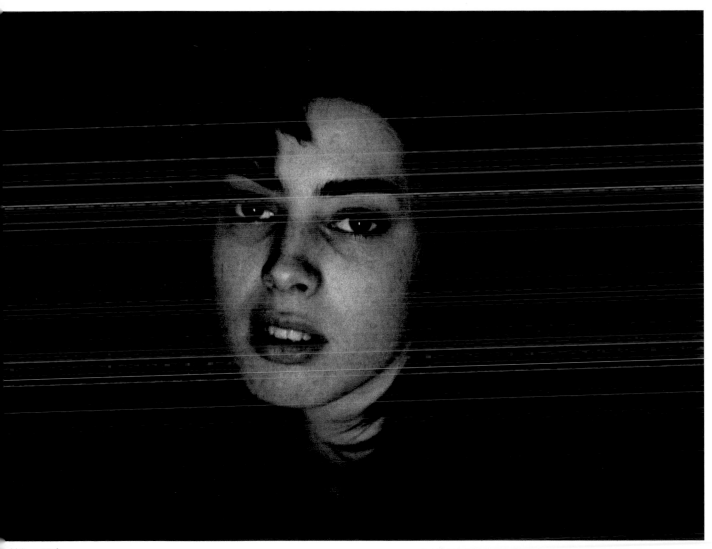

Maddalena, 1986

following page
Waters, Ravenna, Italy 1985

Santa Monica, California, USA, 2004

CONSTANTINE MANOS

Constantine Manos was born in 1934 in South Carolina to Greek immigrant parents. His photographic career began when he was 13, in the school camera club, and within a few years he was a professional photographer. At the age of 19 he was hired as the official photographer of the Boston Symphony Orchestra at Tanglewood. During this time he attended the University of South Carolina, graduating in 1955 with a BA in English Literature.

After military service, he moved to New York, where he worked for *Esquire*, *Life* and *Look*. His book *Portrait of a Symphony*, on the Boston Symphony Orchestra, was published in 1961. For the next three years, he lived in Greece, producing work that resulted in *A Greek Portfolio*, first published in 1972 and an award-winner at Arles and at the Leipzig Book Fair. In 1963 Manos joined Magnum Photos.

Manos's work is in the permanent collections of the Museum of Modern Art in New York, the Museum of Fine Arts in Boston, the Museum of Fine Arts in Houston, the Bibliothèque Nationale in Paris, the Art Institute of Chicago, the George Eastman House in Rochester, and the High Museum of Art in Atlanta.

His book *Bostonians*, which celebrates the people of that city, was published in 1974. A new edition of *A Greek Portfolio* was published in 1999, accompanied by a major exhibition at the Benaki Museum in Athens. In 1995 Manos's *American Color* was published, and in 2003 he was awarded the Leica Medal of Excellence for his continuing work on that project.

I know a Costa Manos photograph when I see one. He does not photograph colour, he lives and breathes colour ... Costa swims in colour. Perhaps this is a bit ironic, since Costa became known in the world of photography with his black and white work *A Greek Portfolio*, an ode to his heritage; but after 'lighting a candle' for his family heritage, Costa dove headlong into colour and has never looked back.

American Color is becoming an epic – monumental, actually. Whenever any artist 'finds' himself and just lets go, then the real work emerges. Costa found this with *American Color* and will not let go ... at least, not until he is finished; and I do not want him to finish any time soon, because every time I see Costa he has new work, and special work, and work that reflects his personality and his life. This is what artists do.

The irony in Costa's early black and white work is matched by the irony in most of his current colour photographs. There is always a little 'twist': you look around and find things 'inside' these pictures. They are not just 'about colour' at all. His quixotic moments suggest mystery, not conclusion. This is what I like the most. Costa does not tell us everything, he just tells us something – he resists 'explanation' in favour of letting our imaginations fly. The imagination and the artistry of Costa Manos know no bounds.

David Alan Harvey

Hollywood Beach, Florida, USA, 2005

Following pages
Daytona Beach, Florida, USA, 1997

Peter Marlow's son Max on a family holiday. Corrubedo, Spain, 2003

PETER MARLOW

Peter Marlow was born in Britain in 1952. Although gifted in the language of photojournalism, he is not a photojournalist. He was initially, however, one of the most enterprising and successful young British news photographers, and in 1976 joined the Sygma agency in Paris. He soon found that he lacked the necessary appetite for the job while on assignment in Lebanon and Northern Ireland during the late 1970s; he discovered that the stereotype of the concerned photojournalist disguised the disheartening reality of dog eat dog competition between photographers hunting fame at all costs.

Since those days, Marlow's aesthetic has shifted – in that he makes mainly colour photographs – but his approach is unchanged. The colour of incidental things became central to his pictures in the same way that the shape and mark of things had been central to his black-and-white work.

Marlow has come full circle. He started his career as an international photojournalist, returned to Britain to examine his own experience, and discovered a new visual poetry that enabled him to understand his homeland. Having found this poetry, he has taken it back on the road: he now photographs as much in Japan, the USA and elsewhere in Europe as he does in the UK.

Peter Marlow's life is a life photographed. All photography is by its very nature autobiographical – we have to be there to push the button – yet Peter's work, the sheer magnitude of it, takes this to a level I've rarely seen before.

Choosing just six pictures was a challenge. I looked at thousands of photographs, in reverse order. I watched Peter and his wife Fiona getting younger, their boys becoming toddlers and then babies, their family retreat in Dungeness reduced to a bare shell. I was reminded of a time when my father played all his home movies backwards (to my absolute delight) or of Martin Amis's *Time's Arrow*, where the narrative is written in reverse, and we end at the beginning of the story.

I discovered a vein of startling visual consistency running through Peter's work – at least for as long as he has been using medium format. Before that his work *does* change: it is in black and white, in 35mm, it is more *photojournalistic*. But to borrow from Chris Boot: 'Peter Marlow is *not* a photojournalist.' With the combination of colour film and a Hasselblad he found a way of looking at the world that remains unique. The thing is, you can always recognize a Peter Marlow picture. How many photographers can claim the same?

Peter tends to look at everything he photographs – the last vestiges of the Rover production line, the final flight of Concorde or the birth of his own children – with the same cool, slightly detached eye. However, this belies Peter's unwavering social conscience and the great importance of family in his life.

My selection includes two pictures of his children. They are wonderful photographs, certainly, but there is another reason I've chosen them. These are pictures by a photographer who is away from home more than he would like, by someone trying to grasp all that is most precious to him – the people he misses most – and the wonder of those valuable morsels of time spent together.

At the end of the process I think I have a better understanding of who Peter is, and I have learnt from him that one should never forget to photograph the things in life that really matter.

Mark Power

Peter Marlow's son Theo on a family holiday. La Chappelle,
Gers, France, 2006

The last days of Concorde. Heathrow Airport,
London, October 2003

Concorde memorabilia. Britain, Christmas 2003

The South Engineering Offices at the MG Rover Plant, Longbridge.
Birmingham, England, 2006

The Paint Plant 'B' conveyor at the MG Rover Plant, Longbridge.
Birmingham, England, 2006

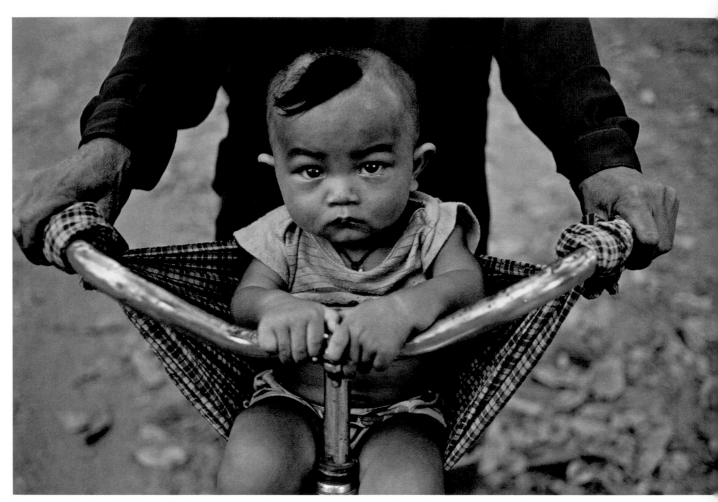

A parent transporting a child in the traditional way.
Angkor Wat, Cambodia, 1998

STEVE McCURRY

Steve McCurry was born in Philadelphia in 1950, and graduated from Pennsylvania State University. After working at a newspaper for two years, he left to freelance in India.

His career was launched when, wearing native clothing, he crossed the Pakistan border into rebel-controlled Afghanistan just before the Russian invasion. When he emerged, he had rolls of film sewn into his clothes that contained some of the world's first images of the conflict. His coverage won the Robert Capa Gold Medal for Best Photographic Reporting from Abroad Showing Courage and Enterprise. He has won numerous awards including the National Press Photographers' Association award for Magazine Photographer of the Year and an unprecedented four first prizes in the World Press Photo contest.

McCurry has covered many areas of international and civil conflict, including the disintegration of the former Yugoslavia, Beirut, Cambodia, the Philippines, the Gulf War and continuing coverage of Afghanistan. His work has been featured in magazines around the globe. His reportage for *National Geographic* has included Tibet, Afghanistan, Burma, India, Iraq, Yemen, Buddhism, and the temples of Angkor Wat.

A high point in his career was finding Sharbat Gula, the previously unidentified Afghan refugee girl, whose picture has been described as one of the most recognizable photographs in the world.

Steve McCurry is a kind of one-man Peace Corps. First, he is driven by curiosity and second by more curiosity, combined with an insatiable wonder about third world countries.

Steve spent time during his studies at university roaming in Africa on a shoestring, and delaying for as long as possible the eventual need to settle on a career. At first he considered becoming a teacher or a historian, but that notion was soon forgotten after he took a photography course and realized that one could travel to the most exotic parts of the world taking pictures and even be paid for it.

But the actual road to glory is less glamorous. Having decided to be a professional photographer, Steve landed a job at a Philadelphia newspaper, where his travels were largely restricted to a 25-mile radius and to tedious and repetitive assignments. Obviously that situation could not continue for long.

Leading a spartan life, Steve saved enough to buy 300 rolls of film with a little cash left over. Armed with hopes and ambition, he set out for India, where he spent two years photographing without any financial support, following in the path of his inspiration – Henri Cartier-Bresson. As Steve puts it: 'I stayed at some of the world's worst hotels and wish I had a nickel for every time I was sick.' But he survived these two seminal years, which confirmed his total dedication to the craft and gave him the kind of experience that toughens and builds character, provided it does not crush it.

 His intense years of dedication and frugality paid off. Steve developed an individual style that has served him well. Applying for Magnum association and then working his way up the ladder, he became a full member in 1991.

With determination and boundless energy, Steve has covered news events, authored one book after another, worked steadily for world class publications, produced extensive essays for the *National Geographic* magazine, received numerous awards and citations, officiated at many photographic workshops and become a distinct presence in the art collectors' market. He continues to visit the Indian subcontinent, while producing a body of ever more compelling work.

A very long way from covering little league games for a Philadelphia daily, Steve McCurry has become one of the most prolific and successful photographers in the world.

Elliott Erwitt

Opposite, top
Western Causeway, Angkor Wat. Cambodia, 1998

Opposite, bottom
The caretaker of Ta Prohm Wat, Angkor. Cambodia, 1999

Following pages
Sleeping with a snake, Tonle Sap. Cambodia, 1990

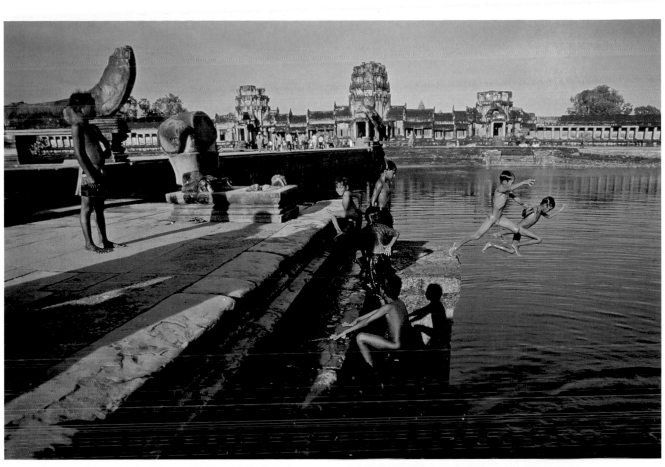

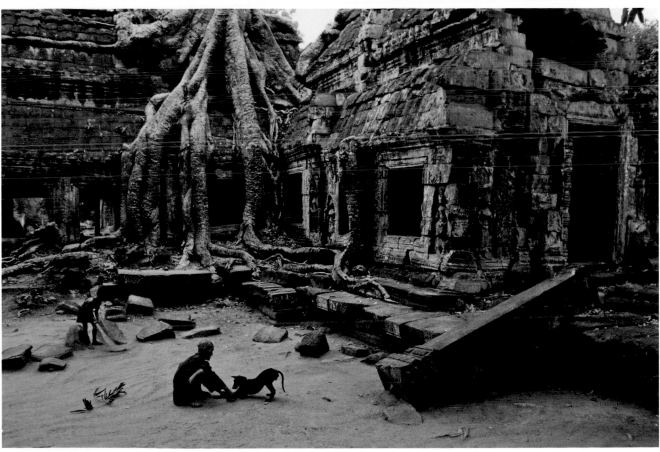

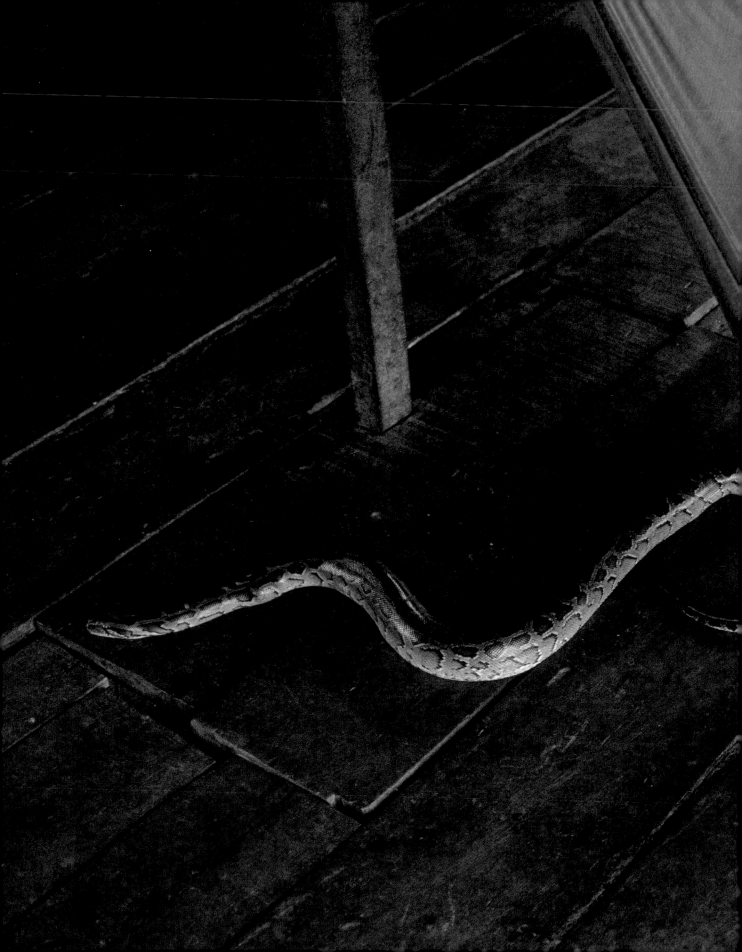

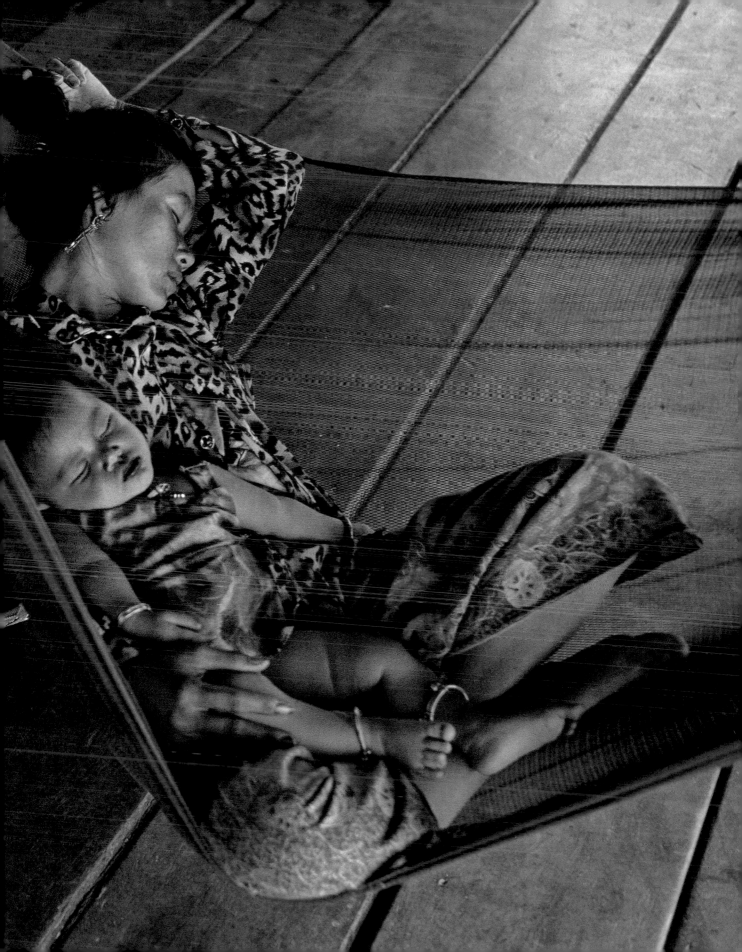

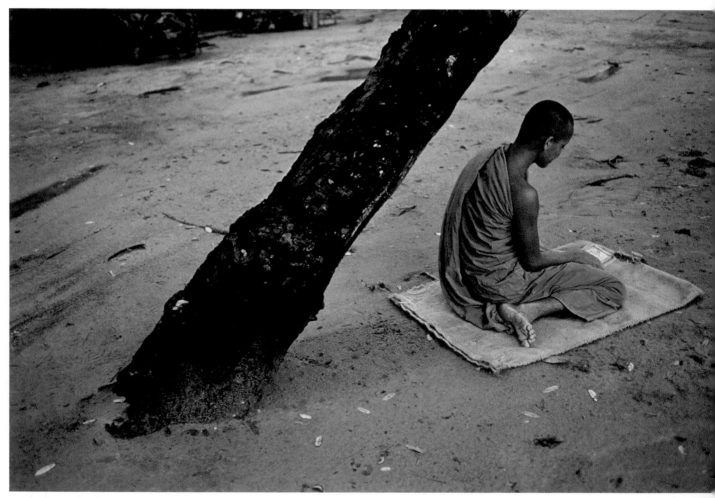

A Buddhist monk at the monastery near the Leper King Terrace,
Angkor Thom. Cambodia, 1998

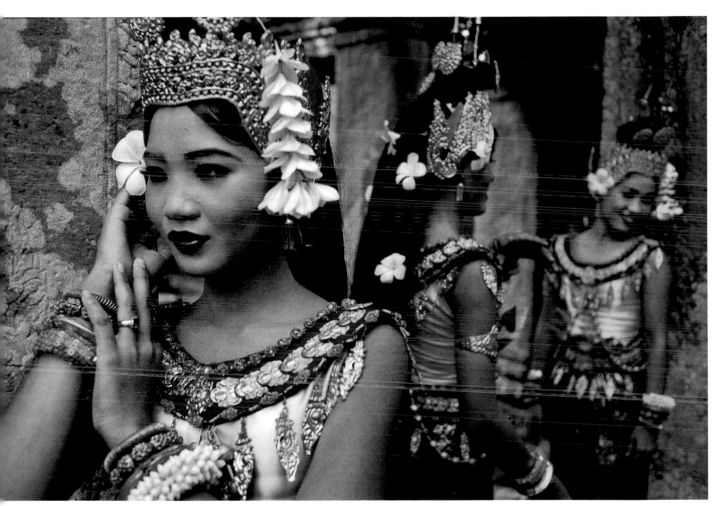

young dancer before her performance at Preah Khan Temple,
iem Reap. Cambodia, 2000.

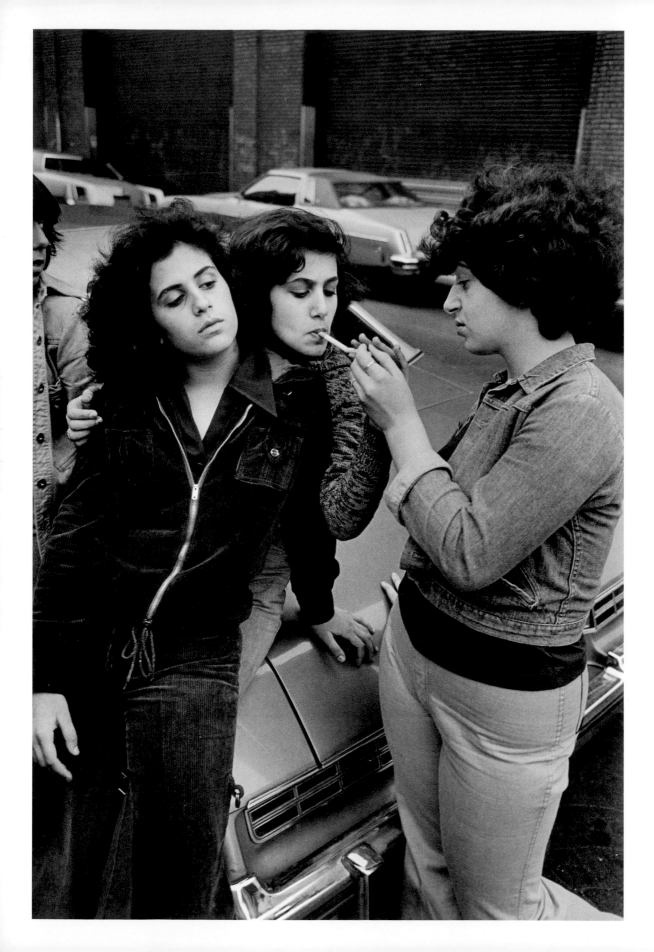

SUSAN MEISELAS

Susan Meiselas was born in the USA in 1948. Her first major photographic essay focused on the lives of women doing striptease at New England country fairs. She photographed the carnivals during three consecutive summers while teaching photography in the New York public schools. *Carnival Strippers* was published in 1976, and a selection of the images was installed at the Whitney Museum of Art in June 2000.

Meiselas received her BA from Sarah Lawrence College, New York, and her MA in visual education from Harvard University. She joined Magnum Photos in 1976. Best known for her coverage of the insurrection in Nicaragua and for her documentation of human rights issues in Latin America, her second monograph, *Nicaragua, June 1978–July 1979*, appeared in 1981.

Meiselas edited and contributed to *El Salvador: The Work of 30 Photographers* and edited *Chile from Within*, which features work by photographers living under the regime of Augusto Pinochet. She has co-directed two films: *Living at Risk: The Story of a Nicaraguan Family* (1986) and *Pictures from a Revolution* (1991) with Richard P. Rogers and Alfred Guzzetti. In 1997 she completed a six-year project curating a 100 year visual history of Kurdistan. Her 2001 monograph, *Pandora's Box*, which explores a New York S&M club, was followed by *Encounters with the Dani*, an account of an indigenous people living in Indonesia's Papua highlands.

Meiselas received the Robert Capa Gold Medal for 'outstanding courage and reporting' from the Overseas Press Club for her work in Nicaragua; the Maria Moors Cabot Prize from Columbia University for her coverage of Latin America; and, in 2005, the Cornell Capa Infinity Award. In 1992 she was named a MacArthur Fellow.

Opposite
Pebbles, JoJo and Ro on Baxter Street, from the series
'Prince Street Girls'. New York City, USA, 1978

The photograph that made me want to become a photographer was *Livia* by Frederick Sommer, a black and white image of young girl in pigtails looking up into my eyes. I believed then that Sommer captured her soul.

One of the photographs that altered the way I saw photography was Susan Meiselas's hillside *Cuesta del Plomo* outside Managua. A picture of a man, his pants still on, but his body decomposed to bones (one of many bodies thrown there by the Somozistas), shocked and humbled me into seeing how a photograph could be so real, present and powerful that it could actually incite change in *me*.

The last incarnation of the hillside *Cuesta del Plomo* was to celebrate the twenty-fifth anniversary of the overthrow of Somoza in Nicaragua. Susan took her now famous images of the revolution and made banners that were placed in their original locations. These visual gifts were a way for the people of Nicaragua to revisit their history, or if unborn or too young at the time, to experience their shared history.

Susan often re-works her ideas like this, sometimes through traditional methods of photography, but more likely through a variety of methods: installation, archive mining, film, the web, etc., presenting us with the gift of a narrative as told by many voices. With her dense, iconic images and collected materials of heaven and hell, she builds a coalition of chronologies that reach deeper and expose more fully than a single image, or even a single understanding of history – whether one's own or collective.

Susan once told me how she would be in her darkroom printing the Carnival Stripper work when the local neighbourhood Prince Street girls would come by and visit her as she was processing. I could only imagine the impact on a 15-year-old girl, as she sees develop before her eyes the image of Shortie lying in the tub, wearing the woes of every woman who has come before her and every one who has come after on her tired face, showing us the little worlds that women live in, carrying the weight of prejudice and presumption in their wide open faces.

Political in nature, but fiercely beautiful in content, Susan's documentation of atrocities, tragedies and daily life offers us a map and timeline for understanding under-represented histories and cultures. It helps us comprehend each of our roles in history and encourages us (me) to engage and participate in the process of changing the way people see the world and, indeed, themselves.

Jim Goldberg

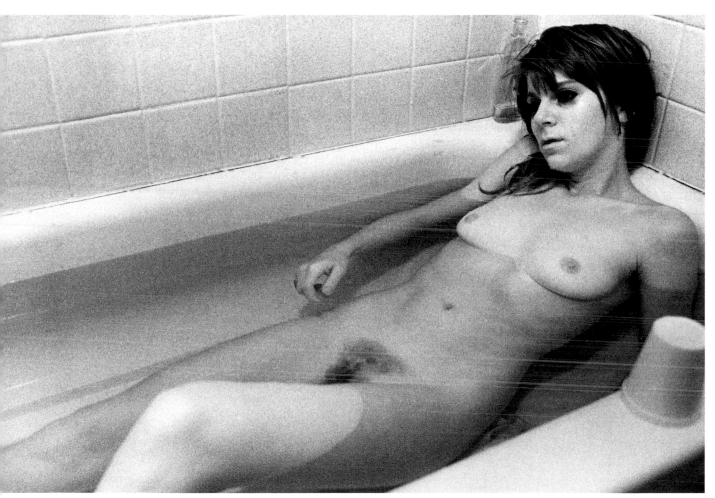

Shortie after hours, from the book *Carnival Strippers*.
South Carolina, USA, 1973

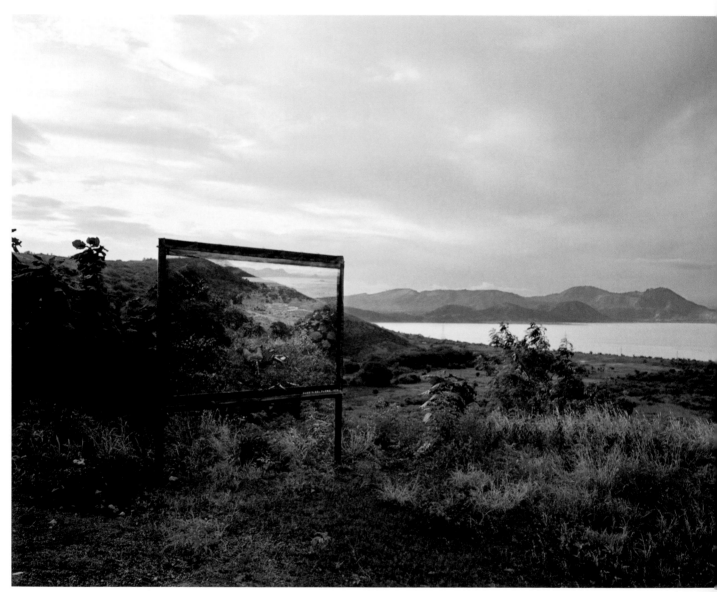

Cuesta del Plomo, Managua, the site of assassinations carried
out by the National Guard in 1978; from the mural series
'Reframing History'. Nicaragua, July 2004

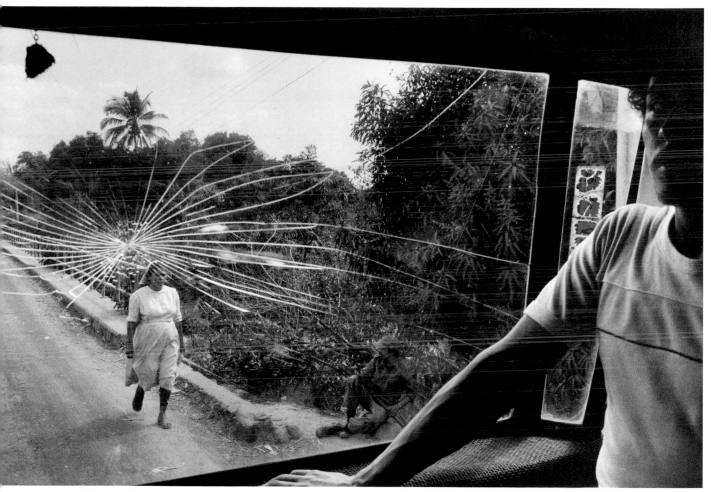

...e road to Aguilares. El Salvador, 1983

INCIDENT NO	REPORTING OFFICER	STAR	DATE(S) & TIME(S) OF OCCURRENCE
	ROUFES ██	██	10-21-91, 1730 - 10-22-91, 0130

NARRATIVE: SUBSEQUENT TO CLEANING UP HER
RESIDENCE AFTER HER EX-HUSBAND VANDALIZED IT, ██(W)██
██████ FOUND THE FOLLOWING WRITTEN ON HER KITCHEN
FLOOR, "DON'T FUCK W/A CRAZY MAN I'LL TEACH YOU
██████████████ YOU'LL BE DEAD BEFORE ANY OF THIS
MATTERS. I LOVED YOU, HOW MUCH. YOU SHOULD HAVE GONE OUT
W/ME BECAUSE I WANT TO DIE NOW + I'M GOING TO TAKE YOU
W/ME I WON'T LET YOU BE WITH ANOTHER MAN! I'M SORRY
BUT YOU HAVE TO GO TO HEAVEN W/ME."

ICSS ENTRY BY:

NOTES

SFPD 377

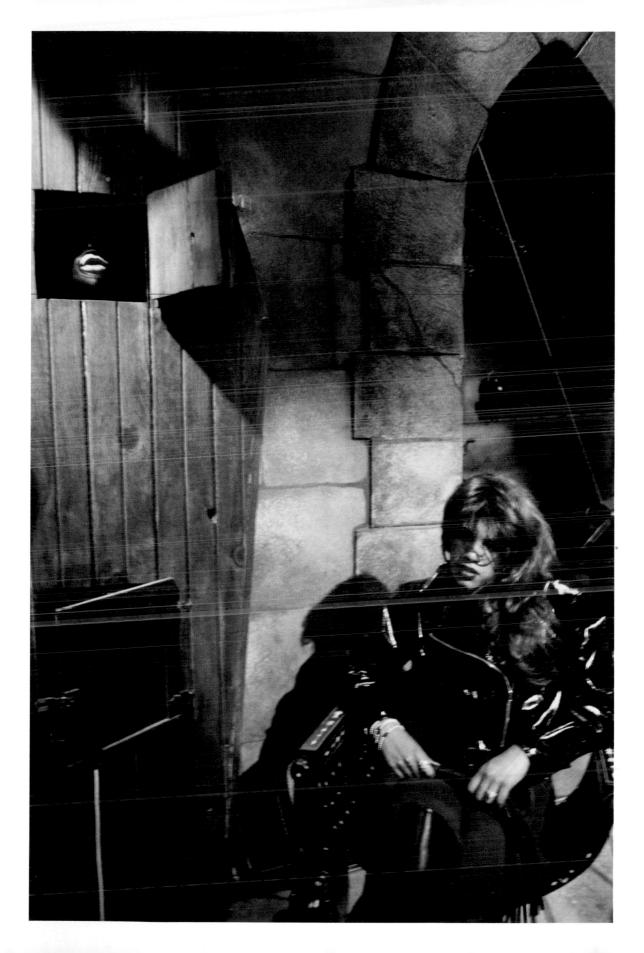

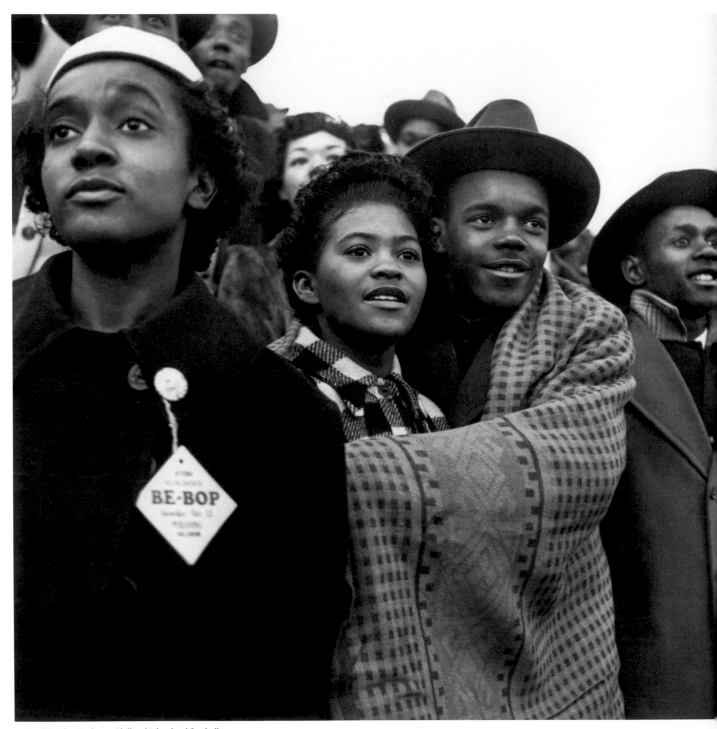

Watching the Dunbar vs Phillips high school football game.
Chicago, USA, 1946

WAYNE MILLER

Born in Chicago in 1918, Wayne Miller studied banking at the University of Illinois, Urbana, while working part-time as a photographer. He went on to study photography at the Art Center School of Los Angeles from 1941 to 1942.

Miller served in the United States Navy, where he was assigned to Edward Steichen's Naval Aviation Unit. After the war he settled in Chicago and worked as a freelancer. In 1946–48, he won two consecutive Guggenheim Fellowships and photographed African-Americans in the northern states.

Miller taught photography at the Institute of Design in Chicago, then in 1949 moved to Orinda, California, and worked for *Life* until 1953. For the next two years he was Edward Steichen's assistant on the Museum of Modern Art's historic exhibit, *The Family of Man*. A long-time member of the American Society of Magazine Photographers, he was named its chairman in the summer of 1954. He became a member of Magnum Photos in 1958, and served as its president from 1962 to 1966. His ambition throughout this period was, in his words, to 'photograph mankind and explain man to man'.

Having been active in environmental causes since the 1960s, Miller then went to work with the National Park Service. He joined the Corporation of Public Broadcasting as executive director of the Public Broadcasting Environmental Center in 1970. After he retired from professional photography in 1975 he devoted himself to protection of California's forests.

Along the way, Miller co-authored *A Baby's First Year* with Dr Benjamin Spock, and wrote his own book, *The World is Young*. He lives in California.

Wayne Miller was born in Chicago. After leaving the US Navy he returned home with a mission: 'to document the things that make this human race of ours a family. We may differ in race, colour, language, wealth and politics. But look at what we all have in common – dreams, laughter, tears, pride, the comfort of home, the hunger for love.'

Miller had seen enough of conflict and thought the only way to avert it was through promoting understanding of other races and cultures, and in so doing to dispel prejudice and racism. It was a mission that inspired his greatest achievements in photography: to produce the landmark book *Chicago's South Side 1946–1948* (published in 2000), from which the six images published here are derived, and to be Edward Steichen's much valued assistant for, and a driving force behind, the *Family of Man* exhibition and book in 1955. Steichen's comment that the exhibition was to be 'a mirror of the essential oneness of mankind throughout the world' reflects exactly Miller's own life's project in photography.

On pages 374 and 375 I have juxtaposed two portraits of meat-packers photographed during the 1948 strike. On the left is an ordinary striker – angry and defiant, yet at the same time cautious and apparently powerless. On the right we meet a strike captain. He is defiant also, but this is a picture of confidence, of certainty.

Together these two perceptive portraits, shot with the child's-eye view of a twin lens reflex camera, emphasize dignity and stature and express the emerging empowerment of Chicago's black community. It was power fought for and won by people such as these: risking personal loss for a greater good. The meat-packing industry, with its conveyor belts and specialized labour, was the protégé of Fordist development in America where the labour force became subsumed by automation and the pursuit of profit. The two men pictured were struggling against both racism and the dangerous and dehumanizing factory work that faced them.

Chicago's South Side 1946–1948 is an impressive testament to the fact that dreams do become reality. Miller's mission, which began on the deck of an aircraft carrier in the South Pacific, to use photography to promote mutual understanding among the diverse family of man, shows once more that photography matters.

Stuart Franklin

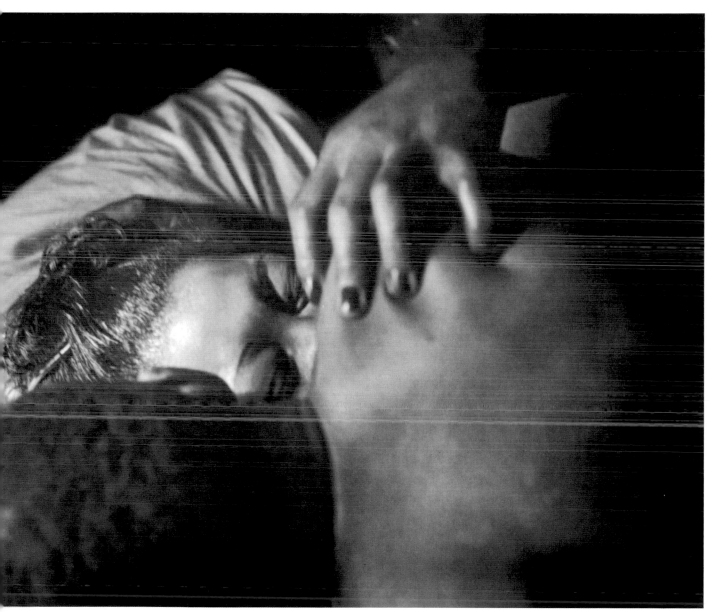

Tuesday afternoon on South Halsted Street. Chicago, USA, 1947

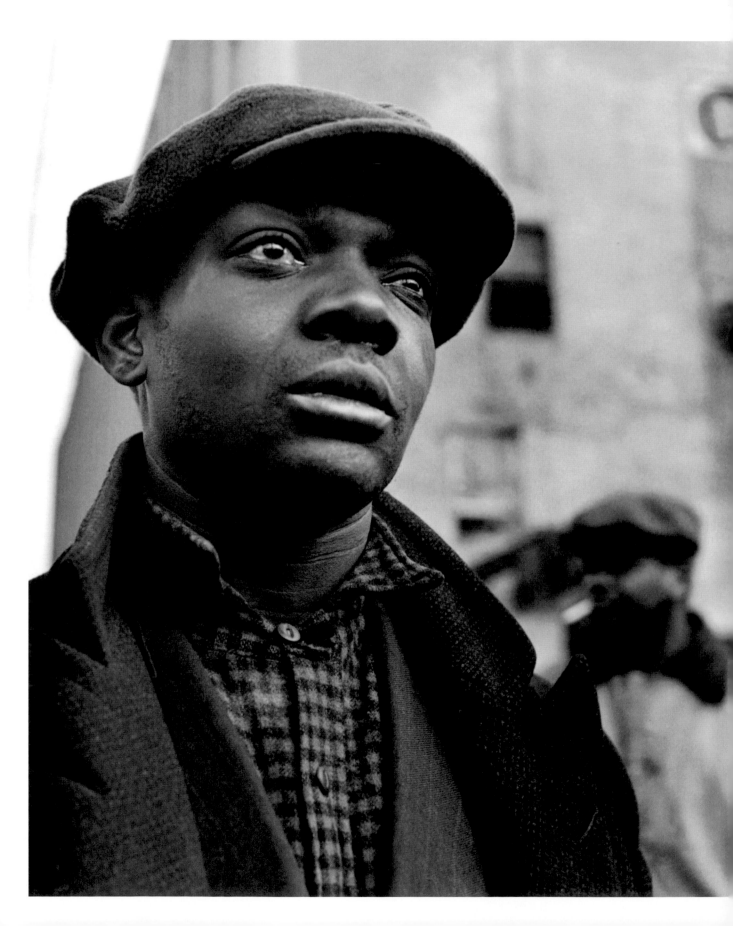

A strike captain during a protest by packing house workers.
Chicago, USA, March 1948

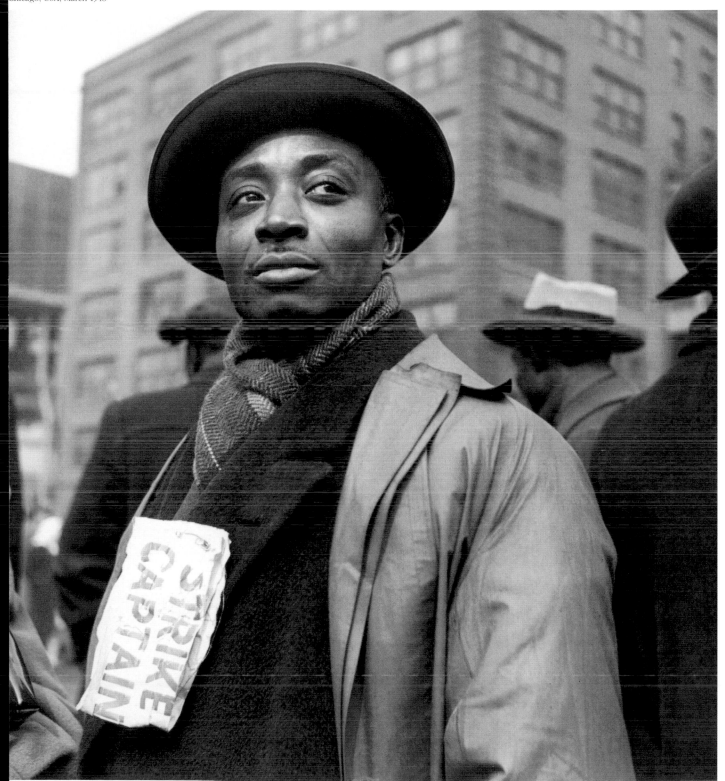

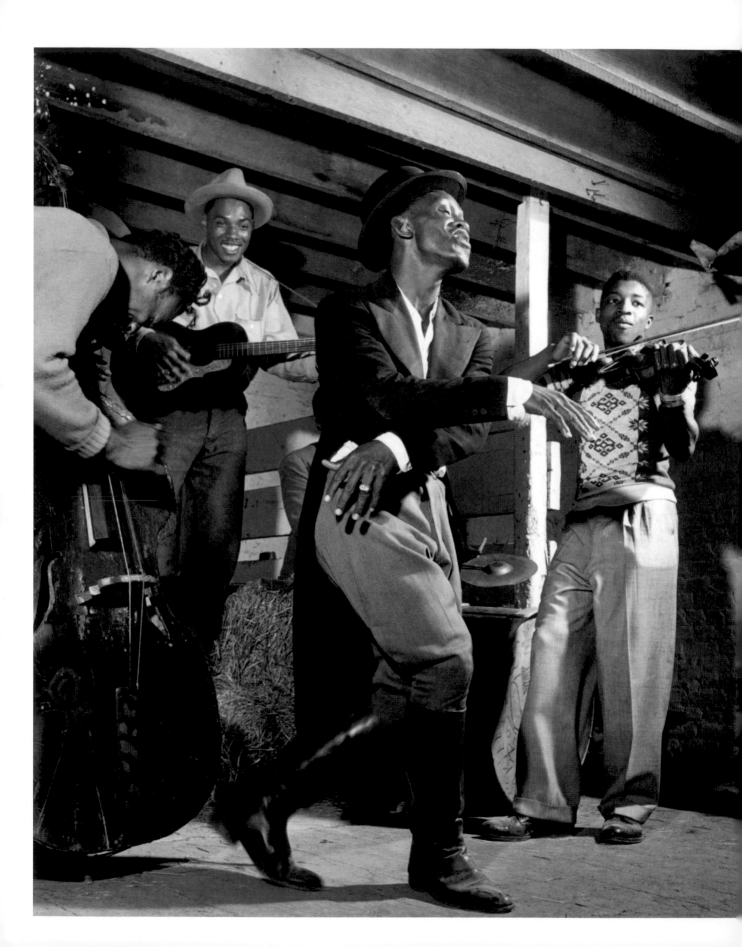

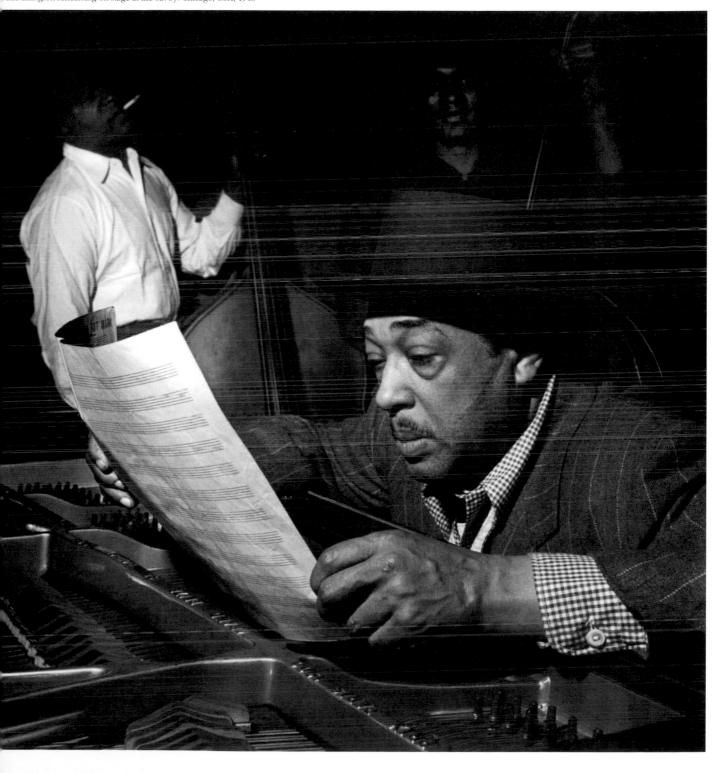

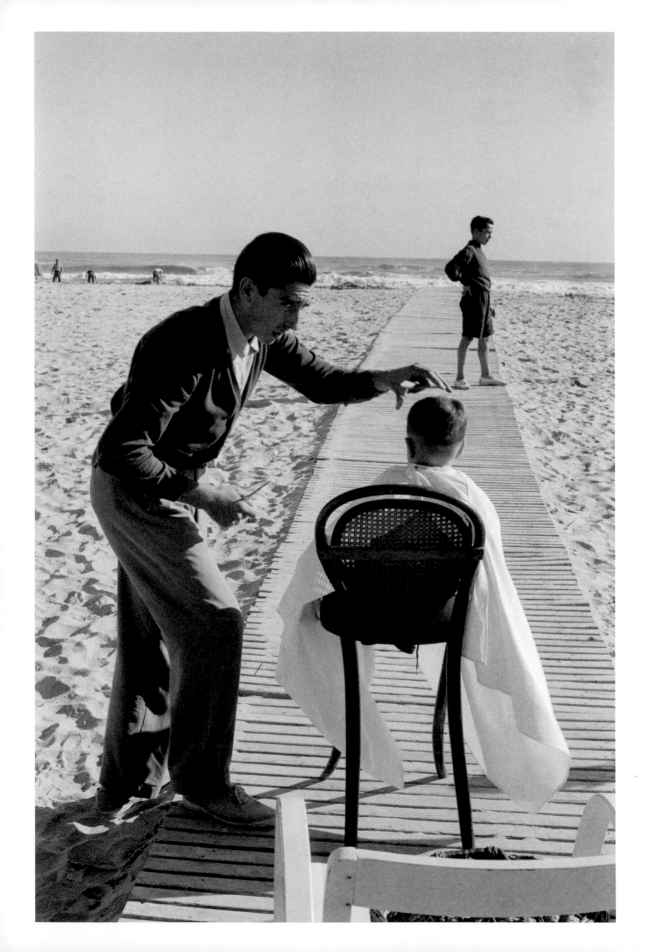

INGE MORATH

Inge Morath was born in Graz, Austria, in 1923. After studying languages in Berlin, she became a translator, then a journalist and the Austrian editor for *Heute*, an Information Service Branch publication based in Munich. All her life Morath would remain a prolific diarist and letter-writer, retaining a dual gift for words and pictures that made her unusual among her colleagues.

A friend of photographer Ernst Haas, she wrote articles to accompany his photographs and was invited by Robert Capa and Haas to Paris to join the newly founded Magnum agency as an editor. She began photographing in London in 1951, and assisted Henri Cartier-Bresson as a researcher in 1953–54. In 1955, after working for two years as a photographer, she became a Magnum member.

In the following years, Morath travelled extensively in Europe, North Africa and the Middle East. Her special interest in the arts found expression in photographic essays published by a number of leading magazines. After her marriage to playwright Arthur Miller in 1962, Morath settled in New York and Connecticut. She first visited the USSR in 1965. In 1972 she studied Mandarin and obtained a visa to China, making the first of many trips to the country in 1978.

Morath was at ease anywhere. Some of her most important work consists of portraits, but of passers-by as well as celebrities. She was also adept at photographing places: her pictures of Boris Pasternak's home, Pushkin's library, Chekhov's house, Mao Zedong's bedroom, artists' studios and cemetery memorials are permeated with the spirit of invisible people still present.

Inge Morath died in New York City on 30 January 2002.

Inge Morath, to me, is above all a lady, and without question an extraordinary persona and photographer. Looking through the endless stream of her photographs, you read a story long in life. She is of course a chronicler, and history will be grateful that she reflected it in her work, reshaping it through herself – becoming part of it herself.

Her biography is legendary. And how much of her history lives on in Magnum! I met her once, and still remember her eyes, soft, clear and soulful – the friendly gaze of a beautiful woman. I looked into those eyes, hoping to see her world imprinted on them.

Through the dates and locales of her photographs, you can trace the trajectory of her journeys. Drawn on the globe, they present a kind of personal calligraphy – Inge's signature on our world. It is the universal, the global vision, in her work that attracts me. And, of course, the lightness and simplicity of a photographer of her class. And of a strong and unknowable woman.

Gueorgui Pinkhassov

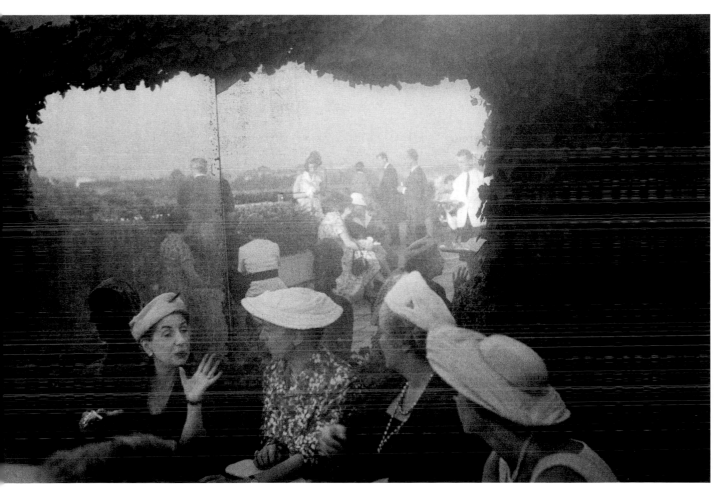

Paris, France, 1957

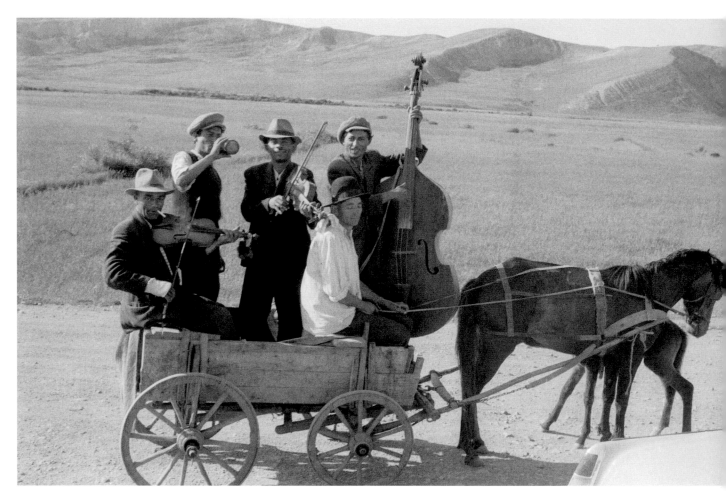

On the way to a wedding. Oltenia, Moldavia, 1958

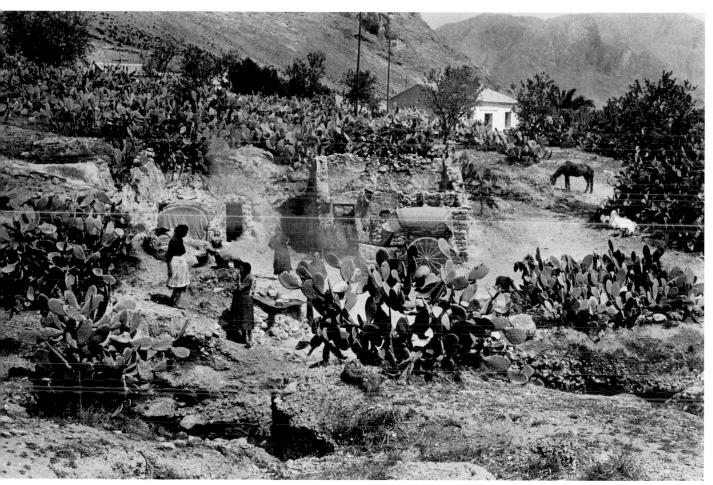

Murcia, Spain, 1954

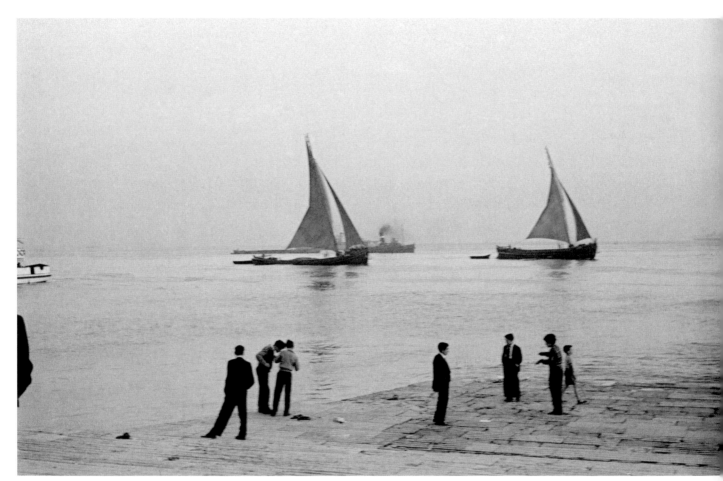

Portugal, 1956

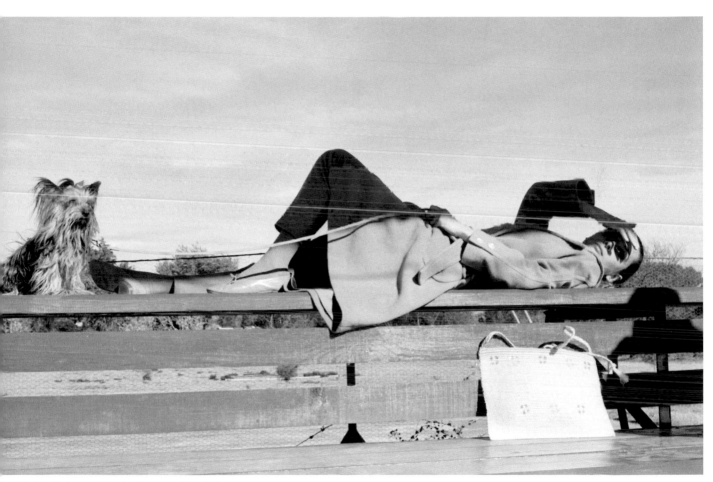

tress Audrey Hepburn with her dog Famous, on the set of
e Unforgiven. Durango, Mexico, 1959

Martin Place, Sydney, Australia, 2002

TRENT PARKE

Trent Parke was born in 1971 and raised in Newcastle, New South Wales. Using his mother's Pentax Spotmatic and the family laundry as a darkroom, he began taking pictures when he was around 12 years old. Today, Parke, the only Australian photographer to be represented by Magnum, works primarily as a street photographer.

In 2003, with wife and fellow photographer Narelle Autio, Parke drove almost 90,000 km (56,000 miles) around Australia. *Minutes to Midnight*, the collection of photographs from this journey, offers a sometimes disturbing portrait of twenty-first century Australia, from the desiccated outback to the chaotic, melancholic vitality of life in remote Aboriginal towns. For this project Parke was awarded the W. Eugene Smith Grant in Humanistic Photography.

Parke won World Press Photo Awards in 1999, 2000, 2001 and 2005, and in 2006 was granted the ABN AMRO Emerging Artist Award. He was selected to be part of the World Press Photo Masterclass in 1999. Parke has published two books, *Dream/Life* in 1999, and *The Seventh Wave* with Narelle Autio in 2000. His work has been exhibited widely. In 2006 the National Gallery of Australia acquired Parke's entire *Minutes to Midnight* exhibition.

Trent and I became nominees of Magnum in 2002 and, even though we live 12,000 miles apart, the shared experience of the tortuous journey to full membership has thrown us together. At each AGM since, the scenario is always the same: I'm dressed in smartish jacket and trousers, while Trent is in T-shirt, shorts and thongs, the embodiment of an Australian surfing dude. We must look an odd couple, but nevertheless we've become great friends.

I have to admit that I am somewhat in awe of Trent's talent. He is, essentially, a street photographer – an extremely difficult thing to do well – but he seems to do it with annoying effortlessness. It seems he has made the genre an appealing option for a new generation of photographers; in short he has reclaimed the streets.

The great road trip is a dream for so many, but for most it never gets any further than that. Trent actually did it; for nearly two years he and fellow photographer (and wife) Narelle Autio explored the Australian outback in an old station wagon. In a series of snaps I've seen since, there is Trent processing his films inside their tent, hanging the negatives up to dry on a nearby eucalyptus. Great stuff.

That work became *Minutes to Midnight*, an apocalyptic view of people trying to come to terms with the realization – in the wake of the 2002 Bali bombing, when 88 Australians lost their lives – that they were a potential terrorist target. Trent's pictures from this series are dark and bleak. Shades of Robert Frank haunt the best of them. It was a memorable day when Trent, Jim Goldberg and I sat in the Paris office trying to put pictures from the series into a sequence that did those remarkable photographs justice. These moments are for me the best part of being with Magnum.

His recent move into colour – and back to the streets – was a brave one, but it works, for colour adds depth and description. It may seem an obvious prerequisite for any photographer to be able to use light effectively, but Trent's understanding of the harsh Australian sun is indeed impressive.

I'm grateful to Trent for showing me something about Australia I didn't already know (even if he looks like a cliché of an Aussie himself).

Mark Power

Town Hall Station. Sydney, Australia, 2006

My parents in their backyard. Newcastle,
New South Wales, Australia, 2003

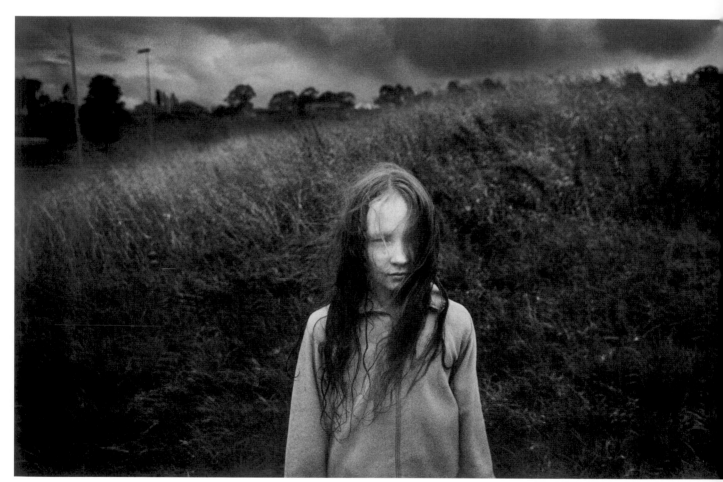

Berwick Suburbs, Victoria, Australia, 2004

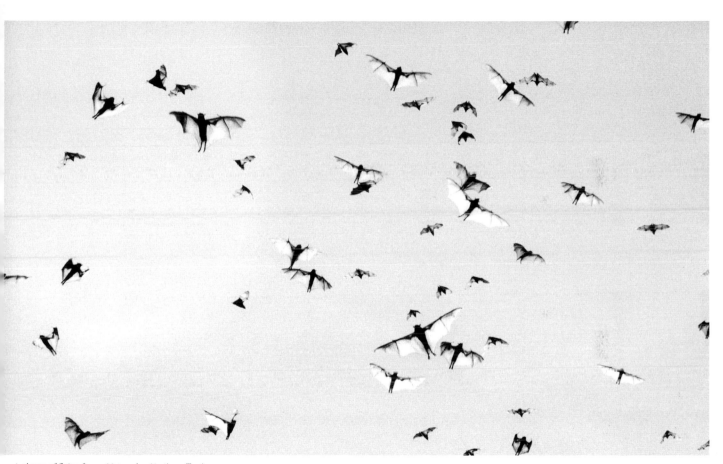

A plague of flying foxes. Mataranka, Northern Territory,
Australia, 2004

Following pages
Midnight: Trent Parke by himself. Menindee, New South Wales,
Australia, 2003

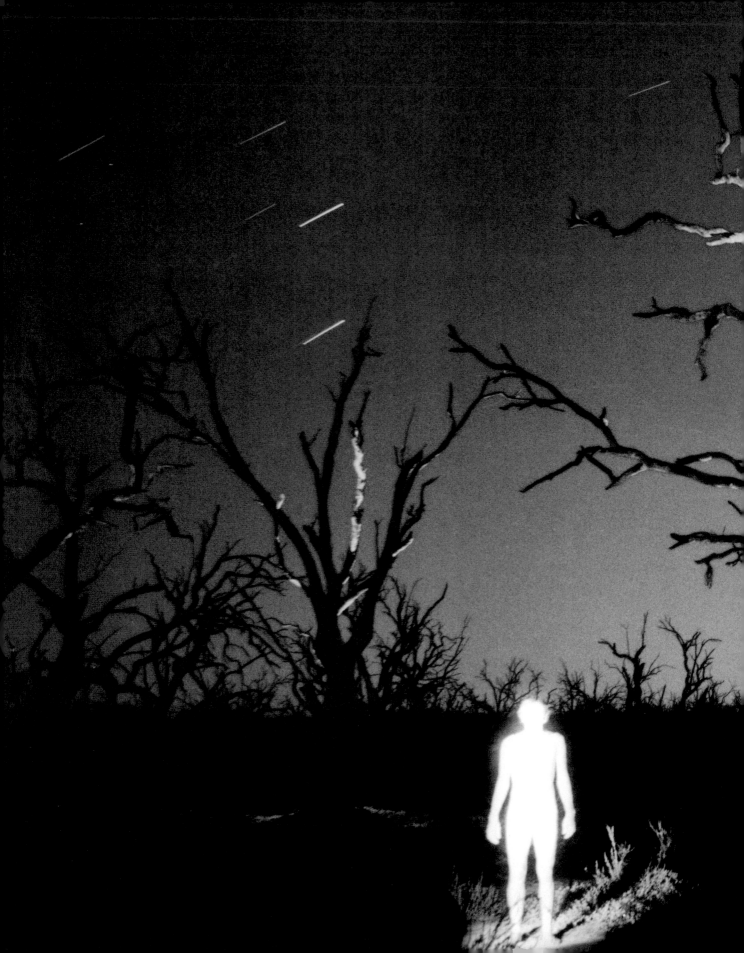

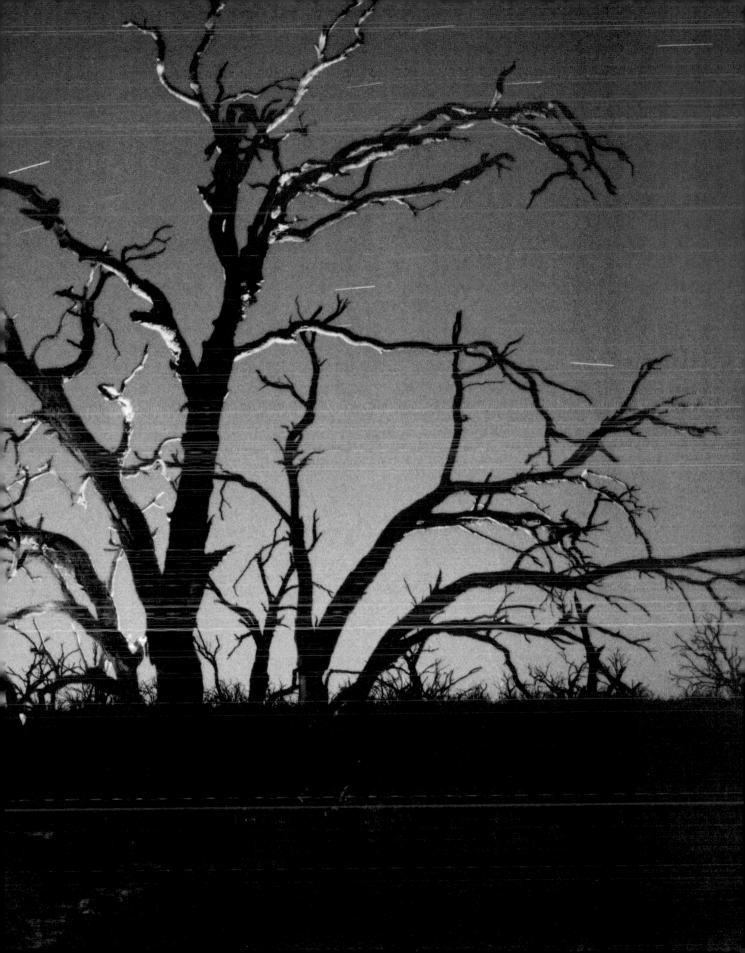

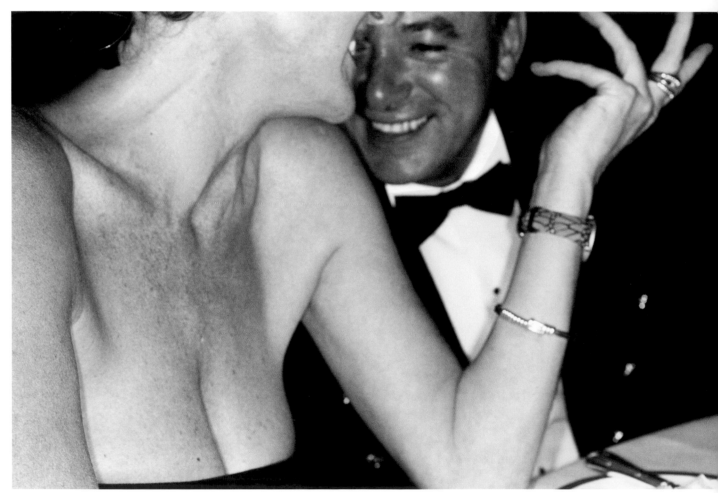

Scarborough, England, 2000

MARTIN PARR

Martin Parr was born in 1952 in Epsom, Surrey. As a boy, his interest in photography was encouraged by his grandfather George Parr, himself a keen amateur photographer.

Parr studied photography at Manchester Polytechnic from 1970 to 1973. To support his career as a freelance photographer, he took on various teaching assignments between 1975 and the early 1990s. At the beginning of the 1980s his work aimed to mirror the lifestyle of ordinary British people, reflecting the social decline and distress of the working class during the era of Margaret Thatcher. He earned an international reputation for his oblique approach to social documentary, and for innovative imagery. In 1994 he became a member of Magnum after much heated debate over his provocative photographic style.

For Parr, the moral atrophy and preposterousness of our daily lives means we can only find salvation through adopting a certain sense of humour. The banality, boredom and lack of meaning of modern times are portrayed in works such as *Bored Couples* and *Common Sense*.

In 2002 Phaidon published the monograph *Martin Parr*. A large retrospective of Parr's work was initiated by the Barbican Art Gallery in London, and has since been shown in the Museo Nacional de Arte Reina Sofía in Madrid, the Maison Européenne de la Photographie in Paris and the Deichtorhallen in Hamburg.

Parr was appointed Professor of Photography in 2004 at the University of Wales, and was Guest Artistic Director for Rencontres d'Arles in the same year. In recent years, he has developed an interest in film-making, and has started to use his photography in different contexts, such as fashion and advertising.

Are there other photographers in Magnum who lead a 'monogamous' life in black and white versus the ones who lead a 'double life' in black and white and colour? There is an eternal discussion among painters between the figurative and the abstract.

When I met Martin Parr for the first time at the film festival in Cannes, he had become essentially a colour photographer. We had long and heated discussions about accepting him into Magnum. To be frank, the disagreements were not only about colour. I supported him when he finally became a member. Henri Cartier-Bresson asked me why we thought Parr was part of the Magnum 'palette'. The world in the 1950s and the 1960s was grey and drab, with the exception of countries like Russia, China, Cuba, etc., where the colour red dominated.

I told HCB that Parr had photographed like all of us in black and white for many years, and maybe he woke up one morning having had a nightmare of a world exploding in colour, tourism and kitsch, which is what some said in a slightly cynical way. We often brought in photographers, and not always successful ones, who would bring new ideas but also upset the apple cart.

There is no doctrine that exists in Magnum about political, religious and social issues. There are probably no two photographers among the sixty or so members who would agree on which kind of camera, lens, film or digital to use. However, the credo laid down by the founding fathers of Magnum was and still is to photograph the human condition of our changing world. This is with your 'third eye', mind and heart, which makes you solely responsible for your actions.

I congratulated Martin Parr on his excellent art direction at the Arles photo-festival some years ago, adding that I was not exactly trying to put an end to the 'Martin Parr-ization of the world in colour', but that I was now working on a book myself to show humanity in colour in a different way.

Food for thought for us all: a young photographer in China asked me some years ago whether I knew what Chinese painters, poets or sculptors would do when they became famous. I did not know. He said they would change their names, in order to see whether they were still any good.

René Burri

...here wasn't anything here that had a feminine touch. I basically
...oved in and plonked things down.' England, 1991

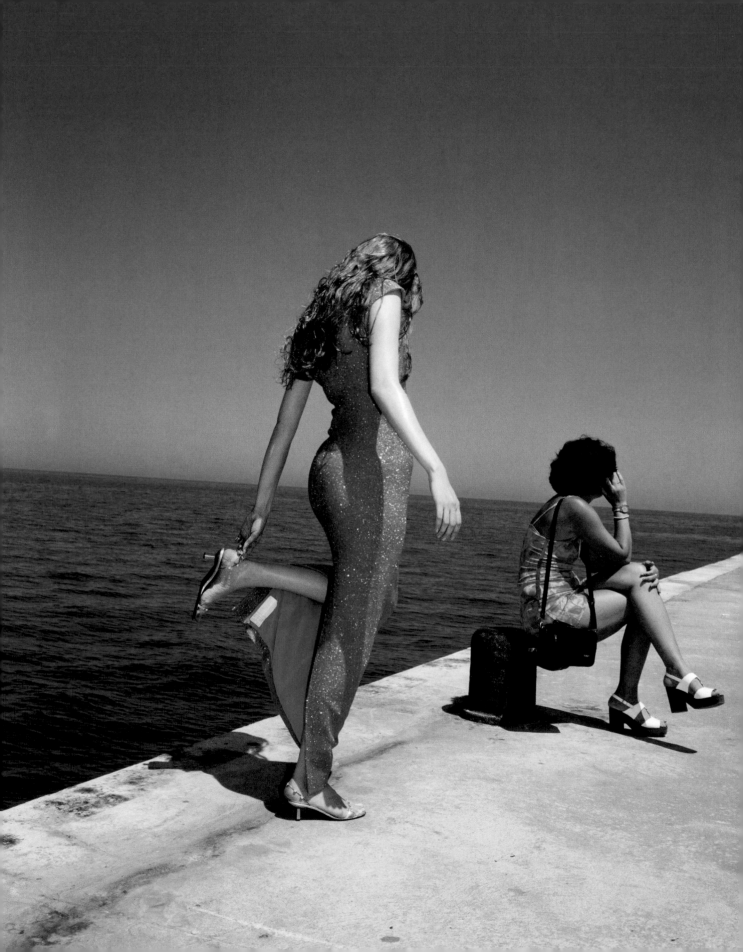

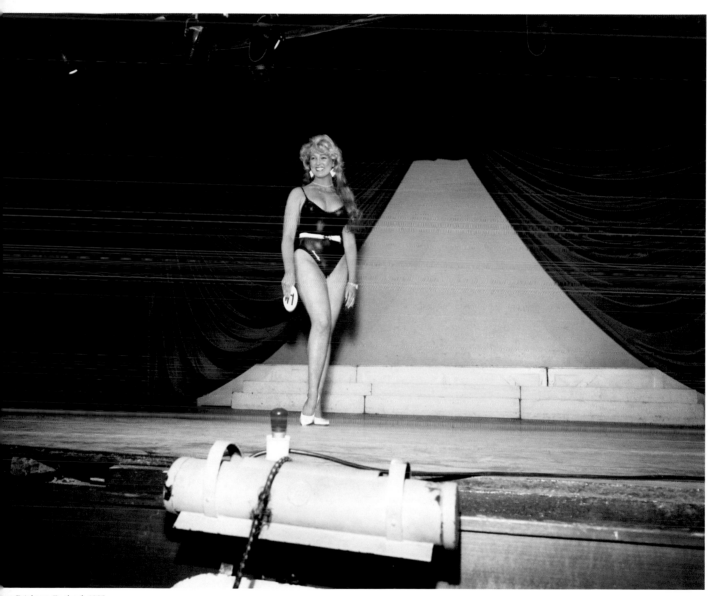

New Brighton, England, 1985

British Fashion Week. England, 1998

...ati store, Paris, France, 1998

A crippled refugee child in Nyala. South Darfur province,
Sudan, 2004

PAOLO PELLEGRIN

Paolo Pellegrin was born in 1964 in Rome. He became a Magnum Photos nominee in 2001 and a full member in 2005. He is a contract photographer for *Newsweek* magazine.

Pellegrin is winner of many awards, including eight World Press Photo and numerous Photographer of the Year Awards, a Leica Medal of Excellence, an Olivier Rebbot Award, the Hansel–Meith Preis, and the Robert Capa Gold Medal Award. In 2006 he was assigned the W. Eugene Smith Grant in Humanistic Photography.

He is one of the founding members of the touring exhibition and installation *Off Broadway* along with Thomas Dworzak, Alex Majoli and Ilkka Uimonen. He has published four books. He lives in New York and Rome.

When I look at Paolo Pellegrin's photos, I feel a sense of impending doom, as if the world is about to end, the sky to fall on my head. His characters seem like actors in a theatre of darkness.

Look at his image of a house destroyed in the Darfur province of Sudan: the earth is scorched, presumably by the Janjawi militias who, we are told, practise the African version of ethnic cleansing. A wall is still erect, a derisory witness of the civil war which is tearing this region apart. Nothing will grow here again, no human being will come back.

Paolo's palette includes the out-of-focus and the movement-blurred – he makes a creative use of black and white, highlighting contrasts, blurring details. What is lost to journalism is won to poetry.

Paolo uses these tools to emphasize his point. His style is at the service of his social conscience; he covers wars and political upheavals, today's great waves of our history … unlike many a photographer today who uses the same tools as gadgets, whose photography is all style but lacks content.

This is why I offered to edit his work for this book.

Abbas

Following pages
top left
Yasser Arafat's funeral in the Muqata compound, Ramallah. West Bank, 2004

bottom left
Iraqi civilians and militants dragging away the body of a fighter killed by coalition forces. Basra, Iraq, 2003

top right
Serbian women mourning a man killed by the Albanians. Obilic, Kosovo, 2000

bottom right
A destroyed village near Nyala. South Darfur province, Sudan, 2004

The mother of a child killed during the Israeli Defence Forces'
incursion into Jenin. Israel, 2002

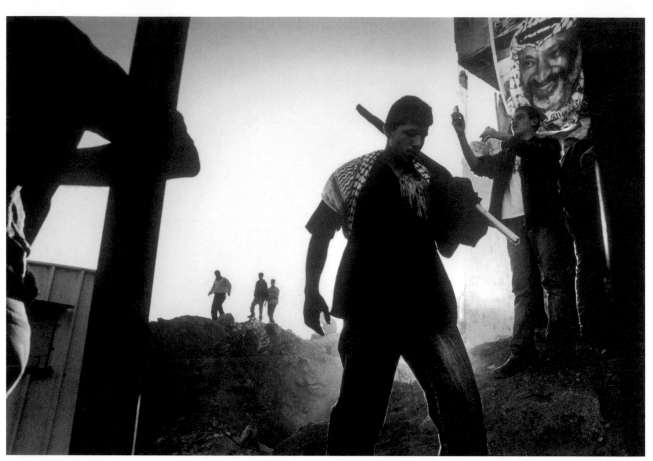

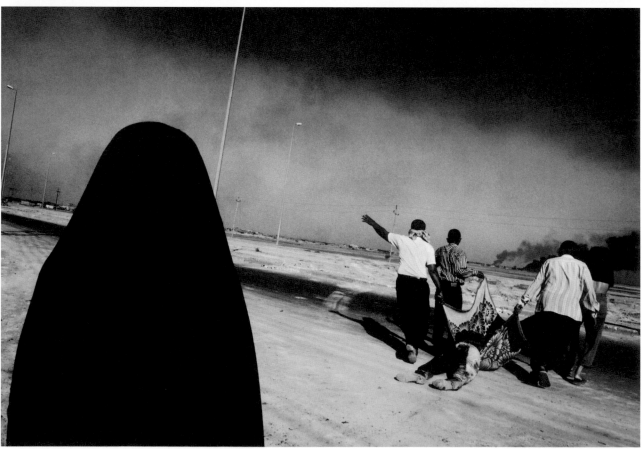

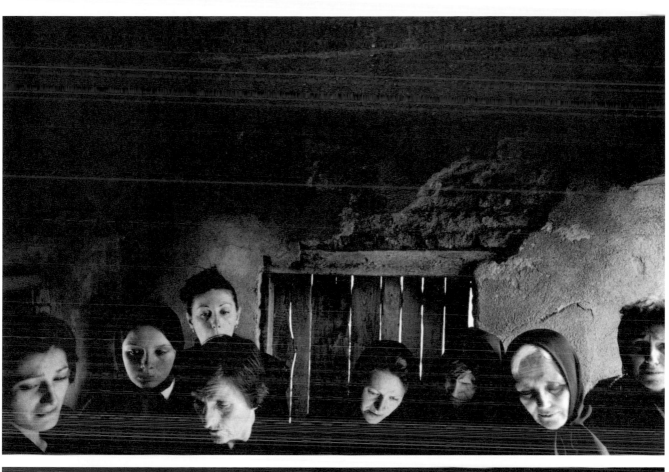

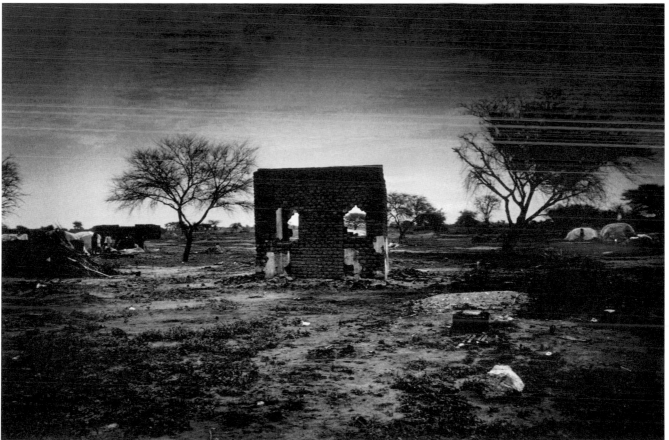

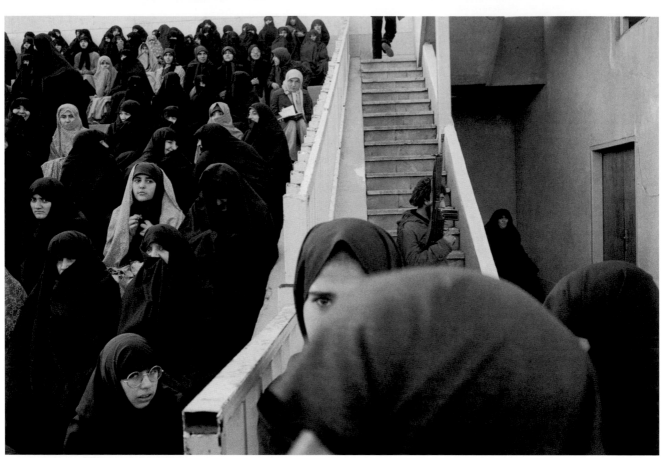

GILLES PERESS

Gilles Peress was born in France in 1946 and studied at the Institut d'Études Politiques and at the Université de Vincennes. Peress started using photography to create museum installations and books in 1971. His books include *Haines* (2004); *A Village Destroyed* (2002); *The Graves: Srebrenica and Vukovar* (1998); *The Silence: Rwanda* (1995); *Farewell to Bosnia* (1994); and *Telex Iran* (1984, reprinted 1997).

His work has been exhibited and is collected by the Museum of Modern Art, the Metropolitan Museum of Art, the Whitney Museum of American Art, the International Center of Photography and PS1, all in New York; the Art Institute of Chicago; the Corcoran Gallery of Art, Washington, D.C.; the George Eastman House in Rochester; the Walker Art Center and the Minneapolis Institute of Arts; the V&A in London; the Musée d'Art Moderne, Parc de la Villette and Centre Georges Pompidou in Paris; the Museum Folkwang, Essen; the Sprengel Museum, Hanover; and the Nederlands Foto Instituut, among others.

Among the awards and fellowships Peress has received are: Guggenheim, National Endowment for the Arts (1992, 1984, 1979), Pollock–Krasner (2002) and New York State Council of the Arts (2002) fellowships, the W. Eugene Smith Grant for Humanistic Photography, the Gahan Fellowship at Harvard University, the International Center of Photography Infinity Award (2002, 1996, 1994), the Erich Salomon Prize, and the Alfred Eisenstaedt Award (2000, 1999, 1998).

Portfolios of his work have appeared on numerous occasions in the *New York Times Magazine*, the *Sunday Times Magazine*, *Du* magazine, *Life*, *Stern*, *Geo*, *Paris-Match*, *Parkett*, *Aperture*, *Doubletake*, the *New Yorker* and the *Paris Review*.

Peress joined Magnum Photos in 1971 and served three times as vice-president and twice as president of the co-operative. He and his wife, Alison Cornyn, live in Brooklyn with their three children.

Opposite
top
A demonstration in a stadium at Tabriz. Iran, 1979
bottom
Jews leaving Sarajevo. Bosnia, 1993

Gilles Peress has made two central contributions to the brief and turbulent history of conflict representation.

Firstly, as in his book *Telex Persan* (1984), he placed the problems of being a witness to the events he was recording at the centre of his work as a photographer. 'Telex' refers to the unfolding dialogue between Peress and the Magnum office in Paris, when Peress was photographing for five intense weeks during the Iran hostage crisis. The problems of being a witness, dealing with the assignments as they came in and getting the correct captions are all part of the text that weaves its way between the photographs. This may not sound so radical, but remember the photojournalist is meant to be a harbinger of truth. Peress acknowledges the inherent problem of this by confessing his subjectivity.

Peress's second contribution, illustrated very well by the selection in this book, is the way he frames his photographs. The framing is fractured and crowded, with people and structures coming in and out of the image. You get the feeling that what is presented is a small excerpt from a wider, more chaotic scene. As Peress has often been on the war front this is indeed the case. However, few photographers have been able to evoke that feeling of energy and chaos as eloquently as Peress. There was also a political motive for developing this new language. Peress was trying to distance himself from the predictable form of photojournalism, where the symmetry and neatness of the images often sanitized a desperate situation.

Despite the chaos depicted, these images have a strangely alluring beauty. Within their sophisticated form, Peress's photographs show high emotion, demonstrated in the desperate hands of the men on the Croatian bus, the determination of those kids running down the street in Belfast and the veiled women with the armed man in Tehran.

Sit back and unravel these complicated, compelling photographs. I have never been in a war situation and honestly hope I will never have to experience this. Yet I suspect these images by Gilles Peress tell me what it might be like.

Martin Parr

Opposite
top
Tabriz, Iran, 1979
bottom
Tehran, Iran, 1979

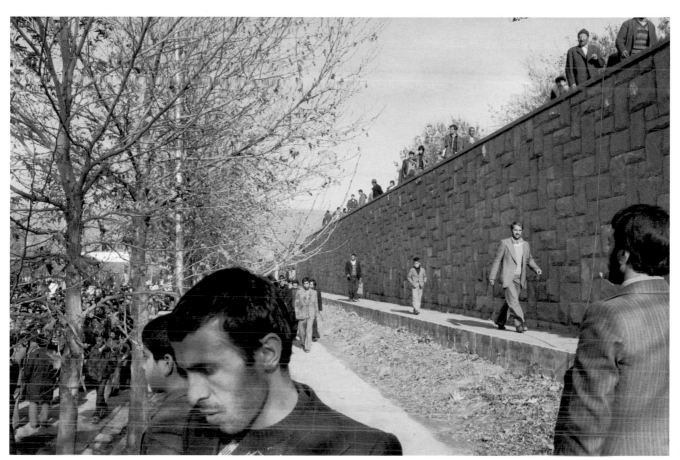
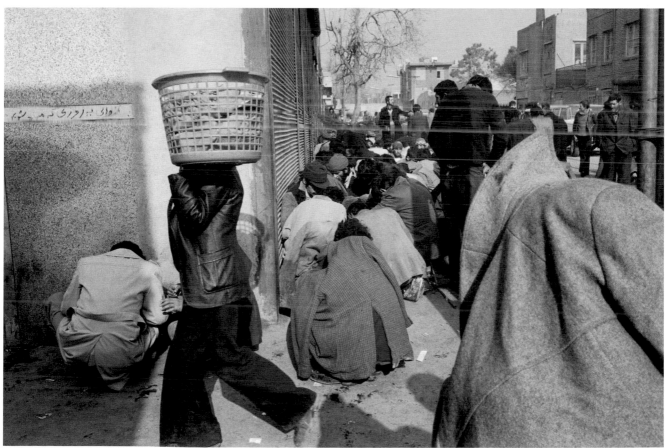

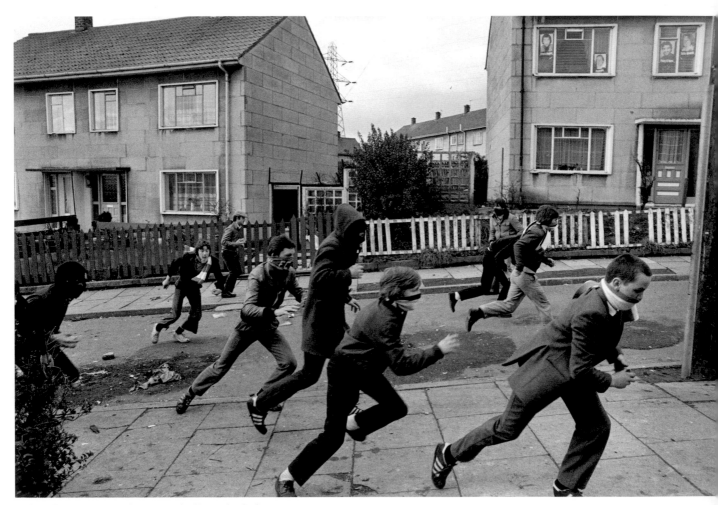

The Ballymurphy estate on the morning of Bobby Sands's death.
Belfast, Northern Ireland, 1981

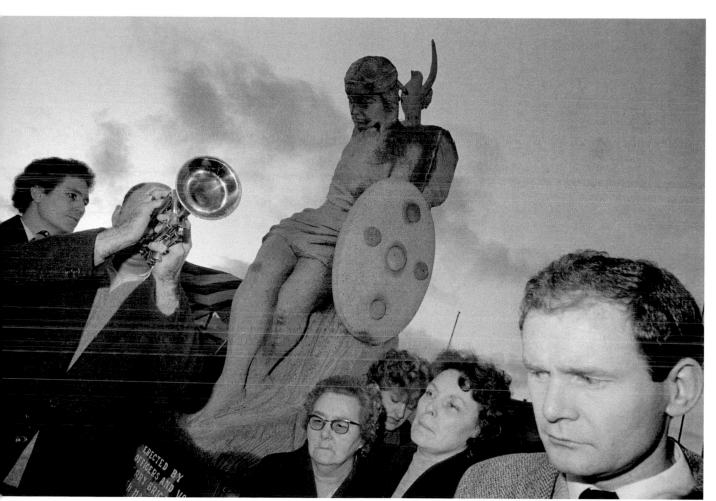

he funeral of an IRA man. Derry, Northern Ireland, 1984

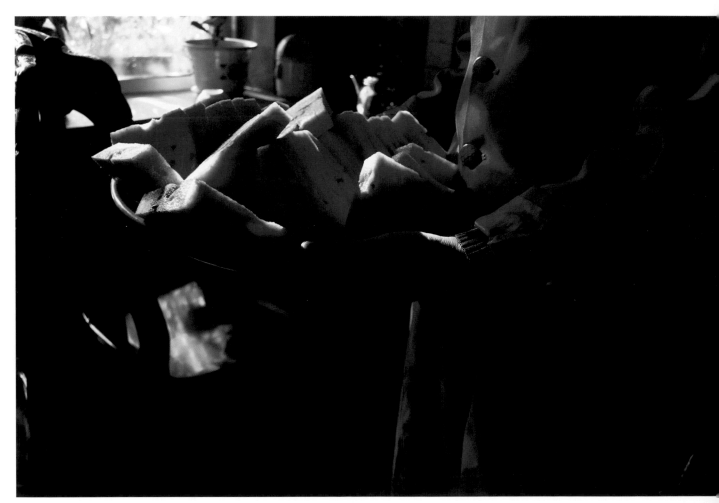

Xianjiang, China, 2006

GUEORGUI PINKHASSOV

Gueorgui Pinkhassov was born in Moscow in 1952. His interest in photography began while he was still at school. After studying cinematography at the VGIK (the Moscow Institute of Cinematography), he went on to work at the Mosfilm studio as a cameraman, then as a set photographer.

In 1978 Pinkhassov joined the Moscow Union of Graphic Arts and was awarded independent artist status. His work was noticed by the prominent Russian film-maker Andrei Tarkovsky, who invited Pinkhassov to work on the set of his film *Stalker* (1979). In the same year some of his images were included in a group exhibition of Soviet photographers held in Paris, where they attracted attention.

Pinkhassov moved permanently to Paris in 1985. He worked for the international press, particularly for *Geo*, *Grand Reportage* and the *New York Times Magazine*, but covering events did not interest him. As his first book, *Sightwalk*, proves, Gueorgui Pinkhassov prefers to explore individual details, through reflections or particular kinds of light, often approaching abstraction. He has been a member of Magnum Photos since 1994.

It is foolish to change the vector of chaos. You shouldn't try to control it, but fall into it.

An artist cannot be nourished by self-will. Curiosity melts you down to the size of the lens's opening, so you can slip into the unknown. 'No one has gone that far before' – this is the only compliment for the insatiable imagination. It's not a sin to get lost. You should lose your way. Just be sure to find a way to get back.

The return, after all, is the most touching – like Brueghel's hunters coming back to the hearth, or Rembrandt's prodigal son returning home. That is the heart of it all – at the end. But it starts, of course, with the feet!

Gueorgui Pinkhassov

Opposite
top and bottom
Murmansk, Russia, 2006

Following pages
Norway, 2005

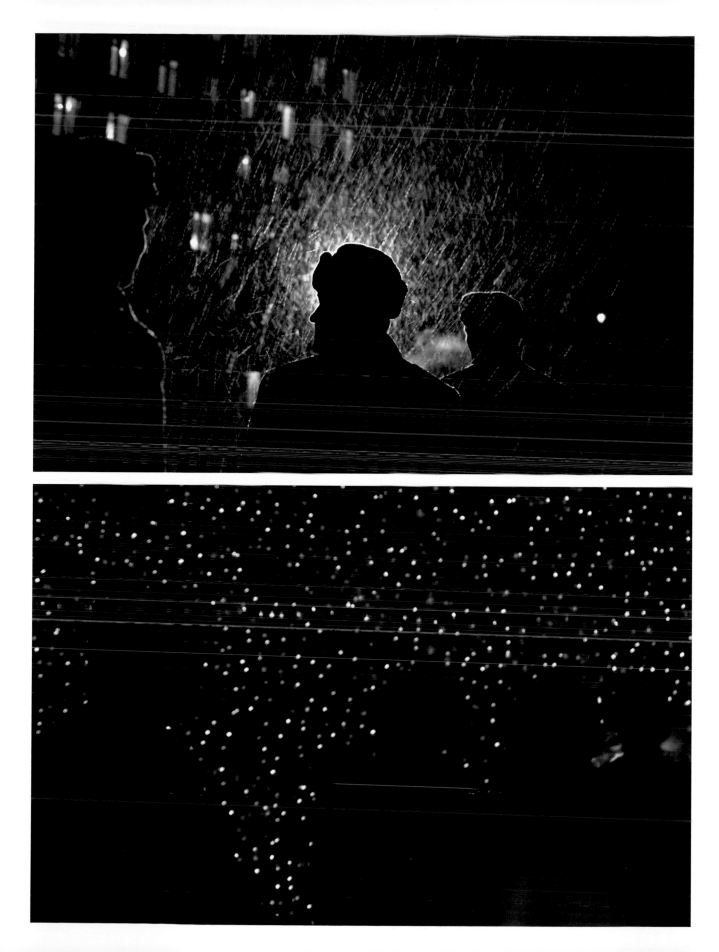

Venice Biennale, Italy, 2003

Lianjiang, China, 2006

Rzeszów, Poland, 2004

MARK POWER

Mark Power was born in 1959 and is British. As a child he discovered his father's home-made enlarger in the family attic, a contraption consisting of an upturned flowerpot, a domestic light bulb and a simple camera lens. His interest in photography probably began at this pivotal moment, although he later chose to study painting and drawing instead. He 'became a photographer' (somewhat accidentally) in 1983, and worked in the editorial and charity markets for nearly ten years, before he began teaching in 1992. This move coincided with a shift towards long term, self-initiated projects, which now sit comfortably alongside a number of large-scale commissions in the industrial sector.

Power's work has been seen in numerous solo and group exhibitions across the world and he has published four books: *The Shipping Forecast* (1996), *Superstructure* (2000), *The Treasury Project* (2002) and *26 Different Endings* (2007). He is Professor of Photography at the University of Brighton.

Mark Power joined Magnum Photos in 2002.

Civilization is doomed. Old myths are collapsing. Work, thought, information, memory, art, representation, science, politics, history, the event itself – these are no more than empty shells. Man yields to a new moral and commercial imperative that manipulates and sets his desires.

When I consider the obscenity of these mutant forms in Mark Power's world view, I hear an echo of my own concern – paradoxically, perhaps, taking into account our different diagnostics and strategies. The definition of art as a reporting tool or way of acting belongs to both of us. While I see an antidote to the reality imposed on us in an ethic of nothingness, he ruffles the surface of things and isn't discouraged when even this fragile, temporary reality shirks its responsibilities. He can look beyond his preconceptions at an empty object, confidently keeping at a respectful distance, and deliver a topographical report on this threatening scene: the world emptied of its helpless actors.

Filled with uncertainty in the presence of what is real, his pictures don't attempt to prove some predefined theory about the state of things. Little by little, Mark Power removes the human and social dimensions of contemporary space to promote this theatre of irony, where sense disappears beneath the spectacular surface.

He contemplates the world from a distance and makes a novel aesthetic analysis of it. By considering the beauty and ugliness and the insignificant banality of our daily surroundings, his meticulous, nostalgic, stubborn collection of this loss of substance creates a truly clear poetic rendition of horror.

His images tell us of the tyranny of signs which, freed from the reality that they signify, multiply and leave us in the grip of fascination. They announce the worst: the numbered reproduction and proliferation of the species ad infinitum, implantable bugs in the living organism, chemically driven molecular machines, incestuous interbreeding between flesh and the machine, the commercialization of the body and thought, and the advent of a virtual humanity that is adapting itself to the disappearance of sense in our existence.

Antoine d'Agata

Building the Airbus A380. Puerto Real, Spain, 2004

The funeral of Pope John Paul II, broadcast live from the Vatican.
Warsaw, Poland, April 2005

yrardów, Poland, February 2005

Building the Airbus A380. Toulouse, France, 2003

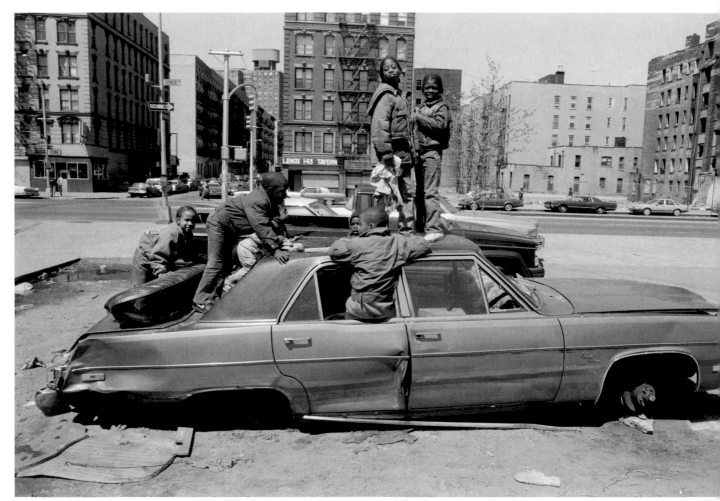

Harlem street scene. New York City, USA, 1987

ELI REED

Eli Reed was born in the US in 1946 and studied pictorial illustration at the Newark School of Fine and Industrial Arts, graduating in 1969. In 1982 he was a Nieman Fellow at Harvard University. At Harvard's Kennedy School of Government, he studied political science, urban affairs, and the prospects for peace in Central America.

Reed began photographing as a freelancer in 1970. His work from El Salvador, Guatemala and other Central American countries attracted the attention of Magnum in 1982. He was nominated to the agency the following summer, and became a full member in 1988.

In the same year Reed photographed the effects of poverty on America's children for a film documentary called *Poorest in the Land of Plenty*, narrated by Maya Angelou. He went on to work as a stills and specials photographer for major motion pictures. His video documentary *Getting Out* was shown at the New York Film Festival in 1993 and honoured by the 1996 Black Film-makers Hall of Fame International Film and Video Competition in the documentary category.

Reed's special reports include a long-term study on Beirut (1983–87), which became his first, highly acclaimed book *Beirut, City of Regrets*, the ousting of Baby Doc Duvalier in Haiti (1986), US military action in Panama (1989), the Walled City in Hong Kong and, perhaps most notably, his documentation of African-American experience over more than twenty years. Spanning the 1970s through the end of the 1990s, his book *Black in America* includes images from the Crown Heights riots and the Million Man March.

Reed has lectured and taught at the International Center of Photography, Columbia University, New York University, and Harvard University. He currently works as Clinical Professor of Photojournalism at the University of Texas in Austin.

Eli Reed and Dennis Stock in conversation, May 2007

ER From first grade I was drawing and painting. I was into Greek and Roman mythology, and science fiction – other realities, other worlds. I went to art school, and my father helped support me, financially and spiritually. Until then, going to college had seemed like an impossibility. I wanted to join the Marines, but I had bad eyesight. One day an art critic saw one of my paintings, and he said I should consider a career in art.

DS Do you remember the people who inspired you?

ER This was the time of the Civil Rights movement, and it made an imprint. Martin Luther King and Malcolm X, you could say they were inspiring.

DS But they didn't inspire you to go to art school.

ER Oh, they did! They encouraged me to be the best at what I wanted to be.

DS When did you first touch a camera?

ER I was 10 years old, and I took a picture of my mother in front of the Christmas tree. I spent so much time looking at that picture – she died when I was 12. When I graduated from high school I got a Kodak Instamatic 104. Then I saw Magnum pictures in photography magazines. That was the beginning of getting serious. It was like taking steps into another world. When did you work on *Planet of the Apes?*

DS That was in 1967.

ER Right. So I saw your picture of an ape at a bus stop – that stopped me in my tracks. And someone lying on the ground with a plane's shadow going by – how the hell did you do that? It's that excess of reality coming at you.

DS (laughs) Well, I'm glad I was a tiny inspiration for you …
What do your pictures say about race?

ER Every picture I take is a rebuttal of race. Colour, shapes, whatever – we're all in the same boat. Am I denying race? No, I'm fighting the best way I know. It's a constant battle. I don't like to talk about it the whole time – it's too tiring, too depressing. At one point I considered becoming a Jesuit priest – I'm not even Catholic! – I thought I'd like to be someone who's doing some good out there.

DS Can you talk about the wedding picture?

ER This guy, who had never done anything wrong, was arrested for robbing a fast food restaurant. The police arrested him because he was black. *People* magazine pushed to get him released, and they sent me to cover his wedding.

I like happy endings.

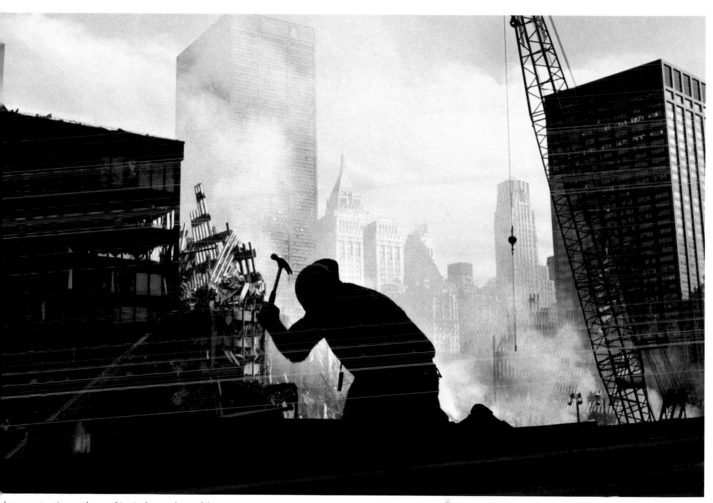

lone construction worker working in the wreckage of the
orld Trade Center. New York City, USA, 12 September 2001

Eli Reed 435

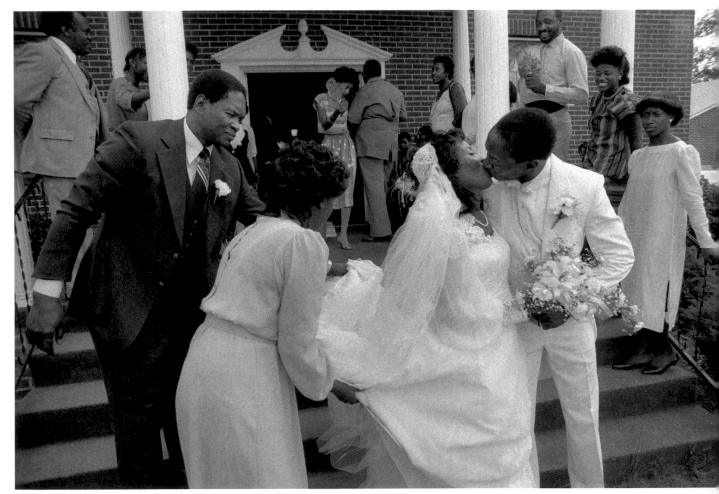

Above
Beaufort, South Carolina, USA, 1984

Opposite
Tenderloin: Merrill Anderson, 23, born on a Navajo reservation in
Arizona, sells found objects to get by. San Francisco, USA, 1999

Ted 'Double Duty' Radcliffe in the men's room.
Chicago, USA, 2002

The Perth Amboy High School Class of 1965 Reunion at the
Clarion Hotel, Edison, New Jersey. USA, 2000

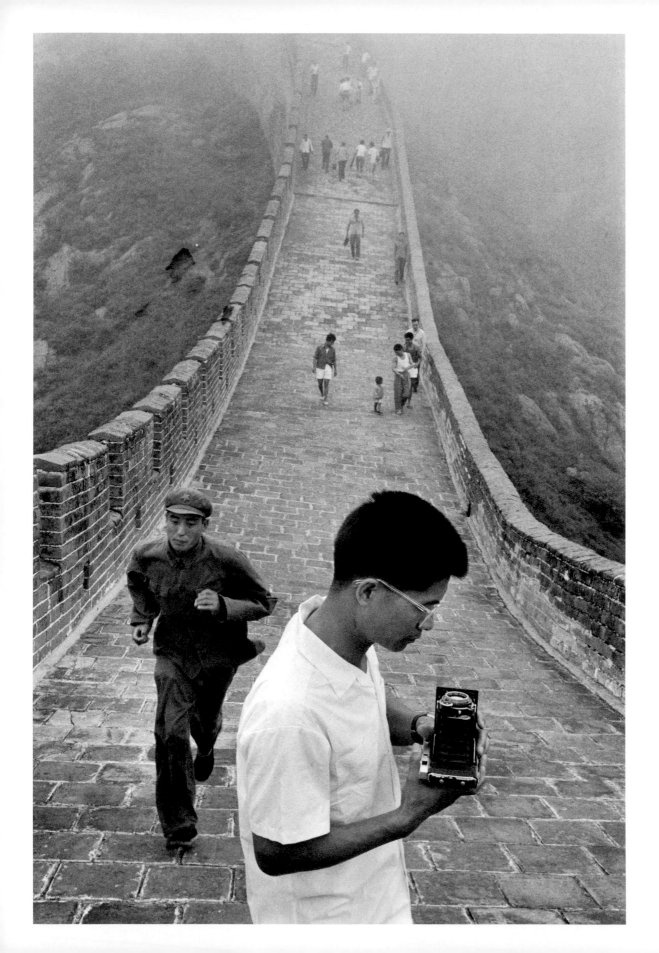

MARC RIBOUD

Born in Lyons in 1923, Marc Riboud was active in the French Resistance from 1943 to 1945. Until 1951 Riboud worked as an engineer in Lyons factories, then became a freelance photographer and moved to Paris in 1952. He was invited to join Magnum as an associate by Henri Cartier-Bresson and Robert Capa in 1952; in 1955 he became a full member.

In the mid-1950s he set off for India in a specially converted Land Rover that once belonged to Magnum co-founder George Rodger, who had used it for his celebrated work in Africa. When he went to China in 1957 Riboud was one of the first European photographers to visit the country; he returned for a lengthy stay in 1965 with writer K. S. Karol. He is best known for his extensive reports on the East: *The Three Banners of China* (1966), *Faces of North Vietnam* (1970), *Visions of China* (1981), *In China* (1996), *Tomorrow Shanghai* (2003), and *Istanbul 1954–1998* (2003). His most important book is *50 Years of Photography*, published at the same time as his big exhibition at the Maison Européenne de la Photographie in 2004.

One of his most famous pictures was taken in Washington, D.C. during the 1967 March for Peace in Vietnam: a young woman holds a flower towards the bayonets of soldiers guarding the Pentagon. Riboud's photographs have appeared in numerous magazines, including *Life*, *Geo*, *National Geographic*, *Paris-Match* and *Stern*. He twice won the Overseas Press Club Award (1966 and 1970), and, in addition to the exhibition at the Maison Européenne de la Photographie, has had major retrospectives at the Musée d'Art Moderne de la Ville de Paris (1985) and the International Center of Photography, New York (1988 and 1997).

Opposite
The Great Wall, Hebei province. China, 1971

In the history of photography some photographers are very reassuring. These are the ones who have defined the culture and made contributions that live on forever. The imagery of Marc Riboud is one such benchmark for me. He has been photographing for a half a century, with the same quiet authority.

My understanding of China was probably defined by the ground-breaking work Riboud did there from the 1950s onwards. Riboud's long term commitment to documenting China has really paid off. He has photographed China from before the Cultural Revolution through to the economic boom which it is currently enjoying.

Riboud's imagery is deceptively simple. Like all good photographers he makes it look very easy. There is an eloquence in the composition, every component is perfectly positioned. The scenarios are both complex and revealing. Herein lies the dilemma: should Riboud be regarded as an artist or a photojournalist?

I imagine Riboud himself would rarely boast of his ability to deliver an assignment on time and elegantly completed. Indeed, most, if not all, of his best work has been self-initiated and it strikes me that his best images are what I would define as free-standing. In other words they still can work very well out of context as there is always a visual or aesthetic twist that makes them memorable. In my view, Riboud is one of the few photographers whose work brings together the worlds of photojournalism and art.

I was torn about whether or not to include Riboud's iconic image of a woman holding a flower in front of a gun in 1967. In the end I was irresistibly drawn to the image Riboud himself shot of this image being used as a poster in 2003. It is a convincing demonstration of how Riboud's imagery has entered the mainstream.

Martin Parr

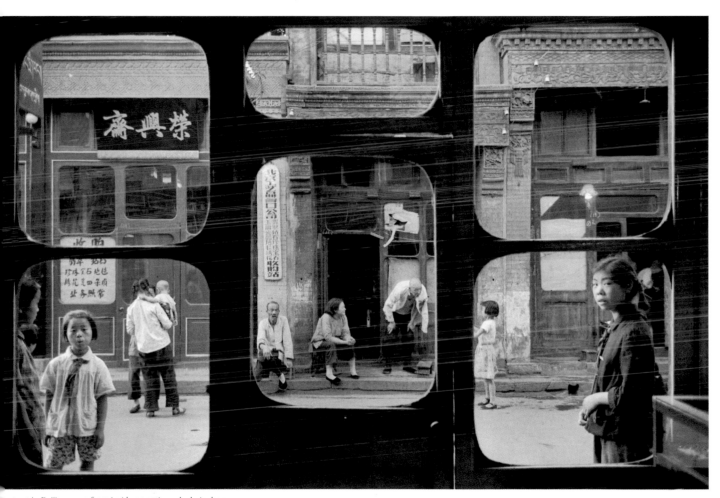

street in Beijing, seen from inside an antique dealer's shop.
China, 1965

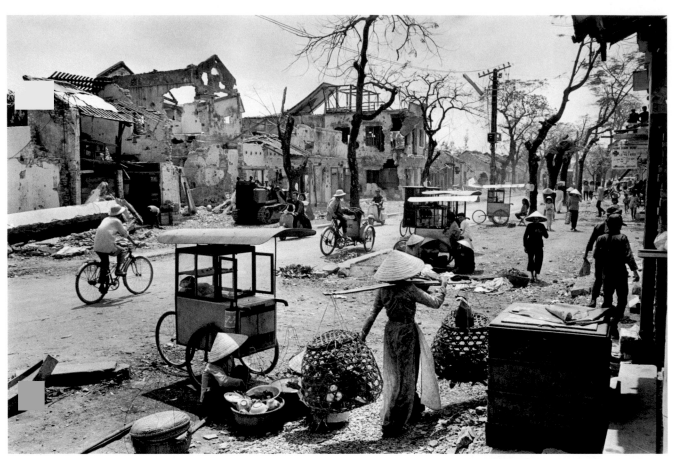

osite, top

former imperial city of Hue, after bombardment by
erican planes. Vietnam, May 1968

osite, bottom

nti-war protest on the streets of London. England, 2003

photographers' rally. Karuizawa, Japan, 1958

Following pages
Pope Paul VI. Rome, Italy, 1972

A wartime evening out. London, England, 1940

GEORGE RODGER

Born in Cheshire in 1908, George Rodger served in the British Merchant Navy. After a short spell in America, he worked as a photographer for the BBC's *The Listener* magazine, followed in 1938 by a brief stint working for the Black Star Agency.

His pictures of the London blitz brought him to the attention of *Life* magazine, and he became a war correspondent. He won eighteen campaign medals covering Free French activities in West Africa, and went on to document the war front in Eritrea, Abyssinia and the Western Desert. He travelled to Iran, Burma, North Africa, Sicily and Salerno, Italy, where he met and befriended Robert Capa.

Having covered the liberation of France, Belgium and Holland, Rodger was the first photographer to enter Bergen-Belsen concentration camp in April 1945. In May he photographed the German surrender at Lüneburg for *Time* and *Life*. Traumatized by the experience of looking for 'nice compositions' in front of the dead, Rodger embarked on a 28,000-mile journey all over Africa and the Middle East, focusing on animal life, rituals, and ways of life that exist in a close relationship with nature.

In 1947 Rodger was invited to join Robert Capa, Henri Cartier-Bresson, David Seymour and William Vandivert in founding Magnum. His next major trip was a Cape-to-Cairo trans-Africa journey, during which he made extraordinary pictures of the Kordofan Nuba tribe which first appeared in *National Geographic* in 1951. Africa remained a preoccupation for him for over thirty years.

Enormously successful during his lifetime, George Rodger died in Kent on 24 July 1995.

'The Blitz' was George Rodger's first picture story; there is a directness and simplicity about it which I have always loved.

In the early days in Magnum's London office, a huge pile of contact sheets lay outside what now seems rather quaint: a darkroom. They were all from George's negatives and represented his life's work. George agreed to let me do a fresh edit of his work and we made new contact sheets so that I would not be distracted by his original china-graph pencil edits.

Fast forward to sunny afternoons in George's garden in Kent, with the annoying buzz of light aircraft above, from Headcorn Aeroclub (George was always threatening to shoot them down one day). We had three boxes – Yes, No, and Maybe – and I have to admit to slipping the odd print in the Yes box when George was distracted. George had done his edit shortly after seeing his contact sheets, and there was no way he was going to change his mind some sixty years later. I worked hard to keep the many new pictures I had found, and tried to persuade him to un-crop many of his best-known images, which he had printed himself in the same way all those years. We became friends, with a mutual respect across the generations, one of the enduring qualities of Magnum.

I put together a series of photocopied books in which I divided his life into sections – Adventure, War, Africa, Assignments and Homecoming – and these were later the source material for the retrospective book, *Humanity and Inhumanity*. I learnt so much – not only about George, and the process of editing, but also confirmed what I knew all along: that George was a very underrated photographer. He was a complicated and passionate man, with fixed ideas about the world and photography, but he was the most incredible storyteller, with a photographic memory of his experiences during the war, which he would later describe as vividly as if they were yesterday.

I visited Henri Cartier-Bresson in his Paris apartment, with my photocopied books, to try to persuade him to write an introduction to the published version. Watching Henri as he turned the pages, I really felt I had achieved something. I could feel a reaction, and my guess was that he had not realized until then what a fine photographer George was.

Peter Marlow

The Heavy Rescue Squad setting out for a day's work.
London, England, 1940

A list of the dead and wounded posted on the walls of City Hall,
Coventry. England, 1940

The chapel of the Women's Services Club,
London, England, 1940

Following pages, left
London, England, 1940

Following pages, right
Members of the Rescue Squads after a night shift.
London, England, 1940

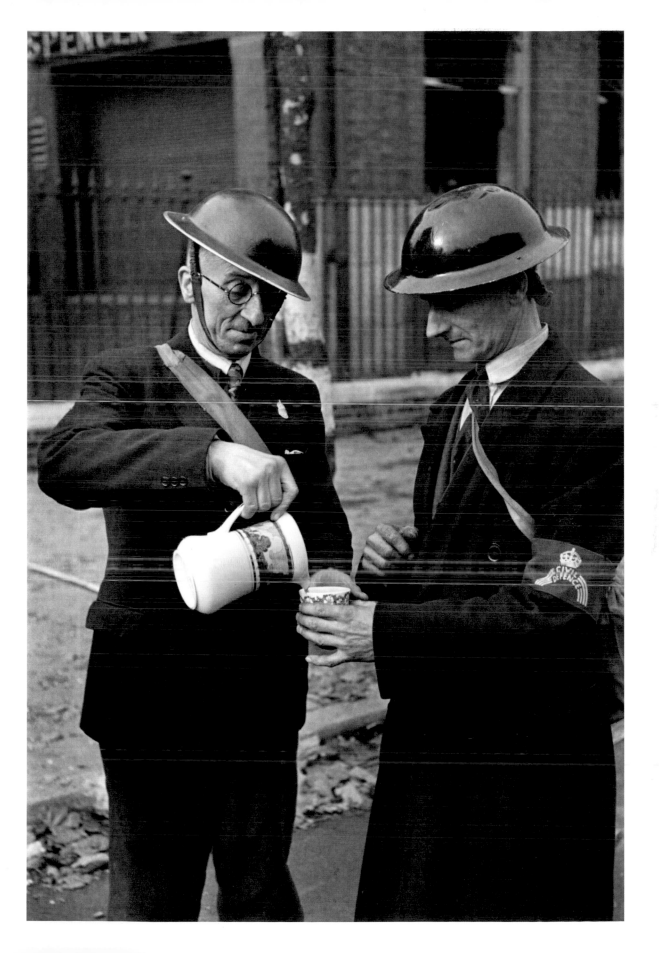

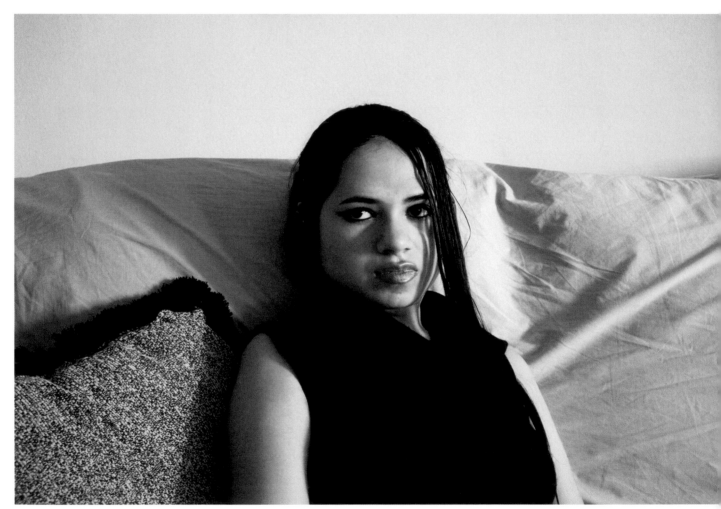

Mariela, no. 27, from the series *The New Life*.
Los Angeles, USA, 2003

LISE SARFATI

Lise Sarfati was born in 1958 and is French. She obtained a master's degree in Russian studies from the Sorbonne in Paris with a thesis on 1920s Russian photography. She was hired in 1986 as official photographer of the Académie des Beaux-Arts in Paris.

She went to Russia in 1989 and devoted nearly a decade of study to this country with the help of a grant from the Ministry of French Culture and Villa Medicis. She received the Prix Niépce and the Infinity Award from the International Center of Photography (New York) in 1996 in photojournalism for her Russian work, and exhibited at the Centre National de la Photographie in Paris in 1996 and at the Maison Européenne de la Photographie in 2002. *Acta Est* was her first monograph, published in 2000.

After the death of Marguerite Duras in 1996, Sarfati photographed the writer's apartment and her house in Neauphle-le-Château. Her pictures constitute a sort of inventory of intimacy taken from the places where Duras lived and worked. Sarfati joined Magnum Photos in 1997 and became a full member in 2001.

In 2003 Sarfati went to the United States and created a series with young characters. This body of work, *The New Life* (*La Vie Nouvelle*), published by Twin Palms in 2005, is designed to be viewed sequentially, as episodes in a open-ended drama in which each character represents material for a new subplot following its own surprising path. The series *The New Life* has been exhibited in major museums and galleries.

In 2004 Domus Artium in Salamanca, Spain, and the Nicolaj Centre of Contemporary Art in Copenhagen, Denmark, showed a retrospective of her work.

Lise Sarfati's photographs are wrapped in silence and soft light. But don't let the gentle description fool you. She is not a Zen photographer. Her pictures drip with longing. This is especially true of *The New Life (La Vie Nouvelle)* – her series of young Americans and their environs. Who are these kids? What are they are looking for? I've looked at these pictures a hundred times and have tried to answer these questions. But Sarfati's pictures are like *haiku*. They defy logical analysis. Each picture is a peephole into a lyrical world, frozen and smoky, perhaps with a soundtrack by Leonard Cohen:

> A bunch of lonesome and very quarrelsome heroes
> were smoking out along the open road;
> the night was very dark and thick between them,
> each man beneath his ordinary load.

(from 'A Bunch of Lonesome Heroes' by Leonard Cohen)

Alec Soth

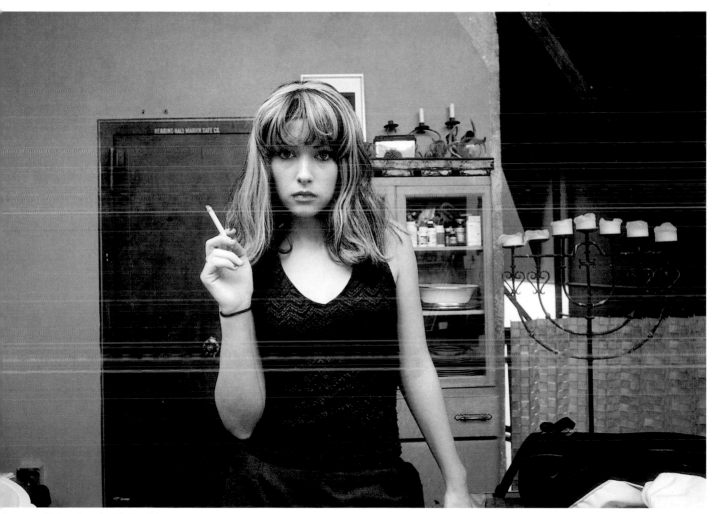

Sloane, no. 34, from the series *The New Life*.
Oakland, USA, 2003

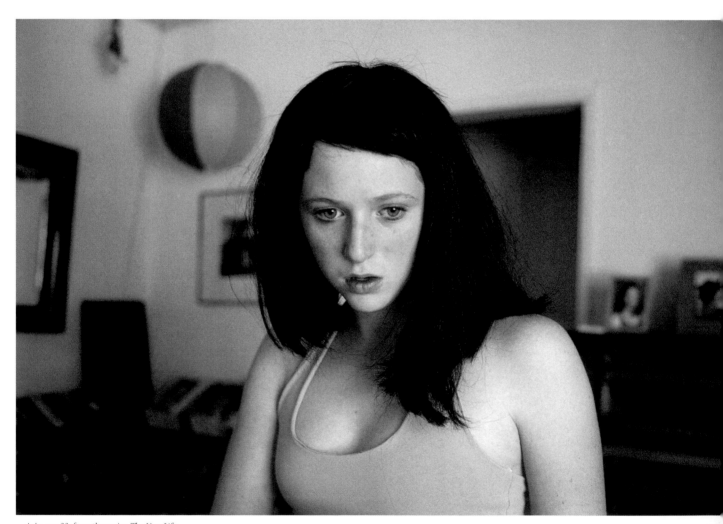

Asia, no. 33, from the series *The New Life*.
North Hollywood, USA, 2003

Terri, no. 31, from the series *The New Life*.
Portland, USA, 2003

Sasha, no. 28, from the series *The New Life*.
Oakland, USA, 2003

Mark, no. 41, from the series *The New Life*.
Hollywood, USA, 2003

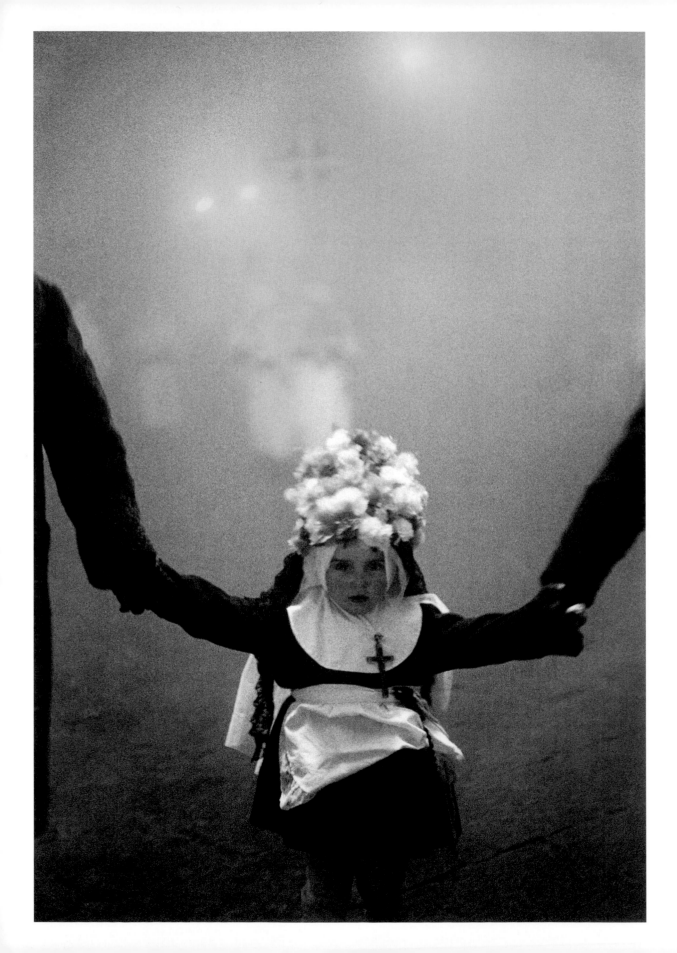

FERDINANDO SCIANNA

Ferdinando Scianna was born in Sicily in 1943. He started taking photographs in the 1960s while studying literature, philosophy and art history at the University of Palermo. It was then that he began to photograph the Sicilian people systematically. *Feste Religiose in Sicilia* (1965) included an essay by the Sicilian writer Leonardo Sciascia, and it was the first of many collaborations with famous writers.

Scianna moved to Milan in 1966. The following year he started working for the weekly magazine *L'Europeo*, first as a photographer, then from 1973 as a journalist. He also wrote on politics for *Le Monde Diplomatique* and on literature and photography for *La Quinzaine Littéraire*.

In 1977 he published *Les Siciliens* in France and *La Villa Dei Mostri* in Italy. During this period Scianna met Henri Cartier-Bresson, and in 1982 he joined Magnum Photos. He entered the field of fashion photography in the late 1980s. At the end of the decade he published a retrospective, *Le Forme del Caos* (1989).

Scianna returned to exploring the meaning of religious rituals with *Viaggio a Lourdes* (1995), then two years later he published a collection of images of sleepers *Dormire Forse Sognare (To Sleep, Perchance to Dream)*. His portraits of the Argentinean writer Jorge Luis Borges were published in 1999, and in the same year the exhibition *Niños del Mundo* displayed Scianna's images of children from around the world.

In 2002 Scianna completed *Quelli di Bagheria*, a book on his home town in Sicily, in which he tries to reconstruct the atmosphere of his youth through writings and photographs of Bagheria and the people who live there.

When I first met Ferdinando Scianna in Paris in the early 1980s he was working as a journalist and writer for an important Italian newspaper (*Corriere della Sera*, I think). He had already published his much noticed book on religious festivals in Sicily and I have always been haunted by the image of the little girl dressed up like a baroque Madonna being hauled through the night by two men.

In all his work one can see that Ferdinando has a great tenderness and love for the female sex, and no doubt this feeling is best shown in his remarkable fashion photographs. His models are never rigid, but are posed in plausible situations that Ferdinando has imagined – always sensuous and desirable.

Ferdinando not only collects photographs but also prints, drawings, paintings and popular art, and he is probably one of the best-read photographers I have met in Magnum. He is a devoted friend, accomplished cook, excellent writer and indefatigable speaker. Thank you, Ferdinando, for giving me so much pleasure looking at your images.

Martine Franck

Opposite
The fashion model Marpessa.
Modica, Sicily, 1987

Following pages
top left
Marpessa playing with children.
Caltagirone, Sicily, 1987

bottom left
Marpessa in the street.
Palermo, Sicily, 1987

top right
Fashion shoot. Cefalù, Sicily, 1988

bottom right
The fashion model Gisele Zelahui.
Valley of the Kings, Egypt, 1989

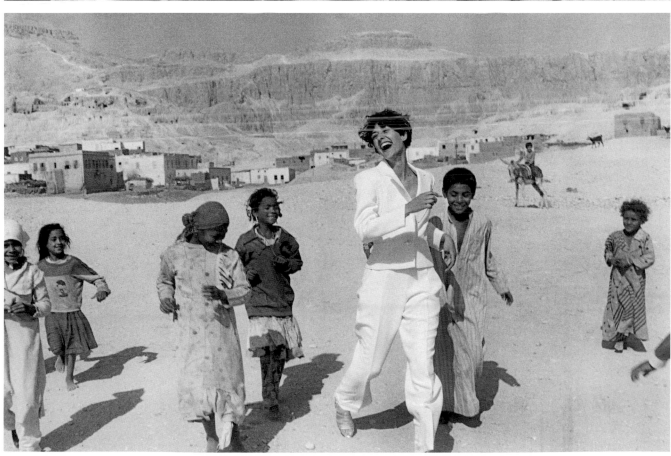

DAVID 'CHIM' SEYMOUR

David Szymin was born in 1911 in Warsaw into a family of publishers that produced works in Yiddish and Hebrew. His family moved to Russia at the outbreak of the First World War, returning to Warsaw in 1919.

After studying printing in Leipzig and chemistry and physics at the Sorbonne in the 1930s, Szymin stayed on in Paris. David Rappaport, a family friend who owned the pioneering picture agency Rap, lent him a camera. One of Szymin's first stories, about night workers, was influenced by Brassaï's *Paris de Nuit* (1932). Szymin – or 'Chim' – began working as a freelance photographer. From 1934, his picture stories appeared regularly in *Paris-Soir* and *Regards*. Through Maria Eisner and the new Alliance agency, Chim met Henri Cartier-Bresson and Robert Capa.

From 1936 to 1938 Chim photographed the Spanish Civil War, and after it was over he went to Mexico on an assignment with a group of Spanish Republican émigrés. On the outbreak of the Second World War he moved to New York, where he adopted the name David Seymour. Both his parents were killed by the Nazis. Seymour served in the US Army (1942–45), winning a medal for his work in intelligence.

In 1947, along with Cartier-Bresson, Capa, George Rodger, and William Vandivert, he founded Magnum Photos. The following year he was commissioned by UNICEF to photograph Europe's children in need. He went on to photograph major stories across Europe, Hollywood stars on European locations, and the emergence of the State of Israel. After Robert Capa's death he became the new president of Magnum. He held this post until 10 November 1956, when, travelling near the Suez Canal to cover a prisoner exchange, he was killed by Egyptian machine-gun fire.

Opposite
Teresa, who grew up in a concentration camp, drawing a picture of 'home'. Poland, 1948

I first met Chim in 1954 when all of the Magnum photographers gathered in New York to celebrate the lives of Werner Bischof and Bob Capa, both of whom had been tragically killed within a period of two weeks. Their loss was so stunning that the survival of Magnum was in question. Whatever gods of good fortune have smiled on Magnum throughout sixty years of turmoil, they came to our rescue. And Magnum was able to go on.

Chim had a great influence on me. A few days after the funeral we sat in a coffee shop on Eighth Avenue and had a long discussion about my career. I was very happy living in Seattle and doing a lot of work in the Pacific northwest. Chim said, 'Boychik, you have to make up your mind whether you want to be the kind of photographer where somebody says "We have Glinn in Seattle", or somebody says "We have a story in Timbuktu, get Glinn wherever he is".' Three months later I was on a plane to Israel and for the next few years I spent most of my time in Europe and the Middle East.

Chim was based in Rome and I found myself going there for mentoring. The Hotel Inghilterra became almost a second home. Chim was not only the concierge for photographers on assignment, but also a rabbi who kept us aware of the seriousness of the times in Europe. If you look at the selections in this book, you see his absorption with Israel and empathy with all the people who suffered through the Second World War. Our relationship wavered between marvellous evenings spent in *trattorie* and the impending doom echoing from the strains of the Kaddish at the burial of Capa and Bischof. The memory of the funeral dirge mingles with the disaster of the Suez.

I was in New York when the news came over the radio about the war between Israel and Egypt. I was able to get the last seat on the last plane to Israel. We had to stop over in Athens to refuel; I spotted Chim by the airport newsstand. We discovered that we were both going to cover the war in Israel, Chim for *Newsweek* and I for *Life* magazine. Chim said, 'Be careful, Boychik, it's dangerous out there.' I raised my eyebrow and said, 'You be careful, Chim,' and he disappeared into the plane. Eight days later I came into the Press Information Office in Jerusalem and the head of the office was weeping. 'Chim was killed in the Suez yesterday.'

I still think of Chim all the time and always say to myself on a job: What would Chim have done?

Burt Glinn

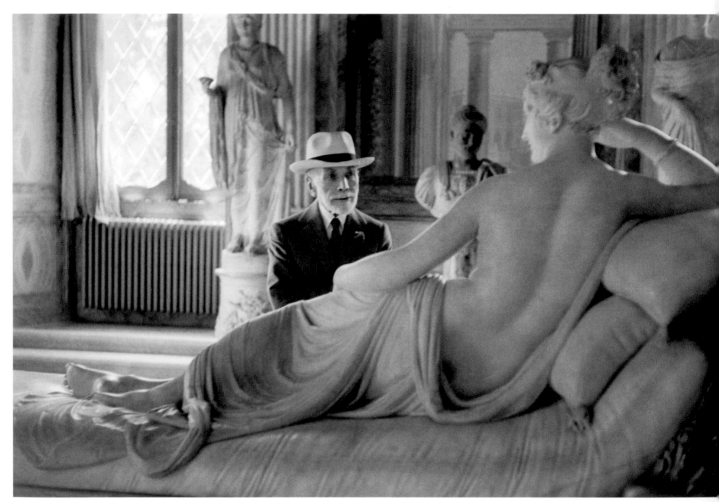

Art historian Bernard Berenson with Antonio Canova's *Pauline Borghese*.
Borghese Gallery, Rome, Italy, 1955

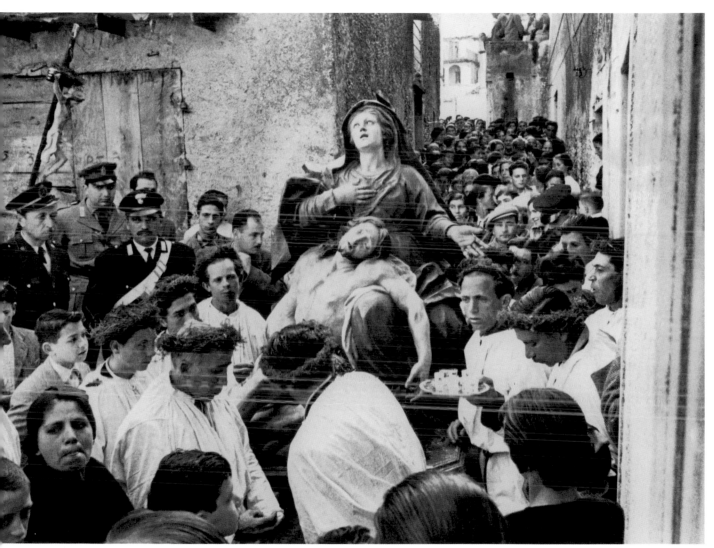

Good Friday. Sicily, 1955

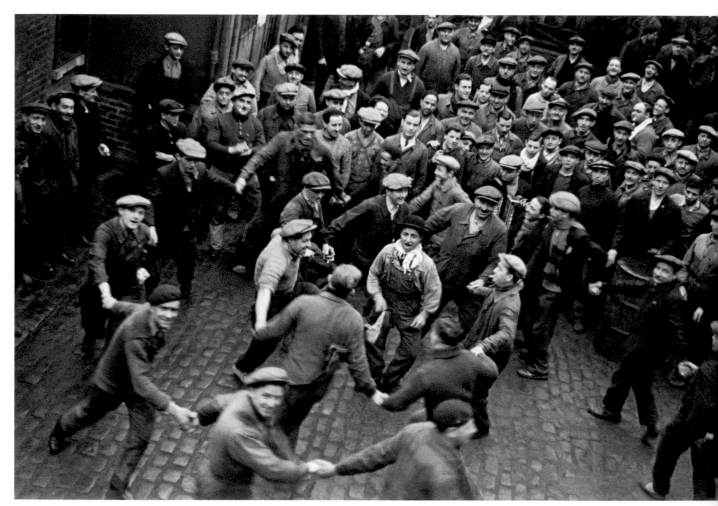

Workers entertaining themselves during a sit-in at their factory.
Paris, France, June 1936

476 David Seymour

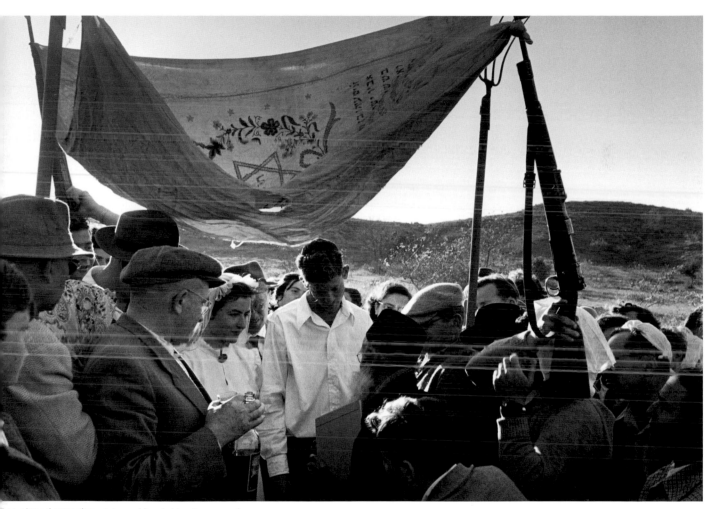

he traditional tent or 'huppa' at a wedding, held up by guns and itchforks. Israel, 1952

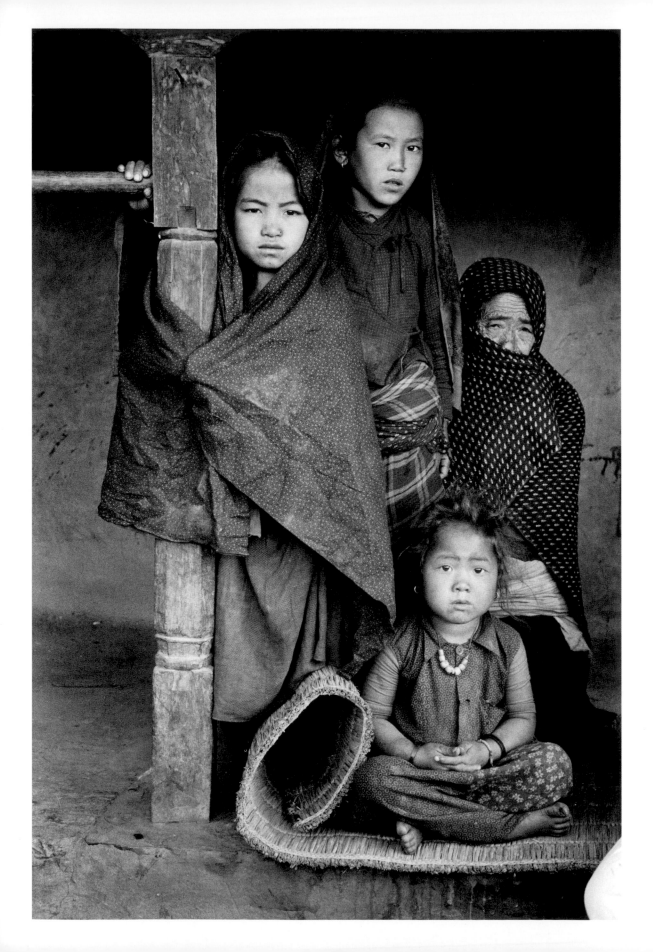

MARILYN SILVERSTONE

Born in London in 1929, Marilyn Silverstone graduated from Wellesley College in Massachusetts, then worked as an associate editor for *Art News*, *Industrial Design* and *Interiors* during the 1950s. She also served as an associate producer and historical researcher for an Academy Award-winning series of films on painters.

In 1955 she began to photograph professionally as a freelancer (with the Nancy Palmer Agency, New York), working in Asia, Africa, Europe, Central America and the Soviet Union. In 1959 she was sent on a three-month assignment to India, but ended up moving to New Delhi and was based there until 1973. During that time she produced the books *Bala Child of India* (1962) and *Ghurkas and Ghosts* (1964), and later *The Black Hat Dances* (1987), and *Ocean of Life* (1985), a journey of discovery that aims to take the reader to the heart of a complex and compassionate Buddhist culture. *Kashmir in Winter*, a film made from her photographs, won an award at the London Film Festival in 1971. Silverstone became an associate member of Magnum in 1964, a full member in 1967, and a contributor in 1975.

Silverstone, whose photographs have appeared in many major magazines, including *Newsweek*, *Life*, *Look*, *Vogue* and *National Geographic*, became an ordained Buddhist nun in 1977. She lived in Kathmandu, Nepal, where she practised Buddhism and researched the vanishing customs of the Rajasthani and Himalayan kingdoms. She died in October 1999 at the Shechen monastery, near Kathmandu, which she had helped to finance.

Silverstone's photographic estate is managed by Magnum Photos under the direction of James A. Fox, a former Magnum Editor-in-Chief and present Curator.

Opposite
Three girls with their great-aunt on the porch of their home.
Pokhara valley, Nepal, 1961

Marilyn Silverstone, who left a career as a Magnum photographer for the simple life of a Buddhist nun, taking the name Ngawang Chodron (the Lamp of Dharma), never abandoned her love for photography. When I first met her she was already living in Shechen monastery in Bodnath, Nepal, the only nun, caring for all the young monks and taking their portraits so as to try to find sponsors for their education and upkeep. With great generosity and patience she would talk to me for hours about Buddhist philosophy and why she had become a nun. She also introduced me to all the *tulku*, child reincarnations of former lamas, who were being educated in her monastery.

Her loathing of war, famine and natural catastrophes is manifest in her compassionate photographs of the victims. She never forgot the under-privileged and seemed to be most at ease in a rural atmosphere, although she also took evocative images of maharajas and kings. Her first important photo story was the arrival in India of the Dalai Lama, who had just fled Tibet in 1959, and her very last essay was, curiously, also on the Dalai Lama about his giving refuge to a group of 'untouchables' who had recently become Buddhists. I remember asking her what she missed most since she had become a nun. She replied quite candidly, 'Clean toilets and hot baths.'

I shall never forget her words: 'The secret is just keep walking through life without analysing it too much or clinging to it too much. Just walk on.'

Dear Marilyn, we love you for your tender images and precious example.

Martine Franck

Opposite
A Harijan woman learning to read.
Lucknow, India, 1960

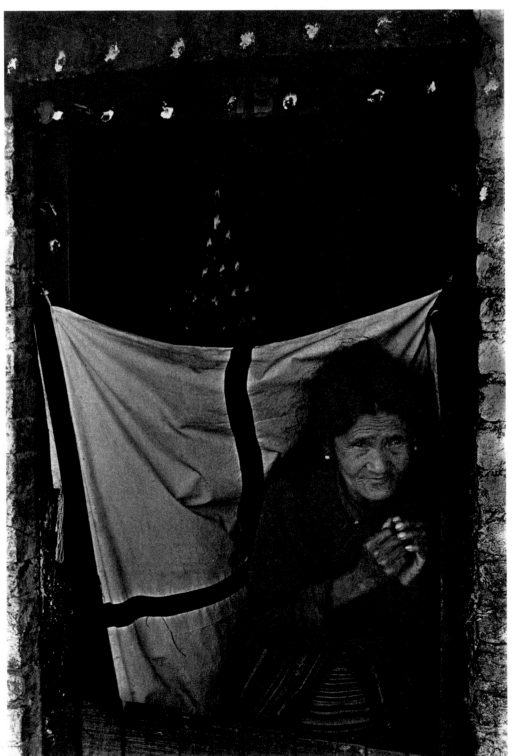

A Tibetan refugee. India/Nepal, 1970

Opposite
The Dalai Lama at the opening of the Tibet
House. Delhi, India, 1965

Following pages, left
A village seen from an American military
helicopter. South Vietnam, 1966

Following pages, right
The body of a nine-day-old baby: his mother
was shot while crossing the border from
Comilla and his grandfather carried him the
rest of the way. Bangladesh, 1971

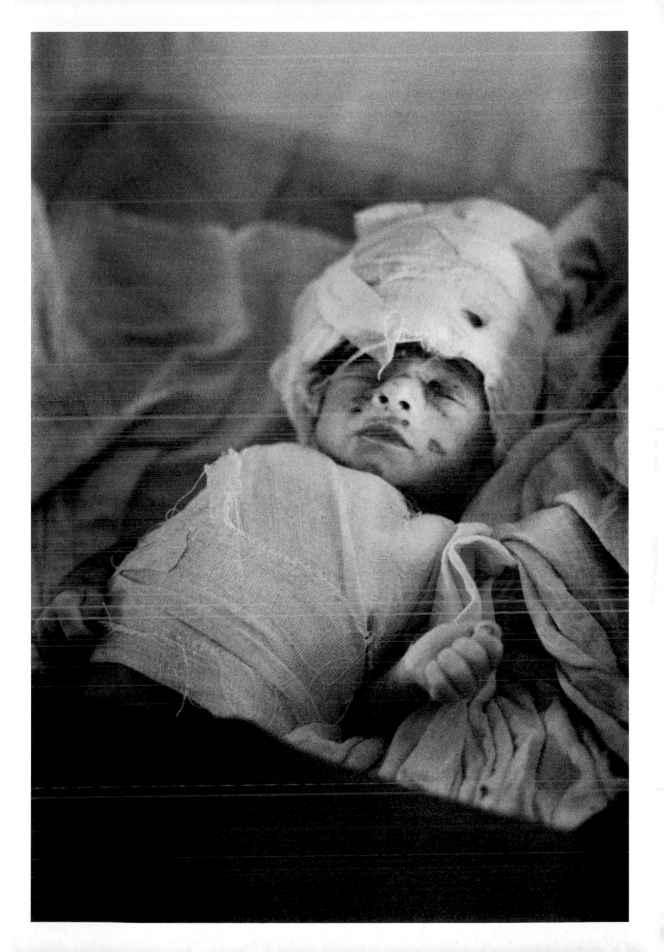

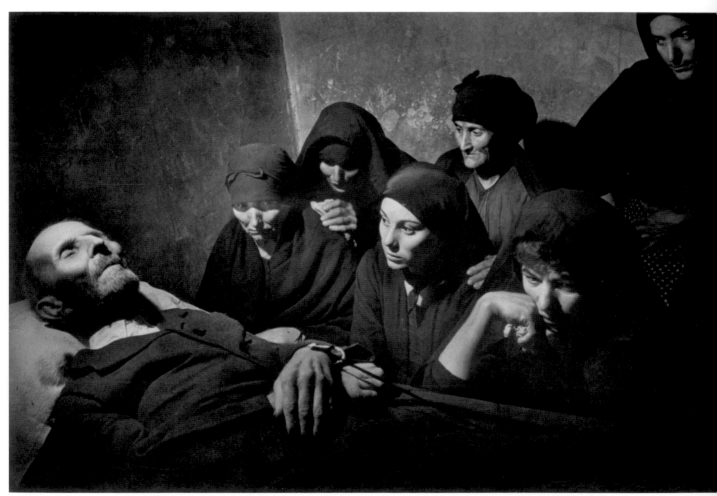

The wake of Juan Larra. Deleitosa, Spain, 1951

W. EUGENE SMITH

William Eugene Smith was born in 1918 in Wichita, Kansas. He took his first photographs at the age of 15 for two local newspapers. In 1936 Smith entered Notre Dame University in Wichita, where a special photographic scholarship was created for him. A year later he left the university and went to New York City, and after studying with Helene Sanders at the New York Institute of Photography, in 1937 he began working for *News-Week* (later *Newsweek*). He was fired for refusing to use medium-format cameras and joined the Black Star agency as a freelance.

Smith worked as a war correspondent for *Flying* magazine (1943–44), and a year later for *Life*. He followed the island hopping American offensive against Japan, and suffered severe injuries while simulating battle conditions for *Parade*, which required him to undergo surgery for the next two years.

Once recuperated, Eugene Smith worked for *Life* again between 1947 and 1955, before resigning in order to join Magnum as an associate. In 1957 he became a full member of Magnum. Smith was fanatically dedicated to his mission as a photographer. Because of this dedication, he was often regarded by editors as 'troublesome'.

A year after moving to Tucson to teach at the University of Arizona, Smith died of a stroke. His archives are held by the Center for Creative Photography in Tucson, Arizona. Today, Smith's legacy lives on through the W. Eugene Smith Fund to promote 'humanistic photography', founded in 1980, which awards photographers for exceptional accomplishments in the field.

The first time I saw W. Eugene Smith's photographs was in a fine art photography class in college. As we worked on our own pictures in the darkroom, we talked with awe about Smith's legendary obsession for perfection, which drove him to spend long days in the darkroom. His drive and idealism fascinated me.

During his coverage of the Second World War, he was severely wounded while on the east coast of Okinawa photographing an essay titled 'A Day in the Life of a Front Line Soldier'. He endured two years of hospitalization and plastic surgery, and commented later that it was his policy to stand up when others were down, and that he had forgotten to duck.

While documenting the story of a chemical company in Minamata, the severity of the irreparable damage caused became apparent. Recognizing Smith and his work as an extreme liability, thugs from the pro-company union attacked him. Smith documented his own beating and, although he survived, he experienced substantial permanent damage to his eyesight.

During the Minamata project, Smith produced one particularly profound image which anyone who has seen it will never forget. The photograph shows a mother bathing her daughter, a young girl (her name was Tomoko Uemura), who suffered extreme birth defects and mental retardation from mercury poisoning. The depth of tenderness, compassion and selflessness displayed by the mother is a gift to all who view the image. Unfortunately, we cannot reproduce this picture because Aileen Mioko Smith, Eugene's partner in the Minamata project and holder of the copyright, and the family of the girl decided that the photograph would no longer be issued. As Aileen Mioko Smith says:

> In 1997, Tomoko's parents asked me to let Tomoko rest. I agreed, and we mutually decided that the photograph would no longer be issued. It's so hard to communicate the beauty of the decision that was made, but it was a positive statement made by both of us.

The image, however, is truly inspiring, and shows the love and compassion to which we should all aspire. Although Aileen Mioko Smith offered other images to replace that one image, I thought it best to forgo the offer and show the last reproduction of the photograph in a major English language publication before it was withdrawn from use.

To me, this image, as well as the others selected here, represents Smith's unique ability to combine the eye of a photographer and the attitude of an artist with raw honesty and uncompromising integrity. All photographers, in one sense or another, are heirs to his legacy.

Steve McCurry

Opposite
A woman spinning. Spain, 1951

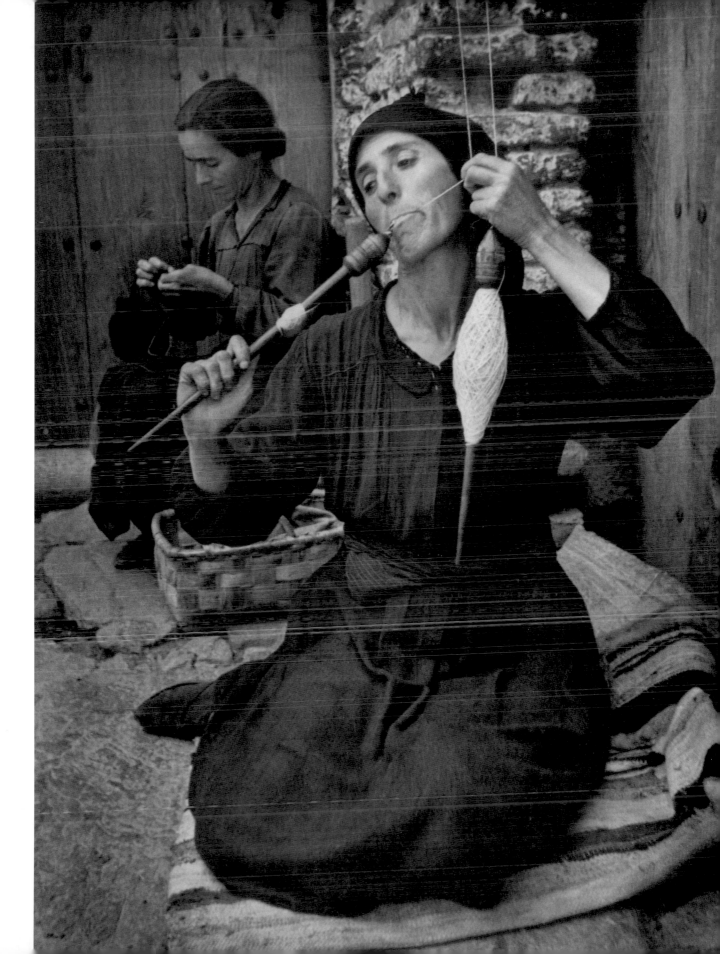

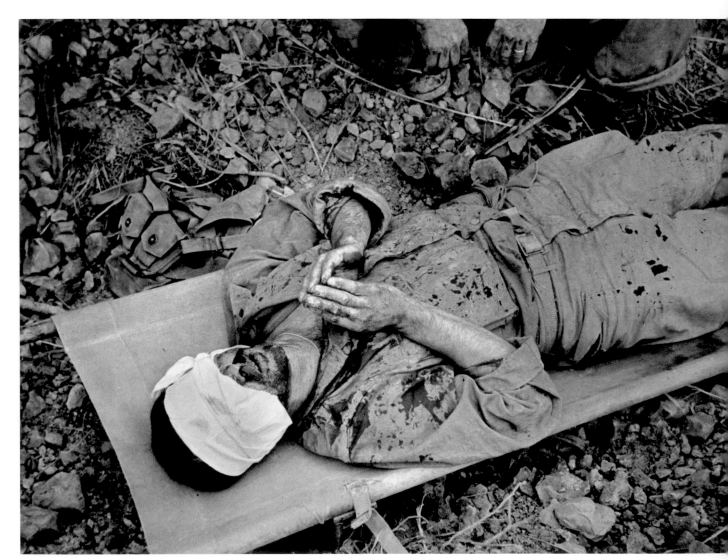

A wounded US soldier. Battle of Okinawa, Japan, 1945

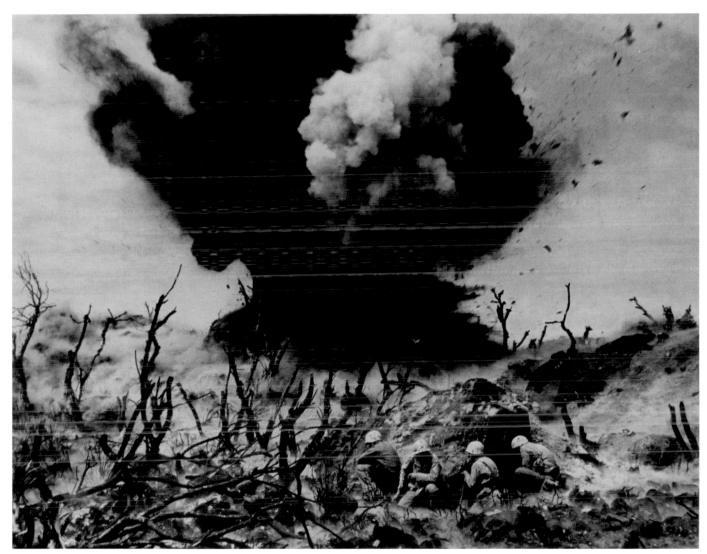

A US Marine demolition team blasting out a cave on Hill 382.
Battle of Iwo Jima, Japan, March 1945

492 W. Eugene Smith

Opposite
US Marine holding a wounded and dying baby found in the
mountains. Battle of Saipan Island, June 1944

Below
Tomoko Uemura in her bath. Minamata, Japan, 1971
(reproduced from *W. Eugene Smith: The Camera as
Conscience*, pages 312–13). For explanation,
see Steve McCurry's commentary on page 488.

'Falls 26', 2005

ALEC SOTH

Alec Soth was born in the USA in 1969. He became a nominee of Magnum Photos in 2004 and an associate in 2006. He is based in Minneapolis, Minnesota.

Soth uses an 8 x 10 camera from the late 1980s that makes almost painting-like pictures. He follows the complicated process of using the large-format camera, and says he is lucky if he manages to make one or two exposures on a given day of shooting.

He has received fellowships from the McKnight and Jerome Foundations and was the recipient of the 2003 Santa Fe Prize for Photography. His photographs are represented in major public and private collections, including the San Francisco Museum of Modern Art, the Museum of Fine Arts, Houston, and the Walker Art Center. His work has been featured in numerous solo and group exhibitions, including the 2004 Whitney Biennal and São Paulo Bienal.

His first book, *Sleeping by the Mississippi*, was published in 2004, and his second, *Niagara*, in 2006. He is represented by the Gagosian Gallery in New York and the Weinstein Gallery in Minneapolis.

Alec Soth makes his photographs in the same way that a writer creates a text. That is to say, it is his language, and the discussion that it induces, that charm me.

The subjects pose simply but their hand gestures unite them. There are no surprises for Alec, and equipped with his 20 x 25 camera, he has to manage everything on the spot. Nevertheless his subjects radiate a power and natural sense that is found practically nowhere else among photographers using large-format cameras.

Alec has a taste for anatomy; he is interested in surfaces and particularly in different kinds of skin, in texture and colour, both dark and pale black, light brown or pink tinted white. Each one describes its own pigmentations, stretch marks, fine varicose veins, spots, smooth or hairy skin. Each body, each skin, tells its story.

From its well-disposed construction, set amid this non-stop flow of water – a masked, erotic landscape – his subjects look as though they have emerged from a folktale, and the buildings – motel or dining room – are sown with symbolic echoes: like the little, rearing, milk-white horse, or the nasty-looking black car parked in front of the motel, or even the leather jacket standing up by itself on the ground …

Opposition between characters, landscapes and still life seem necessary to Alec's work; he sees them as distinct entities that rebound off one another to create a sort of third reality.

A great clarity, or one should say grace, lights up each picture. The lack of artifice reinforces the charms operating in his photographs.

In the Mississippi series I had the feeling that the pictures I found existed more within a projection of memory. Above all in still lifes, repeated doorways, landscapes in a state of decay: all this made me think of memories buried in Alec's subconscious, perhaps from a book that he has read, the outlines of a phrase, a meeting, a perception that found its reality in himself.

Lise Sarfati

'Impala', 2005

Fairway Motor Inn', 2005

Following pages, left
'Cry Baby', 2005

Following pages, right
David', 2005

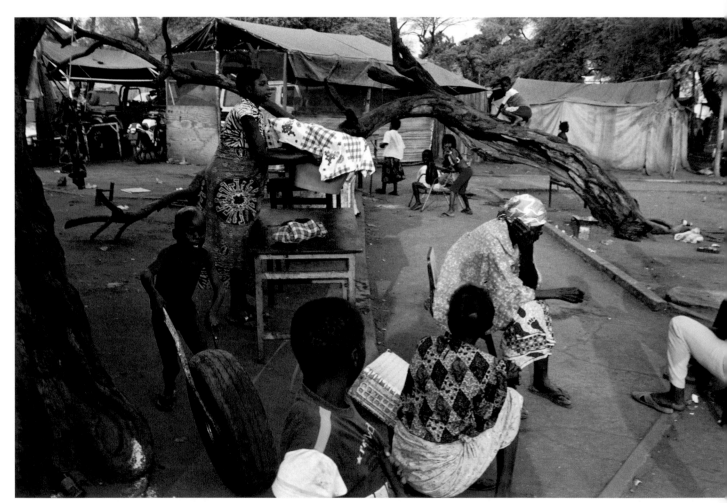

Families displaced from their homes in the country,
now living in an old army barracks. Angola, 1999

CHRIS STEELE-PERKINS

Chris Steele-Perkins was born in 1947 and at the age of two moved to England from Burma with his father. He went to school at Christ's Hospital. At the University of Newcastle-upon-Tyne, he studied psychology and worked for the student newspaper; he graduated with honours in 1970 and started to work as a freelance photographer, moving to London in 1971.

Apart from a trip to Bangladesh in 1973, he worked mainly in Britain in areas concerned with urban poverty and subcultures. In 1975 he worked with EXIT, a collective dealing with social problems in British cities. This involvement culminated in the book *Survival Programmes* in 1982. He joined the Paris-based Viva agency in 1976. In 1979 he published his first solo book, *The Teds*; he also edited the Arts Council of Great Britain's book, *About 70 Photographs*.

Steele-Perkins joined Magnum Photos in 1979 and soon began working extensively in the developing world, in particular in Africa, Central America and Lebanon, as well as continuing to take photographs in Britain: *The Pleasure Principle* explores Britain in the 1980s. In 1992 he published *Afghanistan*, the result of four trips over four years. After marrying his second wife, Miyako Yamada, he embarked on a long-term photographic exploration of Japan, publishing *Fuji* in 2000. A highly personal diary of 2001, *Echoes*, was published in 2003, and the second of his Japanese books, *Tokyo Love Hello*, in March 2007. He continues to work in Britain, documenting rural life in County Durham.

Some photographers, because of their preoccupation with humanity, are closer to me than others. Chris Steele-Perkins belongs to those photographers who are interested in the problems in the Third World and who have participated many times in humanitarian missions across the globe. He tells us: 'I still want to search for new things, to celebrate the world and its people – because, in spite of its horrors and my own personal moments of sorrow, to be a human being still remains something very special.'

His recent work in colour on Mount Fuji and Tokyo, where he met his wife, Mikayo Yamada, shows a real attachment to and understanding of Japanese culture. He emerges as a great artist meditating on modern and traditional Japan.

His remarkable ability to move between modern art and photojournalism has led him to experiment with conceptual photography, creating his own special style in recounting not only the world he sees but also his exceptional, unique and extremely personal way of being in the world.

Bruno Barbey

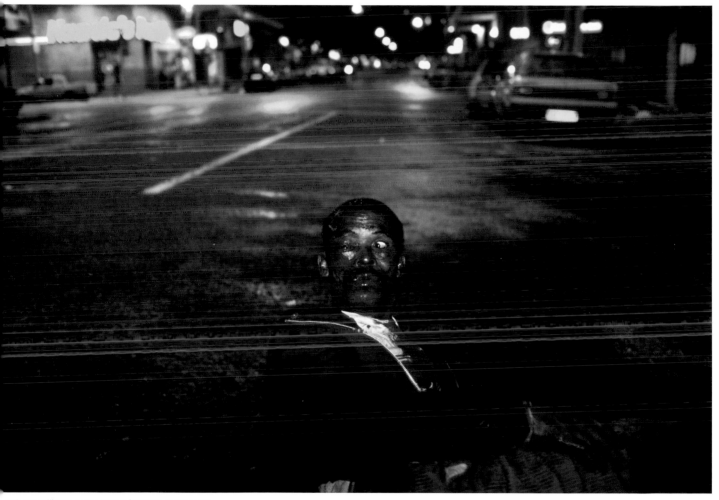

Policing Hillbrow: a man beaten for trying to rob a taxi.
Johannesburg, South Africa, 1995

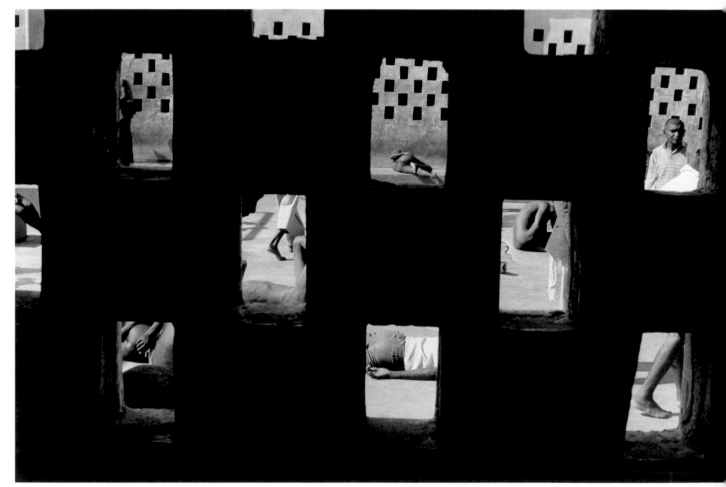

The courtyard of the mental hospital run by the Edhi
Foundation. Karachi, Pakistan, 1997

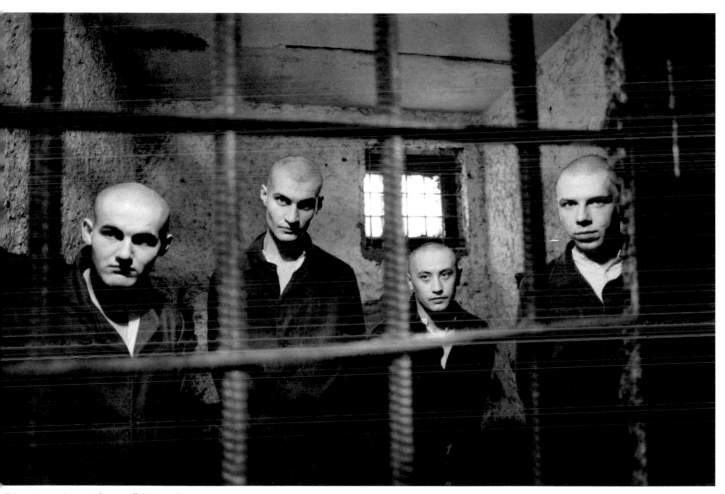

Prison inmates in a punishment cell. Leningrad
(St Petersburg), Russia 1988

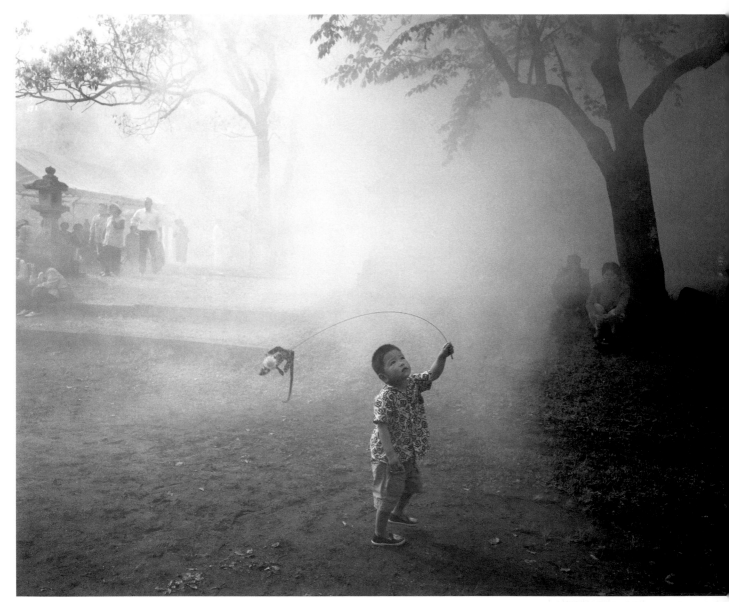

A child with a kite at the Grand Spring Festival.
Wakayama, Japan, 1998

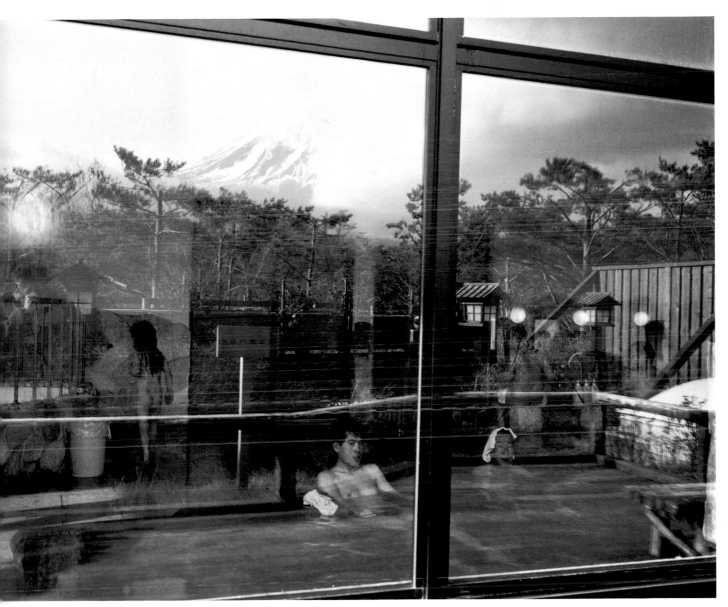

At a hot spring near Kawaguchiko. Shizuoka, Japan, 1999

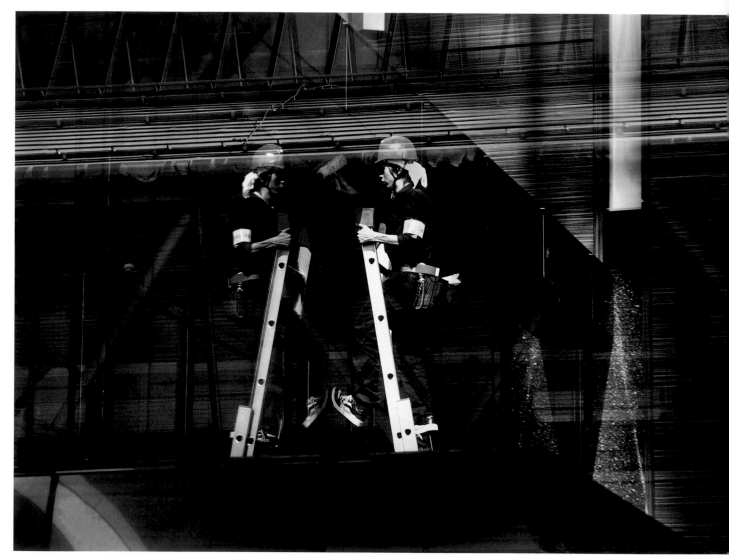

Shiodome, Tokyo, 2005

DENNIS STOCK

Dennis Stock was born in 1928 in New York City. At the age of 17, he left home to join the United States Navy. In 1947 he became an apprentice to *Life* magazine photographer Gjon Mili and won first prize in *Life*'s Young Photographers contest. He joined Magnum in 1951.

Stock managed to evoke the spirit of America through his memorable and iconic portraits of Hollywood stars, most notably James Dean. From 1957 to 1960 Stock made lively portraits of jazz musicians, including Louis Armstrong, Billie Holiday, Sidney Bechet, Gene Krupa and Duke Ellington for his book *Jazz Street*. In 1968 Stock took a leave of absence from Magnum to create Visual Objectives, a film production company, and he shot several documentaries. In the late 1960s he captured the attempts of California hippies to reshape society according to ideals of love and caring. Then throughout the 1970s and 1980s he worked on colour books, emphasizing the beauty of nature through details and landscape. In the 1990s he went back to his urban origins, exploring the modern architecture of large cities. His work is now mostly focused on the abstraction of flowers.

Stock has generated a book or an exhibition almost every year since the 1950s. He has taught numerous workshops and exhibited his work widely in France, Germany, Italy, the United States and Japan. He has worked as a writer, director and producer for television and film, and his photographs have been acquired by most major museum collections. He served as president of Magnum's film and new media division in 1969 and 1970.

Dennis Stock currently resides in Woodstock, New York, and is married to the author Susan Richards.

The Window Washers of Shiodome

I am a photographer of themes, large and small. James Dean, the sun in the abstract, Provence, jazz, flowers, surreal California, hippies, *haiku* and 'the window washers of Shiodome'.

When I joined Magnum in the early 1950s, the variety of different points of interest and style was the accepted means for keeping the agency vibrant. It had a profound effect on how and where I looked for themes. The magazines needed the variety and we needed the magazines. Haas, Cartier-Bresson, Bischof, Hartmann and I often photographed as if we were painters with cameras rather than news photographers. This market for visual discovery made it possible for me to publish thirteen books of my own choosing. Though the climate has changed, this old dog hasn't.

Junko Ogawa (of Magnum) escorted me to a high-tech lobby of a glass high-rise in Tokyo for a radio interview pertaining to my exhibition on James Dean. We reached the lofty heights of the building where we were placed in the guest lounge to await the interview. The view from the glass enclosure was extraordinary. Neighbouring buildings of various shades and colours of glass sparkled and reflected abstract patterns. My eyes drew me to what might be discovered at street level.

Below, on what appeared to be a high-platformed promenade, Junko took me on a tour of Tokyo's latest accomplishment: the newly constructed business district of Shiodome. I marvelled at the glass towers that hovered over us reflecting each others' surfaces; I was informed that Shiodome means 'where the tides end'. This stretch of land was originally marsh and was then transformed into freight train yards.

Later, with no land left to develop in Tokyo, this extraordinary complex was built on steel stilts and platforms above the ground, making a wonderful walking, shopping and restaurant environment, free from traffic. But the real magic was in the reflections in the glass windows and the dexterity of the window washers. On the following days I returned on my own and feasted photographically on the abstract forms and multiple layers of reflections where the window washers bravely climbed to perform their tasks.

Dennis Stock

Shiodome, Tokyo, 2005

Shiodome, Tokyo, 2005

Shiodome, Tokyo, 2005

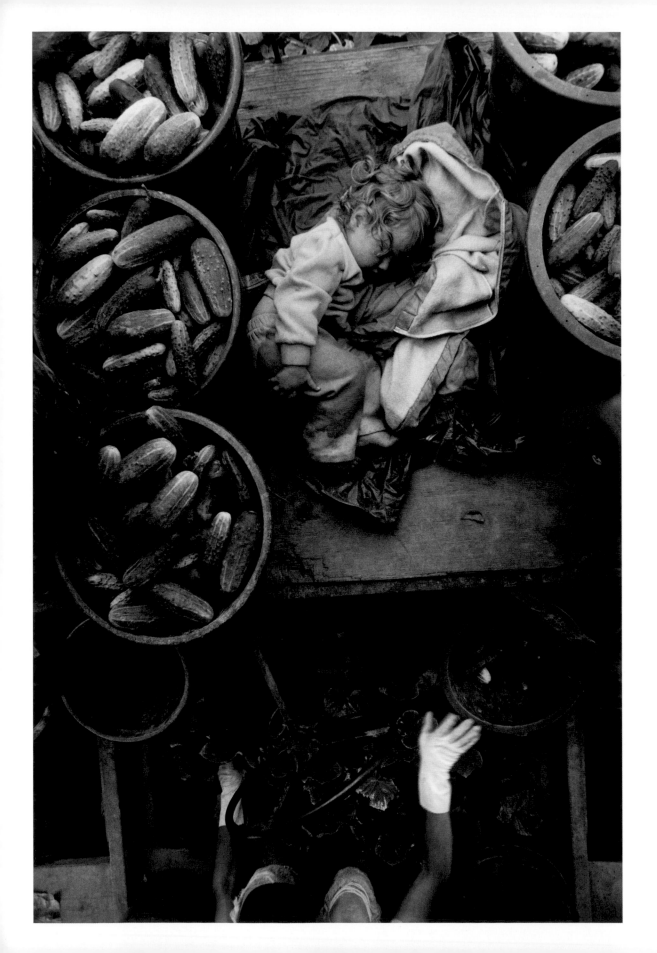

LARRY TOWELL

Larry Towell's business card reads 'Human Being'. Experience as a poet and a folk musician has done much to shape his personal style. The son of a car repairman, Towell was born in 1953 and grew up in a large family in rural Ontario. During studies in visual arts at Toronto's York University, he was given a camera and taught how to process black and white film.

A stint of volunteer work in Calcutta in 1976 provoked Towell to photograph and write. Back in Canada, he taught folk music to support himself and his family. In 1984 he became a freelance photographer and writer focusing on the dispossessed, exile and peasant rebellion. He completed projects on the Nicaraguan Contra war, on the relatives of the disappeared in Guatemala, and on American Vietnam War veterans who had returned to Vietnam to rebuild the country. His first published magazine essay, 'Paradise Lost', exposed the ecological consequences of the catastrophic Exxon Valdez oil spill in Alaska's Prince William Sound. He became a Magnum nominee in 1988, and a full member in 1993.

In 1996 Towell completed a project based on ten years of reportage in El Salvador, followed the next year by a major book on the Palestinians. His fascination with landlessness also led him to the Mennonite migrant workers of Mexico, an eleven-year project completed in 2000. With the help of the inaugural Henri Cartier-Bresson Award, he finished a second highly acclaimed book on the Palestinian–Israeli conflict in 2005. He is currently finishing *The World from My Front Porch*, a project on his own family in rural Ontario, where he sharecrops a 75-acre farm.

Opposite
A Mennonite child. Kent County, Ontario, Canada, 1996

Larry Towell's work often deals with people's relationship to the land. The theme recurs consistently: from the photographs of his family on their farm in Canada and those of the uprooted Mennonites in the New World, to images of the Palestinians struggling to regain their homeland.

Yet within this context there are many Larry Towells: there is the political Larry, the documentary Larry, the social activist Larry, as well as the poetic Larry – and they are often intertwined.

I have chosen to concentrate on the poetic Larry Towell, selecting the two bodies of work that I find most lyrical, suggestive and intimate – his photographs of his family and of the Mennonites.

Alex Webb

Opposite
Mennonites at Cuervo Casas Grandes, Chihuahua. Mexico, 1992

Following pages
Moses Towell eating a wild pear, with his mother, Ann, in the family's pickup truck. Lambton County, Ontario, Canada, 1983

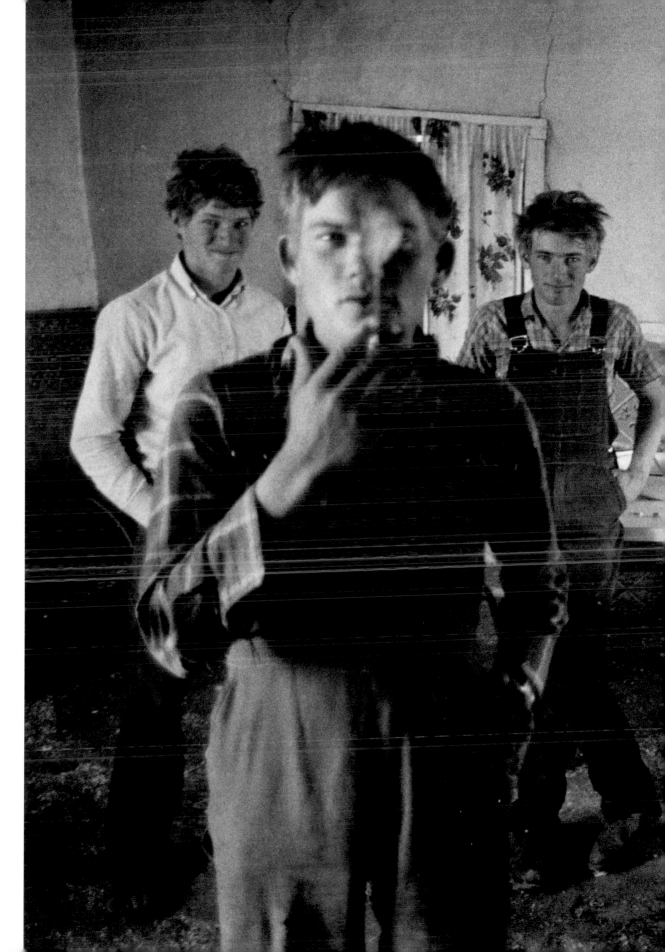

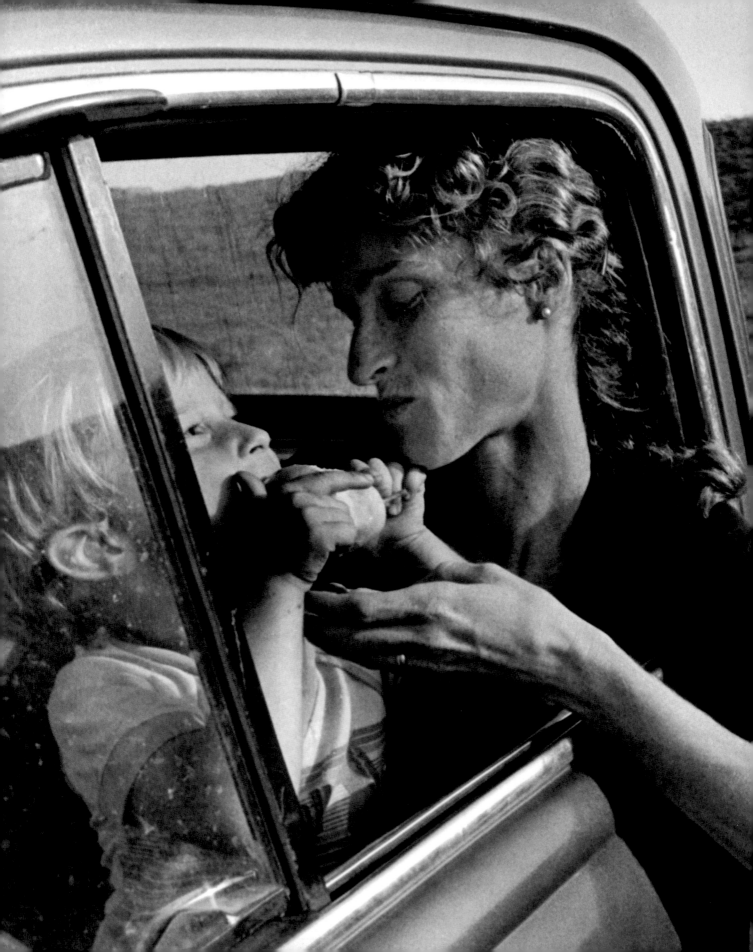

Mennonites at Manuel Colony, Tamaulipas. Mexico, 1994

Noah Towell at the farmhouse. Lambton County, Ontario,
Canada, 1995

Following pages
Mennonites at Durango Colony. Mexico, 1994

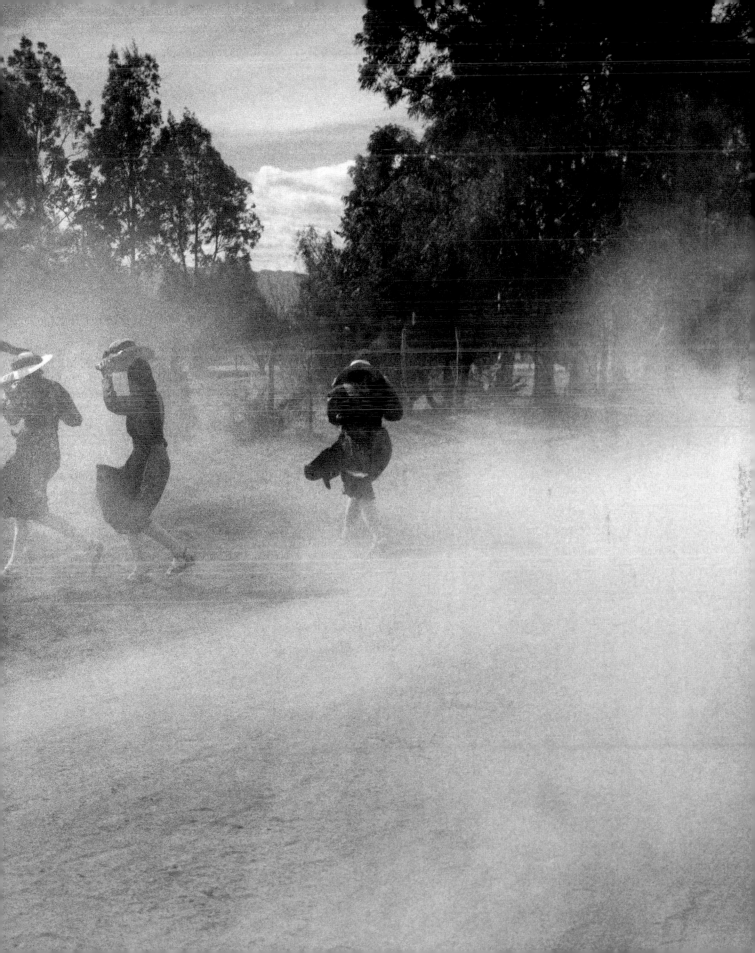

The so-called 'death train', swept off the track north of Galle by the
tsunami, killing more than 1,500 people. Sri Lanka, January 2005

ILKKA UIMONEN

Ilkka Uimonen was born in Finland in 1966 and grew up in a small town just south of the Arctic Circle. After high school, he began to travel extensively throughout the United States, Europe and Asia, working at odd jobs to pay his way. When he was 25 he found a camera in a London pub where he was working. Thus began his career as a photojournalist.

He later enrolled in the Royal Academy of Fine Arts in The Hague, and in 1993 began freelancing for local and national newspapers. In the mid-1990s, he was offered work with the Sygma Photo News agency in New York.

Uimonen has spent a considerable amount of time in Serbia – he arrived in Yugoslavia in 1999 three days before NATO air strikes began. Afghanistan has also been a focus of his work. He first visited the country in 1996, and spoke of the extreme destruction of the land and the deplorable living conditions of its people. Later he visited the central Afghanistan region of Hazarajat, documenting the famine that arose when Northern Alliance forces blocked food deliveries to the ethnic Hazara people.

Uimonen has also spent much time working in Palestine and Israel. When Ariel Sharon made his controversial visit to Jerusalem's Temple Mount and the Al-Aqsa mosque in September 2000, Uimonen photographed a cycle of violence as it moved from one location to the next. The images were published in a book, *Cycles*, a sequence of 61 photographs of the combatants and the innocents.

Uimonen has been an associate member of Magnum Photos since 2002, and has received several awards for his photographs. He lives in Brooklyn, New York.

Ilkka's work comes to me from the edge, the border: between understatement and rage, between nihilism and reform, between hidden and exposed, between darkness and light. His inspiration appears to derive more from painting than photography. Here is fine, straight and original photography that recalls the sombre palette of Munch's storm, Richter's emotive abstraction, and the melancholy of Hammershoi's interiors, where lonely figures, backs turned from the viewer, brood in Scandinavia – Ilkka's homeland.

The delicacy and rawness of the struggle for expression provide Ilkka's photographs with both honesty and strength. I have selected work from the Sri Lanka tsunami series (2005) and *Cycles* (2004). The opening colour photograph reveals the aftermath of the world's worst railway disaster where about 1,700 people died – trapped and drowned as an overcrowded train, *Queen of the Sea*, became pulverized by a 6-metre wave. The other colour photographs, which depict a flooded interior and men gazing out to sea, convey the suddenness and pathos of this terrible event – the tsunami of 26 December 2004 – with a palpable and melancholic stillness that words cannot begin to describe.

There is no introduction, either, to the *Cycles* book. The photographs explore the futility of vicious cycles of violence with sensitive determination. All the faces in the following selection, except for one, are hidden from us and somehow in grief. I focused for a long time on the one young Palestinian woman's face that *is* revealed and, like Ilkka, I have nothing more to say in words. Ilkka may be enigmatic and somehow hard to reach, but his photographs, poised as they are on the border between conventional certainties, are lucid.

Stuart Franklin

Opposite, top and bottom
From *Cycles*. Israel, 2002

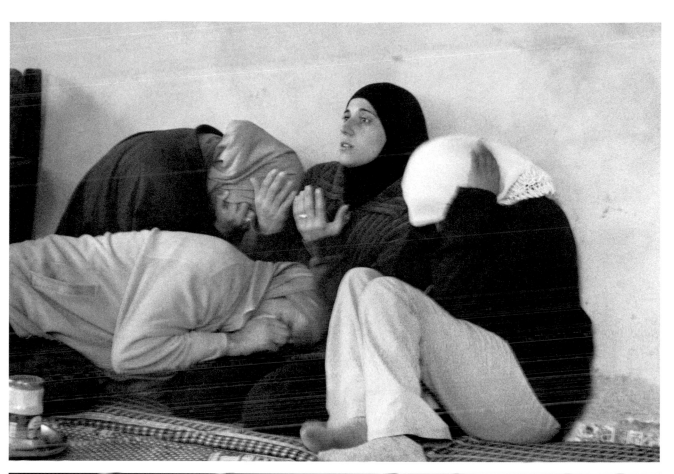
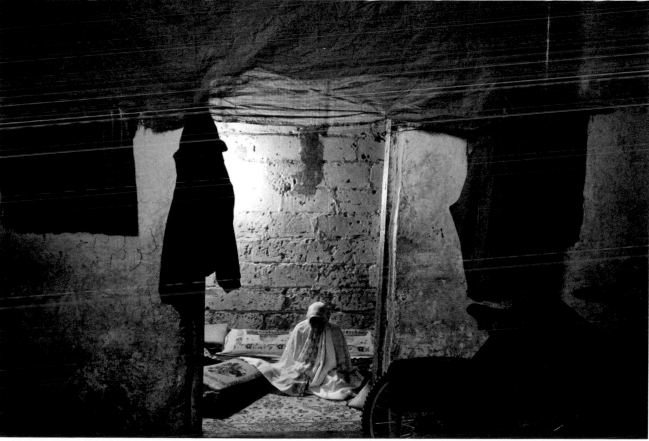

Opposite, top and bottom
After the tsunami: a fisherman at Negombo.
Sri Lanka, January 2005

After the tsunami. Pottuvil, Sri Lanka, January 2005

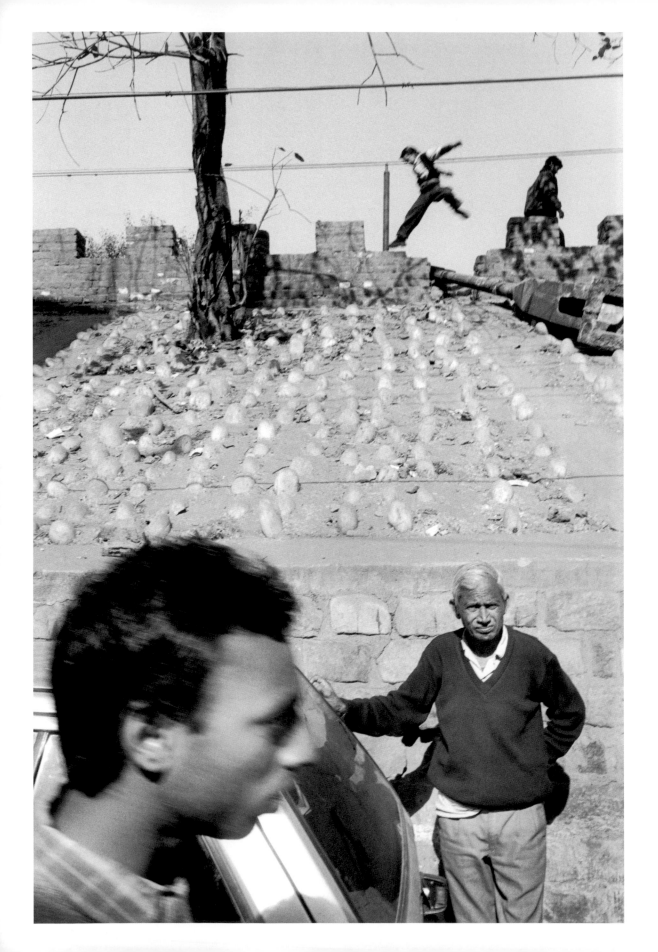

JOHN VINK

John Vink was born in 1948 and studied photography at the fine arts school of La Cambre in Brussels, in 1968. He has been a freelance journalist since 1971.

Since the mid-1980s, Vink has dedicated much time to long-term projects, the first of which was on Italy, between 1984 and 1988. He came to public attention in 1986 when he was awarded the prestigious W. Eugene Smith Grant in Humanistic Photography for *Waters in Sahel*, a two-year documentary project on water management involving migrant and sedentary populations of the Niger, Mali, Burkina-Faso and Senegal.

Vink joined the Vu agency in Paris in 1986, then from 1987 to 1993 worked on *Refugees in the World*, an extensive statement about life in the refugee camps of India, Mexico, Thailand, Pakistan, Hungary, Iraq, Malawi, Bangladesh, Turkey, Sudan, Croatia, Honduras and Angola. The series was published in book and CD-ROM form and became the subject of an exhibition at the Centre National de la Photographie in Paris. In 1993 Vink became a nominee at Magnum Photos, and in 1997 a full member. From 1993 to 2000 he worked on *Peuples d'en Haut*, which chronicles community life in mountainous regions of Guatemala, Laos and the Georgian Caucasus.

Wishing to concentrate on one country instead of continually travelling and wanting to move away a little from the 'photographic scene', Vink has been based in Cambodia since 2000. He currently documents land issues all over Cambodia but also covers other social issues, including the Khmer Rouge trials.

Opposite
Near the railway station at Delhi cobbles have been cemented into a railway bridge to prevent homeless people from settling there.
Delhi, India, 1996

I knew John's pictures long before I met him. Since I started out as a photographer, they have been a source of inspiration.

Looking at them, I tried to imagine what he was doing. What was behind those photographs. How he was travelling around the world. At home on all the continents. In so many different countries. I wanted to be there, too. Wandering. Being close to the people. With little equipment. In sad places. In happy places. In conflicts. Sometimes just at random. Taking pictures. From all those different places, still linked by some gentle and tender humanity.

I chose these pictures because for me they represent this 'being at home in the world'. Constantly on the move, but also there.

Thomas Dworzak

Opposite
Swimming in Krumme Lanke lake. Berlin, Germany, 1997

Following pages, left
Installing a pipeline for drinking water. La Ventosa, Guatemala, 1995

Following pages, right
Kosovar refugees, released from Mitrowice prison, crossing the border, with B-52 bombers overhead preparing to attack Serb positions. Morina, Albania, 1999

Page 540
All Saints' Day celebration. Guatemala, 1995

Page 541
Climbing the wall to dismantle a broken TV antenna. Ushguli, Georgia, 2000

Tehuantepec, Mexico, 1985

ALEX WEBB

Alex Webb was born in the USA in 1952. He became interested in photography during his high school years and attended the Apeiron Workshops in Millerton, New York, in 1972. He majored in history and literature at Harvard University, at the same time studying photography at the Carpenter Center for the Visual Arts. In 1974 he began working as a professional photojournalist and he joined Magnum Photos as an associate member in 1976.

During the mid-1970s Webb photographed in the American south, documenting small-town life in black and white. He also began working in the Caribbean and Mexico. In 1978 he started to photograph in colour, as he has continued to do. He has published seven photography books, including *Hot Light/Half-Made Worlds: Photographs from the Tropics*, *Under A Grudging Sun*, *Crossings*, the limited edition artist book *Dislocations* and *Istanbul: City of a Hundred Names*.

Webb received a New York Foundation of the Arts Grant in 1986, a National Endowment for the Arts Fellowship in 1990, a Hasselblad Foundation Grant in 1998 and a Guggenheim Fellowship in 2007. He won the Leopold Godowsky Color Photography Award in 1988, the Leica Medal of Excellence in 2000 and the David Octavius Hill Award in 2002. His photographs have been the subject of articles in *Art in America* and *Modern Photography*. He has exhibited widely in the United States and Europe, in museums including the Walker Art Center, the Museum of Photographic Arts, the International Center of Photography, the High Museum of Art, the Museum of Contemporary Art, San Diego, and the Whitney Museum of American Art.

Plenty of photographers go shooting in the streets, out and about, hunting down their images from the flux of the everyday. Few do it well. It is a source of great frustration (even for the ones who do it well, because they have good and bad days too). It seems like it ought to be so simple.

But this kind of work is about understanding, concentration, alertness, patience and quick thinking. You have to be able to understand what you are seeing, to anticipate how relationships might change, how changing your position will change things, how different lenses will change things, how your presence can change things, how composition can change things. It is like a complex mental maths with multiple factors being processed simultaneously, the outcome of which demands a physical response: the camera to the eye, the framing, the shutter release – done quickly, as an athlete.

Then, of course, it is not just about those things, it is about a way of seeing the world, one distinct from the formulaic and banal. You could have all the attributes listed above and more, but not take interesting pictures without a creative intelligence directing the work, one that has a view on the world, a sense of beauty, a distinctive vision.

These images are all quite different – some are static, some dynamic; some are structurally simple and some are complex. Some use a restrained palette, others a more strident one but they are all very interesting. It's a kind of magic.

Chris Steele-Perkins

Istanbul, Turkey, 2001

Bombardopolis, Haiti, 1986

Gouyave. Grenada, 1979

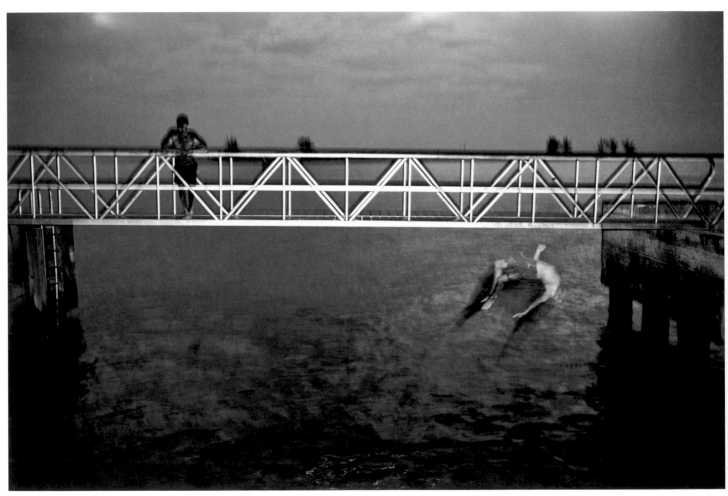

Key West, Florida, USA, 1988

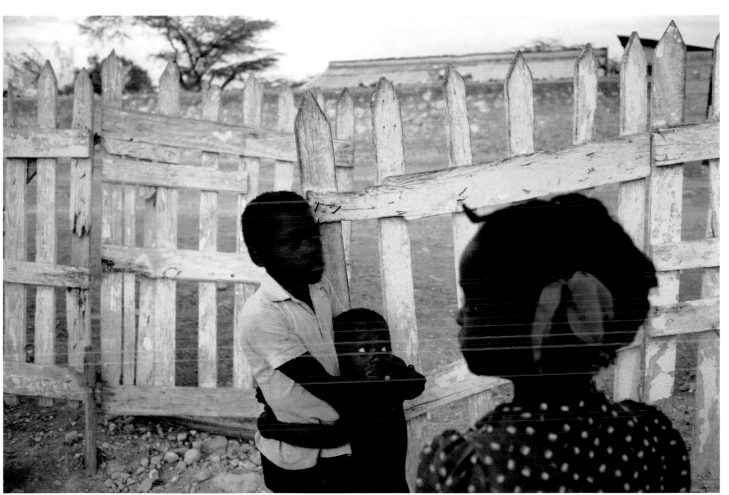

Anse-à-Galets, La Gonave, Haiti, 1986

DONOVAN WYLIE

Born in Belfast in 1971, Donovan Wylie discovered photography at an early age. He left school at sixteen, and embarked on a three-month journey around Ireland that resulted in the production of his first book, *32 Counties* (Secker and Warburg 1989), published while he was still a teenager.

In 1990 Wylie was invited to become a nominee of Magnum Photos and in 1998 he became a full member. Much of his work, often described as 'Archaeologies', has stemmed primarily to date from the political and social landscape of Northern Ireland. His book *The Maze* was published to international acclaim in 2004, as was *British Watchtowers* in 2007. In 2001 he won a BAFTA for his film *The Train*, and he has had solo exhibitions at the Photographers' Gallery, London, PhotoEspana, Madrid, and the National Museum of Film, Photography and Television, Bradford, England. He has participated in numerous group shows held at, among other venues, the Irish Museum of Modern Art, Dublin, the Victoria & Albert Museum, London, and the Centre Georges Pompidou, Paris.

When I first rolled up on Magnum London's doorstep I had no real idea what I was getting myself into. The London Bureau chief then rang around the London photographers to see if anyone was interested in having a look at this guy from Australia.

After several phone calls, I was handed Donovan's address and told that he would see me right away. The details are a bit hazy, but I remember a train ride and walking around lost in suburban streets before finally knocking on Donovan's door. Ushered in, I also remember dodging kids and being led down some stairs into a darkened room under the staircase. Computers and photography equipment filled the entire space. About an hour later I was back out on the street and it felt like I had just been ejected from a whirlpool. I was completely mentally drained. 'Intense' is how I would have described Donovan after that one visit.

A few years later I was in New York for the annual general meeting. Susan Meiselas had kindly allowed me to sleep in her studio. I was on an air mattress on the floor surrounded by her photography book collection. (I was very happy about this as I had been living in a tent for fifteen months and had been deprived of my photography books.)

There were photographers laid out everywhere. Jim Goldberg was in the next room, Larry Towell in another and Donovan in the lounge. I watched with curiosity as, each night, Donovan would go to sleep sitting up. Ever so slowly, as he started to nod off, he would slide down the wall until eventually he was lying flat. I realized that the only way he could get to sleep was to physically exhaust himself and that sleeping sitting up was part of the process of trying to counter a restless mind.

Here is a man who lives, eats and sleeps what he does. He is an artist who continues to challenge himself. He has not been one to stand still in the contentment of what he has already achieved.

Trent Parke

Following pages
H5, B-Wing, Maze Prison, near Belfast; from the series *24 Cells*. Northern Ireland, 2003

Pages 554–55
Watchtower Golf 40 (North/East view), Croslieve Mountain, South Armagh, Northern Ireland, 2006

Pages 556–57
Watchtower Golf 40 (South/East view), Croslieve Mountain, South Armagh, Northern Ireland, 2006

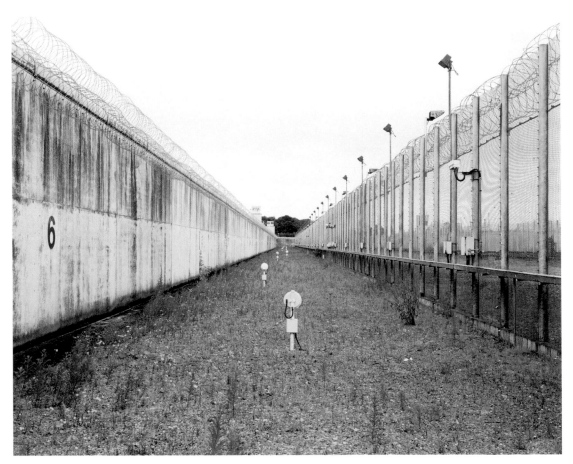

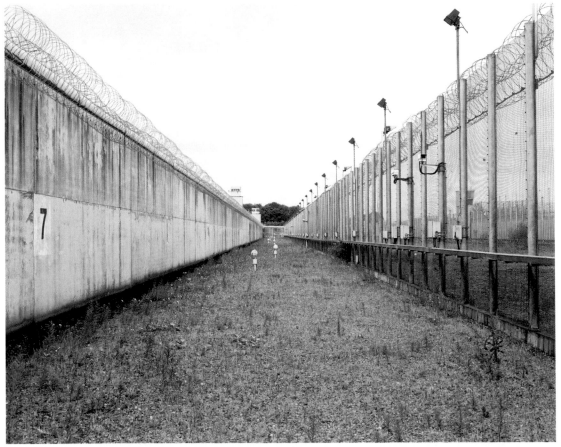

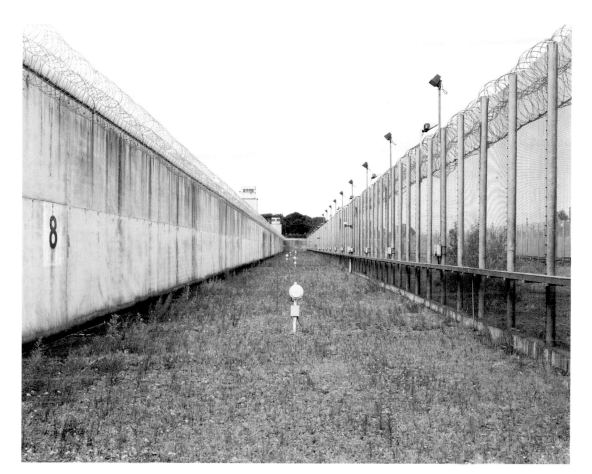

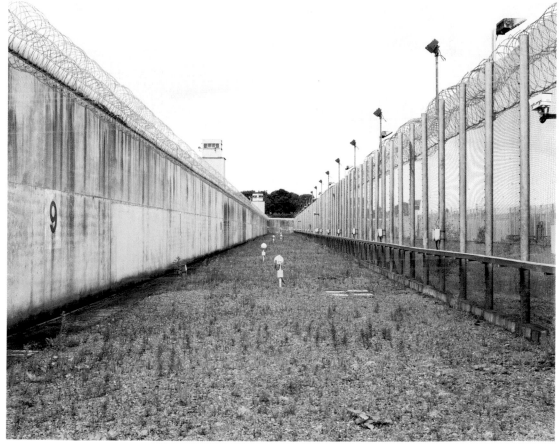

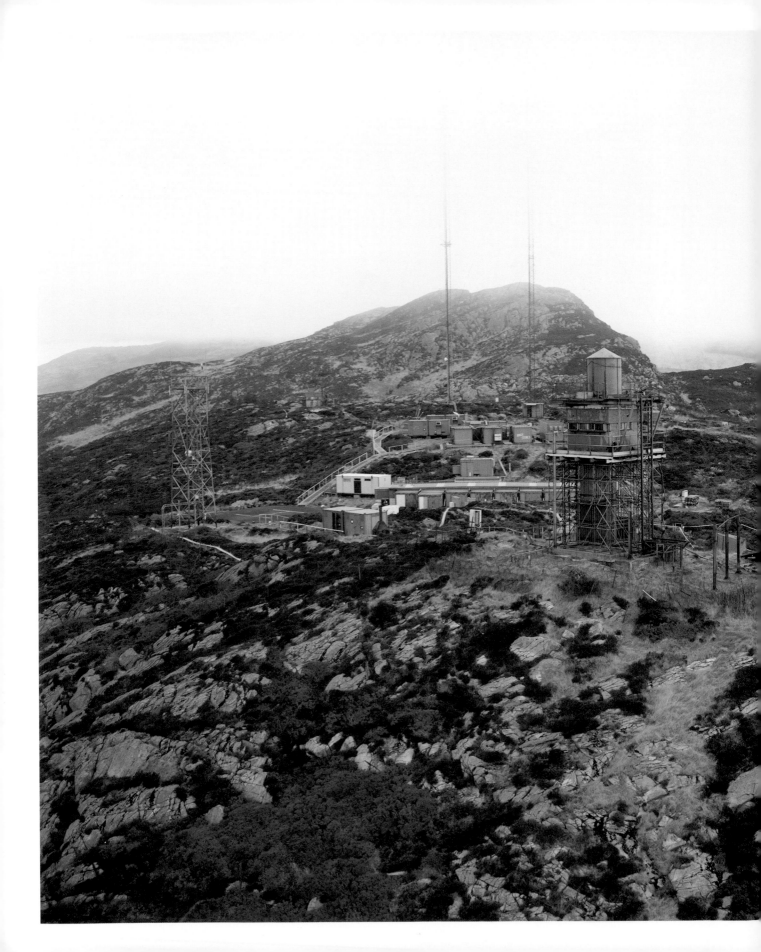

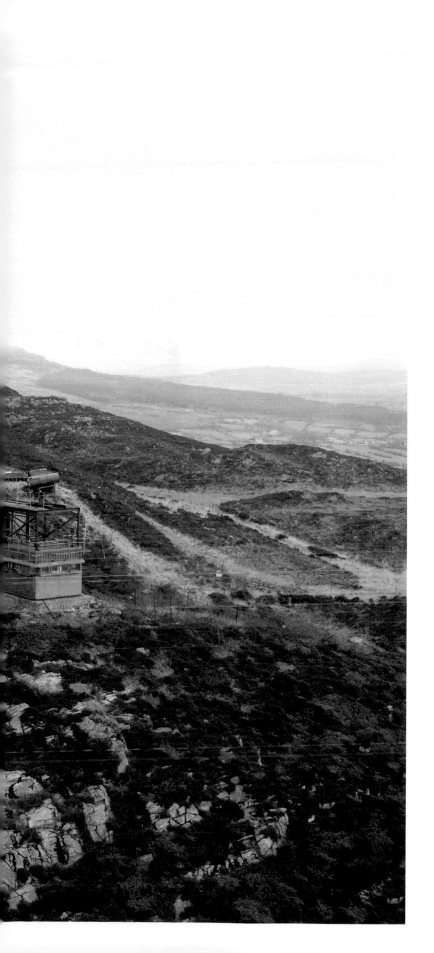

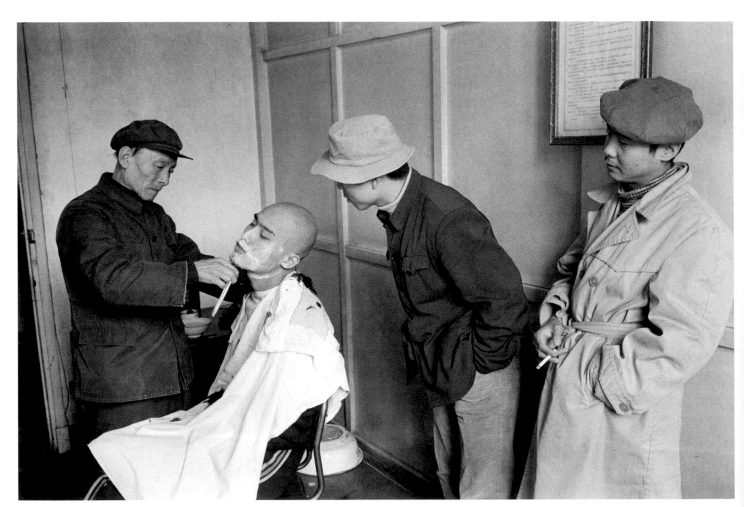

Actors prior to shooting, Peking Studios. China, 1982

PATRICK ZACHMANN

Patrick Zachmann was born in France in 1955. A freelance photographer since 1976 and member of Magnum Photos since 1990, he has dedicated himself to long-term projects on cultural identity, memory and immigration.

Zachmann's reportage on the Naples Mafia led to the publication of the book *Madonna!* (1982). From 1982 to 1984 he worked both on a project on highway landscapes supported by the French Ministry of Culture, and on the challenges of integration facing young French Arabs in the northern neighbourhoods of Marseilles.

After working for seven years on a personal project about Jewish identity, Zachmann published his second book, *Enquête d'Identité* (*Inquest on Identity*), in 1987. In 1989 his story on Beijing's Tiananmen Square was widely published in the international press. Together with other photographers, he created Droit de Regard, an association for the protection and promotion of authorship in press photography.

Still fascinated by the themes of immigration, Zachmann focused on the Chinese diaspora, resulting in the book *W., ou L'Œil d'un Long Nez* (1995), followed by a critically acclaimed exhibition. In 1997 he exhibited his work on Malian emigration.

Between 1996 and 1998, Zachmann directed the short film *La Mémoire de Mon Père*, followed by his first feature-length film *Allers-retour: Journal d'un Photographe*. Both have won awards and have been featured in numerous film festivals.

In 2004 the Parc de la Villette commissioned Zachmann to carry out a study on the Muslim community in Paris and the Île-de-France region. Currently, he is working on a project about nocturnal life in cities, using impressionistic images built on the artificial lights and colours of the night. He is also working on a new book on China.

Patrick is quiet and intense – very intense. He is a thinker, worried and overburdened by something he carries deep inside him. He is also up front. He is a man with an edge, someone who could very well snap and get off in a split second if something, or someone, goes against his principles and what he stands for. With passion and consistency, intuition, instinct, guts.

Obviously, the purpose of this text is not to write about myself; however, I can't help thinking that Zachmann and I are somehow related – like two brothers separated and abandoned at birth, who were both denied an identity. Of course there is no other choice for us but to spend our lives facing this denial. And even if we tackle it differently – Patrick goes for the roots, I go for the individuals – our quest is the same.

I like these photographs of Patrick's work on the Chinese diaspora because he lets his subjects breathe and have a life of their own. Someone told me that I had chosen some pictures that I could have taken myself. It is true, because I am always attracted by mysterious characters, and I like these. They are symbols that tickle my imagination and trigger something deep in me. These images make you think: Who are these guys? What are they doing? Are they real, or very good actors playing their role?

I was close to picking two other photographs by Patrick that I like, but they did not fit in my Zachmann film noir.

Bruce Gilden

Following pages
top left
Thai prostitutes in a massage parlour. Macao, China, 1987

bottom left
Gamblers. Taishung, Taiwan, 1987

top right
Welcoming members of the overseas Chinese association of Taiwan. Taipei, Taiwan, 1987

bottom right
Celebrating Chinese New Year. New York City, USA, 1989

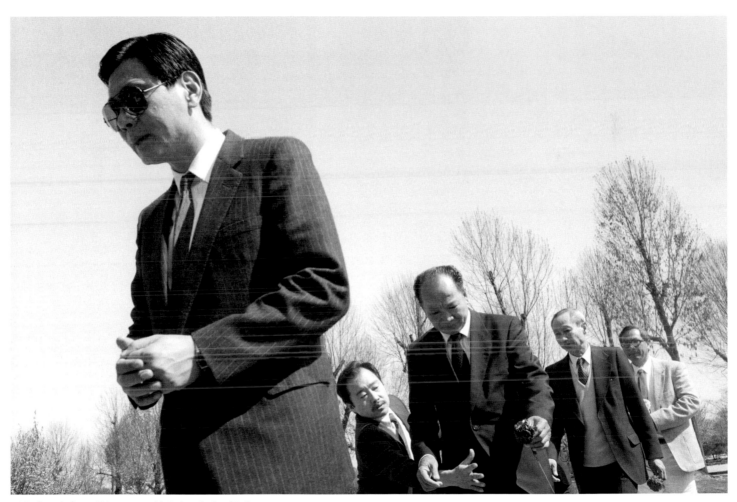

The funeral of a pro-Taiwanese notable in the suburbs of Paris.
France, 1987

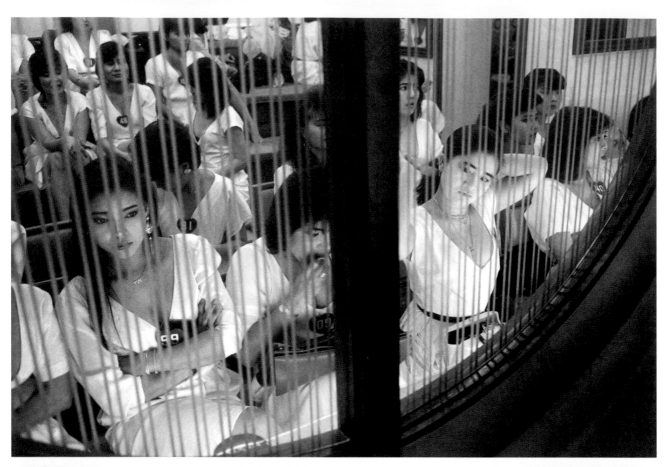

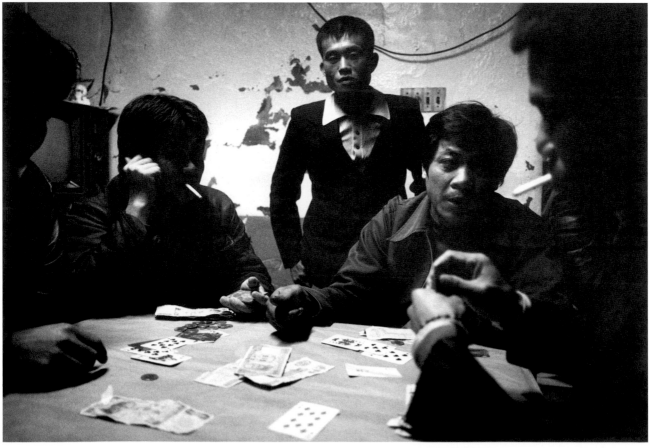

INSIDE MAGNUM PHOTOS

This book celebrates the achievements of what many consider to be the longest surviving artistic co-operative of our times. I can bring to mind no other group of individuals, with varying numbers of members and with the comings-and-goings of any living, breathing organization, that has been working towards a common goal of chronicling the world and interpreting its peoples, events, issues and personalities for more than six decades.

Magnum Photos binds together a group of more than sixty high-powered, high-spirited, highly motivated, highly talented and at times very difficult photographers. Different nationalities, different languages and, increasingly, a different view of what makes good photography: all have a home at Magnum – this book is a testament to the diversity of approach and depth of talent to be found in the collective strength of Magnum's members, associates and contributors.

With this new edition of *Magnum Magnum*, it is useful for many, who may not know of Magnum's origins and achievements, to look at the mechanisms, the infrastructure and – frankly – the hard work which have kept everyone bound together. Working for over a decade as the Head of the Cultural Department in Magnum's London office, time and time again I found myself being asked the same questions: How do you become a member, how does it work? What makes Magnum tick? How do the members interact with each other? This text is my attempt to answer those questions, to give a brief glimpse backstage to get a sense of what goes on inside Magnum Photos.

Despite Magnum's 'back story' being published many times, we need a starting point, to take bearings and to understand the goals which brought Magnum into existence.

Magnum was founded at a meeting in the restaurant of the Museum of Modern Art in New York probably some time in April 1947 (nobody at the time noted the precise date). As has become legend in countless books and articles, the founders – Robert Capa, Henri Cartier-Bresson, George Rodger, David 'Chim' Seymour and Bill Vandivert – were united in their aim of having their own agency which would ensure they could work independently from the commissioning processes of the magazines of the time, but – most important of all – retain the copyright in their images. The initial group of seven photographers (Capa, Cartier-Bresson, Rodger, Seymour, Vandivert, plus Ernst Haas and Werner Bischof) established an office in New York, followed by a Paris office a few years later.

Within ten years of that April day in 1947, a further ten members (among them Eve Arnold, Burt Glinn, Erich Hartmann, Erich Lessing, Marc Riboud and Dennis Stock) had joined the ranks. Everyone had come in on a nod and a wink from Capa or Cartier-Bresson – no official membership structure or route to becoming a member existed at that time.

The early years of Magnum have taken on an almost mythical stature in the history of 20th-century photography. There are plenty of great stories, notably Robert Capa's capacity for coming up with projects and finding money to pay the staff by betting on the horses or playing (and winning) at the poker table. Many of these stories are retold in Russell Miller's *Fifty Years at the Frontline of History*, written as an authorized biography to mark Magnum's fiftieth anniversary and which is particularly strong on the early days. In it he describes the times that could have spelled the end for Magnum, and that earlier members recalled most vividly – the tremendous shock of the sudden loss of Robert Capa, who died in May 1954 when he stepped on a landmine in Indochina, and of Werner Bischof in a car accident in Peru ten days later. After such tragic events the unexpected death of Chim Seymour on assignment during the Suez Crisis in 1956 was a near-fatal blow for the group. With Chim's passing a lot changed. René Burri recalls how in 1958 he felt as if he was joining a family in mourning. Cornell Capa, the younger brother of Robert, was much in tune with American photography and did not always see eye-to-eye with the very differently geared Cartier-Bresson. A more rigorous structure had to be imposed. One way or another, the agency survived.

Here is how Magnum works today. Magnum is a co-operative fully owned by its members, backed up by a devoted and highly motivated (and not particularly well paid) staff in its four offices in New York, Paris, London and Tokyo. Despite attempts to slim down the organization, the staff (not counting photographers' personal assistants) numbers 80 in all.

When we embarked upon producing this book, there were 46 full members, 6 associates and 6 contributors who made up 'the membership', and 5 nominees for membership (Magnum also represents the estates of members who have died). These numbers change with each year – both Mark Power and Trent Parke became full members at the 2007 AGM and, sadly, we have mourned the loss of Philip Jones Griffiths, Burt Glinn and Cornell Capa, who died in spring 2008.

The percentage of the vote required to become part of Magnum is clearly defined – you need 50 per cent of the vote to become a nominee but 66.6 per cent to become a member or associate. All major decisions in Magnum need two-thirds of the vote and this tight constitution is essential to the running of the company. There is a small number of correspondents, photographers who live too far from an office to be represented like the others, but in this age of the internet no more will be created. It is worth noting that there is and has always been a disproportionate lack of female Magnum members. Women do go forward for membership, but somehow the balance never gets redressed.

The different levels of membership can be confusing to those looking in from the outside. The full members are the stockholders in the co-operative, each with full voting rights at the Annual General Meeting (AGM), and the contributors are full members who, after twenty-three years of service, opt to reduce the percentage they pay from their earnings to Magnum and get permission to bill outside the company but they relinquish their voting rights. After twenty-five years it is possible to become a senior member which, in essence, is a type of pension: senior members are allowed to pay preferential rates but retain membership and voting rights. Nominees are elected on a 50 per cent vote, on a trial basis. This stage is a probation period for both sides; it is by no means guaranteed that a nominee will become an associate member. Associates are elected from among the nominees and are on further probation, before going to a second and final vote, usually after two years, though this period can be extended.

Once a member, always a member – unless you yourself decide to leave. Once voted in you need never take a picture again; you are part of the group. For very different reasons not everybody stays the course. You can leave of your own accord, and this does happen: James Nachtwey, Sebastião Salgado, Eugene Richards, Luc Delahaye have all chosen to do so.

The AGM takes places in any one of three of Magnum's four offices: New York, Paris or London. It always takes place in the last weekend of June, from Thursday to Sunday (with a board meeting on Monday).

Thursday is devoted to viewing the portfolios of those hoping to be nominated – these portfolios have already been filtered through the other offices. If there is time left, photographers show each other their new projects.

The first day is also the day of the party for photographers, staff, friends and valued clients – a very agreeable and social way for people to catch up with each other, but allegedly also because this is when people are still talking to one another.

The next two days are devoted to dealing with reports from the four offices and the straight facts and figures of running a business. The last day is focused on the selection of the board members and proposals that have come in from the various members.

From its simple 'nod and a wink' beginnings and lack of formal structure, Magnum has grown into an international organization with offices in three continents. For a full member, a percentage (usually between 25 and 55 per cent) is taken as a fee by Magnum, depending on the nature of the assignment, and this levy pays for running the four offices. At the end of a job (and after regular tax is paid) as little as 20 per cent of the pay from assignments is a Magnum photographer's take-home pay. Glamorous though being a Magnum photographer is, this financial commitment is much higher than in a regular agency – but then Magnum, with its creative diversity and freedom, is no regular agency.

Magnum's presence on the internet has made an enormous difference to the way business is conducted, and to the way the pictures are delivered to the clients. No longer do people come into the offices to look through stacks of boxes of pictures. The paper archives have become more or less redundant, though there is some concern about the potential loss to curators and historians, as inevitably not everything has been scanned and digitized. There are currently about 400,000 images available for viewing and ordering on the website. There are a further 100,000 which have been scanned and digitized, but are not (yet) available to the public.

In an age of information, globalization, and the fragmentation both of media and audiences, the different nationalities and different points of view of its membership have put Magnum in a unique position to interpret and represent our world. The way that audiences receive news, and the role photography has to play within the media have changed significantly in the last sixty years, and most notably in the last ten. For an organization forged by the friendships and common goals of photographers from both 'art' and 'photojournalism' backgrounds, there has always been, from the outside at least, a sense of curiosity about how those two 'camps' are reconciled. After six decades, only Magnum can boast both a strong, ongoing presence and reputation both in the world of art and of journalism and reportage. In recent Magnum history, the Cultural Departments in each of the offices – co-ordinating and facilitating exhibitions, books and print sales – have grown in significance, becoming an important part of the business alongside the more traditional editorial and commercial departments.

Despite having worked for Magnum, I did not anticipate what an enormous task the compilation of this book would be. Because of the nature of the organization, with nobody being the boss who takes the decisions, every single detail had to be checked via thousands of emails and mobile phone calls, waking us from Korea, maybe, or Bangkok, or who knows where in the middle of the night…and that was after – as Stuart Franklin mentions in his Preface – the six solid weeks it took me to get them all teamed up with each other 'in their tents'!

Sometimes photographers were too frail to select someone else's work; one or two photographers did not want to be selected by anyone else; and, as we are also covering the estates, obviously some photographers had to make more than one selection. In one case, a photographer wanted to change the selection so much that the other one no longer wanted to write about him, and he had to write about himself. A handful of the photographers went beyond the call of duty and took on more than two selections, this greatly helping out when the 'sleeping arrangements' went awry.

I could not have done this book without the help of so many of the Magnum staff members, or without the boundless patience of the editors at Thames & Hudson who stayed calm and very English when deadline after deadline went crashing past. The book could not have been done without Stuart Franklin, who regularly had to put on his presidential hat to make sure it stayed on track, or without Martin Parr, who came up with the idea as a sort of throw-away remark at the 2006 AGM but who then helped to turn the concept into reality; he was always at the end of the phone, always willing to intervene when things got hairy, always there to help or encourage, wherever he was in the world.

However, it is between the lines of the photographers' own words that one really gets the picture of how Magnum has been able to survive all these years: Henri Cartier-Bresson's conversation with Eve Arnold over a drink on a terrace in the 1950s, Peter Marlow's dedication in reordering the whole of George Rodger's archive to prepare for the retrospective show that honoured him weeks before he died, Larry Towell, writing touchingly about how he would like to have been Bischof's friend, had time not separated them. No essay can quite conjure up the atmosphere of an AGM like the one written by Trent Parke, describing various photographers dossing down on Susan Meiselas's floor in New York.

I feel that the explanation of Magnum's survival lies in the quality of the photographs in this book and in the texts the photographers contributed: for whatever structure one creates for an organization it is not the process but the underlying humanity that will be the key to its success.

Brigitte Lardinois

SELECT BIBLIOGRAPHY

This bibliography represents a selection of books that include work by Magnum photographers, but it does not list individual members' publications.

1960 *Magnum's Global Photo Exhibition,* The Mainichi Newspapers/Camera Mainichi, Tokyo

1961 *Let Us Begin: The First 100 Days of the Kennedy Administration,* Richard L. Grossman (ed.), Simon & Schuster, New York
 Creative America, Ridge Press for the National Cultural Center, New York
 J'Aime le Cinéma, text by Franck Jotterand, Éditions Rencontre, Lausanne

1963 *Fotos van Magnum,* Stedelijk Museum/Magnum Photos, Amsterdam

1964 *Peace on Earth,* text by Pope John XXIII, photographs by Magnum, Ridge Press/Golden Press, New York

1965 *Messenger of Peace,* Doubleday, New York

1969 *America in Crisis,* photographs selected by Charles Harbutt and Lee Jones, text by Mitchel Levitas, Ridge Press/Holt, Rinehart and Winston, New York

1979 *This Is Magnum,* Pacific Press/Magnum Tokyo

1980 *Magnum Photos,* introduction by Hugo Loetscher, Saint-Ursanne, Switzerland

1981 *Paris, 1935–1981,* introduction by Inge Morath, text by Irwin Shaw, Aperture, New York

1982 *Terre de Guerre,* René Burri and Bruno Barbey (eds), text by Charles Henri-Favrod, Magnum Photos, Paris

1985 *After the War Was Over,* introduction by Mary Blume, Thames & Hudson, London
 Après la Guerre…, Chêne, Paris
 Eine Neue Zeit, DuMont Buchverlage, Cologne
 Magnum Concert, introduction by Roger Marcel Mayou, Triennale Internationale de la Photographie au Musée d'Art et d'Histoire, Fribourg
 The Fifties: Photographs of America, introduction by John Chancellor, Pantheon Books, New York

1987 *Bons Baisers,* Collection Cahier d'Images, Contrejour, Paris
 Israel: The First Forty Years, William Frankel (ed.), introduction by Abba Eban, Thames & Hudson, London

1988 *China: A Photohistory, 1937–1987,* Thames & Hudson, London
 Terre Promise: Quarante Ans d'Histoire en Israël, Nathan Image, Paris

1989 *In Our Time,* William Manchester (ed.), text by Jean Lacouture, W. W. Norton & Company, New York
 Magnum: 50 Ans de Photographies, text by William Manchester, Jean Lacouture and Fred Ritchin, Éditions La Martinière, Paris

1990 *À l'Est de Magnum, 1945–1990,* René Burri, Agnès Sire and François Hébel (eds), Arthaud, Paris
 Music, Michael Rand and Ian Denning (eds), André Deutsch, London
 Ritual, Michael Rand and Ian Denning (eds), André Deutsch, London

1992 *Heroes and Anti-Heroes,* introduction by John Updike, Random House, New York

1994 *Magnum Cinéma,* Agnès Sire, Alain Bergala and François Hébel (eds), text by Alain Bergala, Cahiers du Cinéma/Paris Audiovisuel, Paris

1996 *Americani,* introduction by Denis Curti and Paola Bergna, text by Fernando Pivano, Leonardo Arte, Milan
 Guerras Fratricidas, Agnès Sire and Martha Gili (eds), texts by Régis Debray, Javier Tusell and José Maria Mendiluce, Fundación Caixa, Barcelona
 Magnum Landscape, text by Ian Jeffrey, Phaidon Press, London

1997 *Magnum: Fifty Years at the Frontline of History,* text by Russell Miller, Grove Press, New York
 Magnum Photos, Photo Poche Nathan, Paris

1998 *1968: Magnum dans le Monde,* texts by Eric Hobsbawm and Marc Weizmann, Hazan, Paris
 Israel, Fifty Years, Aperture, New York
 Murs, Sommeil, Combattre, Arbres, Stars, Couples, Déserts, Naître, La Nuit, Écrivains (series), Jean-Claude Dubost, Marie-Christine Biebuyck and Agnès Sire (eds), Finest SA/Éditions Pierre Terrail, Paris

1999 *Magna Brava: Magnum's Women Photographers* (Eve Arnold, Martine Franck, Susan Meiselas, Inge Morath and Marilyn Silverstone), text by Sara Stevenson, Prestel, Munich, 1999
——— *The Misfits*, Phaidon Press, London

2000 *GMT 2000, A Portrait of Britain at the Millennium*, HarperCollins, London
——— *Magnum Degrees*, introduction by Michael Ignatieff, Phaidon Press, London

2001 *New York September 11 by Magnum Photographers*, introduction by David Halberstam, Power House Books, New York

2002 *Arms Against Fury, Magnum Photographers in Afghanistan*, texts by Mohammad Fahim Dashty, Douglas Brinkley, Lesley Blanch, John Lee Anderson and Robert Dannin, powerHouse Books, New York
——— *Magnum Football*, Phaidon Press, London

2003 *La Bible de Jérusalem*, Éditions La Martinière, Paris
——— *Magnum Photos Vu par Sylviane de Decker Heftler. Paris Photo, 2002–2003*, Filigranes Éditions, Trézélan, France
——— *New Yorkers as Seen by Magnum Photographers*, powerHouse Books, New York
——— *The Eye of War*, Weidenfeld & Nicolson, London

2004 *Magnum M1: Rencontres Improbables*, Magnum Photos/Steidl, Göttingen
——— *Magnum Photos Vu par Michael G. Wilson: Paris Photo, 2004*, Filigranes Éditions, Trézélan, France
——— *Magnum Stories*, Phaidon Press, London
——— *Muhammad Ali*, Abrams, New York
——— *Periplus: Twelve Magnum Photographers in Contemporary Greece*, text by Sylviane de Decker-Heftler, Atalante, Paris

2005 *EuroVisions*, text by Diane Dufour and Quentin Bajac, Magnum Steidl/Centre Pompidou, Paris
——— *Magnum Histories*, Chris Boot (ed.), Phaidon Press, London
——— *Magnum Ireland*, Brigitte Lardinois and Val Williams (eds), introduction by John Banville, texts by Anthony Cronin, Nuala O'Faolain, Eamonn McCann, Fintan O'Toole, Colm Tóibín and Anne Enright, Thames & Hudson, London
——— *Magnum M2: Répétitions*, Magnum Photos/Steidl, Göttingen
——— *Magnum Sees Piemonte*, texts by Giorgetto Giugiaro, Erik Kessel and Diane Dufour, Regione Piemonte
——— *Venedig*, photographs by Mark Power, Gueorgui Pinkhassov, Martin Parr, Paolo Pellegrin and Robert Voit, Mare, Hamburg

2007 *L'Image d'Après: Le Cinéma dans l'Imaginaire de la Photographie*, texts by Serge Toubiana, Diane Dufour, Alain Bergala, Olivier Assayas and Matthieu Orléan, Magnum Steidl/La Cinémathèque Française, Paris
——— *Madrid Immigrante: Seis Visiones Fotográficas sobre Immigración en la Communidad de Madrid*, texts by Joaquim Arango, Chema Conesa, Eduardo Punset and Diana Saldana, Communidad de Madrid
——— *Tokyo Seen by Magnum Photographers*, text by Hiromi Nakamura, Magnum Photos, Tokyo
——— *Turkey by Magnum*, introduction by Oya Eczacibasi, texts by Diane Dufour and Engin Ozendes, Istanbul Museum of Modern Art, Istanbul

ACKNOWLEDGMENTS

I would like to thank warmly all the Magnum staff for their valuable contribution to this book. The following have offered particularly welcome support: at Magnum London, Ileana Athanatos, Nick Galvin (the unsung hero of the Magnum Archive), Dominique Green, Fiona Rogers (whose diligence in handling material as it arrived was indispensable) and Francesca Sears; at Magnum Paris, Marie-Christine Biebuyck, Eva Bodinet, Micheline Fresne, Julien Frydman and Gaelle Quentin; and at Magnum New York, Mark Lubell, Matt Murphy, Megan Parker and Tom Wall (whose upbeat emails kept us all going when we thought this would never work). Philippe Séclier's work on compiling the Select Bibliography was invaluable.

Others have been immensely helpful and cooperative on behalf of photographers or their estates: Steve Bellow, Marco Bischof, Linni Campbell, Jimmy Fox, Martine Franck, Bridget Freed, Irene Halsman, Ruth Hartmann, John Jacob, John Morris, Jinx Rodger, Ben Schneiderman, Agnès Sire, Aileen Mioko Smith, Kevin Smith and the late Richard Whelan.

I am grateful to all the Magnum photographers for agreeing to participate, and for sticking with it; and thanks, too, to the assistants who often smoothed the way in this complicated process. René Burri, Elliott Erwitt, Thomas Hoepker and David Hurn have all been enormous sources of help; and I would particularly like to thank Stuart Franklin and Martin Parr, whose hard work and sound advice were instrumental in the making of this book.

My personal thanks go to Janice Hart and Val Williams at the London College of Communication and to Ravi Sawney for their support, and to Des McAleer and Fergal McAleer for the understanding they have shown when I so often had to absent myself to work on this book.

At Thames & Hudson I am grateful to Thomas Neurath, Johanna Neurath and Neil Palfreyman. Finally, my very special thanks go to Andrew Sanigar of Thames & Hudson, Philip Watson, the book's editor, and Martin Andersen, the book's designer. The tireless help, endless patience and hard work of everyone concerned have contributed to making this book something of which we can all feel proud.

Brigitte Lardinois